The Art of Harvey Kurtz

EXPOSED: THE TRUTH ABOUT **RADIATION**
Americans face 90% exposure this winter.

"The covers of *MAD* no. 11 and *Humbug* no. 2 changed the way I saw the world forever! . . . Even though I've made a name in my own right, I still feel like a worshipful fanboy."

—R. CRUMB

"*MAD* was the first comic enterprise that got its effects almost entirely from parodying other kinds of popular entertainment. . . . To say that this became an influential manner in American comedy is to understate the case. Almost all American satire today follows a formula that Harvey Kurtzman thought up."

—RICHARD CORLISS, *TIME*

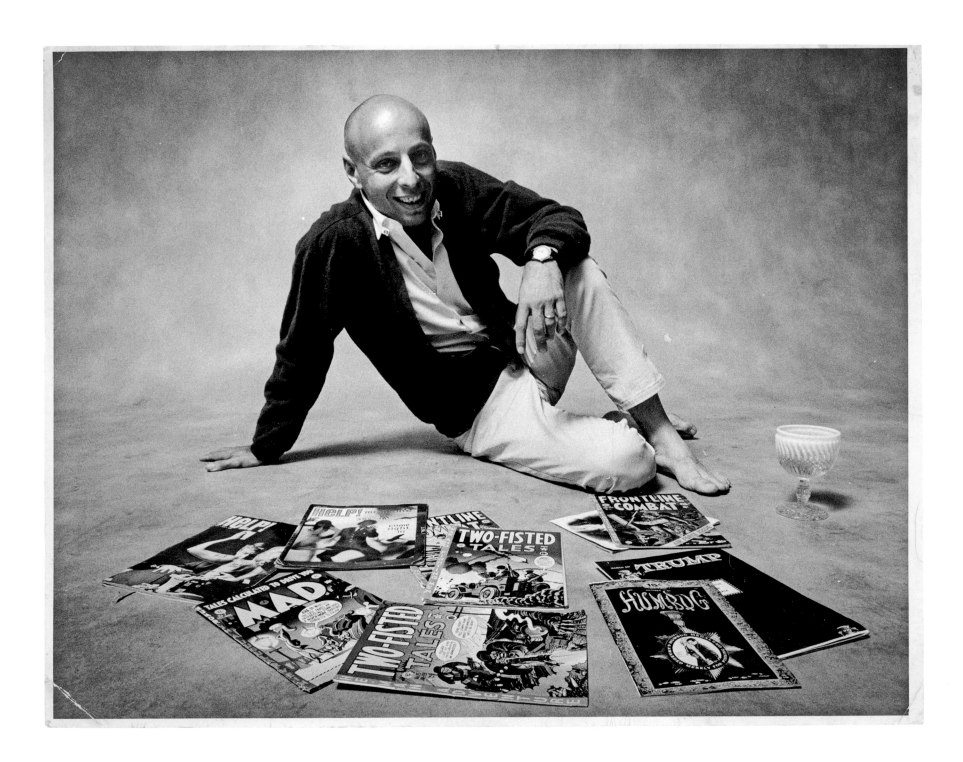

The Art of
Harvey Kurtzman

THE MAD GENIUS OF COMICS

By Denis Kitchen and Paul Buhle

Introduction by Harry Shearer

DESIGNED BY KITCHEN, LIND & ASSOCIATES

ABRAMS COMICARTS, NEW YORK

Editor: Charles Kochman
Assistant Editor: Sofia Gutiérrez
Designers: Jonathan Bennett, John Lind for Kitchen, Lind & Associates
Art Director: John Lind
Production Manager: Anet Sirna-Bruder

Library of Congress Cataloging-in-Publication Data
Kitchen, Denis, 1946–
 The art of Harvey Kurtzman / by Denis Kitchen and Paul Buhle.
 p. cm.
 ISBN 978-0-8109-7296-4
 1. Kurtzman, Harvey—Criticism and interpretation. I. Buhle, Paul, 1944–
 II. Title.
 PN6727.K87Z75 2008
 741.5'6973—dc22
 2008004809

HNA ■■■■■
harry n. abrams, inc.
a subsidiary of La Martinière Groupe

115 West 18th Street
New York, NY 10011
www.hnabooks.com

Acknowledgments

This book would not have been possible without the encouragement, cooperation, and
friendship of Adele Kurtzman and her daughters, Meredith and Nellie. Providing generous
access to archival materials and their candid feedback, patience, and acceptance of the bitter-
sweet memories of Harvey's career ups and downs were all central to the making of this book.
We hope Harvey would have been pleased.

Special thanks go to executive editor Charlie Kochman, who shared our vision for this
dream project from the start. We are delighted to kick off the Abrams ComicArts imprint
with this book. Thanks also to all others involved at Harry N. Abrams, in particular editorial
assistant Sofia Gutiérrez, managing editor Andrea Colvin (deep gratitude for keeping this book
on track), publisher Steve Tager, and Anet Sirna-Bruder in production.

We are indebted to designers John Lind and Jonathan Bennett for their extraordinary
dedication and skill (and for all the long hours) in making this book gorgeous.

Appreciation goes to Harry Shearer for his introduction, to Elizabeth Kurtzman and Marc
Hirschfeld for bringing Harry to the book, and to Patty Freedman at Andrew Freedman Public
Relations for facilitating.

We are grateful to the following individuals for generously providing critical images from
personal collections or institutional archives, and/or for special favors along the way: Scott
Allie at Dark Horse Comics; John Benson; E. B. Boatner; Glenn Bray; Claudine Dixon
and Kate Bergeron at the Hammer Museum; Jacques Dutrey; Neil Egan at Abrams; Grant
Geissman; Terry Gilliam; Lloyd Greif; Wendy Hurlock Baker at the Archives of American
Art/Smithsonian; Michelle Ishay at Abrams; Lee Loughridge for additional coloring help; Scott
Nybakken at DC Comics; Patrick Rosenkranz; Jim Titus at Bissel & Titus; and Craig Yoe.

Paul Levitz at DC Comics; Cathy Gaines Mifsud at William M. Gaines Agent, Inc.; and
Marcia Terrones at *Playboy* all went the extra mile granting us permission to use copy-
righted images.

And, finally, the authors extend thanks to friends, family, and colleagues who helped make
this project become a reality: Amie Brockway, Alvin Buenaventura, R. Crumb, Tony & Angela
DiTerlizzi, Danny Fingeroth, Ron Grele at the Columbia University Oral History Research
Office, Terry Gilliam, Todd Hignite, Ralph Keyes, Stacey Kitchen, John Kricfalusi, Ellen Lind,
Jay Lynch, Greg Sadowski, Art Spiegelman, and James Vance.

The text of this book was set in **Adobe Garamond Pro** by Adobe Systems, designed by
Claude Garamond and Robert Slimbach. Captions are set in AVENIR by Linotype, designed by
Adrian Frutiger. Display type is set in NEUTRAFACE by House Industries, designed by Richard
Neutra and Christian Schwartz, and **Gotham** by Hoefler & Frere-Jones, designed by Tobias
Frere-Jones.

The images for this book were selected by Denis Kitchen and John Lind from various
sources including the Kurtzman archives. The majority of images were photographed directly
from the originals in Fall 2007.

The layout was assembled using InDesign CS2 & CS3 by Adobe Systems.

This book was produced for Harry N. Abrams, Inc., by Kitchen, Lind & Associates, LLC.

www.kitchenandlind.com

Front endpapers | Detail from "May Queen" for *Compact*, by Harvey Kurtzman (May 1952).
Page ii | Detail from the cover of *Humbug* no. 2 (September 1957), by Will Elder from Harvey
Kurtzman pencils.
Page iv | Detail from cover concept art to *MAD* no. 1 (1952), by Harvey Kurtzman.
Page vi | Photo of Harvey Kurtzman among samples of his work (1965).
Page ix | Illustration from Harvey Kurtzman letter to Adele Hasan (1947).
Page x | Detail from "Marley's Ghost" presentation sample by Harvey Kurtzman (1954).
Page xii | Detail from variant version of "Times Square" for *Pageant*, by Harvey
Kurtzman (1960).
Page 242 | Detail from "Dracula: Curse of the Vampire" for *L'Echo des Savanes* (1974).
Back endpapers | Photo of Harvey Kurtzman by E. B. Boatner (circa 1976).

Contents

INTRODUCTION BY HARRY SHEARER.....................................*xi*

PREFACE.....................................*xiii*

Chapter 1 HEY LOOK! IT'S THE '40S.....................................I

THE EARLIEST YEARS.....................................I

HIGH SCHOOL OF MUSIC AND ART.....................................5

LOUIS FERSTADT SHOP.....................................I2

WORLD WAR II EXPERIENCE.....................................I3

POSTWAR: THE CHARLES WILLIAM HARVEY STUDIO.....................................I8

TIMELY AND STAN LEE.....................................22

"HEY LOOK!".....................................23

ENTER ADELE.....................................30

LATE-'40S DIVERSIFICATION.....................................38

BRIDGE TO A NEW DECADE.....................................47

Chapter 2 KURTZMAN REWRITES HISTORY, IN PICTURES
(AND LATER SAVES E.C. COMICS).....................................49

TWO-FISTED EDITING.....................................59

KURTZMAN METHODS.....................................60

OTHER BATTLEGROUNDS.....................................67

"CORPSE ON THE IMJIN!".....................................70

Chapter 3 KURTZMAN'S *MAD*.....................................8I

THE IMPETUS BEHIND *MAD*'S CREATION.....................................8I

*MAD*MEN.....................................83

"SUPERDUPERMAN!".....................................97

DECONSTRUCTION BEFORE IT HAD A NAME.....................................I06

MAD BECOMES A MAGAZINE.....................................I06

"3-DIMENSIONS!".....................................II5

Chapter 4 THREE MAGAZINES AND FREELANCE HELL.....................................I2I

THE BIRTH AND QUICK DEATH OF *TRUMP*.....................................I22

ENTER *HUMBUG*, THE CARTOONIST COLLECTIVE.....................................I25

"MARLEY'S GHOST".....................................I36

JUNGLE BOOK.....................................I5I

FINDING WORK WHEREVER IT WAS: 1959–6I.....................................I60

A GRAPHIC NOVEL THAT DIDN'T KNOW WHAT IT WAS.....................................I60

"THE GRASSHOPPER AND THE ANT".....................................I6I

A FINAL HELPING OF MAGAZINE.....................................I88

Chapter 5 SATIRE IN TECHNICOLOR.....................................209

"LITTLE ANNIE FANNY" ORIGIN STORY.....................................2I6

"LITTLE ANNIE FANNY: AMERICANS IN PARIS".....................................2I9

PERFECT COLLABORATORS.....................................2I9

OTHER PROJECTS DURING THE "ANNIE" YEARS.....................................223

OFFSETTING LATE-CAREER CONSOLATIONS.....................................224

"LITTLE ANNIE FANNY".....................................226

SOURCES.....................................238

INDEX.....................................239

THE ESSENTIAL HARVEY KURTZMAN.....................................*24I*

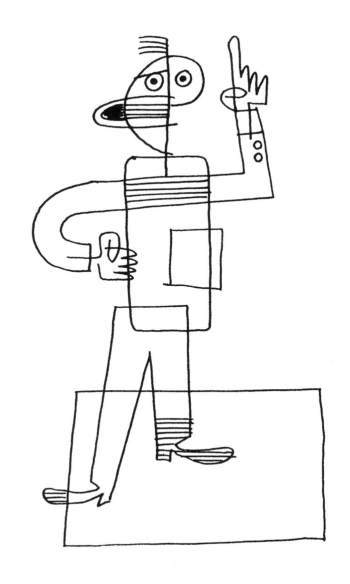

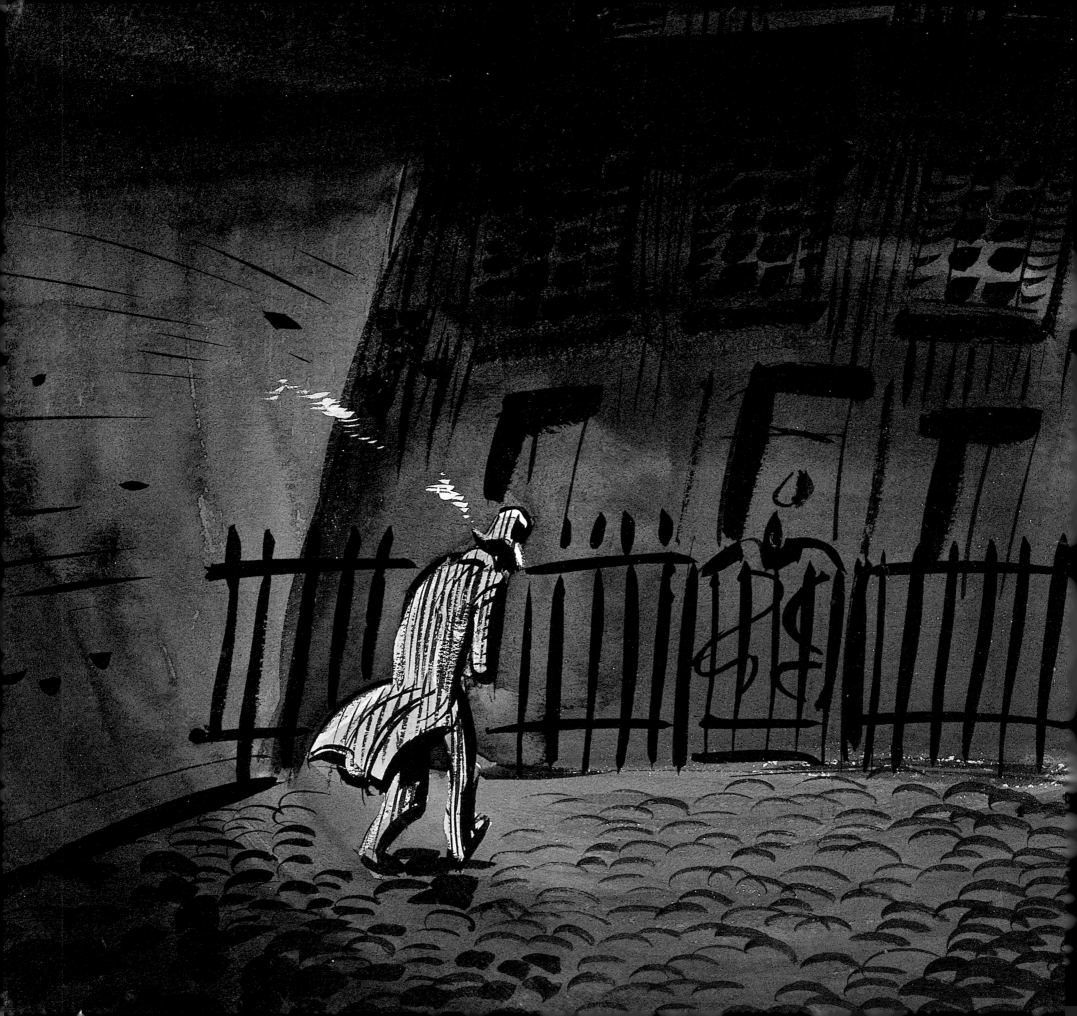

Introduction

WITHOUT HARVEY KURTZMAN, there would have been no *Saturday Night Live*. What a horrible thing to say about him, but it's true.

And it's still horrible.

Harvey Kurtzman taught two, maybe three generations of postwar American kids, mainly boys, what to laugh at: politics, popular culture, authority figures.

OK, this might be better. Without Harvey Kurtzman, there would have been no *Simpsons*.

I was a kid in school when the furious adult protest against horror comic books drove *Tales from the Crypt* and its ilk from the newsstands. I still remember the first edition of *MAD* being passed furtively along the rows of desks in school. Harvey and his crew lit a fire of subversive laughter. They taught us to pay attention to sloppiness of thought and execution in our politics and culture, and they taught us that "popular" need not, for a magical moment at least, be synonymous with "lowest common denominator."

Pals of mine went to work for Harvey on *Help!* They were young, living in New York, working for someone we had learned if not to idolize, at least to look up to as a leader in satirical and parodic visual entertainment. I envied them deeply. But I had an army to stay out of.

Without Harvey Kurtzman, there would have been no "Little Annie Fannie." (Hey, we've all got to eat.)

Harvey blazed a trail that made a lot more money for the people who followed him. Lenny Bruce would have understood that.

Kurtzman didn't set out to make Art; it just ended up that way.

—HARRY SHEARER

Harry Shearer is a comic personality and multiple hyphenate: author, director, satirist, musician, radio host, playwright, multimedia artist, and record-label owner. He is a voice actor on *The Simpsons*, was a cast member on *Saturday Night Live*, and has appeared on screen in *The Right Stuff*, *This Is Spinal Tap*, *The Truman Show*, *A Mighty Wind*, and *For Your Consideration*. He is a Grammy-nominated musician, the winner of two Cable Ace Awards, and the author of *Man Bites Town*; *It's the Stupidity, Stupid*; and the bestseller *Not Enough Indians*.

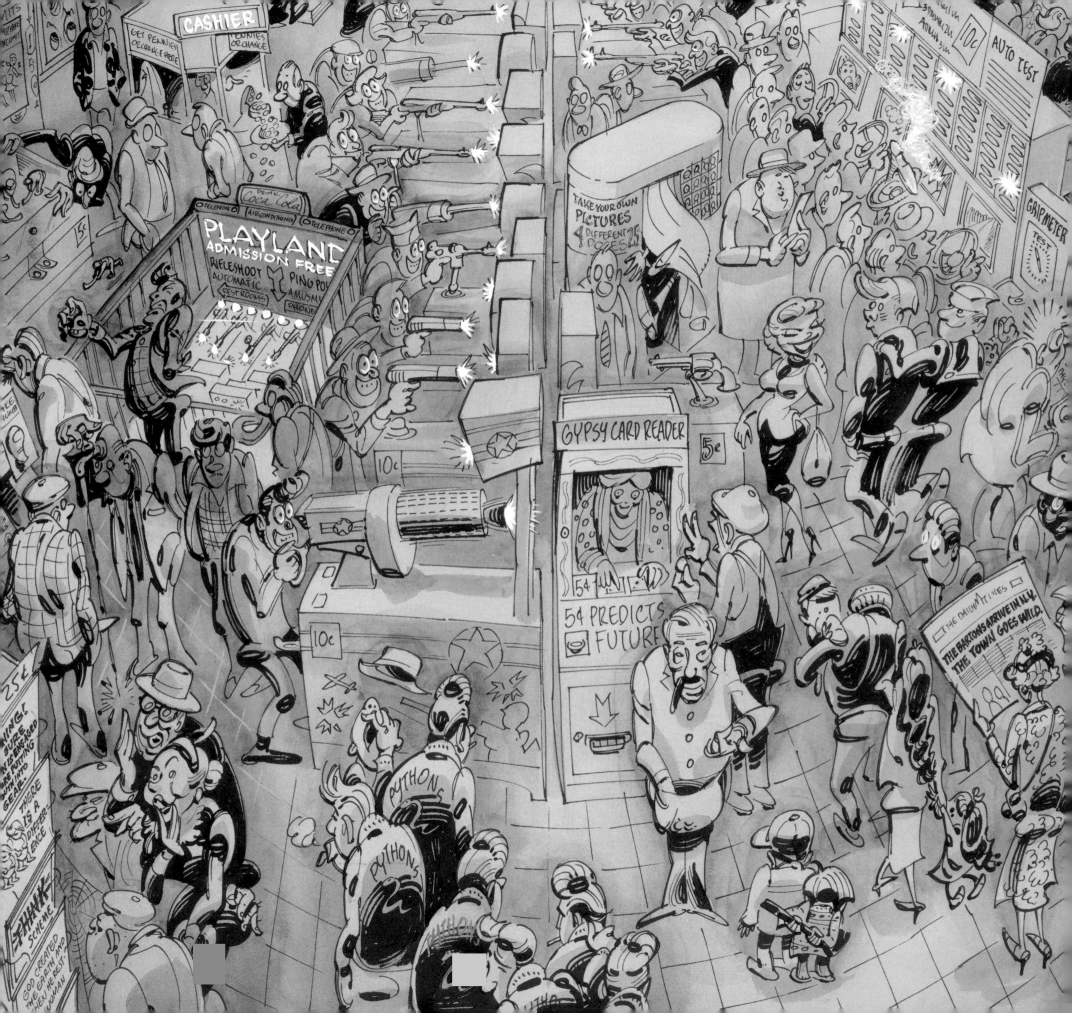

Preface

WITH *MAD* ALONE, Harvey Kurtzman's position in comics and the cultural pantheon is secure. As protégé Art Spiegelman has noted, "Kurtzman's *MAD* held a mirror up to American society, exposing the hypocrisies and distortions of mass media with jazzy grace and elegance. He's our first post-modern humorist, laying the groundwork for such contemporary humor and satire as *Saturday Night Live*, *Monty Python*, and *Naked Gun*."

In *MAD* and all his subsequent ventures, Kurtzman drew a bead on the phony aspects and idiosyncrasies of modern commercial culture—from advertising to film to comic book clichés. He took on Senator Joseph McCarthy as surely and seriously in the pages of *MAD* as Edward R. Murrow did on television. Kurtzman also took on comic art censorship, which was then sweeping across the profession. And he did it all with a laugh.

But there was much more to Harvey Kurtzman than *MAD*. He edited and sometimes wrote and drew E.C. Comics' New Trend titles, offering searing insights into the cruelties and ironies of warfare, from ancient times to modern. No comics, and scarcely any art, had ever been so scrupulously researched and meticulously drawn as this subject was in his hands. Until then warfare had often been romanticized and glamorized in popular art.

Kurtzman was not only the twentieth century's most influential editor of both serious-minded comics and comics with a sense of humor, he was also an important artist in his own right. There are many who wish circumstances had permitted Kurtzman to focus entirely on his magnificent solo creations. But, as both an editor and creator, his influence on his own and subsequent generations of cartoonists and writers was—and is—

profound. The respect and loyalty that top collaborators like Will Elder, Jack Davis, Wally Wood, Al Jaffee, Arnold Roth, Russ Heath, and others had for Kurtzman was best demonstrated by a not-so-simple gesture—they followed him from magazine to magazine, doing their very best work under his often stern direction.

Kurtzman had a great gift for discovering and nurturing talent. His first editorial assistant at *Help!* in 1960 was no less than later celebrity feminist Gloria Steinem, whom Harvey ironically tried to set up on a blind date with his friend *Playboy* publisher Hugh Hefner. Kurtzman replaced Steinem with another fresh face, Terry Gilliam, who first developed his directing chops doing photo novels known as *fumetti* for *Help!* And Kurtzman didn't just provide inspiration for *Monty Python's Flying Circus*. When he hired a virtually unknown actor named John Cleese in 1964 to play the lead in a Gilliam-scripted *fumetti* about a man who harbors unhealthy desires for his daughter's Barbie doll, Kurtzman literally set in motion the subsequent formation of *Monty Python* several years later.

In the early and mid-1960s, Kurtzman discovered and gave the first national exposure to young cartoonists such as Robert Crumb, Gilbert Shelton, Jay Lynch, Skip Williamson, and Joel Beck—all rabid fans of Kurtzman's *MAD*, *Humbug*, and *Jungle Book*, and all key members of what soon came to be known as America's counterculture. Their debuts in *Help!* proved direct precursors to *Zap*, *Bijou Funnies*, *Feds 'n' Heads*, and the other underground comix that blossomed not long after *Help!*'s demise.

Crumb calls Kurtzman, his mentor, "as good as any cartoonist in history," and has often declared

that the early *MAD* and *Humbug* comics fundamentally changed his life. Virtually every other underground cartoonist has likewise acknowledged Kurtzman's influence and expressed respect and affection. Harvey, in turn, would reciprocate that respect and affection. Often called the father of underground comix—or "the spiritual godfather," according to Art Spiegelman—Kurtzman himself used a funnier term: "father-in-law."

If he had a Midas touch for talent, Kurtzman had a reverse Midas touch for business, which was never his strong suit. His biggest gambles—leaving *MAD* for *Trump*, starting *Humbug*—proved disastrous. His best-known creations and successes—*MAD* and "Little Annie Fanny"—contributed heavily to the fortunes of others, but were not owned or controlled by him. Harvey's good friend Will Eisner, the legendary graphic novel creator, was the rare artist who also excelled at business and owned the majority of his prodigious output. As Kurtzman's widow, Adele, laments, "Harvey repeatedly asked Will for advice. But he never took it."

Kurtzman spent most of the final three decades of his career producing the risqué satire "Little Annie Fanny" for *Playboy*, where he found perhaps his largest audience: As many as seven million readers every month would see each lavishly rendered episode. But, chafing under severe creative restrictions, taking heat even from admirers for Annie's political incorrectness—or for wasting his considerable talent—and, eventually, experiencing declining health and skills, his later years were not his best.

What you are about to read is Harvey Kurtzman's story, told through a combination of words and pictures—just as he would have wanted it.

CHAPTER I

Hey Look! It's the '40s

I T'S TEMPTING to think of Harvey Kurtzman's artistic life as one divided into neat categories: "before *MAD*" and "after *MAD*." In fact, those categories do correspond with his greatest public triumph and his most influential moment in mass media. Kurtzman's story, however, follows a more complex path, through the underbrush of American popular culture and politics.

Kurtzman was, above all, the child of a profoundly misunderstood time. The 1930s was the most unusual decade of the twentieth century, one whose innovations a more conservative America has been withdrawing from ever since, and from whose contributions not a single citizen has failed to benefit. Like so many leading writers and artists of television's 1950s Golden Age, Kurtzman carried the values of the New Deal years into the citizen's army (a crusade against fascism that only a small minority of Americans failed to support) and beyond. Despite many contradictions, these war years would turn out to be a climax to the 1930s' impulses, and they were the moment when popular artists caught up with the social changes that had shaken society since the stock market crash of 1929 and established the path that lay ahead.

Comic books were the newest of the mass arts, appearing on the market after network radio and before television, and they were uniquely monopolized by youngsters (including young soldiers at

home and overseas). They were generally viewed by the middle classes and the aspiring upper class as pulp trash. That comics should become an "art form" was a notion that seems to have developed only from the inside, and only in the minds of a handful of innovators.

But artistic maturation and achievement in this mass, million-selling, commercially fertile field was nevertheless a possibility. Comics art emerged and matured with a startling suddenness before the industry suffered the severe blows all too typical of the McCarthy era. To understand that development, one needs to comprehend the young Harvey Kurtzman.

THE EARLIEST YEARS

The early life of Harvey Kurtzman mirrors that of many other hard-pressed immigrants—especially New York Jewish families—launching sons into artistic and intellectual realms as well as into worldly success. Harvey's story is unusual in that despite being placed in an orphanage temporarily, he blossomed rapidly afterward and found himself, along with future colleagues, in a new kind of public school—a tribute to the surge of social programs during the New Deal era.

Not much is known about his family before immigration, and Kurtzman himself revealed surprisingly little to interviewers, even friends,

perhaps because of some especially painful early memories. His mother, Edith, and his biological father, David Kurtzman, had been raised as Russian-Jewish urbanites, more sophisticated than rural *shtetl*-dwellers, and at the very least literate in a day and age when large numbers of Jewish women arrived in the United States without schooling. Edith arrived from Odessa to meet her husband-to-be. They married and lived in Brooklyn, where Harvey and his older brother, Zachary, were born—Harvey on October 3, 1924. Their father, a blue-collar worker, died a few years later, at age thirty-six, of a bleeding ulcer, leaving the family in such despair that when Harvey was four years old his mother was forced to place him and his brother in an orphanage for several months.

Not every orphanage was bad, of course. But for a child who had been loved, the removal from home and mother must have been traumatic. Several months later Edith remarried; a fellow Russian-Jewish immigrant, Abraham Perkes, was a highly skilled brass engraver, and together they reclaimed Harvey and his brother. Edith also sent herself to night school after the children had grown a little—evidence of determined self-improvement for someone who would not again enter the job market. She was, meanwhile, famous within the family for an immaculately kept household: a simple but essential point of dignity.

Opposite | Ulcers detail | circa 1945–47 | Harvey Kurtzman created a dozen color illustrations on the subject of stomach ulcers in the mid-1940s. These were possibly published but were more likely postwar samples Kurtzman created for his portfolio. Painted in tempera on illustration board.

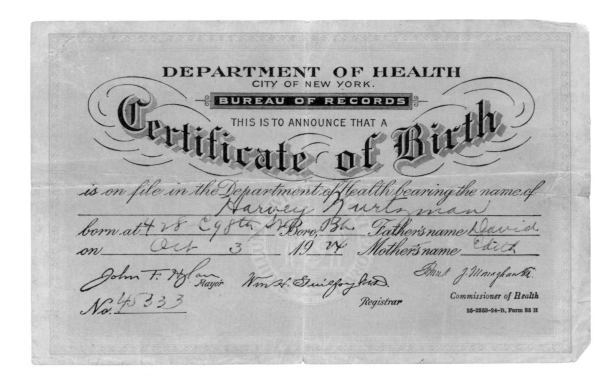

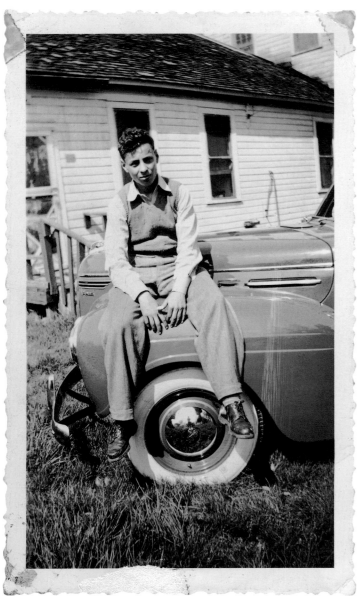

Left | Young Harvey on a fender | circa mid-1930s.

During evening walks, Harvey's stepfather used to keep him waiting outside a neighborhood tavern while he belted down a few. But while working on the engraving plates for printing jam and jelly jars, his stepfather would invite young Harvey to help out with a design or drawing and definitely encouraged him to think of himself as a professional artist.

The family, meanwhile, had moved to the neighborhood where Harvey would later best remember his boyhood self: the Bronx, 184th Street and Clinton Avenue. It was a notably non-Jewish neighborhood—not that Jews were absent, but they were few relative to Italians (especially Sicilians) and not particularly numerous compared with other groups, like the Irish. The Bronx of those days had lost most of the semi-rural character evident just a decade earlier, but remained a place distant, in many ways, from the neighborhoods of Brooklyn and the Lower East Side. Families in modest single-family houses still sometimes had chickens in the yard, and the true countryside was a fairly short subway ride away.

For many Jewish families in various New York neighborhoods and beyond, it was also a prosperous moment in American history. For working-class Jews in healthy trades (unlike the garment industry, where seasonal work employed hundreds of thousands of Jews, but was consistently haphazard), compensation was stable. By the late 1920s, the Bronx in particular aspired to, and to some degree had already reached, the desired status of the lower middle class. But it did not achieve, it is important to note, any great cultural or geopolitical sense of security within wider America.

Kurtzman was only four years old when New York Democrat Al Smith—a "wet" (anti-prohibitionist) Catholic and a champion of fellow immigrants—ran into the steamroller of Calvin Coolidge's Protestant-Republican backers. The Ku Klux Klan and other right-wing citizens groups, often armed, had been on the rise since the days of the first Red Scare, and by the mid-1920s had actively taken over city, county, and even state governments in parts of the Midwest as well as the South and Southwest. In 1924, the year

Above | Birth certificate | October 3, 1924 | Harvey Kurtzman's natural father, David Kurtzman, died when Harvey was four, and he and his brother Zachary were placed in an orphanage.

of Harvey's birth, immigration quotas were passed, blocking Jews (among others) from entering the United States. Millions could have been spared the horrors to come. According to the folk legend of two generations, Jews were secure only east of the Hudson—in the rest of the big country, perhaps not. For much of the Gentile population, Catholic and Protestant alike, Jews were judged to be non-white (only a war and a holocaust would finally change prevailing attitudes).

This insecurity had a curiously positive side. American Jewish institutions dug in and flourished. The Yiddish press and the Yiddish theater attained high points during the 1920s that would be viewed, decades later, as the Golden Age of American *Yiddishkayt*. Harvey's parents must have had their own political inclinations reaffirmed. The American Communist Party's *Daily Worker* came into the household, and Harvey's mother swore, even decades later, that she could "read between the lines" of the capitalist press, including the *New York Times*. Harvey claimed that he had learned from her to be a "nudge" on social issues. His stepfather, a strikingly handsome and forceful man, was a militant trade unionist. Both parents were eager for their sons to imbibe Jewish secular and progressive culture.

Black Friday, 1929, came to Wall Street, and the Depression hit home before Harvey had even reached grade school. For those many Jews inclined toward radicalism and Marxist interpretations, the Crash was proof positive of what they had already believed: The system was doomed. Something else had to be created.

It's impossible to say how these sentiments shaped or directly affected Kurtzman's childhood. He was recognized by his teachers as a bright boy, skipping a grade early on. He was neither a tough guy nor a bespectacled introvert. He later remembered drawing with chalk on sidewalks back in Brooklyn—his first public art—and planning with his fellow schoolboys a successful "military" mission, giving the neighborhood bully a taste of his own medicine. At Kurtzman's memorial in 1993, his brother Zachary remembered the street drawings best, along with Harvey's obsession with a microscope given to him by their stepfather; Harvey carried it from place to place, curious about everything.

By second grade his teachers were encouraging him to do crayon posters for school events. At only eight his mother enrolled Harvey in art classes at Pratt Institute. As remarkable as it seems now, a boy that age could and did take the subway himself, on Saturdays, to Manhattan for a few hours of instruction and encouragement. Harvey threw himself into the effort. He later recalled that he had been rather indifferent to the rest of his schoolwork, even history, where his artistic and editorial work would later demonstrate his mastery of details and large themes. Whatever he learned, beyond basic literacy, outside his comics world would remain largely self-taught. He was, if there can be such a thing, at once an autodidact intellectual and a schooled (mostly public-schooled) artist.

In later life, Harvey had fascinating memories about the politics and popular culture that had swirled around his childhood self. Jewish summer camps were flourishing despite the Depression, the mark of upper working-class and lower middle-class left-wing families who believed in a fresh-air break from the city and could afford the minimal tuition. Within the Left, the most self-consciously Jewish camp was Kinderland in upstate New York, where children had intensive Yiddish literature classes, took part in dancing troupes with tributes to American class struggle or to Russian life, and listened to "folk music," which often had a sharp political edge.

Young Harvey evidently shared his parents' sentiments on class and race. But he didn't like the camp. "I tried not to go, and I didn't make friends.… Kinderland seemed so goddamned programmed." He thoroughly disliked the romanticizing of the Soviet Union, but he also didn't like the seemingly insular self-identification of being collectively Jewish. Dogma was as obnoxious to him when coming from left-wing groups as it was when coming from religious Jews.

Neither Harvey nor his brothers were bar mitzvahed, as a matter of mutual consent between parents and sons. Not that they were ashamed of being Jewish. But being Jewish-Americans, to them and most of their generation, was something else, something very different and better—even for those who still attended the occasional service and politely put up with religious-minded relatives.

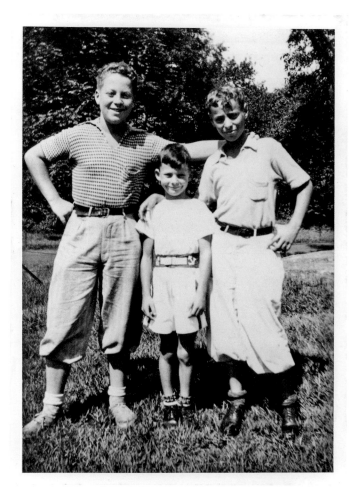

Three brothers | circa 1934 | Zachary, Daniel, and Harvey.

In the Groove with Solid Jive

"In his mad rush for the paper, he never forgets to turn on the radio"

Top left | High school strip | circa 1940 | Kurtzman's earliest known surviving comic strip was done for *Overtone,* the student paper for New York City's High School of Music and Art. **Bottom left | High school woodcut | 1941 |** While relatively crude, this woodcut from the High School of Music and Art yearbook hints at the strong composition and exuberance of Kurtzman's mature style. **Right | High school woodcut | 1941 |** A teenage boy's mind is not on girls in this woodcut illustration, one of two that Kurtzman created for his 1941 high school yearbook.

Much of the cultural-political movement in the Jewish community at the time had been going in the same general direction since 1935, when the familiar Marxist vision of apocalyptic class conflict and revolution (or fascism) had been cast aside for the idea of a Popular Front, combining liberals with radicals for more modest goals. Jewish unionism and associated secular fraternal movements that were connected with labor were also at their peak, a decade or so before the combined effects of the Holocaust, the founding of the state of Israel, and the impact of upward mobility tipped the Jewish institutional balance in favor of religion and business interests. As Harvey was leaving grade school, the Left and its liberal allies had also established themselves within the far-flung agencies of the New Deal, emphatically including wide areas of art and culture from mural painting to popular theater.

For a generation younger than his biological parents and stepfather, the New Deal years and the Popular Front enabled Jews with socialistic instincts and anxieties about anti-Semitism to accept a vision of a changing, improving American life, with themselves a vital part of it. Jewish intellectuals and artists around them, often barely mentioning their own Jewishness, were articulating inclusive democratic "American" themes on the radio, in music halls, and in films. It is from this tradition that Harvey Kurtzman grew.

HIGH SCHOOL OF MUSIC AND ART

The High School of Music and Art (known as Music and Art for short), at Convent Street and 135th Street, opened in the late 1930s out of a wide public determination to create a space where kids of all social and economic classes could turn their early creative talents into useful careers and lives. Spearheaded by reformist mayor Fiorello LaGuardia, decades later it would be renamed in honor of him and merge into the institution best known for the inspiration behind the movie *Fame*.

Several of Harvey's future comics colleagues attended Music and Art, including Will "Willy" Elder, Harry Chester, Al Jaffee, Charles Stern, John Severin, and Al Feldstein. Harvey and Harry were close friends; his future closest collaborator, Will Elder—Wolf William Eisenberg at the time—was a year older, but they were not great pals then. As Harvey entered high school, there were only two self-identified aspiring cartoonists in Music and Art, and he was one of them. The other was not Wolf Eisenberg but Harold Van Reil, one of the few African-American students at Music and Art. During school, the two engaged in spirited cartoon rivalry. In an accomplished drawing in Kurtzman's yearbook, Harold playfully daydreamed about hiring thugs to kill his competitor. Another classmate's doggerel in the 1941 yearbook predicted widespread fame for both:

> As well known personalities
> of near and far localities,
> We prophesy with confidence,
> events that lie ahead.
> A rule to hold for all of us
> (and can you beat the gall of us?)
> Is this: Some day the fame of '41
> will be widespread.
> Kurtzman? Van Riel?
> Why, cartooning's their lingo,
> While Riger cleans up
> what with dishes and bingo . . .

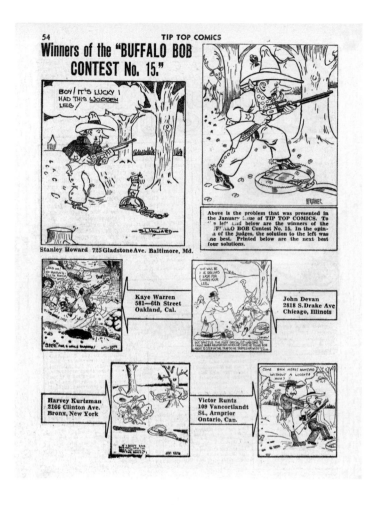

Buffalo Bob contest | 1939 | At the age of fourteen Kurtzman's entry in a Buffalo Bob cartoon contest appeared as a runner-up winner in *Tip Top Comics* no. 36 (April 1939). Publication at that age was a huge thrill and no doubt played a part in the young artist's professional aspirations. "That crisp new dollar, when I was a kid living in the Bronx," he later noted, "boy, that was the biggest dollar that I ever owned in my life." Ironically, just four issues earlier his eventual collaborator Jack Davis also won a dollar in a Buffalo Bob contest.

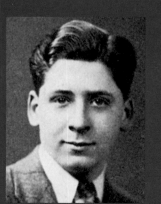
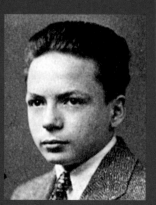
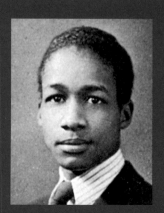
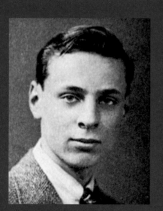

High school classmates | 1941 | Classmates from the 1941 Music and Art yearbook (left to right): Charles Stern, later a partner in the Charles William Harvey Studio; Harry Chester, Harvey's lifelong friend and a business associate at *MAD*, *Trump*, and *Humbug*; Harold Van Reil, Harvey's friend and primary cartooning rival in high school; and Kurtzman himself at age sixteen. Four other comics-related classmates, Wolf Eisenberg (Will Elder), Al Jaffee, John Severin, and Al Feldstein, were not in the 1941 graduating class.

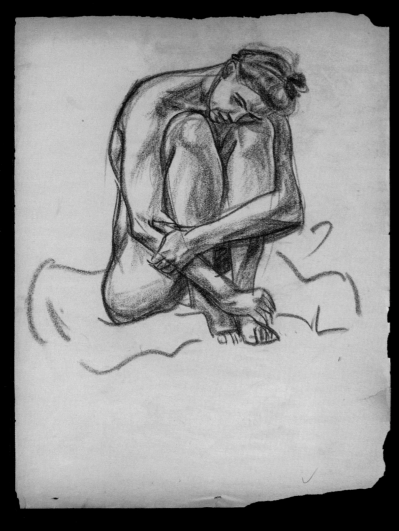

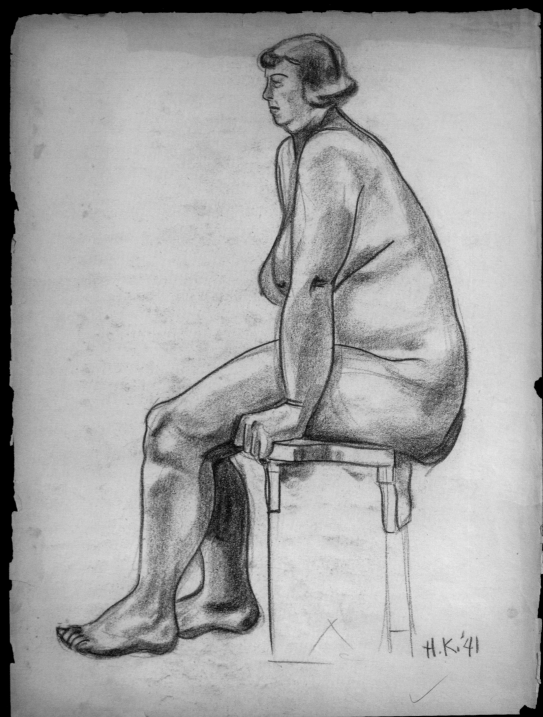

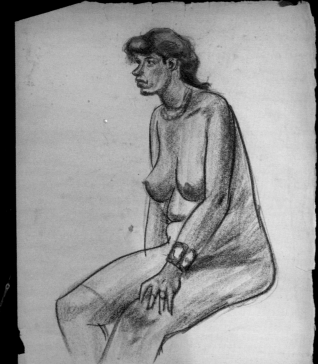

Figure drawings | 1941 | Harvey Kurtzman made these charcoal drawings in 1941. They were possibly done while he was a senior at the High School of Music and Art in New York, but more likely were drawn at the Art Students League after graduation. As late as 1947 Kurtzman was attending life drawing classes. In a February 10, 1947, letter to Adele he noted, "Last night, we went to a life class and I sat around all night looking at naked women. I did a couple of nice studies, which I would like you to see some day!" However, for reasons unknown, the 1941 drawings, done while Kurtzman was still a teenager, were the only such charcoals he kept.

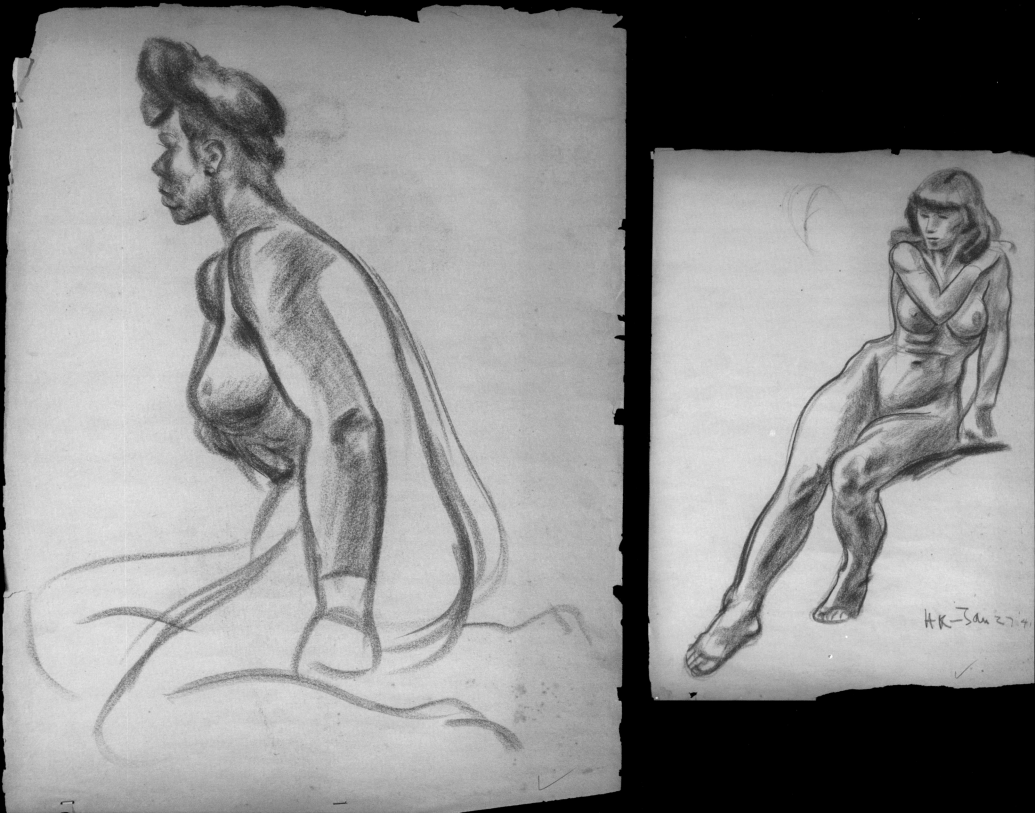

Unlike the numerous aspiring artists around him, Harvey had already, technically, been nationally published. In 1939, at age fourteen, he successfully entered a contest in the comic book *Tip Top* about saving comical hero "Buffalo Bob," thus winning a cameo appearance and a one-dollar prize. The young entrant drew himself intervening in Bob's predicament with the punch line, "If I don't save Bob now, how the heck am I goin' to win this contest?" By placing himself within the panel to do the saving, Kurtzman had already shown his strongest side. He was a more than capable artist, but as he frequently insisted, *ideas* were the strongest part of his talent.

The students at Music and Art were all to be trained broadly, by teachers who themselves had what they believed to be the opportunity of a lifetime, to rise above the usual frustration of public school work. As Elder observed later, the teachers made the students feel not only

that they were special, but "part of a big, very important movement." On a larger scale, they were. At the peak of Franklin D. Roosevelt's political reforms, this meant the advance of the nation; in democratic terms, it meant moving toward a higher life and culture. Only during the Second World War, and then in a different sense, would the vision of government and crucial parts of blue-collar life join together so completely and with such optimism—notwithstanding the march of Fascism, a pair of oceans away.

Both Harvey and Willy were guilty of the constant clowning that prefigured their work in *MAD*. In the school's lunchroom they did takeoffs of the film and comic book scenes of the day, particularly Willy. Kurtzman first glimpsed Willy as the older boy engaged in wild physical comedy, sometimes with his close friend Al Jaffee. Kurtzman described a typical scene in a 1980 interview:

We'd act out all the clichés . . . the Operating Room Routine, with the surgeon operating (on a paper milk container), the nurse wiping the sweat off his head, handing him the instruments (scalpel, forceps, screwdriver). Or the First World War routines: the air battle with the German ace going down gracefully in a flaming Fokker (hard cheese).

Kurtzman was coming to a crucial point with this recollection, and he delivered it with emphasis:

All over New York there were Jewish guys in separate high schools doing the same routines. *Sid Caesar eventually did all the routines we anticipated. And it was no coincidence. We were feeding off the same material, reacting to Hollywood the same way, coming to the same conclusion.*

[EMPHASIS IN THE ORIGINAL]

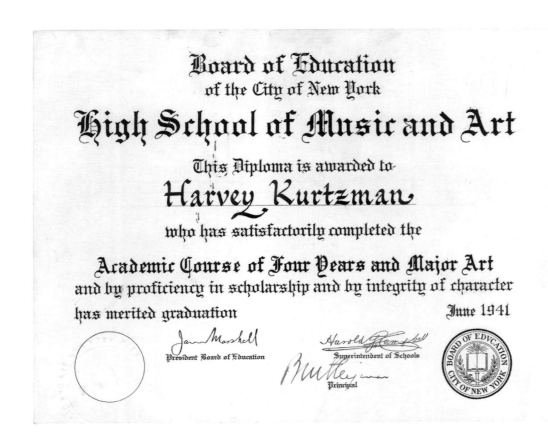

High school diploma | 1941 | The High School of Music and Art was a progressive, experimental school founded in the late 1930s for students gifted in the arts.

Of course they were also reading comic books and had been reading the funny pages since they were small. In his 1991 introduction to *From Aargh! to Zap! Harvey Kurtzman's Visual History of the Comics*, Kurtzman said that newspaper comic strips were his first love, "from Caniff's *Terry and the Pirates* to Gould's *Dick Tracy* to Foster's *Prince Valiant* to Raymond's *Flash Gordon*." Kurtzman was also an unabashed admirer of Will Eisner, whom he called "*the* greatest. . . . *The Spirit* had become the standard by which other comic books would be measured. Eisner became a virtuoso cartoonist of a kind who had never been seen before." Another cartoonist Kurtzman thought highly of was Al Capp. Characters from Capp's *Li'l Abner* repeatedly show up in Kurtzman's work as a form of homage. Critics and scholars have observed that Harvey's exacting professional work of the later 1940s owed its chiaroscuro effects considerably to Caniff, but his viewpoint, panel design, and page layout (especially splash pages) owed more to Eisner.

No photographs are known to have been taken, or survived, documenting the chalk

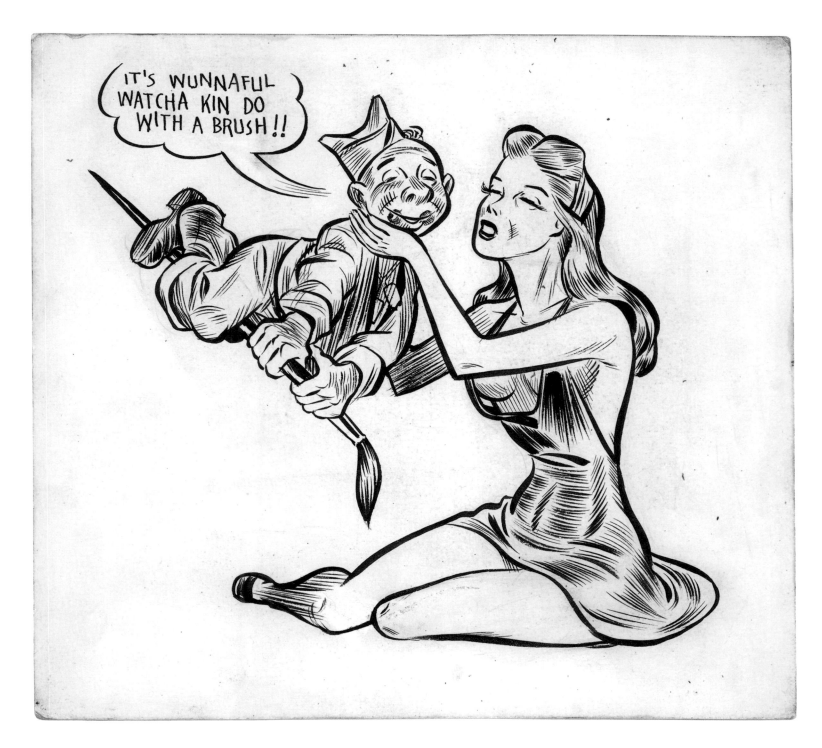

Army illustration | circa 1943–45 | This racy illustration, probably unpublished, expressing the artist's love for both beautiful women and his drawing tool, is a rare early self-portrait.

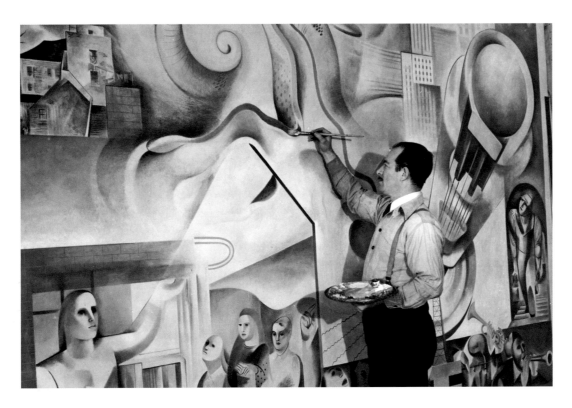

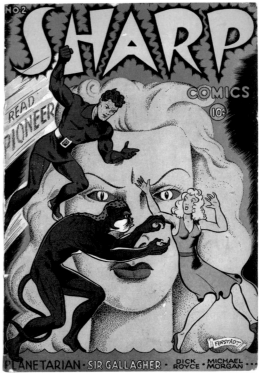

drawings Kurtzman created on the sidewalks of his East Bronx neighborhood. He claimed that kids and even some adults gathered around each day as he drew his next ephemeral installment. Kurtzman called his street art "Ikey and Mikey." The original "Mike and Ike" was the work of Rube Goldberg, the most famed of the Jewish artists in the funny pages, best known for his cartoons depicting crazy contraptions.

Goldberg's "Mike and Ike" (subtitled "They Look Alike") was fascinating in part because, as virtually all New Yorkers at that time would have recognized, Mike was Irish and Ike was Jewish. It was not only a funny strip, but also a quiet appeal for brotherhood between groups that sometimes saw bitter conflict. Nothing pleased a certain kind of New York cop more than planting a club upon the head of a Jewish striker, especially a "Red" one, and the charge of "Christ killer" was heard even from some pulpits; for their part, Jewish families often

considered the Irishmen knuckleheads and ignorant boozers. With "Ikey and Mikey," was Kurtzman making a point, consciously or unconsciously, about himself and his boyhood friends and schoolmates? We don't know, but it would have been consistent with the sensibility he displayed in his later work.

Following his graduation in 1941, Harvey, then sixteen, and his classmate Harry Chester won scholarships to Cooper Union. Schooling there left ambiguous memories. "Cooper Union was a good school. It had all the courses; it had good teachers." But, Kurtzman insisted, as he would throughout his life, that talent was "inborn." Besides, he really wanted to draw comics, which was not a course of study that would be available in any school, even in New York City, for decades to come.

Kurtzman met his first professional cartoonist in 1942, but it was a confusing experience on more than one level. He had just picked up

a new book, *Classic Comics and Their Creators* by Martin Sheridan. Among the numerous profiles of famous syndicated cartoonists was one on Alfred Andriola, who then drew the popular Charlie Chan comic strip. Some of Andriola's words in that book jumped out at the impressionable young artist:

> I owe a great deal to both [Milton] Caniff and [Noel] Sickles for their patient teaching while I was with them, and this is as good a place as any to express my gratitude. I have found that in this business the established fellows always are ready to give a hand to the newcomers. I try to follow through, and I see anyone who so much as nibbles for an interview. If he has talent, he gets all the help I can give.

Famous cartoonists were not then, nor now, easily accessible to fans or the general public.

Left | **Louis Ferstadt** | **1939** | Kurtzman's first professional comic book work was done for the Louis Ferstadt studio in 1942. Ferstadt, a committed left-winger and painter, sometimes made his living in the comic book industry. Ferstadt is shown here creating a mural for the WPA Federal Art Project in 1939. **Right** | *Sharp Comics* **no. 2** | **1945** | Cover showing Louis Ferstadt's own comic book art. *Sharp* no. 2 (1945) is so rare and obscure that it was not even listed in Robert Overstreet's comprehensive *Comic Book Price Guide* until its sixth edition in 1976.

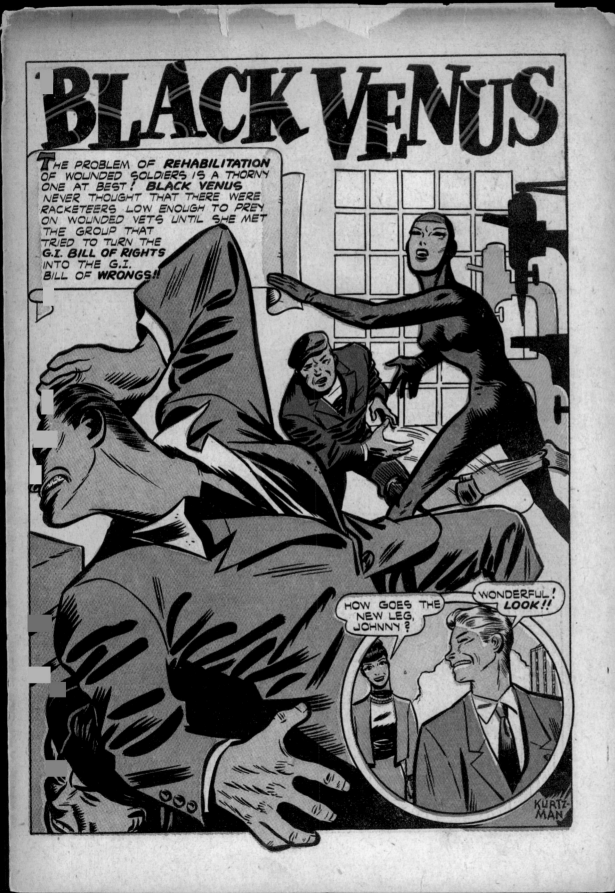

"Black Venus" splash page | *Contact Comics* no. 11 | March 1946 | On furlough from the army, Kurtzman picked up odd jobs, including a "Black Venus" story assignment for comic book packager L. B. Cole. The example shown here (the first of six pages) is a second story produced in early 1946, about a criminal scam targeting discharged GIs, done shortly after Kurtzman's own honorable discharge.

Kurtzman, seventeen or eighteen at the time, would not have been comfortable knocking uninvited on the door of Rube Goldberg or Milton Caniff, but Harvey excitedly responded to Andriola's encouraging open invitation.

Kurtzman made an appointment, went to the artist's downtown studio with his portfolio of samples, and rang the doorbell. A young male assistant wearing an apron over bare legs ushered him in. Kurtzman later described Andriola as "kind of a slight guy, and very effeminate," who looked him over from head to toe before opening the portfolio. "He looks at my stuff, goes through it very quickly, and tells me I shouldn't be a cartoonist. I should get out of the profession. That was one of the worst days of my life."

Kurtzman left Andriola's studio understandably demoralized. With a naiveté reminiscent of his later creation Goodman Beaver, Kurtzman subsequently realized that "[Andriola] was homosexual. Not that that makes any difference,"

he later recalled, concluding, however, that Andriola's open door policy for young artists came with ulterior motives. Fortunately Kurtzman dismissed Andriola's harsh advice and continued to beat the city pavements with his portfolio.

LOUIS FERSTADT SHOP

Kurtzman bounced around from one menial job to another. He lettered large banner signs for A&P grocery windows and was even briefly a union buster at Schneider Press while attending Cooper Union in the evenings for two years. Later in 1942, Kurtzman landed a job in the studio of a struggling painter forced to labor in the "lowly" field of comic books. Shortly before his death in 1993, Kurtzman reminisced about walking into the studio where he first broke into his chosen profession. Typical comics industry "bullpens" were claustrophobic, with tightly packed drawing tables set up for efficient assembly-line production. But the studio Harvey

described entering that day was relatively large, with a high ceiling. Partially finished oil paintings were set up on easels and stacked against walls. The air, he vividly recalled, was heavy with the smell of turpentine. The drawing tables, where a handful of artists were working, seemed out of place.

The artist looking for apprentices was Louis G. Ferstadt (1900–54), a characteristic figure of the day. A Russian Jewish immigrant, Ferstadt was a natural cartoonist with an accomplished pen-and-ink style who briefly drew an obscure comic strip in 1926–27 called "The Kids on Our Block" for the *New York Evening Graphic*. But the strip never caught on. With high aspirations, Ferstadt turned to fine art as a career. The Great Depression was an especially tough time for artists, and he survived in part by creating large murals for the WPA Federal Art Project. By the early 1940s, Ferstadt kept the wolf from the door by operating a comics atelier.

In 1989 Kurtzman reflected candidly on his humble break-in. "I did all sorts of menial work. . . . I was very bad at it, but they were buying everything. It didn't matter. It was that moment in history when I could slide into position. [Ferstadt] was a pitiful character. He was a would-be painter, a portrait painter, [and] seemed to be pretty good at it, but he starved."

Ferstadt packaged material for Quality, Ace/Periodical House, and Gilberton Publications (which produced *Classic Comics,* later *Classics Illustrated*). He was also a committed left-winger, with a strip in the *Daily Worker*. Kurtzman, with his family background, would have been a natural protégé for Ferstadt. However, Kurtzman was never attracted to Marxism, and he was distinctly nervous about Ferstadt's leftist leanings.

"Politically, we didn't see eye to eye," Kurtzman said. "What was ironic was he was subscribing to a philosophy of 'take care of the working man,' and he was probably—or we felt like he was—underpaying us. But I don't want to be unfair to Lou. I'm sure he was doing his best." In another interview Kurtzman noted, "Louie worked us as hard as any capitalist boss, but he was really nice to us."

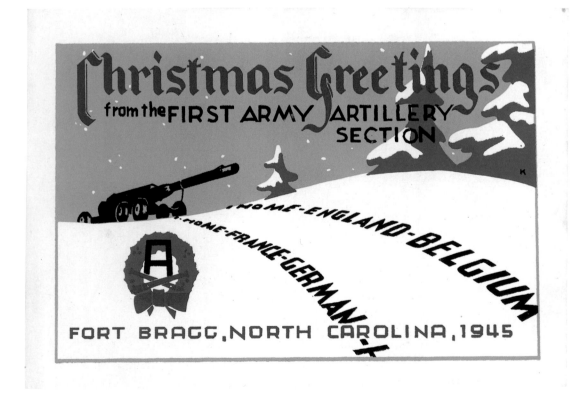

Fort Bragg Christmas card | 1945 | Instead of cranking out a sappy Christmas card for a Fort Bragg artillery section, the twenty-one-year-old Kurtzman's typographic tread track design cleverly communicates the season, the unit's heading home from overseas campaigns, and a year fading from view. It is also the only surviving example of Kurtzman using the silkscreen technique.

Kurtzman's initial work under Ferstadt's auspices was on *Moby Dick,* the fifth volume of the fledgling Gilberton imprint. Kurtzman left no distinctive mark on the finished product, but more important was his submergence into the comic book production world. He met the people who bought and sold stories and art, learned to ink, then began to draw stories and, finally, to write stories, improving his talent as he went along.

Kurtzman's other earliest comic book work in 1942 and early 1943 involved producing third-rate adventure material like "Lash Lightning,"

"Mr. Risk," and "Unknown Soldier" for *Four Favorites*; "Magno & Davey," "Paul Revere, Jr.," and "Buckskin" for *Super Mystery Comics*, both published by Ace/Periodical House; and humor material like "Bill the Magnificent" and "Flatfoot Burns" for Quality's *Hit Comics* and *Police Comics* in 1943. This is the first time Kurtzman was credited for his work, whether with just his initials or with his full name.

It can be said that this early professional work was far from distinguished. He later lamented, without a trace of egotism, "I never had a style, so I had nothing to sell." In another interview

Kurtzman dismissively referred to his pre-war output as "very crude, very ugly stuff." Nonetheless there were some subtle hints of what was to come. His "Unknown Soldier" story, while probably just a bit of supernatural eccentricity, could also be seen as a departure from the usual wartime flag waving—a take on war as grim as much as heroic.

WORLD WAR II EXPERIENCE

Kurtzman's draft board called in 1943. Though he trained in the infantry, he never went over-

Boys hiking | circa mid-to-late 1940s | This illustration of hiking boys is undated and not known to have been published. The vigorous brushwork, layered wash tones, and added white highlights probably places it as mid-to-late 1940s, created as magazine or tryout work.

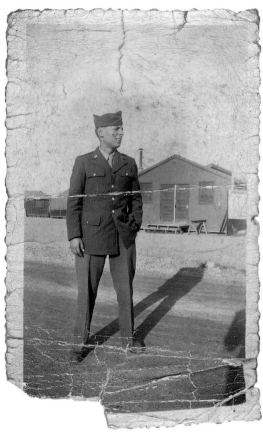
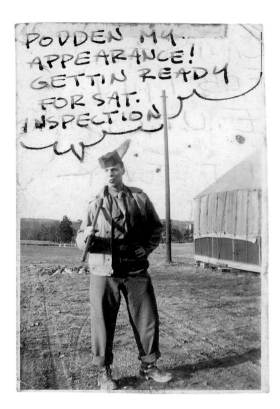

seas during World War II. His Army service included stops with Engineering in Louisiana, the Artillery in South Carolina, the Morale Services Branch of the Information-Education Division in Camp Sutton, North Carolina, and the 25th Infantry Regiment based in Camp Maxey near Paris, Texas. Kurtzman's creative talent, however, was not wasted while he served. He illustrated instructional manuals and military posters, and drew spot illustrations for mimeographed flyers promoting camp events. He also contributed strips ("Pvt. Brown Knows") and even sports cartoons and pin-ups for camp papers and newsletters.

On furlough, Kurtzman scored an assignment in a new kind of emerging comic. Wonder Woman had been a sensation with her 1942 debut appearance, a comics counterpart to the stereotyped but also very real women who went

into factories for the war effort. Overnight, in ways typical of the comics industry, female super heroes began to appear. Editor and artist Leonard B. Cole invited Kurtzman to work on "Black Venus," a super heroine unimaginable only a few years earlier. Cole was packaging books such as *Contact Comics* for Rae Herman, the only female publisher in comics at that time.

By the end of October 1945, Kurtzman placed several gag strips in *Yank*, the widely read army weekly, shortly before its publication ceased. Had Kurtzman been drafted earlier, he might have done more such work. *Yank*'s feature editor, Sgt. Ray Duncan, sent an encouraging note following Kurtzman's first acceptance, noting, "I like your weird style of drawing."

With steady assignments, Kurtzman's "weird style" evolved and became increasingly refined

during his service years. "You get smart with a pencil, you get better. That happens," he later observed. "I always tell my students to draw, draw, draw, draw, because the more you draw, the more you computerize, and the better you draw. That happens to all would-be cartoonists." The surviving work from Kurtzman's army years shows increasing sophistication, sometimes inviting comparisons to his distinctive postwar style, epitomized by "Hey Look!" Besides honing these skills while in uniform, Kurtzman managed to pick up freelance work from nearby businesses while he was stationed in North Carolina in 1944. Among the now-brittle tear sheets he proudly saved were newspaper ads for the Plaza Airport and Union National Bank in Charlotte, and trade magazine ads for the Hatch Full Fashioned Hosiery Company in Belmont.

Above | Army photos | circa 1943 (left and middle) and February 1944 (right) | Kurtzman, in fatigues and wielding a broom, at Camp Sutton, N.C. The word balloon was intended for his mother's amusement. **Opposite | Army poster work | circa 1944 |** Buck Private Harvey Kurtzman holds his original art for an Army Emergency Relief poster.

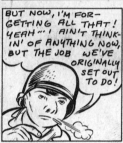
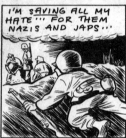
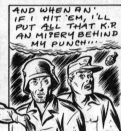
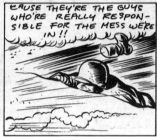

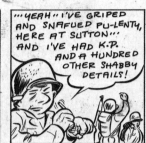
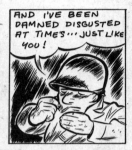
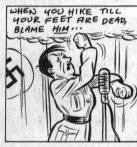

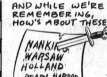
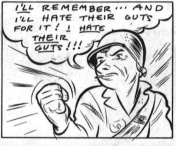
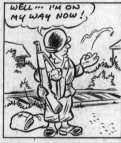
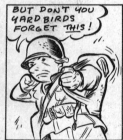
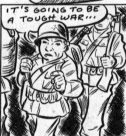
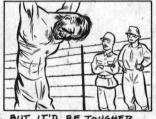
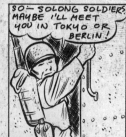
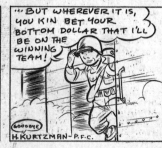

Left | *The Carry All* vol. 1, no. 19 | June 10, 1944 | P.F.C. Kurtzman's army duties while stationed at Camp Sutton, N.C., included illustrating the base newsletter. This example features a patriotic strip that pulls no punches.

Opposite left | Basic training poster | 1944 | One of the educational posters Kurtzman created for the Engineer Unit Training Center at Camp Sutton, N.C.

Opposite top right | *Yank* gag cartoon | 1945 | One of at least three gag cartoons that Kurtzman successfully sold to *Yank*, just before the prestigious army weekly ceased publication.

Opposite bottom right | *Yank* letter | October 30, 1945 | *Yank*'s features editor, Sgt. Ray Duncan, complimented Kurtzman's cartooning and bought several drawings just as the magazine ended its run.

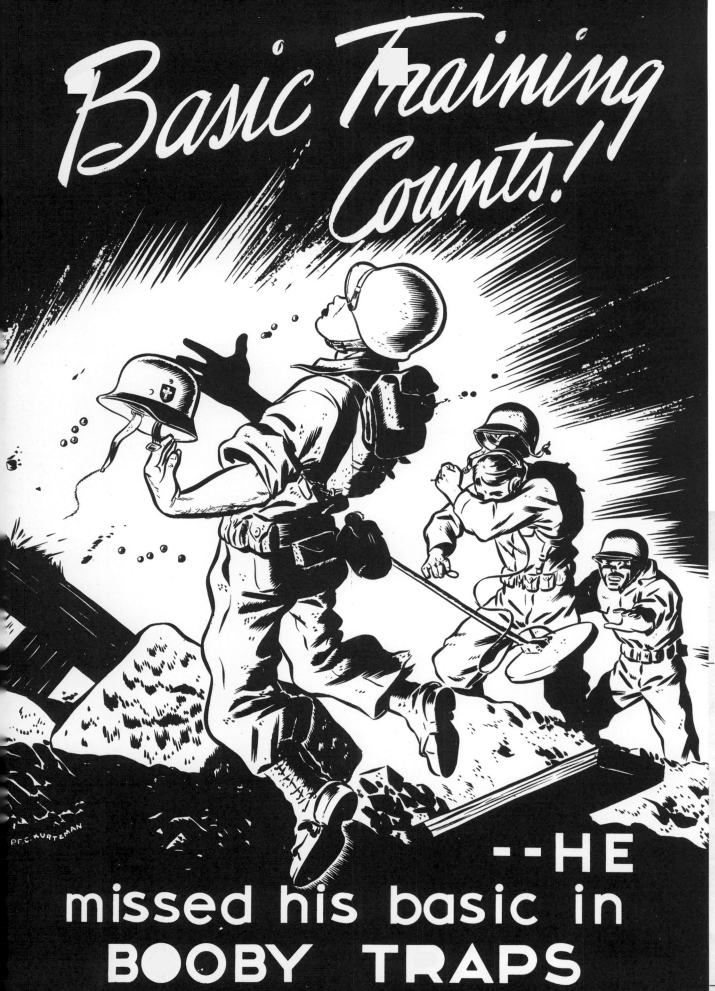

" . . . AND NOW ALL THE MEN HAVE A JOB TO DO—NOBODY
LAYING AROUND IDLE."
—T-5 Harvey Kurtzman

YANK
THE ARMY WEEKLY

30 October 1945

IN REPLY
REFER TO

205 EAST 42nd STREET
NEW YORK 17, N. Y.
PHONE: MURRAY HILL 5-8383

T/5 Harvey Kurtzman, 32973437,
HQ, FUSA, Artillery Section,
Fort Bragg, S.C.

Dear Cpl. Kurtzman:

 Thanks for sending us the five cartoons, and I'm
sorry I haven't got around to acknowledging them sooner.
I've just taken over this job and I'm up to my ears in
work. Anyhow I'd like to hold onto three of the drawings
for possible use in YANK. One of them, incidentally, is
appearing on the back cover in next week's issue. That one
is the GIs carrying the brass in a richshaw or whatever it
is. Also I'm holding onto the little guy with the shovel
and the late diners in the mess hall. The last one I'm sure
will be used right away too. You'll receive copies of them
from me when they appear. I'm returning the other two here-
with.

 I like your weird style of drawing, and I'd like to
see more of your work right away. In order to make the closing
issues of YANK I'll have to see them within the next two weeks
though. Thanks again, and I'm sorry I waited so long to answer.

 Sincerely,

 Ray Duncan

 Sgt Ray Duncan
 Feature Editor

Army camp flyer, "What Can You Do?" | March 1945 | Kurtzman illustrated numerous mimeographed flyers for camp events. Clarity of line was not a strong point of the low-run duplication process (made obsolete by photocopies in the 1960s). This example solicits volunteers for a talent show.

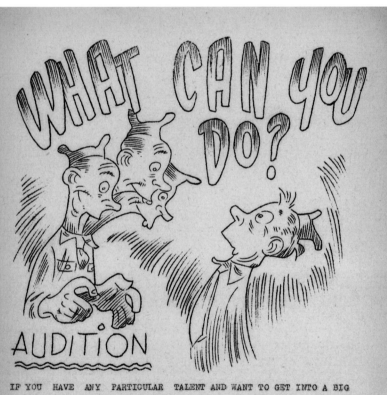

But it was race relations that Kurtzman personally remembered the most vividly regarding his service in Southern camps. He had only heard of racial segregation before; this time he saw it live, and it disturbed him enormously, in no small part because others around him seemed to take it for granted. In one incident, he took a personal risk:

In the army back then, blacks and whites were strictly separate. Isolated. It was a real feeling of bigotry. . . . Whenever we'd be going into town . . . invariably, there were a bunch of [enlisted] guys hanging out, waiting for the bus to come. They'd be dressed in their going-to-town outfits. . . . You salute in certain circumstances when you're crossing an officer's path or when an officer is walking down the street and you're passing him. . . . [But] whenever a black officer would come to [this] scene, it became very obvious that he was being ignored, because everybody would turn their backs. And it was one of those situations that you're looking at and you don't know what to do. . . . This one time . . . there were ten [white] guys waiting for the bus, and down the street comes an [African American] officer. And I knew I had to take a stand. . . . I said, '*Ten*-shun. *Salute!*' And everybody suddenly snapped to because . . . they were being told what to do. And they saluted. And they must have hated my guts. . . . I turned my back to them so I wouldn't have to suffer the consequences.

Apart from his ethical beliefs, the searing reality of Jewish persecution in Europe (the facts of the Holocaust were not yet widely known) seemed to fix itself upon his conscience. The humiliation of African Americans at the hands of whites left Kurtzman equally outraged, as much as anything that he would ever experience in his life.

Honorably discharged from the army in November 1945, Kurtzman returned home to face the aftermath of a serious family crisis. His step-father, Abraham Perkes, an engraver, had been charged with, and convicted of, forging ration coupons. The blue-collar family was hit hard.

All three brothers had to rally to support their mother until Perkes's three-year jail term ended. It was one more experience for Kurtzman in an already uncertain life.

POSTWAR: THE CHARLES WILLIAM HARVEY STUDIO

Upon his return home, other crucial shifts started to take place in Kurtzman's life. He reentered comics at a moment when the field was passing through stages of superheated evolution. The success of the war years and skyrocketing comic book sales brought new investment, creating more publishing companies and encouraging others to expand their lines. The era of packaging shops was largely being replaced by a freelance system, and Louis Ferstadt was no longer a player. Competition for a job—any job—as discharged GIs flooded the workplace was intense.

Kurtzman picked up sporadic assignments, like the second installment of "Black Venus," and got a foot in the door at Timely Comics. He briefly shared a studio with Fred Ottenheimer and then rented an "awful" room in Greenwich Village. After a while Kurtzman looked up Ramon Gordon, a fellow artist and army buddy he knew from his stint in engineering in Louisiana. Gordon was subletting from Irving Geis, another artist and designer, a "fancy" studio space in the Fuller Building on 57th Street. Geis later art directed *Scientific American* and eventually reunited with Kurtzman on *Trump.* Though neither Gordon nor Geis had connections to comics at the time, Kurtzman saw the opportunity to upgrade his situation, so he joined the pair. However, after a series of "triangular arguments," the short-lived alliance disintegrated.

Around this time, one day in 1946, following his own army tour, Willy Eisenberg (who would soon change his name to Elder) ran into Al Jaffee's younger brother, Harry, an artist who happened to be en route to lunch with their mutual Music and Art friend, Harvey Kurtzman. Willy went along, and in that moment the two aspiring artists experienced a reunion that would shape the rest of their careers and lives.

Opposite | "A 'Normal' Day at the Chas•Wm•Harvey Studio!!!" | 1949 | John Severin, another Music and Art alum and sometime resident at the Charles William Harvey Studio, created this drawing of the madhouse, most likely in early 1949, when both Severin and Robert Q. Sale were paying studio rent to Kurtzman, who was then wrapping up work on his "Hey Look!" strips (on the wall and drawing board). Kurtzman and John Benson in *Squa Tront: The Complete Guide to E.C. Comics* (no. 9, 1983) identified the characters, clockwise from left, as Frank Dorsey (under the drawing board), Lester Persky, Kurtzman ("in my Sigmund Freud days"), Will Elder, a customer from the studio's Vantines account, Charles Stern, John Severin ("Slante Gael!"), and Robert Q. Sale. Benson quotes Kurtzman explaining Sale's dialogue: "Sale used to stutter, but he could sing commercials without stuttering, so he would accompany the commercials constantly."

Following his break-up with Geis and Gordon, Kurtzman conspired to join forces with Eisenberg and yet another fellow Music and Art alum, Charles Stern. Combining the given names of the three partners, they formed the Charles William Harvey Studio and found affordable space in a factory building at 24 East 21st Street. "A rathole loft studio," Kurtzman recounted in 1962. "A huge skylight, with a bookcase and a couple drawing tables jammed in against the wall, all around a big bed where we worked and entertained."

In early 1947 the Charles William Harvey Studio officially opened its doors. Opened, that is, to practically no business. "We used to stand on the roof there and throw darts, or hold up a sign, 'WE NEED WORK,'" Kurtzman recalled. "We knew nothing about the business, yet we insisted on making elaborate presentations and portfolios, and we didn't know what to do with [them]. We were making them, really, to fill space, to fill time . . . to fool around instead of working because . . . we were bachelors; we weren't really serious about our work. It's only when you start getting hungry that you get serious."

They began with the noble idea of sharing everything. "We were the Charles William Harvey Studio, and [thus] everything we would do would be divided by three. [You] could never make money that way. But that didn't bother us. We were having a good time," Kurtzman said. They would soon discover, however, that they were not true partners.

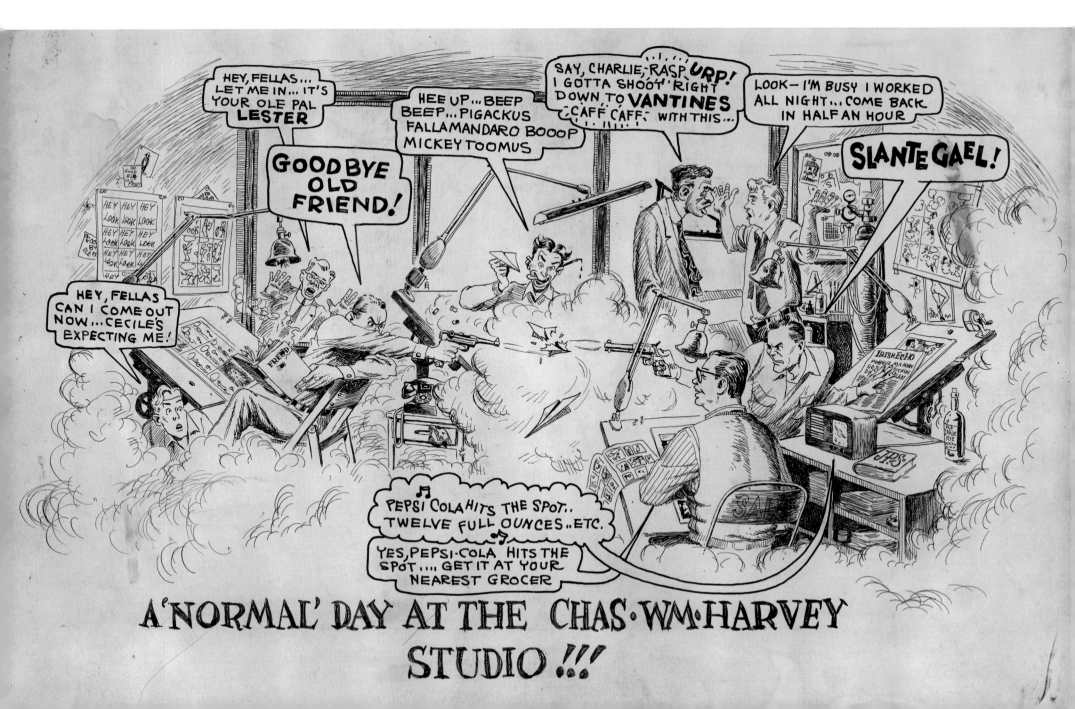

A 'NORMAL' DAY AT THE CHAS·WM·HARVEY STUDIO !!!

Man on desert island with box of ties | circa 1943–46 | This flotsam necktie variant on the hoary desert island gag is possibly the earliest surviving color work by Kurtzman. Not ~~known to have been published, it was possibly created as a portfolio sample. Painted in tempera, with shading in dry brush on illustration board.~~

The threesome finally got a real gig to create a press pamphlet for theater chains to promote *Hollywood Barn Dance,* a 1947 movie starring country-western singer Ernest Tubb & His Texas Troubadours. "So there were the three of us, and we were all-for-one, one-for-all, going into business. We were partners. And then we were suddenly faced with the problems of who does what," Kurtzman continued. "The pamphlet had elements: It has the small advertisements, the bigger advertisements . . . and then a come-on cover, an attractive cover that would put a cap on the whole package. The little movie advertisements were hack; they were junk. But the cover was the plum. That's the one you wanted to do. So here we were, a partnership, the Three Musketeers, but everyone was a chief. We had no Indians.

"How did we decide [who did what]? We decided we'd vote. And we voted. One [vote] each! We barely made it through. We resolved it, eventually. I did the cover. And we never did another thing after that, not together. We just drifted off into separate little worlds."

The 21st Street studio proved untenable. Their industrial neighbors included odious chemical companies, they experienced at least one fire scare, and they had no hot water. The young artists' own rowdy behavior was also irking their landlord. As early as March 1947, the group was already looking to get out, as Harvey wrote to his girlfriend Adele Hasan, then attending college upstate: "The Charles William Harvey Studio is now attempting to move from this stinking-sky-lighted-cold-water factory to another one. We have a lead on Broadway & 26th, also with a skylight. The renting agent is an American Veteran's Committee member, and the A.Y.D. [American Youth for Democracy] is located right downstairs in the building. It has an opening to the roof to escape through when the cops start clamping down on Jew Communists." For context, the American Veteran's Committee was a liberal group targeted during the red scare, while the A.Y.D. was likewise regarded as a Communist front.

In November, keeping their collective name, the group moved to larger space at 1151 Broadway.

The three artists continued to share a common accounting ledger; however, following the Ernest Tubb debacle, they drew cash disbursements based on the money they brought in individually, not collectively. Over the course of the studio's tenure, Kurtzman consistently drew the most income, but it was certainly not a lucrative living.

Though never famed for his business acumen, Kurtzman was the most practical and businesslike of his comrades. He personally rented the new studio space for eighty dollars per month from a downstairs restaurateur named Rosenblum. Besides the rent, Kurtzman personally paid the phone bill, insurance, and the cleaning and towel services, and then he sublet space to studio compatriots Stern and Elder and a string of others, typically at twenty-five to thirty dollars per month. Future E.C. Comics and *MAD* artists John Severin and Dave Berg, later famed *Astérix* co-creator René Goscinny, Rita Gersten, and Robert Q. Sale were among those subletting from Kurtzman and using the office, which Kurtzman maintained through the end of 1951.

Above | Ulcer illustrations | circa 1945–47 | Three of a dozen ulcer illustrations Kurtzman created in the mid-1940s. The word balloons, empty here, were intended to contain text. The highly stylized figures deviate from Kurtzman's typical style, suggesting either experimentation or an approach demanded by a client. There is no indication that these were published. They may have been rejected or simply created as portfolio examples during the early Charles William Harvey Studio period. Painted in tempera on illustration board.

TIMELY AND STAN LEE

Concurrent with his time in the Charles William Harvey Studio, and integral to Kurtzman's development as a creator, was his relationship with Timely Comics and Stan Lee. Timely was part of a substantial publishing operation run by Martin Goodman under a Byzantine collection of corporate names ("Tax dodges," Kurtzman later speculated). Remembered today for his comic book line, Goodman also published men's adventure, health, and muscle magazines, and crossword puzzle digests. A little-known fact is that Harvey Kurtzman earned part of his living, early on, cranking out crossword puzzles, something he was quite good at.

"The Organization Man in the Grey Flannel Executive Suite," the second story in *Harvey Kurtzman's Jungle Book* (1959), satirizes publishing and ethics in general but is also to a large degree a roman à clef. "Crafty Lucifer Shlock" *is* Martin Goodman, while the young man, Goodman Beaver, entering Shlock Publications, Inc., "full of intellect, ideals, and moral convictions, with a burning enthusiasm to create new things . . . good things for better living for his fellow man," who is soon assigned work creating crossword puzzles greatly represents Kurtzman (*despite* the name Goodman).

Kurtzman's preference, of course, was to make comics, not crossword puzzles. A distant relative of Martin Goodman, Stan Lee (né Stanley Lieber) was the young but autocratic editor of Goodman's eclectic comic book division. Timely evolved into Marvel Comics, and Lee, starting in the early 1960s, achieved considerable fame as creator and co-creator of many of the brand's enormously popular super hero characters, such as Spider-Man, the Incredible Hulk, and Fantastic Four. However, in early 1946, both Lee and Kurtzman were essentially unknown comics industry drones. The big difference was that Lee, at twenty-three, had already been on his relative's payroll for half a dozen years and wielded some power, while Kurtzman, at twenty-one, was barely eking out a freelance living.

"Stan wanted to give me something to do. He liked my work [but] he didn't have anything for me," Kurtzman recalled of that lean period. Fortunately for the struggling artist, "They had this problem of getting fillers." (Periodical publishers often need single-page and partial-page "filler" material on hand to fill in any open pages that develop as publications near press time and the primary editorial material doesn't neatly mesh with the paid advertising space.)

In an industry that was already regarded as a very low form of art and entertainment, comic book filler pages represented the lowest of the low. But Kurtzman was desperate for work and gratefully accepted the assignment. He developed a pair of characters who were never named—a "big guy" and a "little guy"—and Lee came up with the filler's title, "Hey Look!"

The "Hey Look!" fillers were always single or partial pages, and they never earned Kurtzman more than $37.50 each. Without steady comic book assignments, Kurtzman would be forced to seek hard-to-find illustration work elsewhere or accept more dead-end crossword puzzle assignments. And while the early "Hey Look!" pages show promise and, in retrospect, as a body of work, are critical to his artistic and editorial development, they did not immediately spring forth as obvious works of genius. By Kurtzman's own admission, "the first was horrible alongside the last."

The "Hey Look!" pages would eventually bowl over publisher William M. Gaines and lead to Kurtzman's groundbreaking E.C. war comics and *MAD*. But with demand for his filler material tenuous at best, how was Kurtzman able to sustain "Hey Look!" and evolve as he did?

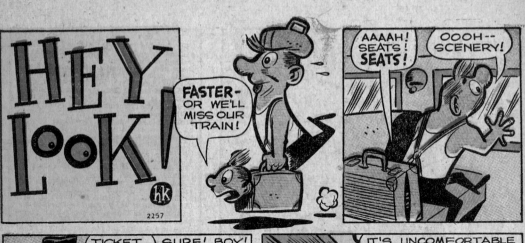

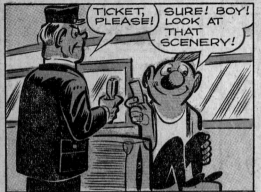

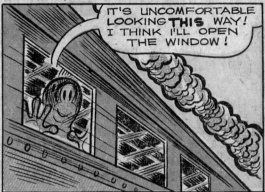

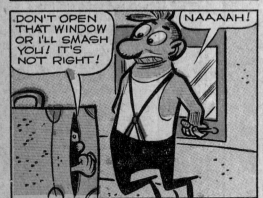

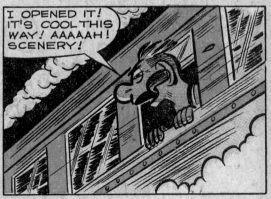

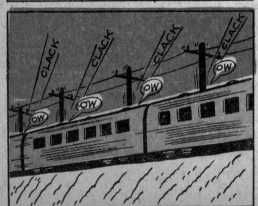

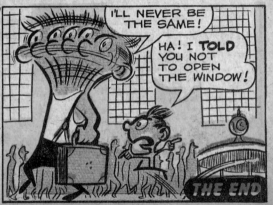

Harvey Kurtzman created over 150 "Hey Look!" features for Stan Lee from early 1946 to early 1949, an average of a strip per week. As mere "filler" material, "Hey Look!" flew under the radar at Timely/Marvel. Kurtzman was given virtual free rein with his often surreal humor, and the strips proved an ideal training ground for the ambitious cartoonist's developing style and writing. The strip's dramatic maturation is apparent over the three-year course. At a critical juncture in Kurtzman's faltering career in late 1949, he brought his portfolio to the E.C. Comics office where publisher William M. Gaines howled with laughter for an hour over the "Hey Look!" pages. Kurtzman's resulting foothold at E.C., within a few years, would dramatically change the course of comics.

"Hey Look!" | 1948 | The diagonal layouts of the fifth and seventh panels emphasize the speed of the train, and their juxtaposition on the page helps draw the eye, never a given with the vast majority of filler pages. First appearance in *Rusty* no. 16 (February 1948).

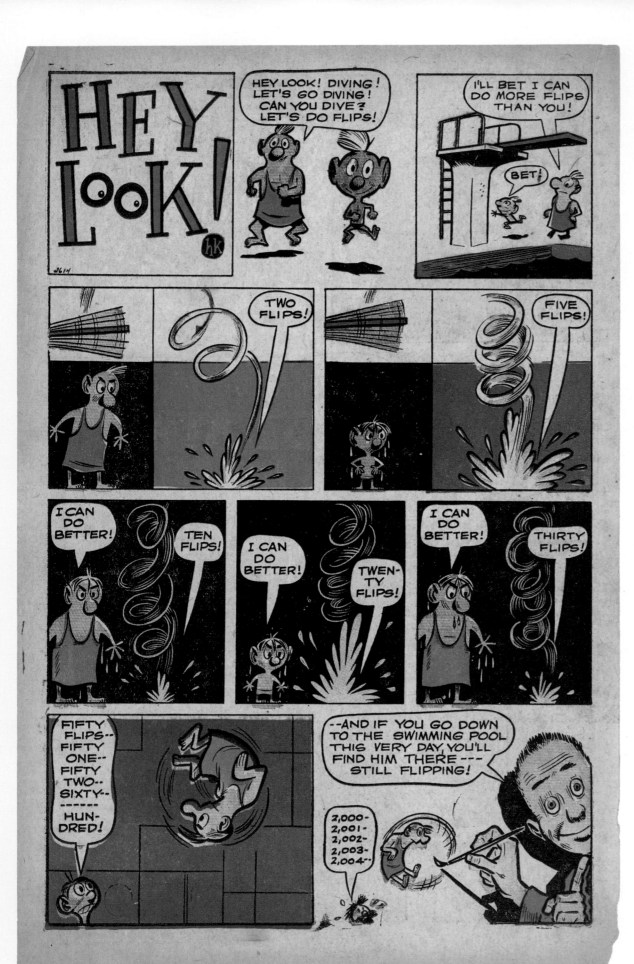

"Hey Look!" | 1948 | Kurtzman inserting himself into the strip was a characteristic surreal touch in his later work, but the bonus of this particular gag is a rare early self-portrait. This installment originally appeared in *Comedy* no. 1 (May 1948).

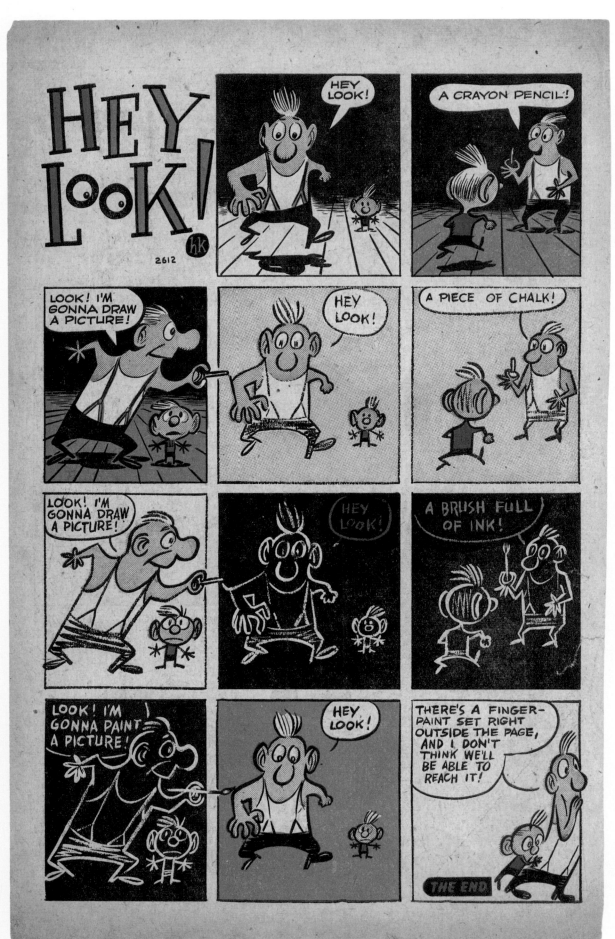

"Hey Look!" | 1948 | Roughly a decade before drawing this strip, a teenage Kurtzman was making his own chalk drawings of "Ikey and Mikey" for the amusement of residents in his East Bronx neighborhood. This page originally ran in *Nellie the Nurse* no. 14 (August 1948).

"Hey Look!" | 1948 | The darkness of the movie theater is emphasized with the interior of the word balloons being black against a black background. First appearance in *Margie* no. 43 (October 1948).

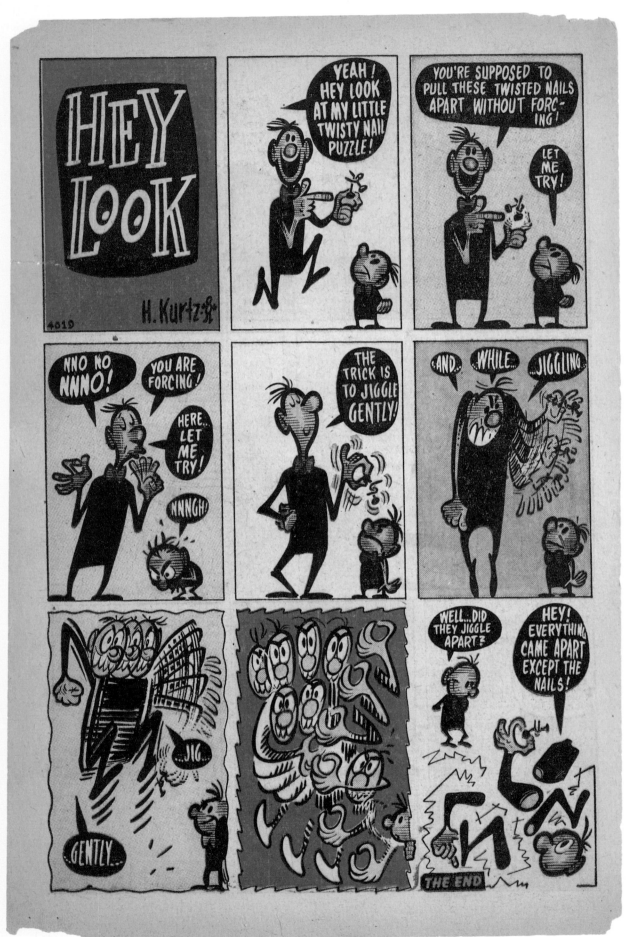

"Hey Look!" | 1949 | This twisty nail gag demonstrates the kinetic energy inherent in Kurtzman's drawing style. Originally appeared in *Gay Comics* no. 36 (February 1949).

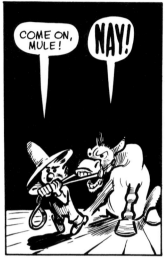
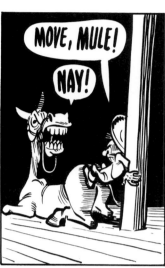
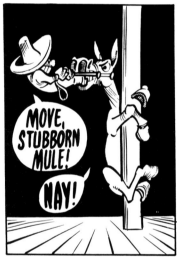
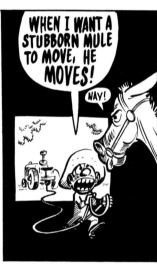
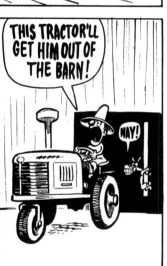
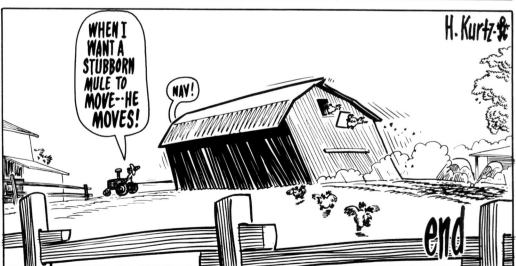

"Hey Look!" | **1949** | Originally published in *Willie* no. 19 (May 1949), this was the very last "Hey Look!" published by Timely/Marvel.

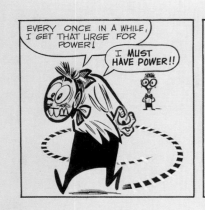
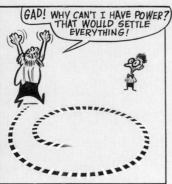
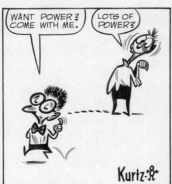
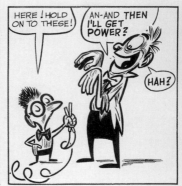

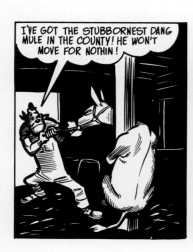
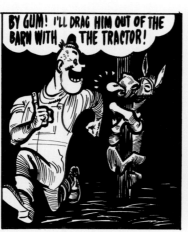
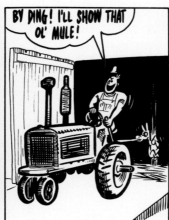
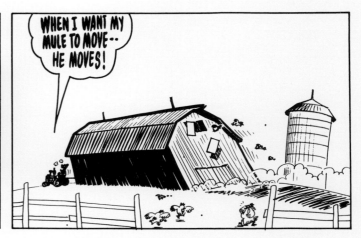

Top | "Silver Linings" original art | 1948 | Harvey Kurtzman was able to sell a recurring strip to the prestigious *New York Herald-Tribune* in 1948. Though shaped like a daily strip, "Silver Linings" was in fact a Sunday strip appearing in color. It was, effectively, a reformatted "Hey Look!" for a considerably more sophisticated audience. Unfortunately, it ran on an experimental, space-available basis and was short-lived. Only nine strips are known to have run.

Bottom | Unpublished comic strip | circa early 1940s | During most of his career, Kurtzman created various sample comic strips that he tried, without success, to sell to newspaper syndicates. This unnamed strip (the farmer is named Clem in others) is an example of one of his earliest efforts. Later, while creating his "Hey Look!" pages for Stan Lee, Kurtzman several times reached back and stole one of his own gags. Compare the precursor above to the barn and mule gag on the opposite page.

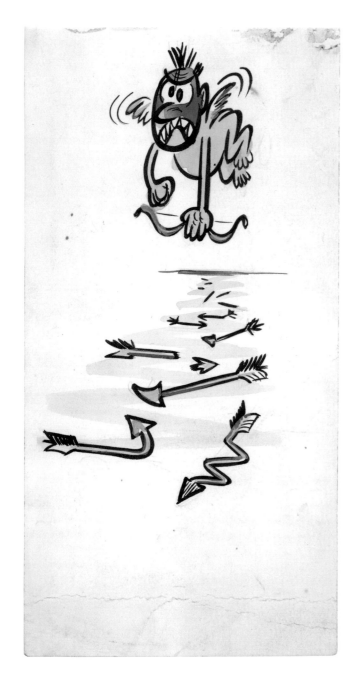

ENTER ADELE

It is impossible, of course, to predict how a man's life, career, or even an industry might have been altered if fate had dealt a slightly different hand. But integral to an understanding of the trajectory of Harvey Kurtzman's career—and thus comic book history (and thus, western civilization)—is the intercession of the woman who would become his wife.

Adele Hasan, fresh out of high school, responded to a classified ad and took a job at Timely Comics in 1945 as a proofreader while Harvey Kurtzman was still in uniform. She worked in a section of the bullpen alongside artists Al Jaffee, George Klein, Syd Shores, Frank Giacoia, and others. "Bull" pen was an apt description, because very few women worked in the comics industry. Violet Barkley, "an attractive inker," was the only other woman Adele recalled in Timely's offices.

Despite his young age, or perhaps as an over-compensation for it, Stan Lee ran the Timely shop, located in the Empire State Building, with an iron hand. Employees would often show up early, relax with a coffee, or chat, but at precisely 9:00 A.M. a loud whistle was blown, and everyone was expected to jump into their respective tasks. Adele vividly recalls one morning when Frank Giacoia was puffing his cigar and lingering over a newspaper article and Stan spotted him moments after the whistle. Giacoia was summarily sent home and his pay docked for the day as an example for other potential "shirkers." On some mornings Stan might be perched cross-legged atop a file cabinet, and employees were expected to bow to him as they entered, partly out of genuine arrogance but also reflecting the "jokey atmosphere" that prevailed in the office.

Adele and Violet were the objects of considerable attention in the overwhelmingly male environment. "I had good legs then," Adele recalled with a droll smile in 2007. She responded in particular to George Klein, a handsome penciler and inker on the company's super hero features, and they dated a number of times. In early 1946,

via an introduction from Al Jaffee, she accepted a date with Al's best friend, Wolf Eisenberg (Will Elder). The date took them to a Music and Art reunion, where they ran into Harvey Kurtzman. Adele was already familiar with Harvey's periodic contributions to Timely and had seen him in the office from time to time. "I thought he was cute," she said, "And I loved his sense of humor." Adele never dated Elder again, but she was attracted to Harvey, whom she described as being in "his trench coat and pipe days." Following the chance meeting, she confided to their mutual pal Jaffee that Harvey "was the kind of guy I'd like to marry."

Stan Lee and Martin Goodman were shrewd marketers, always watching trends and jumping on genres that seemed to be gaining market shares. Competitors regarded them as egregious copycats. The pair also wanted to know what their readers wanted, and the cheapest way to conduct a market survey was via Timely's own publications. In early 1946 Timely ran full-page house ads headlined, "Now You Can Be the Editor!" Readers, presumed to be kids, were invited to return a coupon noting their favorite and least favorite features, with the enticement of a "BIG PRIZE . . . a crisp new one dollar bill" to the "50 neatest and most interesting" responses.

Though hired as a proofreader, Adele performed a variety of tasks in the hectic office. When Stan informed her that she would have the tedious task of sorting and tallying the market survey responses, her first thought was that she hoped readers liked Harvey's "Hey Look!" pages as much as she did.

They did not.

The actual results, in fact, showed that very few readers were excited by Kurtzman's infrequent contributions. Adele, who viewed her office job as a mere temporary gig before going to college, never regretted what she next did. She discarded the actual tally and "stuffed the ballot box" to indicate that Harvey was the readers' favorite. When Stan Lee was shown the official summary, he was shocked, but responded decisively, saying, "We've got to get *that* guy more work!"

Left | Valentine illustration | February 1947 | Harvey Kurtzman self-portrait as a frustrated Valentine's cherub: The blunted arrows reflect Harvey's fears of unrequited love from his putative girlfriend, Adele. **Opposite | Photo of Adele | 1948 |** Taken around the time of Adele's marriage to Harvey Kurtzman in September 1948.

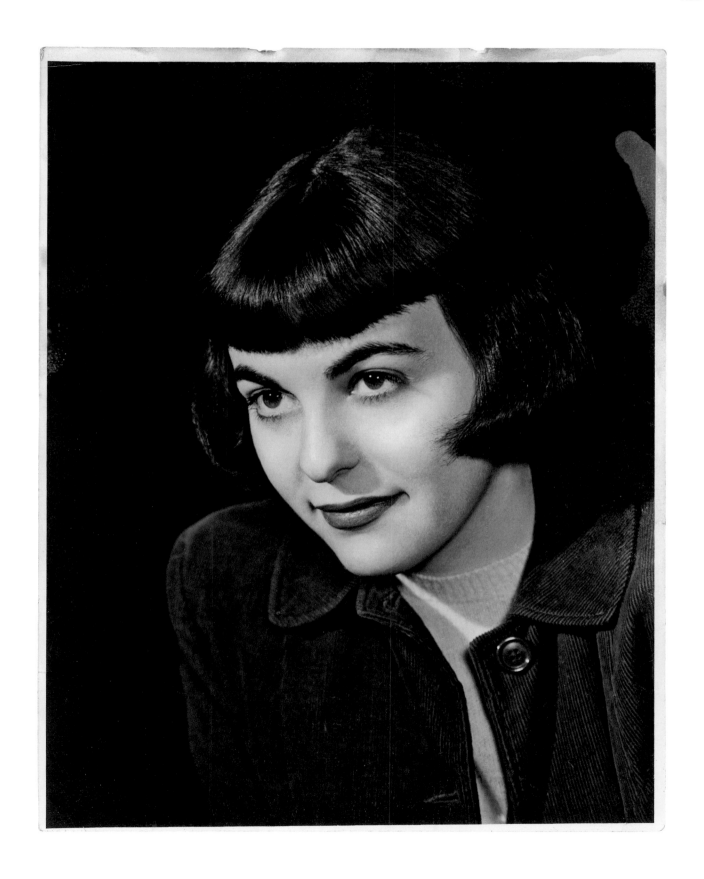

VIEW FROM OUR
SMALL BACK PORCH-
CAPE COD SEPT. 48
(that's Adele in the chair)

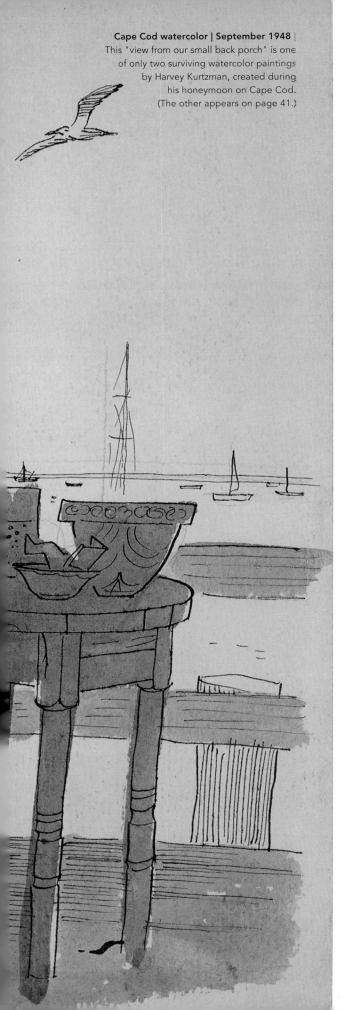

Cape Cod watercolor | September 1948 | This "view from our small back porch" is one of only two surviving watercolor paintings by Harvey Kurtzman, created during his honeymoon on Cape Cod. (The other appears on page 41.)

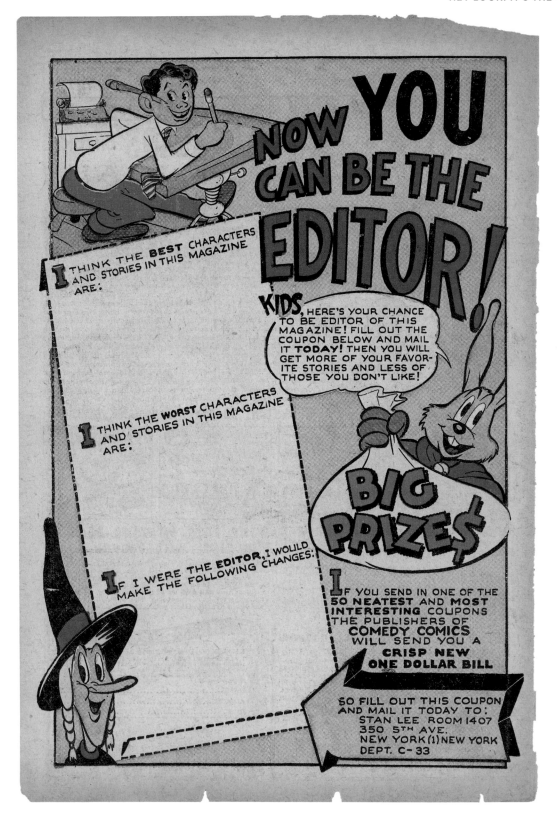

Above | "Now You Can Be the Editor!" ad | 1946 | Editor Stan Lee placed this announcement in Timely/Marvel's comic books in early 1946 as a market survey to determine which features readers liked best. Stan tapped his young assistant, Adele Hasan, to tabulate the results. A fan of Kurtzman's humor, she hoped the occasional freelancer would win. When he didn't even come close, Adele stuffed the ballot box. Impressed by Kurtzman's proven "popularity," Lee assigned more work to the cartoonist. Kurtzman came to the office more often, and he and Adele dated. Two years later they married. A career was launched; the rest is history.

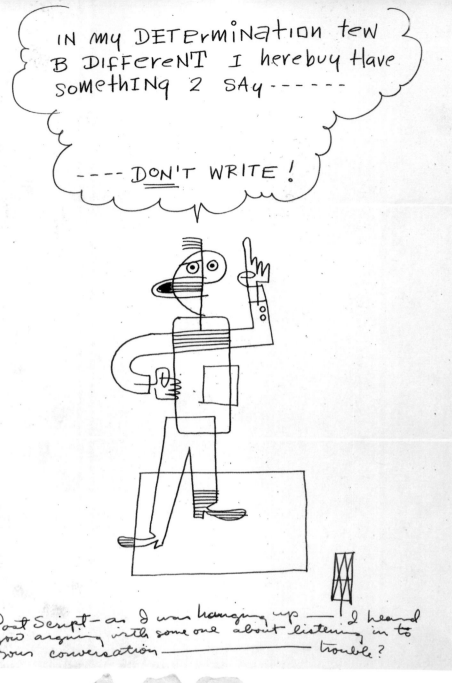

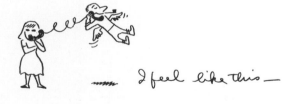

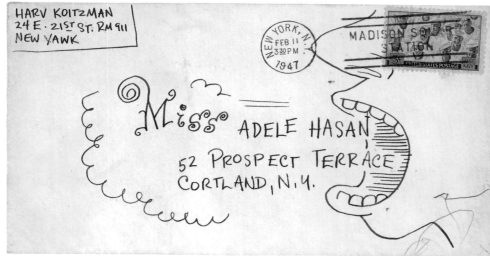

Illustrated letters to Adele | 1946–47 | After Adele Hasan left the Timely/Marvel office in late 1946 to attend college, she and Harvey maintained an intense long-distance relationship based on phone calls and correspondence. Many of Harvey's letters were playfully illustrated. Note the big guy and little guy from "Hey Look!" singing happy birthday to Adele on a letterhead from the newly formed Charles William Harvey Studio (right). The bottom envelope features Homer and Hickstaff from "Pigtales."

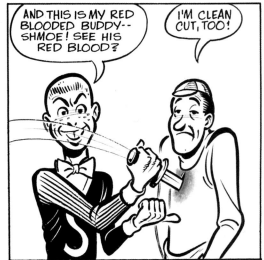
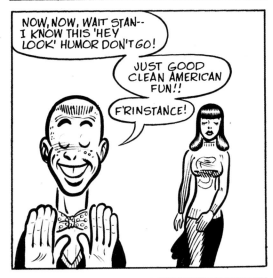
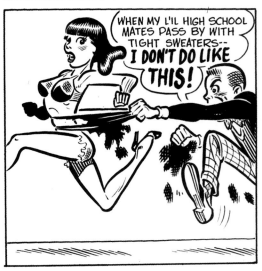
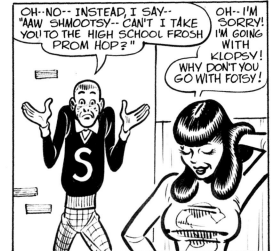

Inside joke for Stan Lee | 1949 | Stan Lee decided that the "Hey Look!" fillers had run their course in 1949 and wanted Kurtzman to begin doing longer features for Timely/Marvel Comics. Fearing that he would have to produce "Archie"-type stories, Harvey Kurtzman created this spoof for Lee's eyes only. Though Lee no doubt laughed at this in-joke (reproduced here for the first time), he nonetheless assigned Kurtzman the onerous task of illustrating a "Blondie"-type strip called "Rusty."

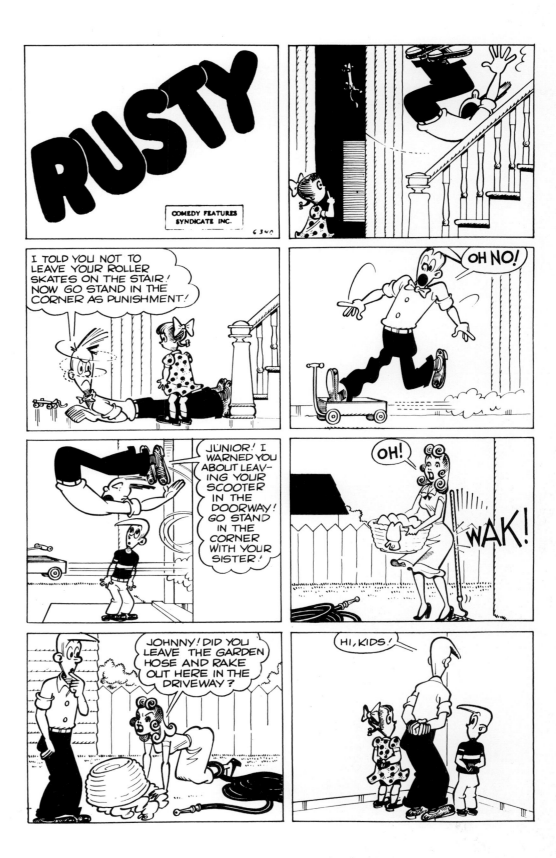

"Rusty: Household Accidents" | *Hedy Devine* no. 35 |
October 1949 | Following his three-year run and creative free
rein on "Hey Look!" Kurtzman accepted an assignment from
Stan Lee in 1949 to produce "Rusty," a blatant rip-off of Chic
Young's popular "Blondie" newspaper strip and comic book.
After fifty torturous pages and "the worst year of his life,"
Kurtzman left Timely/Marvel for other prospects.

Kurtzman's enhanced workload at Timely included several "Pigtales," funny animal stories starring Homer, a big pig, and Hickstaff, a small pig. Whether intended or not, they were porcine parallels to his big guy and little guy in "Hey Look!" Lee bought a half dozen "Pigtales" stories in 1946. Each story, at five to seven pages long, resulted in decent freelance pay. When Harvey increasingly came to the Timely office to drop off work and pick up checks, he and Adele engaged in innocent flirting.

Kurtzman gratefully accepted Stan's increased enthusiasm for his work. "Hey Look!" remained a mere filler, but producing it regularly not only added steady income, it tested his ingenuity and sharpened his innate skills. From 1946 through 1949, Kurtzman created slightly over 150 "Hey Look!" pages, roughly one per week. The earliest pages, in Kurtzman's own harsh assessment, were "real ugly stuff," but as he gained confidence and hit his stride the pages became genuine cartooning gems. With little or no meddling from Lee, Kurtzman was able to engage in whatever quirky, self-referential, or surreal style of humor he wished, and over the three years his drawing and compositions noticeably improved, not to mention his confidence. As comics historian John Benson noted, "Kurtzman's time on 'Hey Look!' was crucial to the flowering of his talent. It was a virtual three-year training ground for every aspect of his storytelling, art style, and form of humor."

In one sense, "Hey Look!" was a kid's strip with plenty of visual gags—the world seen from the point of view of a boy. To succeed at escaping the usual funny-page adult view of children's minds was itself rare enough. But

"Hey Look!" was constantly inventive, unlike the usual clichéd kids' strips of the time, developing fresh lines of observation. Its style was unusual—angular rather than pseudo-realistic, an unconscious or semi-conscious study in what made comics different than studio painting or photography.

With Harvey getting more work at Timely, he and Adele started dating. By the fall of 1946, she left Timely and enrolled at the State Teachers College in Cortland, New York, little aware of the long-term effect her petty ballot transgression might have. While at school she freelanced for Lee, creating fillers herself (one-page prose stories) while maintaining a steady and intense correspondence with Kurtzman. By early 1948 she dropped out of STC, returned to New York City to attend Hunter College, and in September she and Harvey married.

LATE-'40S DIVERSIFICATION

"Hey Look!" pages provided a bread-and-butter base during this period, but Kurtzman also created other longer pieces for Timely/Marvel Comics, including "Muscles Malone" an eight-page one-shot called "Flying Fists!" in *Krazy Komics* no. 1 (August 1948) about a dimwitted carnival boxer. That same year Kurtzman accepted an offbeat assignment to illustrate *Survey: A Comic Magazine Devoted to the Juvenile Market.* A compilation and professional analysis of 1,940 young-reader interviews, *Survey* was intended to lure prospective advertisers with promises of eight million monthly readers of Marvel Comics. Kurtzman illustrated the cover and insides of the comic book–size publication with a combination of his "realistic" and "Hey Look!" styles.

"Pigtal~s" splash page | *Funny Comic-Tunes* no. 23 | **Fall 19~6** | Splash page for the "Tree Surgeons" episode of "Pigtal~s," a funny animal feature Kurtzman created for Stan Le~'s Timely/Marvel comics line.

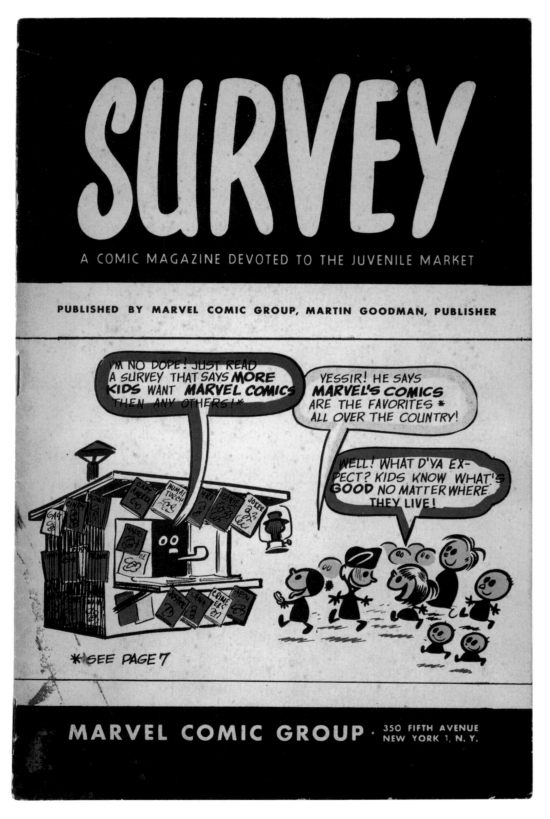

Marvel's *Survey* | **1948** | In 1948 Stan Lee assigned Kurtzman to illustrate an unusual Marvel Comics publication. *Survey: A Comic Magazine Devoted to the Juvenile Market* analyzed data about the comic book reading habits of 1,940 young readers. Kurtzman illustrated the comic-sized publication in both his cartoony "Hey Look!" style and his more realistic style. It was published in small numbers for a target audience of prospective advertisers. Possibly the rarest of all Marvel comics, Kurtzman's file copy may be the only issue extant.

If "Hey Look!" was not a cult favorite at the time (as measured in that fateful kids' survey), it was enough to launch Kurtzman into a short-lived Sunday newspaper strip experiment, "Silver Linings." It, too, was "filler," but instead of appearing in low-rent children's comics, these Sunday color strips graced the prestigious *New York Herald Tribune*. Only nine "Silver Lining" strips ultimately ran between March and June 1948, but they demonstrated that Kurtzman's unique brand of humor could make the jump from a distinct juvenile market to a mass market. His career showed signs of breaking out. But before he could take two steps forward, there was one step backward.

By the beginning of 1949, Stan Lee was no longer interested in "Hey Look!" and approached Kurtzman to create longer comics material for Marvel's family-oriented line. Kurtzman, fearing he would have to produce *Archie*-type comics, created an in-joke page for Stan's eyes only, lamenting the loss of "Hey Look!" and depicting Archie as a knife-wielding sex maniac (certainly not the last time Kurtzman would satirize *Archie*). Lee was no doubt amused; regardless, he assigned Kurtzman to draw "Rusty," an unabashed imitation of Chic Young's popular "Blondie" syndicated comic strip. Kurtzman described his fifty-page run on "Rusty" as "undoubtedly the worst year of my life."

"Stan was writing it and I was drawing it. I really busted my hump on trying to imitate the 'Blondie' style, and I *did*. . . . I look back on it today and I think I *did* my job. [But] Martin Goodman passed the word that I wasn't drawing *enough* like 'Blondie.'. . . It was a bad experience."

Disenchanted with prospects at Marvel, by 1949 Kurtzman was spreading his work around to other publishers. "Rusty" made clear that the freedom of expression he enjoyed with "Hey Look!" was an aberration: The filler material had simply flown beneath Lee and Goodman's radar. Kurtzman developed "Egghead Doodle" and "Genius" as variants of "Hey Look!" A few of these fillers still landed at Timely/Marvel, but he sold most to Toby Press, a publishing company owned by cartoonist Al Capp and run by his brother Elliott Caplin. Lee and Caplin shared one business philosophy that Kurtzman liked, a practice rare in the comics industry at that time: Each purchased

first publishing rights only, meaning that Kurtzman retained the copyrights to his fillers. In reality it was, perhaps, less a sign of respect than a disdain for the future "value" of such marginal material.

But Caplin also allowed Kurtzman to produce more than single-page filler material for his line. Kurtzman created three five-page stories featuring "Pot-Shot Pete . . . Sheriff of Yucca-Pucca Gulch"

for Toby's *John Wayne Adventure Comics* and *Billy the Kid*, as light sidebars to the poker-faced bulk of the cowboy adventures. "Pot-Shot Pete" aimed in a direction only hinted at in "Hey Look!": a satire on comic strips and comic books, more specifically on the genres of popular culture, unlike anything then being done in comics with any systematic effort.

Satirizing genres had been an occasional feature

of comics from their beginnings. Harry Hirshfeld's "Thirty Second Movies" in the first years of the twentieth century cleverly satirized the Perils of Pauline serialized films of endangered women and various urban excitements. In 1947, Will Eisner took on "Li'l Abner" in *The Spirit*, while Al Capp's "Fearless Fosdick" parodied Chester Gould's "Dick Tracy," who in turn had spoofed

Cape Cod watercolor | September 1948 | Kurtzman found time during his Cape Cod honeymoon to paint.

Chic Young's "Blondie"—and Kurtzman satirized them all in a single "Hey Look!" The notion of a humorous reflection on the genre of comics, destined to be a hallmark of the early *MAD*, was still a fresh idea at this time.

"Pot-Shot Pete" hit all the clichés and hit them hard: the nubile but still un-kissed sweetheart (who preferred kissing Pete's horse), the bad guys (who turn into machine-gun-carrying modern-day mobsters), the panicky townsfolk, and the arriving cavalry (who turn out to use bombers and a fleet of ships with big guns). The strip was briefly done, but the over-the-top humor most definitely presaged what would later come to be known as the Kurtzman touch.

Over the years a question has often been asked about this period in his life: What prepared Kurtzman for the career that lay ahead?

Perhaps the most important development in comics during wartime, as he later recalled, was not skyrocketing sales or improving techniques, but a reinvention of comics genres that could only be called "comics noir."

The films *The Maltese Falcon* (1941), starring Humphrey Bogart and based on the famous novel by Dashiell Hammett, and *Murder, My Sweet* (1944), based on a bestseller by Raymond Chandler, had already appeared in wartime. The emergence of noir in fiction and in film was mostly owed to the embittered experience of postwar American disillusionment—a widely felt crusade for democracy as a race for personal and corporate power.

Comics noir was embodied by the work of Charles Biro, a writer Kurtzman recalled reading with "the same excitement . . . that I felt about the underground comic books of twenty years later." Kurtzman, like other readers, was brought "nose to nose with reality" in these stories (especially when compared with the convenient fictions of standard comics narratives). Biro's vehicle was the comics title *Crime Does Not Pay*, published from 1942 to 1956 for 126 issues by Lev Gleason Publications.

Crime Does Not Pay certainly previewed the vastly innovative war and social drama titles that Kurtzman and others would soon create for E.C. Comics. The "crime" stories had no continuing characters; indeed, the protagonists were usually either dead, in jail, or being executed at the end of each story. As in pulp fiction and, by 1946, increasingly in films, the criminals rather than crimefighters were becoming the real protagonists, inevitably stirring a certain empathy in readers and the audience. The agents of the legal system operated as a moral force—less interesting by far, especially in contrast to the real stars.

Above left | Baby Meredith photograph | 1950 | Left to right: Harvey Kurtzman, his baby daughter Meredith held by Jack Davis, and Will Elder. The photo suggests the closeness of the artists and their families. As the new decade began, fatherhood put additional financial pressure on Kurtzman's unsteady freelance career. **Above right | Carnivorous telephone | circa mid-1940s |** This small and irregularly shaped Kurtzman illustration was possibly part of a love letter to Adele.

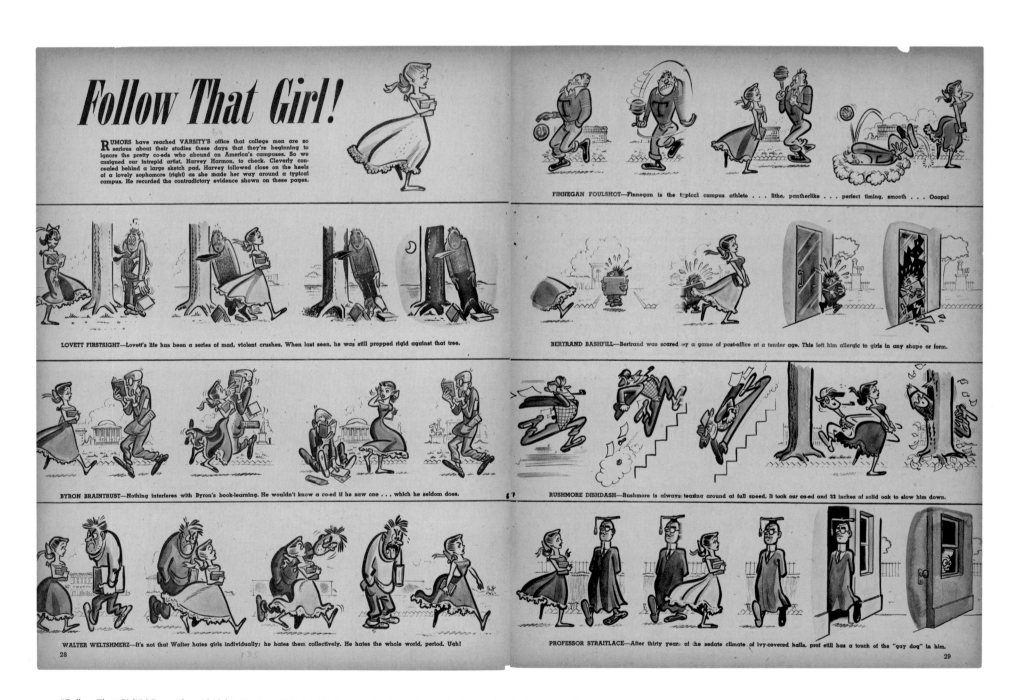

"Follow That Girl!" | **December 1949** | In *Varsity*, a "Young Man's magazine" targeting collegiate males, Kurtzman, aka Harvey Harmon, reveals the effect an attractive sophomore has on various men on campus. Much of Kurtzman's humor is timeless, but the last line, using the word "gay," demonstrates how quickly a slang term can evolve into having an alternative meaning.

UPHOLSTERER'S INTERNATIONAL UNION

SOCIAL SECURITY PROGRAM

A REPORT TO U.I.U MEMBERS AND EMPLOYERS

Here are some

NO UNNECESSARY WAITING

NO COST TO MEMBERS

NO DISCRIMINATION

GREATER BENEFITS THAN COMMERCIAL INSURANCE

of the highlights

EMPLOYER PAYS ALL THE COSTS OF INSURANCE

POLICY CAN BE CONVERTED

On leaving employment, insured members can convert life insurance part of coverage to individual insurance policy without medical examination.

NO MEDICAL EXAMINATION

NO AGE LIMITATIONS

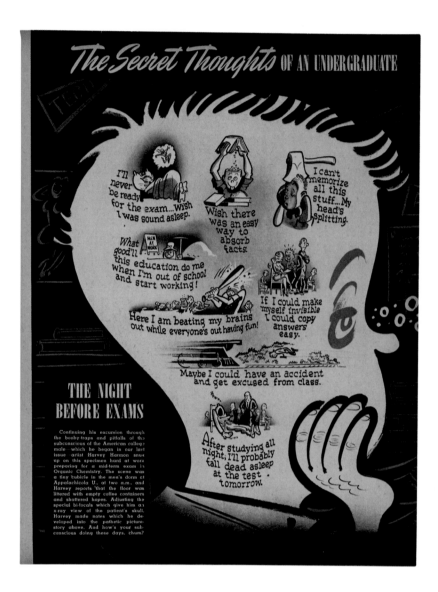

Left | Upholsterer's International Union Social Security Program | 1948 | While the bulk of Kurtzman's postwar 1940s work was done for Timely/Marvel Comics, he took on a variety of freelance projects at the Charles William Harvey Studio. One of his more obscure jobs was to whimsically illustrate the social security program manual for the Upholsterer's International Union.

Above | "The Secret Thoughts of an Undergraduate" | June 1949 | *Varsity* magazine provided Kurtzman with a succession of illustration and strip assignments at the end of the decade. Some of his best compositions and most nuanced work of this period appear in *Varsity*. Curiously enough, in this magazine Kurtzman worked under the pen name Harvey Harmon, the only time in his career he used another name.

13

SPEED

The ox, the horse, the engine,
the trolley and the ship — all thought
their middle name was "Zip"

By LUCY SPRAGUE MITCHELL
Copyright 1948 by E. P. Dutton & Co. From the
"Here And Now Story Book" by Lucy Sprague Mitchell.

ONCE there was a big beautiful white ox. His back was broad, his horns were long and his eyes were large and gentle. He went slowly sauntering down the road one sunshiny summer day. As he walked along he swung from side to side carefully putting down his small feet. And this is what he thought:

"I am pleased with myself — so large, so broad, so strong am I. Is there anyone else who can pull so heavy a load? Is there anyone else who can plow so straight a furrow? What would the world do without me?"

Just then he heard something tearing along the road behind

Children's Digest | 1950 | This *Children's Digest* illustration, and brief work for Kunen Books with René Goscinny, suggests that Kurtzman could have had a career in children's books if he hadn't steadfastly pursued comic books.

By 1947, when the wartime style of hyper-patriotic comics had faded badly, *Crime Does Not Pay* had become possibly the best selling of all comics (on their covers, the publisher boasted a readership of six million). By 1950 there were dozens of imitations, and critics raised a howl against the supposed effects of crime comics on young, pliable minds.

At this same time, however, in the late 1940s, a lasting impression of a different kind of comic had also been made upon Kurtzman.

BRIDGE TO A NEW DECADE

The work that Harvey Kurtzman did for Ace/Periodical House, Quality Comics, Aviation Press, and Timely (other than his brainchild "Hey Look!") was little more than standard. An eight-page 1949 Western collaboration with later E.C. artist John Severin on "Prairie Schooner Ahoy!," while inauspicious in style or narrative, was his best non-humor effort to date, and it presaged the interaction with other artists that would dominate his later work from the 1950s on: It was a lot of effort at low pay.

During this period Kurtzman also contributed several short features and illustrations to *Varsity: A Young Man's Magazine.* His *Varsity* comics were essentially done in his "Hey Look!" style, but Kurtzman (using the pen name Harvey Harmon) was able to address a more sophisticated college audience. He also picked up illustration jobs from *Parents Magazine* and developed several innovative children's books for Kunen Books, including four in collaboration with Charles William Harvey Studio tenant and close friend René Goscinny. The children's books never took off, and the discouraged Goscinny moved to France, where within the decade he would find fame and fortune in Europe with *Lucky Luke* and *Astérix.*

As the decade closed, one connection proved decisive. Kurtzman took his portfolio to the offices of Educational Comics, thinking they actually published "educational comics." There, fatefully, he met William M. Gaines, who not long before had inherited E.C. Comics from his father, Max.

But Bill Gaines was not interested in maintaining such E.C. titles as *Picture Stories from the Bible.* By 1949, when Kurtzman came to him, Gaines was transforming Educational Comics into Entertaining Comics, with half a dozen new titles in the crime, love, and romance genres.

Gaines looked at Kurtzman's portfolio and laughed uproariously at the "Hey Look!" samples, but he had no immediate need for his skills. Instead he referred Harvey to his brother David, who periodically worked on commercial projects with E.C. The referral led to *Lucky Fights It Through,* a comic mass-distributed for public educational purposes. The job didn't pay much—only $161 for sixteen pages of art—but was nonetheless welcome after a lean period.

"The Story of That Ignorant, Ignorant Cowboy," as *Lucky* was subtitled, was sui generis. The comic contained sheet music with lyrics, including this line about an infected loose woman: "So if you've known Katey, please listen to this: Only a doctor can cure syphilis! Don't be an ignorant cowboy."

Lucky Fights It Through was an incongruous cross-blend of the two-fisted, gun-handy hero comic, only with a public health message. America was entering a phase that would extend all the way to the 1960s' Great Society, with abundant education on birth control, mass inoculation, and public assistance for the physically and mentally disabled. If not the egalitarian society envisioned during the New Deal, it was a caring society, and Kurtzman, conscious or unconscious of the implications, played a proper part in it.

Kurtzman was an educator and a truth teller—and his message never changed, regardless of the form.

As the 1940s came to a close and they entered a new decade, Harvey and Adele became parents. With the birth of their first child, Meredith, financial security for the growing family became the foremost concern. *Lucky Fights It Through* proved fortuitous indeed.

Neither Harvey or Adele suspected that the unlikely introduction to Gaines and E.C. Comics would be the catalyst for much bigger things to come.

Lucky Fights It Through **splash page | 1949 |** This educational comic book about a syphilitic cowboy named Lucky was a chance assignment after meeting E.C. Comics publisher William Gaines in 1949. The $10-per-page assignment proved a critical toehold at E.C., which eventually led to Kurtzman's groundbreaking war comics and *MAD.*

Kurtzman Rewrites History, in Pictures

(And Later Saves E.C. Comics)

THE FABLED but short-lived E.C. comic book empire lies at the root of Harvey Kurtzman's triumphs. The stories and the art for this innovative line of comics amounted to a revolution that paved the road for *MAD* comics and magazines, as well as a larger, fresh notion of satire. But the flourishing of E.C. Comics proved scarcely less important for the history of comics art in its own right. Harvey Kurtzman joined a growing operation, with many of the industry's best artistic talent (including himself, as a freelancer), already engaged under Bill Gaines's command.

The value of Kurtzman's work was not understood at the time beyond the ranks of comics readers and professionals. Formal criticism, misdirected when not wholly lacking, added little to the admiration of Kurtzman's devotees. Then, and in the decades immediately to follow, few fully grasped what he had tried to do and had been able to accomplish. The little-recognized keepers of the flame, mostly in the comics fan press, had been watching closely all along through the shadows of relative obscurity. Ultimately, the recognition of comics art as "real" art opened up new readers, fans and scholars alike, appreciative of Kurtzman's contributions in this relatively brief but vital moment of the 1950s.

A common but misplaced impression has the comic book trade suffering so heavily from the media competition that by 1950 comics had had their day and it was rapidly passing. The fabled Golden Age of Comic Books was surely near an end, according to this view, as the Golden Age of Television had opened, including inventive children's shows that would steal away the next generation of what would doubtless have been comics readers.

The reality, however, was different. TV sets and clear reception moved across the country in spurts, with variations in the length of each given broadcast day and in programming choices. Besides, millions of children and adolescents were reluctant to give up the one medium that they had practically all to themselves. Fully five hundred distinct comics titles were appearing at mid-century, although "distinct" might wrongly suggest they were not mostly copies of one another. Something new, something interesting enough to reach the literate adult comic book reader, would require a very special twist.

E.C. Comics was the embodiment of that twist. Founder M. C. "Max" Gaines had been among the comics pioneers not only in the formation of the industry proper, but also on its didactic side. The publisher of All American Comics, he was also responsible for its sister company DC Comics publishing *Superman*. Gaines subsequently sold his share of All American in 1945, and he focused his energy publishing Educational Comics until

he died two years later in a boating accident.

E.C.'s continued existence and its half decade of astounding success could almost be taken as another accident. Young Bill Gaines, dropping out of college, had no preparation for running the publishing business he and his mother, Jessie, had inherited, nor did she. Perhaps it was the sense of challenge to the twenty-five-year-old chemistry major and World War II vet to make good in a business apparently holding its own through a confusing moment in pulp publishing, but stuck in a creative rut. "First thing I knew, I had to read our comics. Next thing I knew, I was in love with them."

Things looked bad, the consumer boom apart, for the New Deal–style liberalism and the sentiment that Kurtzman and others carried into the war effort. California senator Richard Nixon dramatically accused FDR intimate Alger Hiss of being a traitor, and the Red Scare besieged liberal Hollywood. Global gloom spread as the Russians tightened their hold on Eastern Europe, and the prospect of a third world war came into view. While things were going crazy (another word used at the time was "mad"), editor/writer/artist Al Feldstein walked into Bill Gaines's office.

It was a historic moment. The ideas they'd been discussing took months to jell. Some changes that would prove crucial to E.C. could, however, have been seen, in retrospect, to be present within

Opposite | *Frontline Combat* no. 7 cover detail | July–August 1952 | Harvey Kurtzman's line is pure motion. French comics historian Jacques Dutrey calls it a combination of "movement and shapes, energy and aesthetics. Though it may look deceptively simple to the casual observer, it is the end product of a long process of paring an elaborate drawing down to its essential line. Nature is not straight. In Kurtzman's art even the horizon is curved."

popular culture since the early 1940s. In line with the easing of prohibitions on sex and violence in the movies and comics after Pearl Harbor, various envelopes were now being pushed. High heels and tight sweaters became more evident in comics, although features showcasing "headlights"—provocatively semi-dressed nubile women—were soon to grow a great deal more provocative as young artists felt more and more free to make their own innovative proposals.

The first big idea Gaines and Feldstein had for E.C.'s salvation centered on a different but similarly less-censored genre: horror. From the days of 1930s pulps, this genre had occupied a niche between the morbid edge of crime-solving and the wilder "fantasy" side of "fantasy and science fiction." Radio shows like *Inner Sanctum,* dwelling on the morbid without stirring up too much public outcry, had been hugely popular for at least a decade. Gaines himself happened to be a great aficionado of pulp fiction. He would speed-read at night and bring plot notions into the office the morning after he had slept (or not slept) on "borrowed" ideas. Some supernatural features had already found their way into *Moon Girl* and another E.C. standard, *Crime Patrol.* These hinted at what was to come.

Albert Feldstein, an energetic young artist with experience near the lowest levels of the trade, was eager to make money and was never one to spend time pondering the consequences. He would swiftly lay out a breakdown of Gaines's latest story idea on Bristol boards, adding dialogue. Mostly, the ideas were "adapted" enough to protect E.C. from being sued for plagiarism, or the stories sprang from familiar formulae and were turned into something original. Melodrama, not originality, was the goal, and the message was delivered as much by the style—the use of first person in omniscient narrative, and a punch-line panel—as any plot particular.

Following his sidebar assignment on *Lucky Fights It Through* in 1949, Kurtzman began picking up regular story assignments from E.C. in 1950. One of his first, "House of Horror," was very much in the formulaic vein. As Kurtzman later quipped, "I recall the flaking paint [on the old house] because I drew each flake in great detail. . . . After that, they gave me as much work as I could handle. Now, I could eat regularly." Indeed, with regular E.C. gigs, Kurtzman's 1950 income effectively doubled from what he made the previous lean year.

In the spring of 1950, *War Against Crime* morphed into *The Vault of Horror,* and *Crime Patrol* morphed into *The Crypt of Terror,* soon to become *Tales from the Crypt. Gunfighter* became *The Haunt of Fear. Saddle Romances* became *Weird Science,* while *A Moon, a Girl . . . Romance* became *Weird Fantasy.* The "New Trend" was born, and Educational Comics officially became Entertaining Comics.

New Trend, unrecognized by critics, was instantly recognized and well received by distributors and readers, who could see the changes reflected in the art. Gaines made known that he was going to pay better rates to less-than-famous artists than the other smaller companies did, which held great appeal to the men and handful of women eking out a living through long days and often hyper-intensive and tedious weeks at the drawing table. Gaines and Feldstein demanded the very best work from their freelancers. Artists would be paid on acceptance, not just on delivery, which was a practice almost unknown in the trade. But they got results: By 1953, E.C.'s horror titles had circulations hovering around 400,000 each. The science fiction titles were less successful, but Gaines maintained them nonetheless.

Proof of Diamond & Gold Rings ad | 1952 | Kurtzman's fastidiousness in story research, editing, writing, and layouts is legendary. A virtually unknown side of these work habits involved the unglamorous oversight of press proofs. Each E.C. comic book he edited typically involved several hundred or as many as a thousand often-minuscule corrections to the printer's pre-press department. His editorial punctiliousness is evident in this sample proof, where even an ugly ad for "pseudo diamond" and "simulated ruby" rings received the same high production standards Kurtzman applied to actual comics pages. Every tiny stray spot of ink or broken line is dutifully circled with abbreviated marginal instructions to the printer (cropped in this example). The tedious task of proofing would only be rewarded by a second round of cleaner proofs. This example is from the last page of *Frontline Combat* no. 8 (September–October 1952).

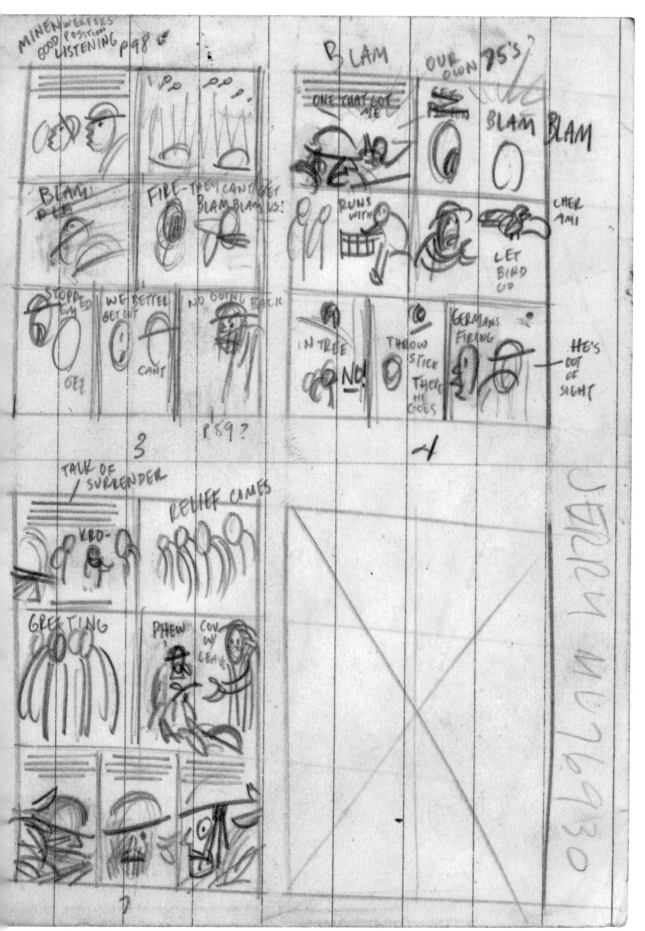

"Lost Battalion!" thumbnails | 1952 | For *Two-Fisted Tales*
no. 32 (March–April 1953) | Kurtzman created two stages
of layouts for every E.C. story he wrote for himself and his
collaborators. First he created small "thumbnail" breakdowns
of the full story in pencil. Each original thumbnail page is
only 2 ¼ inches high, and individual panels are merely ¾ of
an inch in height. Yet Kurtzman's first tiny visual impressions
are surprisingly close to the final renderings.

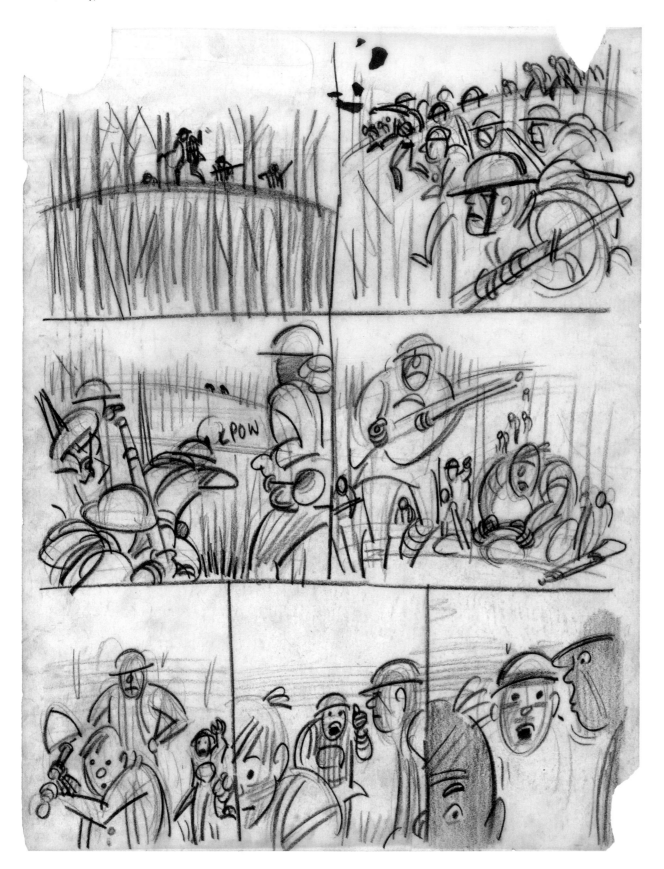

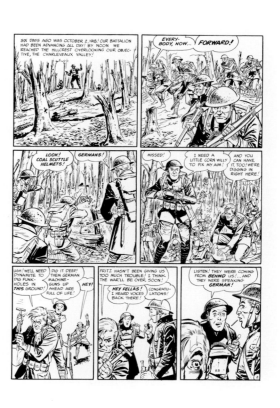

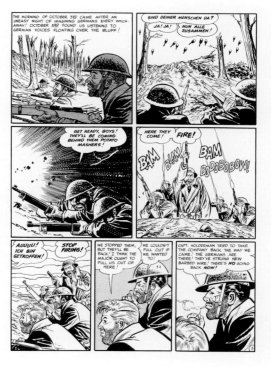

"Lost Battalion!" vellum overlays | 1952 | For *Two-Fisted Tales* no. 32 (March–April 1953) | Following the thumbnail stage, Kurtzman created large page layouts on vellum sheets using a heavy pencil. These were drawn approximately the size of the collaborating artists' original pages. "Lost Battalion!" is one of a handful of E.C. stories in which all three visual stages survive (the vast majority of large vellums were routinely discarded after pages were completed). These excerpts provide a never-before-seen metamorphosis of Kurtzman's process, focusing on pages 2 and 3. Kurtzman's insistence that artists follow his layouts closely didn't always make him popular with collaborators. "Lost Battalion!" was penciled in late 1952 on vellum measuring 14 x 18 1/2 inches.

"House of Horror" panel | 1950 | One of Harvey Kurtzman's first assignments for E.C. Comics, as a hungry freelancer and expectant father, was to illustrate the story "House of Horror" for *The Haunt of Fear* no. 15 (May–June 1950). Years later he remarked on the unexpected significance of his inherent attention to detail. "I recall the flaking paint [on the old house] because I drew each flake in great detail. . . . After that, they gave me as much work as I could handle. Now, I could eat regularly." In general Kurtzman did not appreciate or approve of E.C.'s horror line.

To the assorted innovations at E.C. already under way, Feldstein as the rising editor added an especially important amendment for the artists: Each should draw in his or her own style rather than the familiar "house style" of other companies. And they would sign their own work, as if they were real artists and not hacks dreaming of better jobs in advertising. This move succeeded grandly. E.C. readers developed an instant attachment to particular artists, eagerly awaiting their contributions to the next issue on the stands.

The young artists, nearly all of them a few years out of the service, urged one another on, instilling a camaraderie that might have reminded Kurtzman of Music and Art, with its instructors telling the blue-collar boys and girls that they were something special, destined to go somewhere. Will Elder, Wally Wood, Jack Davis, Johnny Craig, Graham Ingels, Bernie Krigstein, Reed Crandall, Al Williamson and, of course, Kurtzman himself were determined to leave a record of their best efforts.

Most of the artists were lower middle-class New Yorkers, a generalization more precisely accurate for class than geographic origins. Elder, Kurtzman's best friend among them, came from a home considerably poorer than Kurtzman's. His parents had emigrated from Poland, and his father, a needles trade worker in dire straights during the Depression, gave endless emotional support and an oil painting set to the "meshuggina" (Yiddish for "crazy") boy who played endless pranks on family and neighbors but who also showed much early promise as an artist. Will made up for his indifference in schooling by self-education in art history and literature, but what he really wanted was to be a successful comics artist.

Wally (or Wallace) Wood, another of the more admired of Kurtzman's collaborators before and during *MAD*, was in some ways an opposite type. He was emotionally withdrawn, unlike the effusive Elder, and an artist with an alcohol problem. A Minnesotan, Wood spent little time in art school and more time in factory work and print shops, until he joined the Merchant Marine and became a paratrooper, finally emerging as an artist looking for comics work. Wood was known to drive himself beyond exhaustion with twenty-hour stretches of work, boxes of Marlboros, and gallons of coffee. His outlet, if he can be said to have had any, was folk music, especially the Weavers with their frequently iconoclastic, quietly left-wing message songs. Wood was fanatical in his devotion to his art, like Elder, but was emotionally cut off; he would eventually be engulfed in a downward swirl toward personal oblivion.

Like Kurtzman, Al Feldstein was essentially self-taught. It is notable that Feldstein had never (according to his own account) been very good in English, as Kurtzman had never been a particularly good student in history. The two could hardly claim much more than a solid high school education between them. Both attended Music and Art, though a grade apart, so Feldstein and Kurtzman were not strangers when they crossed paths at E.C. In fact, Kurtzman harbored lifelong guilt from a high school incident with Feldstein a decade earlier. Though it remained unspoken between them, it added another layer to a relationship that would grow increasingly complicated.

"I was a wise guy kid in the lunchroom," Kurtzman recalled. "I did some pretty stupid things [like] drop bottles between the tables to hear them crash. Moronic stuff. And Feldstein came over to me one day and said, 'Don't do that.' He scared me. I didn't do it again, and I felt very bad about it. Feldstein was the good guy and I was the bad guy. I hate the fact that that happened."

Feldstein had a special talent for story breakdown and for combining different plot elements into various "new" stories, offering at the end a sudden surprise whose purported shock could not have been too much of a revelation to experienced E.C. readers. O. Henry had been the popular literary master of that kind of ending, and Kurtzman was to reinterpret that strategy in ways true to his own genius. But Gaines and Feldstein at E.C. already had the concept down cold. No matter how expected, their endings induced a surge of excitement, an urge among many readers to flip pages ahead and see the conclusion, then turn back at leisure to see how the dialogue and pictures propelled the story.

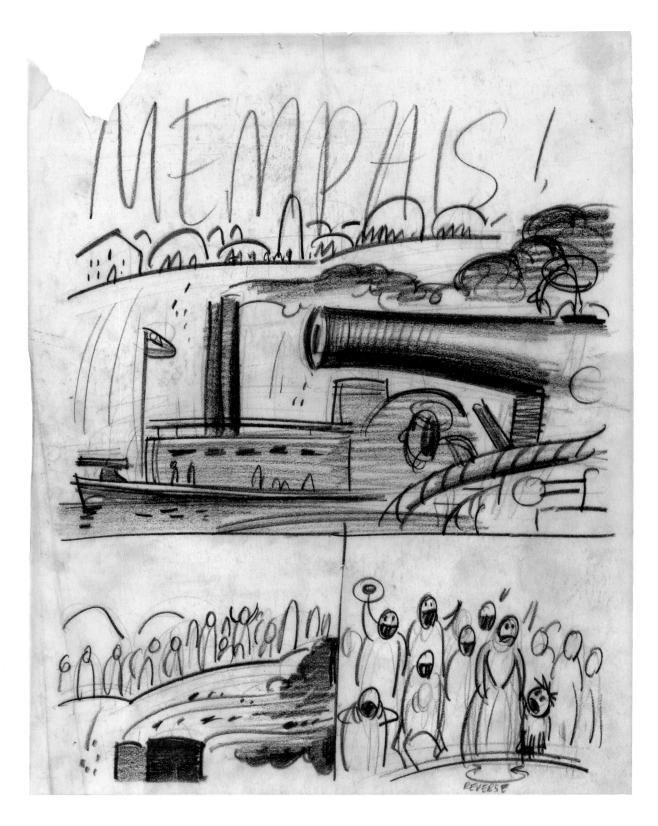

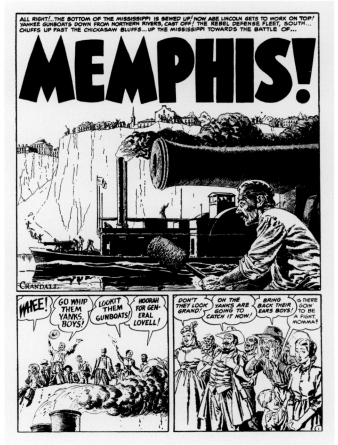

Left | "Memphis!" splash on vellum | 1953 | Kurtzman's vellum layouts for his collaborating artists are remarkable for their forceful and impressionistic line and bold composition. Kurtzman worked large with thick, blunt pencils. The vellum overlays for "Memphis!" and "Lost Battalion!" are among only seven sets known to have survived out of a total of 132 stories Kurtzman did for *Frontline Combat* and *Two-Fisted Tales*.

Above | "Memphis!" printed splash | 1953 | Artist Reed Crandall took certain liberties in his interpretation of Kurtzman's layout for the "Memphis!" splash page, making the foreground figure prominent in the opening panel and zooming in on the third panel crowd. Ordinarily Kurtzman didn't tolerate deviations. The story ran in *Two-Fisted Tales* no. 35 (October 1953).

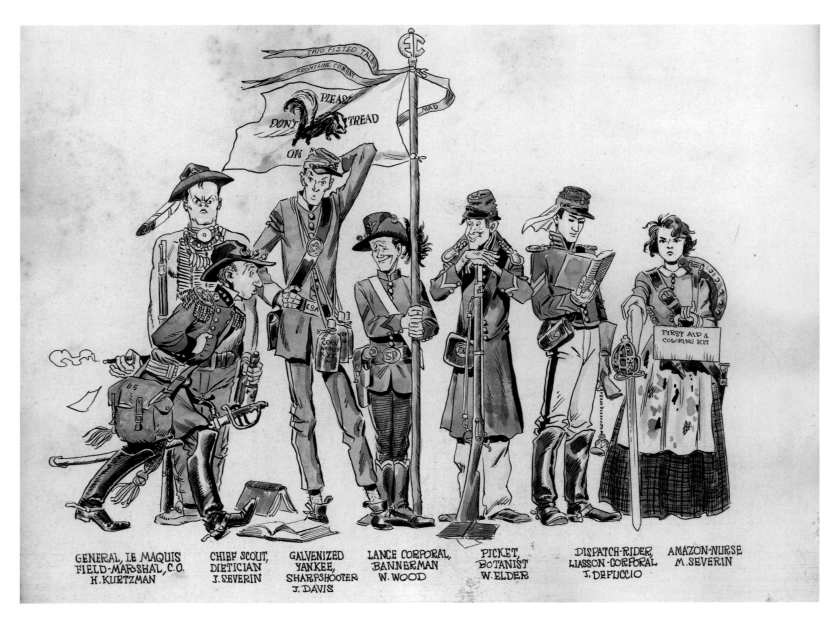

GENERAL, LE MAQUIS
FIELD-MARSHAL, C.O.
H. KURTZMAN

CHIEF SCOUT,
DIETICIAN
J. SEVERIN

GALVENIZED
YANKEE,
SHARPSHOOTER
J. DAVIS

LANCE CORPORAL,
BANNERMAN
W. WOOD

PICKET,
BOTANIST
W. ELDER

DISPATCH-RIDER,
LIASSON-CORPORAL
J. DEFUCCIO

AMAZON-NURSE
M. SEVERIN

Though Kurtzman had a negative personal reaction to the gore in horror comics, considering it unsuitable material for children, he nevertheless had reasons to appreciate the uniqueness of the E.C. effort. As comics historian Robert (R.C.) Harvey observed: Coming from where Kurtzman was, the young artist found himself driven by a storytelling compulsion that he was only just beginning to understand in the development of his own art. He did his share of storytelling early on in *The Vault of Horror* (two pieces) and *The Haunt of Fear* (also two pieces), and in the more social or political *Weird Science* (six pieces) and *Weird Fantasy* (also six pieces) between 1950 and 1953. These stories, however, like the rest of the horror pieces, were essentially scripts dictated to him by Feldstein.

Kurtzman had more to work with, however, in E.C.'s science fiction lines. Here, the broad social themes dealt with topics as politically daring as all-out global war and the destruction of human civilization, but also the potential privatization of education (in some definitely non-utopian future where salesmanship was the driving principle of space exploration and planetary development).

E.C. was to become famous in this small but significant corner of veiled social criticism for anti-racist intimations (removed fictively to outer space) and for warnings against atomic doomsday. (They would also become known for fantastically busty women in space outfits,

John Severin caricatures of the E.C. Comics staff | circa 1952–54 | John Severin depicts himself and several fellow E.C. artists as Civil War soldiers. Inspecting the troops is "General, Le Maquis [*sic*] Field-Marshall, C.O. [Commanding Officer] H. Kurtzman." Jack Davis, a proud Southerner in a confederate uniform, is playfully identified as a "galvenized [*sic*] Yankee." Wally Wood's banner pole has ribbons for the three E.C. titles Kurtzman edited. Will Elder's botanist title jokingly references a "head-to-toe case of poison ivy" he once contracted. "Dispatch-Rider" Jerry DeFuccio began as a research gofer for Kurtzman. Severin's sister Marie was E.C.'s principal colorist, which explains her "First Aid & Coloring Kit."

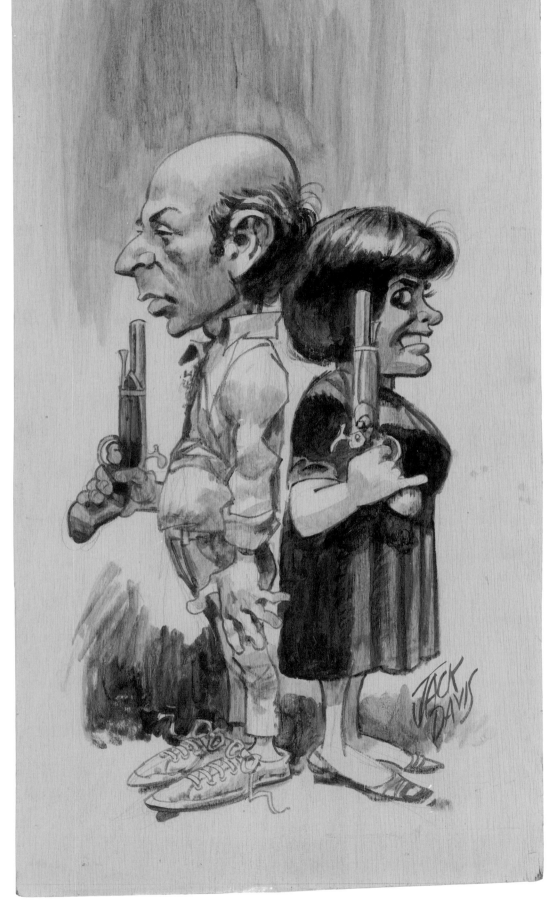

drawn by Wally Wood in particular.) Interestingly, Kurtzman drew steadily for *Weird Science* in its first seven issues, tackling such subjects as radioactive children, the old Nietzchean Man and Superman theme, which he reworked, and "The Last War on Earth." The liberal, antiwar social messages here, at least, were fairly unrelenting. But he also had other work to turn to. Kurtzman had not gone beyond being mainly an artistic contributor quite yet, although his artistic style was definitely outside even the E.C. mainstream.

TWO-FISTED EDITING

Harvey Kurtzman began to show his unique editorial talent in his own brainchildren, *Two-Fisted Tales* and *Frontline Combat.* How this remarkable phase of his career and of his comics development came about is a source for much speculation. Robert Harvey suggests that Kurtzman proposed to Gaines the need, in the rapidly growing E.C. empire, for an adventure title along the lines of Roy Crane's newspaper strip "Captain Easy." Feldstein himself remembers Kurtzman urgently wanting more money, and requiring his own title, or titles, to get it. His first results appeared some six months after the initial New Trend titles debuted in late 1950, with *Two-Fisted Tales,* followed by *Frontline Combat* in mid-1951.

Neither title bears any apparent resemblance to "Captain Easy," which was one of those familiar strips where (as in other typically global strips with American heroes) natives are put in their place through derring-do, while the star-spangled superiority of Anglo-Saxon physique and intellect are continually reasserted. Artistically speaking as well, what Kurtzman had in mind had just as few similarities to comic strip heroism at large. The degree of realism that he wanted in his stories simply did not exist, not even in the most noir of comics, like *Crime Does Not Pay.* What Kurtzman set out to do would be stylized to resemble the constructed "reality" of familiar comic formats, but with some important changes.

Jack Davis portrait of Harvey and Adele dueling | circa early 1950s | Family friend and E.C. colleague Jack Davis created this previously unpublished caricature of a dueling Harvey and Adele sometime in the early 1950s. The exact source of the joke is lost but it is probably no more than a cartoonist's exaggerated view of any couple's periodic feuds. The original is rather unusual: painted in brown acrylic over pencil on wood paneling measuring 17 1/2 x 30 inches.

The artistic freedom within comics that enabled Kurtzman to create in this fashion happened almost by accident at E.C. He later recalled:

Bill and Al tried to control what I was doing. I had offbeat ideas that would drive them crazy. Bill never really understood what I wanted to do, but after a while he began to leave me alone. And Al had his own comics to edit, so he didn't stand in my way. . . . [T]hat's how I came to edit my own comic books at E.C.

Kurtzman not only wanted, he *insisted* that artists follow his layouts to the letter. Some artists felt rather naturally uncomfortable, even stifled, with this compulsory guidance. Bernie Krigstein, who had a fine arts background, found himself at home in E.C., drawing almost fifty stories for various titles. But his utter admiration

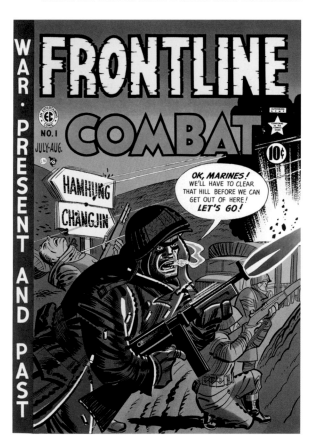

for Kurtzman from a distance—working at competitor Atlas—quickly hit a dead end when the master was calling the shots. Krigstein came into *Frontline Combat* toward the end of its run, worked a bit on *MAD*, and later expressed dissatisfaction because he had sought what amounted to artistic autonomy of his own, free of Kurtzman's precise direction.

Jack Davis was more typical, recalling in later decades that "When you'd pick up a story, Harvey would sit down with you and he . . . acted it out, all the way through. . . . You felt like you'd lived the story." Others recorded not so much a mixed feeling as a teamwork sensibility, with each artist pushed to do his best, and Kurtzman pushing the hardest. Alex Toth expressed the experience best as "just a matter of respecting the man who'd written the story and laid it out. You usually agreed with him, because his eye was so keen, the outcome of the art so splendid."

KURTZMAN METHODS

The ways in which Kurtzman accomplished the goals that he set out for himself in comics were in and of themselves strikingly original. Even the best comics shops ran more or less like factories (the majority could be fairly described as sweat shops, the "putting-out" system of the old needles trade, since most artists worked at home or in rented rooms, not at a shop or studio). Will Eisner provided the most relevant model because he set himself up as a champion image-maker, laying out the work for largely journeymen artists (many of whom never really advanced artistically) and for up-and-coming youngsters whom he helped apprentice, like Jules Feiffer.

Kurtzman was more of a medieval-style craftsman amid the budding geniuses working the same trade. Without being an ideologue in the least, indeed barely conscious of any direct political intent, Kurtzman pointed the way toward the uplifting of a familiar art—comics—perhaps the most commonplace form that popular culture had yet produced. And how did Kurtzman do it? By careful, indeed almost *obsessive,* attention to the details of history; by disregarding the idealization of war and the

militarization of society since 1945; and by looking at the sweep that history offered, with a lucid gaze that William Morris would surely have admired.

Kurtzman's legendary long hours in the New York Public Library researching stories for his titles attest to his method of truth-telling, not in the satiric (and thus exaggerated) sense of *MAD* and other projects to come, but in the sense that without factual precision, no story could be told well. This already posed a major potential shift in the creation of comic books, one in stark contrast to the philosophy of the original E.C. Comics, where Max Gaines once screamed at an artist laboring on *Picture Stories from the Bible*, "I don't care how long it took Moses to cross the desert, I want it in three panels!"

Plenty of work went into breakdowns for *Classics Illustrated,* of course, but accuracy was never a hallmark there. Other nonfiction comics in the mainstream, like *True Comics,* edited by Elliott Caplin, did not particularly live up to their claim because "true" was only another gimmick. These also remained flat in both story and art. Indeed, only by the late 1970s, with underground comix like Leonard Rifas's *Corporate Crime,* Larry Gonick's *Cartoon History of the Universe*, and Jack Jackson's Texas trilogy, did fact-based nonfiction comics attract the general public—decades after others had been producing instructional comics on various subjects and for various employers such as the military.

Kurtzman was trying something genuinely new, and new to himself as well. These stories were not meant to persuade, in the sense of *Lucky Fights It Through.* Instead they were stories and images that aimed to entertain the reader and compel contemplation—something almost unthinkable for the comics industry, which relied upon rapid reading as much as on anonymous writers and artists. All beloved comics can be read and enjoyed again and again, of course. But unlike, say, Carl Barks's marvelous *Uncle $crooge* comics or John Stanley's *Little Lulu*, Kurtzman's stories could be read as history.

Their mood was usually the result of character; in action and war comics this was most often a melancholy development. Rascals as well as

Above | *Frontline Combat* no. 1 cover proof | **July–August 1951** | Proof sheet of Harvey Kurtzman's cover for the debut issue of *Frontline Combat*. War comics would never be the same.

moralists would meet their demise, of course, but in Kurtzman's work their trajectories had been signaled early on, not mainly because white-and-black hats were being distributed, but because the inner character, rarely as simple as in super hero comics, was moving toward a preordained end. It was fatalism, as lively as a vintage Russian novel or a then-current noir film. But the stories were also profoundly about the situation of Americans at mid-century. War, including the permanent preparation for all-out war, was not only what civilization had come to (if only reluctantly, according to the bipartisan rhetoric of the time) but, in the view of mordant observers, what its core meaning had been all along. Redemption, if it could be found at all, demanded clear-eyed understanding of frightful realities.

Thus *Two-Fisted Tales*, replacing the line of horror comics *The Haunt of Fear*, and his other war title, *Frontline Combat*, were never intended to be about modern war alone. Scenes from Alexander and the Legions of Caesar to the German forests where resistance gathered against the Romans, or Napoleon's victories and losses, were all vividly and realistically presented. Artist George Evans later complained, jokingly, that Kurtzman wanted all the Napoleonic legion represented, and Kurtzman answered back that he had only wanted half because "we didn't have enough room in the panel" for the entire army.

Kurtzman and his artists captured Bunker Hill in the American Revolution: perfectly dressed British soldiers confronted by the guerilla warfare of upstart Yankees throwing rocks, forcing the Empire to needless sacrifice in an empty victory. Likewise, the British were seen at more successful imperial duty in Asia (as recorded semi-humorously by Kipling, no doubt), as were the two sides in the American Civil War, the romantic fliers of World War I, and of course the U.S. troops of the Pacific and European theaters in the Second World War.

These were distinct enough, part of a mini-trend of films and novels beginning shortly after V-J Day, painfully realistic in their treatment of American doughboys in the field, intermittently bored and terrified, but hardly ever John Wayne–

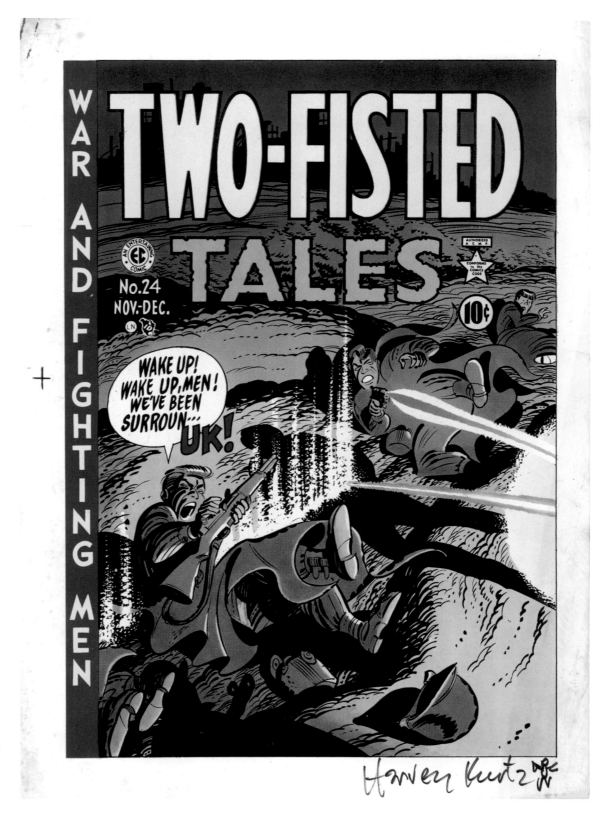

Two-Fisted Tales **no. 24 cover proof | November–December 1951|** Cover proof to *Two-Fisted Tales* no. 24, signed by Kurtzman.

like. More remarkable, more completely outside the mainstream of comic books, newspaper strips, popular films, and magazine fiction (still a booming trade) were Kurtzman's sympathetic approaches toward "the other," those designated "enemies" on racial as well as military grounds, who were typically slaughtered with little compunction.

Thus "War Dance!," drawn by John Severin, a seven-page story in *Frontline Combat* no. 13 about the primal struggles between Pawnees and Poncas as Europeans pressed westward and options disappeared, didn't focus on whites at all, instead conveying the actions and mindset of would-be tribal conquerors. In this story, aggressive leader Red Knife ends up banished from his own tribe, homeless and friendless on the prairies as the price of his folly. His narrative is not unlike Custer's, the one drawn by Wally Wood in a more famous E.C. story ("Custer's Last Stand," *Two-Fisted Tales* no. 27), except we see Custer from a crucially different angle of the ordinary soldier who perceives his commander as the "peacock" that he is, interested only in advancing a career through bloody glory. Severin would later say that Kurtzman, "a genuine, card-carrying genius," had the unique advantage of the artist/writer: "The difference been Harvey's approach to *Two-Fisted Tales* and mine was the difference between an intellectual and a song-and-dance man." Taking nothing away from Severin, who was an important and thoughtful artist, Kurtzman was the savant.

A remarkable example of Kurtzman's story-telling and point of view can be seen in "Atom Bomb!" (*Two-Fisted Tales* no. 33) Depicting the life of one very ordinary Japanese family during the atomic holocaust of Nagasaki, with its unthinkable destructive power, radiation poisoning, and struggle for survival, Kurtzman ends the story with the grim facts of destruction and "hope in the whole world" for rebuilding itself. But that last panel is not much consolation, because Wood's brilliant drawing and the use of color and high-contrast panels was sheer horror—as pure as any that E.C. Comics had offered for titillation. This, instead, was realistic horror, and it was more frightening by far.

Kurtzman had the energy to direct a fresh line of comics. War sells, and in that sense the subject had been as obvious as his departure from super heroes had been innovative. *Two-Fisted Tales* ran forty-one issues over the course of four years, eased out by pressure from its own sister publications and the changing demands on Kurtzman's energies.

The outbreak of the Korean War in 1950 prompted the formation of *Frontline Combat* (fifteen issues over three years). Largely about the "police action" (or undeclared war—the most devastating undeclared war in history, to that point) and the United States' role in it, *Frontline* also flashed back to other wars in a less spectacular way. The heavy focus on Korea notably intensified the psychological element and the individual experience of war.

"Big 'If'!," drawn by Kurtzman himself in the fifth issue (1952), may have been the ultimate expression of his intent as writer, artist, and editor. "Normally, the traditional war comic depicted American soldiers merrily and bare-handedly killing little gap-toothed yellow men with their rifle butts," he recalled. "And I thought that was a terrible disservice to the children who were reading those stories. I think you must make a contribution in this life, and through the two war comic books that I edited, mine was to make my readers aware of the reality of war."

From a technical point of view, as Robert Harvey keenly suggests, Kurtzman was less realistic than "abstract and telegraphic," exaggerating and contorting his subjects as suited the mood of his stories. In other words, Kurtzman had, in his own way, brought comics forward into a modern art distinctly different from the stylized super heroes or, for that matter, the funny animals of the comics mainstream.

In the case of "Big 'If'!," Kurtzman achieved his goal by particularizing an incident at the moment in a soldier's life when fate descends upon him. As the strip closes in seven panels, the doomed Paul Maynard looks at himself in the third person, at how he might, with luck, have missed death by seconds. In the final panel the narrator states, "And man's destiny goes marching on!" Clearly not a happy destiny.

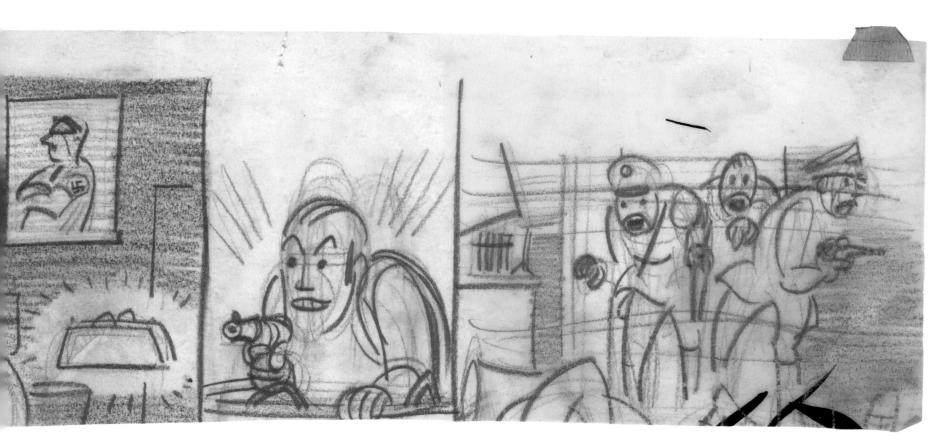

"Flash Gordon" daily strip | March 18, 1953 | Harvey Kurtzman wrote and laid out the daily "Flash Gordon" comic strips that appeared in newspapers from November 1951 to April 1953. For a while legendary artist Frank Frazetta penciled the strips based on Kurtzman's layouts. But inker Dan Barry later commented on the short-lived collaboration: "[Kurtzman] insisted on laying out the strip in his very stylized way. When you see an animator showing a guy belting someone else and his arm is bent like a rubber band, the action looks terrific. Then you try to put realistic drawing on it and it changed completely. . . . The layouts inhibited me." Within a year of leaving this assignment, Kurtzman parodied the strip in "Flesh Garden" (*MAD* no. 11, May 1954). Pencil on vellum.

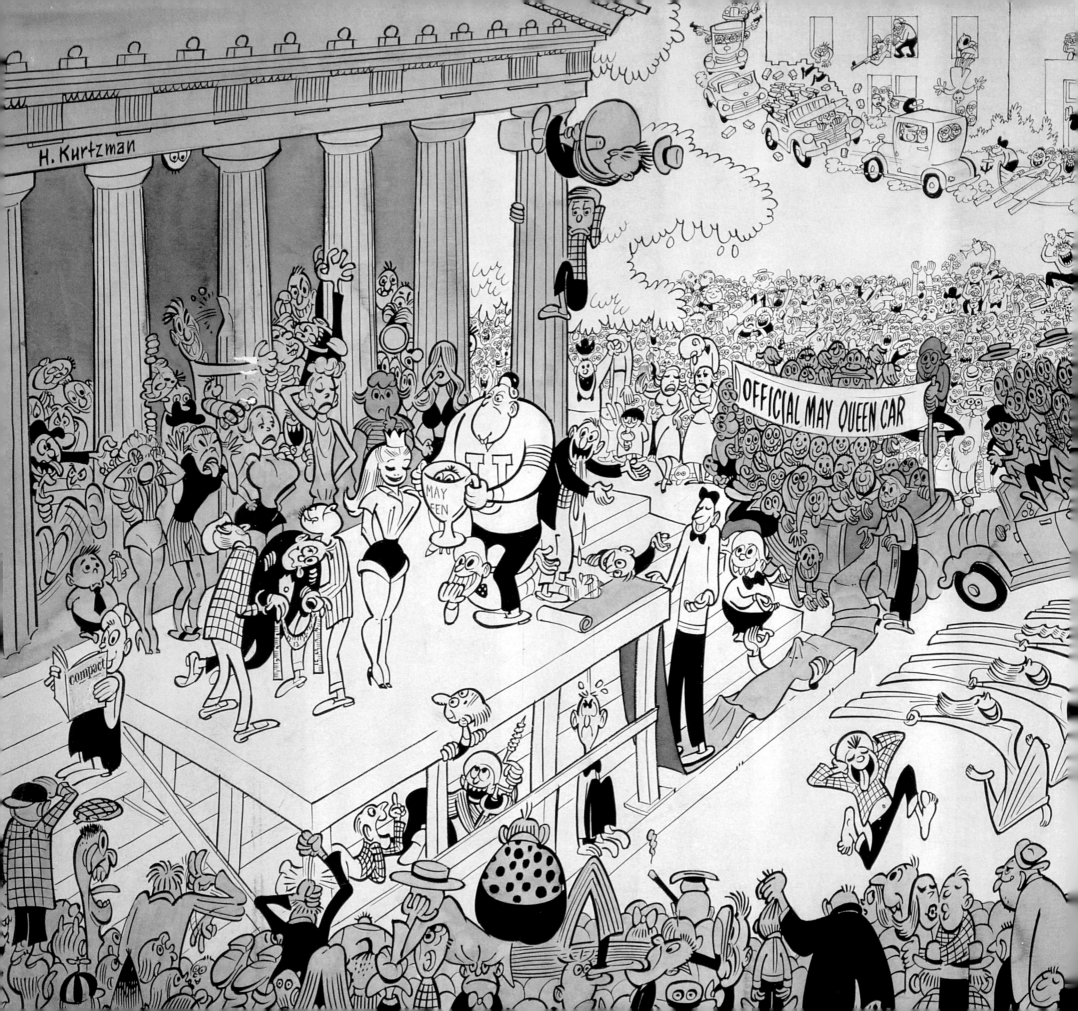

"Scenes from College Life: Crowning the May Queen," *Compact* no. 5 centerfold | May 1952 | One of Harvey Kurtzman's largest (45 x 24 inches) and most ambitious illustrations, "Scenes from College Life: Crowning the May Queen," was drawn in 1951 for the digest-size *Compact* magazine ("The Pocket Magazine for Young Moderns"). The campus scene includes hundreds of zany figures, but Kurtzman balances the dense crowd scenes with tones and open spaces for a lyrical composition that invites the eye to flow along visual paths. *Compact* severely cropped this image for its centerfold, and the limitations of halftone reproduction on cheap paper in the early 1950s further diminished the impact. It can truly be said that this magnificent image is being properly seen in this book for the first time.

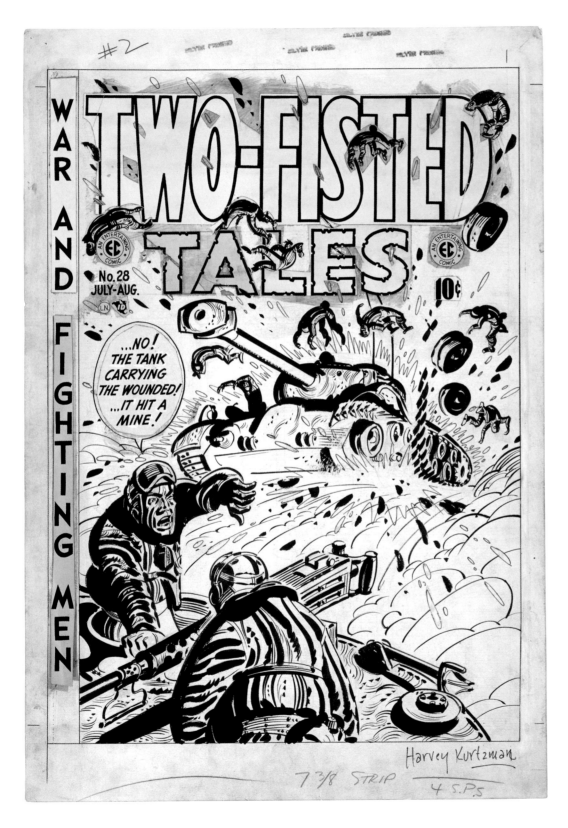

Two-Fisted Tales no. 28 cover art | 1952 | The residual yellow stains on Kurtzman's original art for the cover of *Two-Fisted Tales* no. 28 (cover dated July–August 1952) are the result of aging rubber cement applied to movable elements. The red outlines (not visible on the printed cover) are Kurtzman's color guides to the printer, indicating exactly where color breaks occur (ordinarily defined by black lines inherent in the art).

Kurtzman drew at least one story in each issue of *Two-Fisted Tales*, sometimes two, and the covers for the first twelve issues. It was a monumental effort, but he outdid himself with *Frontline Combat*, where he illustrated all the letter and text-page headers personally, and drew the first nine covers, and at least one story in all but the final six issues. Kurtzman was already handling two of the ten best-known and best-selling E.C. Comics titles as the overall brand steadily gained an unmatched reputation for quality. E.C. was focused, and Kurtzman was the unimaginably focused editor.

This reality was deeply embedded in the craft of production at all levels. Gaines and Feldstein had, from the beginning, worked as a team, with Gaines feeding stories to Feldstein to break down or change, in turn handing off the penciled story-boards or outlined ideas to individual artists to carry through. Kurtzman's idea of teamwork was quite different. He had no particular quarrel with Gaines or Feldstein, but he also had no reason to work with them. His genius could only develop in autonomy. And "his" artists were to be anything but autonomous.

Kurtzman frequently disregarded deadlines set by Gaines, giving himself the necessary days or weeks to complete historical research or, for *Frontline Combat* in particular, to talk to GIs or engage in correspondence with them, getting their unwritten stories of what happened in a particular battle or campaign. Then Kurtzman developed a treatment of the story, one not so different in a sense from a cinematic treatment that would be created for the production of a film—except here he needed no studio permission and no stars. He developed "thumbnail sketches," miniatures of the comic narrative, with captions and dialogue in balloons. Then he went back to write, more certain of "what characters have to say," and revised repeatedly on tracing paper.

The comic would be nearly ready for the artist by now, with Kurtzman supplying reference materials, including photos and drawings to work from. Finally, Kurtzman did large layouts on vellum. He also designated color, which was not merely a matter of taste but a growing sensibility of the artistic impact of color on the reader—a moment of revolutionary change beyond the comics

pages, and one more in line with contemporary animation and modern art.

In *Two-Fisted Tales* and *Frontline Combat*, an individual panel might be shown in a single color, raising the level of visual intensity, or in a variety of colors, varying from panel to panel in patterns. One-color backgrounds—highly unusual for comics—would be offered as an experiment in narration, like the frequent use of oversized splash panels. Or the form might return to customary comic book styles for pages at a time. The rules meant less and less, while the focus upon a visual and narrative perfection allowed the inevitable stylized panel-fillers to give the reader a breather.

In a field where consumers were generally considered to be too dumb to care, E.C. created an intensely loyal cult of aficionados. Horror often picked up the slack of the lesser-selling "social" themed comics like *ShockSuspense Stories*, with their treatment of lynchings, civil liberties violations, and the American tendencies toward fascism. But to the avid E.C. fan, all the books "mattered."

OTHER BATTLEGROUNDS

It was a mission as well as an art form. But not everything was going well, even in this creative hothouse. To say that Kurtzman and his fellow artists resented the fact that their pay did not go up with the circulation of their titles would be a considerable understatement. Gaines, in some ways a smaller-scale Walt Disney with a strong sense of paternalism for his workers, measured value in "team picnics" and staff Christmas gifts (one year, he gave movie cameras to Kurtzman and other key artists), unwittingly stoking resentment. They had made E.C. very successful, and they wanted more money—and had no doubt that they deserved it.

Kurtzman resented Gaines's piecework payment system that rewarded prolific contributors like Feldstein while providing no financial incentive for Kurtzman's heavily researched and labor-intensive war stories. He was feeling burned out by the long hours and relatively low pay. The answer lay in creating something that didn't require long unpaid hours at the library, and based on a talent of Kurtzman's that had first gotten Gaines's attention: humor.

AD-MAN'S DREAM WORLD Cartoonist Harvey Kurtzman, suffering from SF (Slogan Fatigue), speculates on what life might be like if everybody actually reacted to basic urges the way advertising copywriters say they do

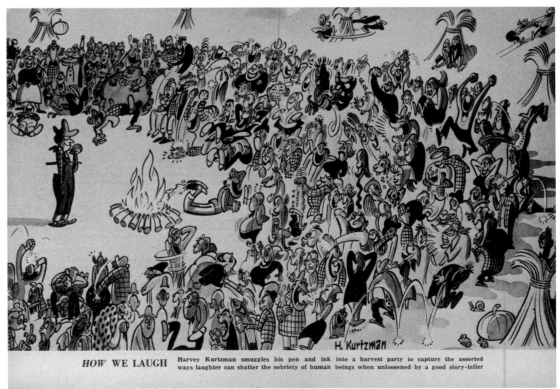

HOW WE LAUGH Harvey Kurtzman smuggles his pen and ink into a harvest party to capture the assorted ways laughter can shatter the sobriety of human beings when unloosened by a good story-teller

Top | "Ad-Man's Dream World" | *Why* no. 6 | September 1951 | While freelancing for E.C. Comics in the early 1950s, Kurtzman also sought work elsewhere. One of his reliable patrons was Elliot Caplin, brother of "Li'l Abner" cartoonist Al Capp. In 1951, Caplin was the publisher of the digest-size *Why: The Magazine of Popular Psychology.* He paid Kurtzman $50 for this detailed centerfold crowd scene illustrating an article called "Sex Is a Salesman." **Bottom | "How We Laugh" | *Why* no. 7 | November 1951 |** Kurtzman received $75 (a 50 percent raise) for this "How We Laugh" centerfold illustrating "The Six Basic Rules for Successful Story-Telling."

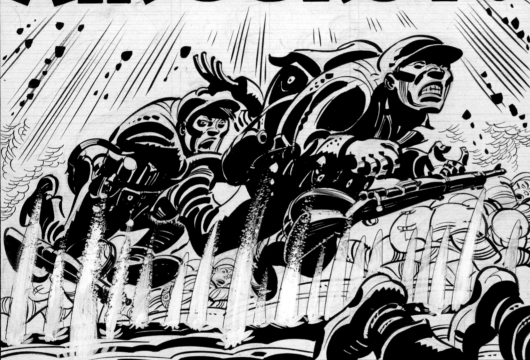
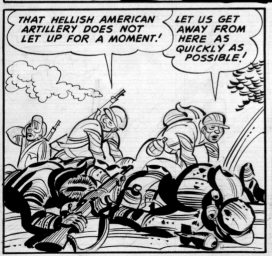
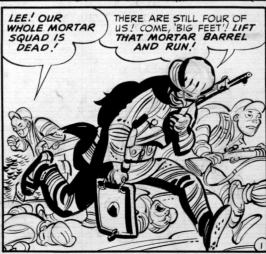

Left | "Air Burst!" splash art | 1951 | The splash page to "Air Burst!" from *Frontline Combat* no. 4 (cover dated January–February 1952) is an outstanding example of Kurtzman's composition and brushwork. It was the single war story he was most proud of.

Above | Kurtzman covers for *Two-Fisted Tales* no. 19 (January–February 1951) and no. 24 (November–December 1951)

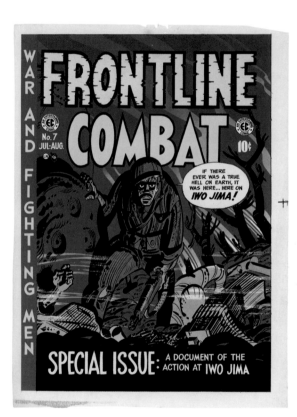

Left and above | *Frontline Combat* **no. 7 cover art and color proof | 1952 |** The original black-and-white art for the cover to *Frontline Combat* no. 7 with the corresponding color proof (cover dated July–August 1952) provides a before-and-after example of the application of mechanical color to line art. Kurtzman's emphasis on red and yellow tones underscores the hell-on-earth theme.

CORPSE ON THE IMJIN!

The Korean War, which lasted from June 25, 1950, through July 27, 1953, provided the backdrop for the E.C. Comics titles *Two-Fisted Tales* and *Frontline Combat*, and naturally inspired quite a few of Harvey Kurtzman's stories in both series. But "Corpse on the Imjin!" (*Two-Fisted Tales* no. 25, January–February 1952) isn't about a battle ripped from headlines. This six-page story reduces the war to a solitary GI observing a North Korean corpse as it floats down the river. As he speculates on how the dead soldier met his fate, the American suddenly faces an intensely choreographed fight to the death, culminating with one more body belly down on the Imjin. Kurtzman's thoughtful, more realistic and human depictions of war were in stark contrast with competing gung-ho war comic books that glorified war, almost never displayed moral ambiguity, and frequently featured Koreans as garishly yellow-skinned and buck-toothed "gooks."

By posing the most familiar question of battle—how did they die and who killed them?—Kurtzman, writer and artist combined, asked a more difficult, often unspoken question of every war. That is, the seeming pointlessness of conflict, especially modern technologically armed conflict, taking away the gift of life precious to all beings. Kurtzman's depiction of brutality had little or nothing to do with the John Wayne of films or the Captain America of wartime comic books. The apparent meaninglessness of the Korean War (that huge and bloody operation labeled a "police action") evidently drove Kurtzman to the extremity of his theme and his unsparing art. "Have pity for a dead man!" Only a brave artist would say it, as the war dragged on and the media, echoing the government, warned that dissent might be treason.

SILVER PAINTED

C-1

19

IT IS A DARK DAY IN MAY! LIGHTNING FLICKERS IN THE SOUTH KOREAN HILLS, AND A STORM WIND ROARS OVER THE IMJIN RIVER! OUT IN THE MIDDLE OF THE RAIN SWOLLEN IMJIN, A LONELY CORPSE FLOATS WITH THE RUBBLE DOWN TO THE SEA! FOR THIS IS WHAT OUR STORY IS ABOUT! A...

CORPSE ON THE IMJIN!

BUT MANY THINGS FLOAT ON THE IMJIN! DRIFTWOOD, AMMUNITION BOXES, RATION CASES, SHELL TUBES!

...WE IGNORE THE FLOATING RUBBLE! WHY THEN, DO WE FASTEN OUR EYES ON A LIFELESS CORPSE?

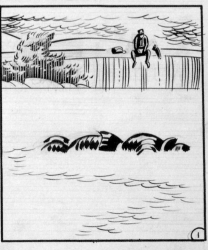
...THOUGH WE SOMETIMES FORGET IT, LIFE *IS* PRECIOUS, AND DEATH IS UGLY AND *NEVER* PASSES UNNOTICED!

Two Fisted Tales

6¼ x 9

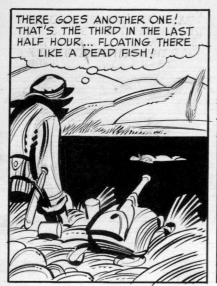

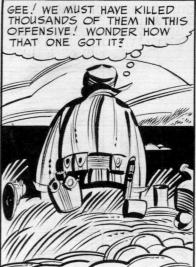

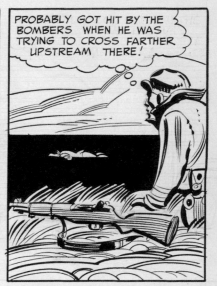

THERE GOES ANOTHER ONE! THAT'S THE THIRD IN THE LAST HALF HOUR... FLOATING THERE LIKE A DEAD FISH!

GEE! WE MUST HAVE KILLED THOUSANDS OF THEM IN THIS OFFENSIVE! WONDER HOW THAT ONE GOT IT?

PROBABLY GOT HIT BY THE BOMBERS WHEN HE WAS TRYING TO CROSS FARTHER UPSTREAM THERE!

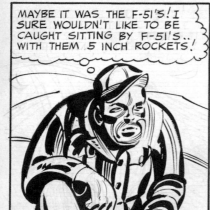

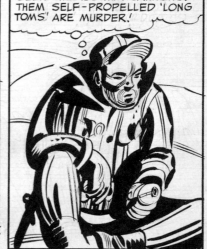

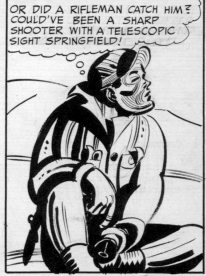

MAYBE IT WAS THE F-51'S! I SURE WOULDN'T LIKE TO BE CAUGHT SITTING BY F-51'S.. WITH THEM .5 INCH ROCKETS!

THEN AGAIN, IT COULD HAVE BEEN THE 155 MM CANNONS! THEM SELF-PROPELLED 'LONG TOMS' ARE MURDER!

OR DID A RIFLEMAN CATCH HIM? COULD'VE BEEN A SHARP SHOOTER WITH A TELESCOPIC SIGHT SPRINGFIELD!

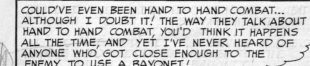

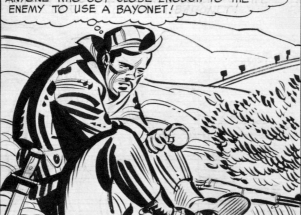

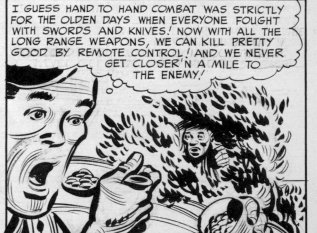

COULD'VE EVEN BEEN HAND TO HAND COMBAT... ALTHOUGH I DOUBT IT! THE WAY THEY TALK ABOUT HAND TO HAND COMBAT, YOU'D THINK IT HAPPENS ALL THE TIME, AND YET I'VE NEVER HEARD OF ANYONE WHO GOT CLOSE ENOUGH TO THE ENEMY TO USE A BAYONET!

I GUESS HAND TO HAND COMBAT WAS STRICTLY FOR THE OLDEN DAYS WHEN EVERYONE FOUGHT WITH SWORDS AND KNIVES! NOW WITH ALL THE LONG RANGE WEAPONS, WE CAN KILL PRETTY GOOD BY REMOTE CONTROL! AND WE NEVER GET CLOSER'N A MILE TO THE ENEMY!

2

CORRECTION, SOLDIER! NOT CLOSER THAN **FIFTEEN FEET**... FOR THE ENEMY IS WATCHING YOU EAT YOUR C-RATIONS NOT FIFTEEN FEET FROM YOUR RIFLE!

HE IS WET AND SCARED AND HUNGRY, AND HIS EYES GO FROM YOUR C-RATION CAN TO YOUR RIFLE! THE WIND HIDES ALL SOUND **AS HE SPRINGS!**

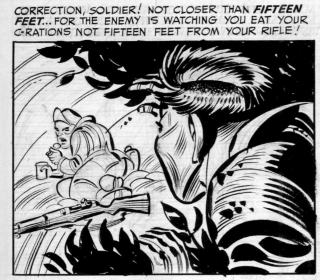
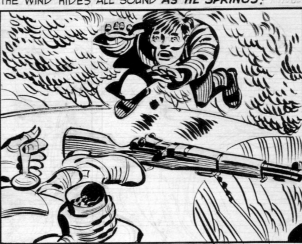

YOU SEE HIM OUT OF THE CORNER OF YOUR EYE AND YOU KICK OUT WITH BOTH YOUR FEET!

YOU KICK CLUMSILY AT YOUR RIFLE, BECAUSE THAT IS ALL YOU CAN DO TO GET IT OUT OF HIS REACH!

THE RIFLE TUMBLES OVER THE BANK AND INTO THE IMJIN RIVER! AND THEN THERE'S JUST THE SOUND OF THE WIND!

WHERE ARE THE WISECRACKS YOU READ IN THE COMIC BOOKS? WHERE ARE THE FANCY RIGHT HOOKS YOU SEE IN THE MOVIES? HE PICKS UP A BROKEN STICK!

HE'S A LITTLE FELLOW AND HE GRINS AS HE CIRCLES YOU WITH HIS STICK! YOU WIPE AT YOUR NOSE, AND THEN YOU REMEMBER YOUR BAYONET!

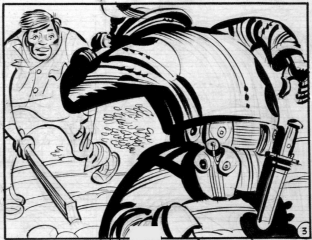

FOR _____ (PUBLICATION) MONTH & ISSUE NO. PAGE NO.

YOU GRIP YOUR BAYONET TIGHT... **TIGHT!** DEEP INSIDE, YOU DON'T **REALLY** BELIEVE YOU CAN STICK A KNIFE INTO A HUMAN BEING! IT'S ALMOST SILLY...

THEY SAY THE MAN WHO MOVES FIRST HAS WON HALF THE BATTLE, AND THE LITTLE GUY STRIKES OUT AT YOU WITH THE STICK... **CRACKS YOUR FINGERS!**

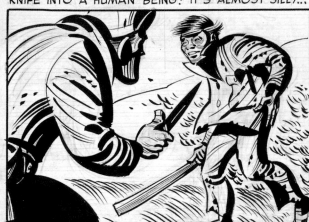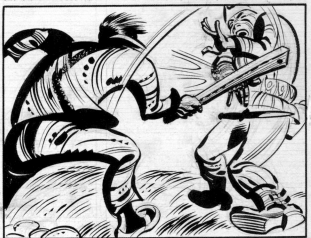

YOU'VE LOST THE BAYONET AND NOW YOU'RE HURT! HE CLUBS YOU ON THE ARMS, THE SHOULDERS...

BUT THE PAIN MAKES YOU **REACT**... YOU FEEL A SURGE OF FEAR... HATE... ENERGY... TINGLING IN YOUR MUSCLES...

YOU SHRIEK AND CHARGE LIKE A CRAZY BULL TO ESCAPE THE STINGING CLUB! YOU CLUTCH AT HIM!

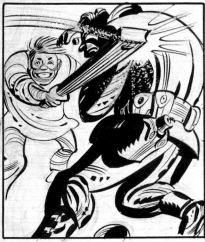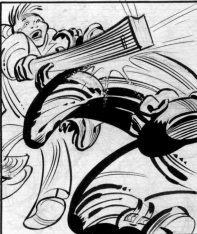

HE'S REALLY HURT YOU AND YOUR LEGS ARE WOBBLY AND HE STRIKES AND STRIKES AND STRIKES!

YOU OUTWEIGH HIM THOUGH, AND WITH ALL THE STRENGTH YOU CAN MUSTER, YOU PUSH HIM TO THE RIVER...

...AND YOU BOTH FALL! YOU RELAX AND YOU FALL! YOU NEVER KNEW FALLING COULD BE SO PLEASANT!

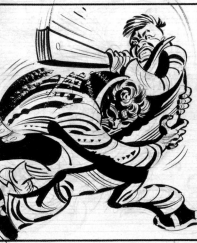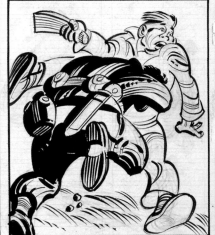

4

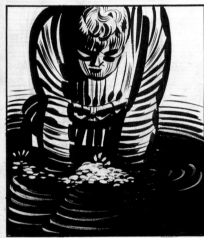

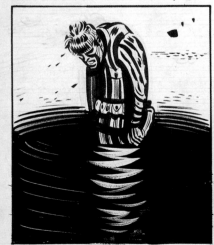

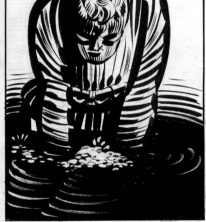

THE WIND IS RUSHING FITFULLY OVER THE IMJIN! IT STIRS THE HAIR ON THE BACK OF THE DEAD MAN'S HEAD!

THE WATER RIPPLES BEFORE THE WIND... LAPS AT THE SHORE...SWAYS THE BODY FROM SIDE TO SIDE!

THE FLOWING RIVER GENTLY SWINGS THE BODY OUT, AWAY FROM THE BANK AND INTO THE CURRENT!

AND NOW THE CURRENT, WEAK NEAR THE SHORE, SLOWLY TURNS THE BODY AROUND AND AROUND...

...AND IT IS AS IF NATURE IS TAKING BACK WHAT IT HAS GIVEN! HAVE PITY! HAVE PITY FOR A DEAD MAN!

FOR HE IS NOW NOT RICH OR POOR, RIGHT OR WRONG, BAD OR GOOD! DON'T HATE HIM! HAVE PITY...

...FOR HE HAS LOST THAT MOST PRECIOUS POSSESSION THAT WE ALL TREASURE ABOVE EVERYTHING... HE HAS LOST HIS *LIFE!*

LIGHTNING FLASHES IN THE KOREAN HILLS, AND ON THE RAIN SWOLLEN IMJIN, A CORPSE FLOATS OUT TO SEA.

Harvey Kurtzman

The decision to forgo the war titles for humor was strictly a practical one for Kurtzman. But after persuading Gaines to publish a humor comic, the launch of *MAD* proved not just a pivotal moment in Kurtzman's career, and in comics history, but one with profound influence on the larger culture.

After initially disappointing sales, *MAD* quickly proved to be one of E.C.'s winners. But Kurtzman was still frustrated by his head-butting and financial quarrels with Gaines. With sales quickly climbing to 750,000, *MAD* was showing genuine break-out potential and Kurtzman's talents were not going unnoticed.

The June 1954 issue of *Pageant* featured a glowing article, "Now Comics Have Gone *MAD*." The magazine was in love with Kurtzman's comic book, but its top management also had an eye on Kurtzman himself. Publisher Alex Hillman made a lucrative offer for Harvey to join their magazine.

MAD had, despite everything to come, been Harvey Kurtzman's baby from the first moment of its conceptualization. But Kurtzman had long dreamed of being part of the "slick" magazine publishing field, and had earlier been trying to persuade Gaines to change *MAD*'s format from that of a comic book to a magazine. Gaines firmly resisted. But as Kurtzman expressed temptation at *Pageant*'s offer, Gaines felt compelled to reconsider:

> I didn't know anything about publishing
> magazines. I was a comics publisher, but
> remembering this interest, when he got
> this offer, I countered his offer by saying
> I would allow him to change *MAD* into a
> magazine, which proved to be a very lucky
> step for me. . . . If Harvey had not gotten
> that offer from *Pageant*, *MAD* probably
> never would have changed format.

The new format (issue no. 24, cover dated July 1955) was an instant success—so successful that it had to be reprinted, which was something virtually unknown in the magazine publishing industry. Kurtzman was delighted to finally helm an actual magazine, but still felt constrained by what he viewed as Gaines's stingy rates for contributors (twenty-five dollars per page).

Any potential explosion from E.C.'s restive talent, however, was defused or at least delayed by the larger crisis affecting the comic book industry and E.C. in particular. There had been rumblings and warnings well before Senator Estes Kefauver (a presidential hopeful and big winner in congressional investigations of organized crime) turned his attention toward the supposed "comics menace."

Gaines (with publishers Lev Gleason, Rae Herman, and others) helped institute in 1948 the comics industry's own quasi-censor, the Association of Comic Magazine Publishers (ACMP), to offset pressures exerted by critics, notably Dr. Fredric Wertham, who publicly attacked what they viewed as the harmful effect of comics on young readers. Although E.C. quit the ACMP in 1950, the effects on Gaines and the industry were felt for generations.

Fredric Wertham was a liberal sort, certainly on racial issues. A psychologist who helped found a clinic in Harlem to treat indigent, troubled New Yorkers, he had developed an obsession with comic books by the late 1940s. His articles, such as "Horror in the Nursery," and excerpts from his 1954 bombshell, *Seduction of the Innocent*, reached wide and receptive audiences in publications like *Collier's* and the *Ladies' Home Journal*.

Wertham's claims about the harm comics were causing and the straight-faced acceptance of his charges by responsible authorities now seem profoundly silly. But if prior "threats from Hollywood" had the potential to destroy the morality of American youngsters, the widely mistrusted comic books were awaiting a supposed dragonslayer. In fact, many competitors to E.C. had indeed gone off the deep end in their publications, with extensive gore and suggestions of sadism in their crime and horror comics.

However, it wasn't just the horror titles that caused problems for E.C. Making fun of Santa Claus even proved too much for some. In 1953, *Panic* (Feldstein's subsequent sister publication to Kurtzman's *MAD*) ran a take-off of Clement Moore's classic sentimental poem, "A Visit from St. Nicholas," in which Will Elder's children dreamed of

lifetime subscriptions to E.C. Comics (and also of Marilyn Monroe) while Dad dozed off from his consumption of booze. Immediately upon publication, the attorney general of Massachusetts denounced the highly innocent piece as "pagan," and copies of the issue were banned with the same logic by which blue laws ended Red Sox games on Sundays, while strip shows were allowed to continue a few blocks away.

On April 21, 1954, Senator Kefauver opened his hearings with none other than William M. Gaines as his chief (hostile) witness. The hearings were even held in New York's Foley Square, site of the 1949 "trial" of American Communists. Gaines, shunning the advice of his legal aides and the strategy of his contemporaries (the Hollywood blacklist victims, who stood on their First Amendment rights and refused to testify), decided to squarely confront the issues at hand. Gaines naïvely thought logic could win the day and decided against the good advice of the American Civil Liberties Union to await the judgment of a higher court.

In his testimony, Gaines regarded Wertham as not only wrong about the charge that reading comics led to juvenile delinquency, but that he was profoundly ignorant of the real content of comics, especially the content of E.C. Comics. Against Wertham's specific complaints that E.C. comics promoted racial prejudice, Gaines indignantly responded that "we have, I think, achieved some degree of success in combating anti-Semitism [and] anti-Negro feeling." Accused of promoting sadism, Gaines answered more weakly that E.C. stories were never directive: Fantasy was fantasy. He insisted, "My only limits are bounds of good taste, what I consider good taste."

After the hearings, E.C.'s comics came back in droves to their distributor, Leader News, the bundles unopened. Retailers and distributors had been successfully intimidated. Gaines would say if they printed 600,000 of a comic, they needed a "sell through" of 60 percent or more just to remain profitable. Significant slippage meant death.

Gaines held a press conference in September 1954, announcing that E.C. would drop all horror and crime comics. "We are striving to put out comics which will offend no one—which will, without losing entertainment value, be known as a clean, clean line."

E.C.'s "New Directions" included the action-oriented *Impact, Valor,* and *Aces High,* the tabloidish *Extra!,* the soapy *Confessions Illustrated,* the medical *MD,* the downright cerebral *Psychoanalysis,* and despite Gaines's avowal to drop horror, *Adult Tales of Terror Illustrated.*

But the efforts at an E.C. revival were unsuccessful: According to Gaines's own account, every one of the new titles lost money because many comics wholesalers and retailers wouldn't handle them. The fallout from the congressional hearing and bad press had caused a severe backlash. E.C.'s already weak distributor, Leader News, went bankrupt, stiffing Gaines. One hundred thousand dollars in debt to the printer, Gaines now faced a dead end. After a spectacular run, unprecedented in so many ways, E.C. was finished, and closing down seemed the only option. Gaines, in despair, talked about investing his remaining personal capital in a camera store.

With the rest of E.C.'s line in utter collapse and the company about to go under, dragging the reformatted *MAD* with it, Harvey Kurtzman confronted Gaines, emotionally telling him that throwing in the towel completely would "be a pity, because *MAD* had a tremendous future." Gaines did believe in the magazine's prospects, and he was tempted to roll his dice on the one ray of hope. But his resources were virtually depleted, and he only owned half the business. His mother, Jessie, "controlled the purse strings."

Harvey later described how Bill asked him "to come uptown and give this pep talk to his mother so that she would lend him the necessary money to go on." Kurtzman's enthusiasm and the magazine's track record persuaded Jessie Gaines. With a fresh infusion of one hundred thousand dollars of his family's money, Gaines paid off his printer debt, canceled the rest of E.C.'s line, and sacked several employees, including Al Feldstein. Gaines then signed a new distribution deal with the powerful American News Company, which was eager to have the fast-rising *MAD* Magazine.

Kurtzman had persevered and saved E.C. But could he save himself?

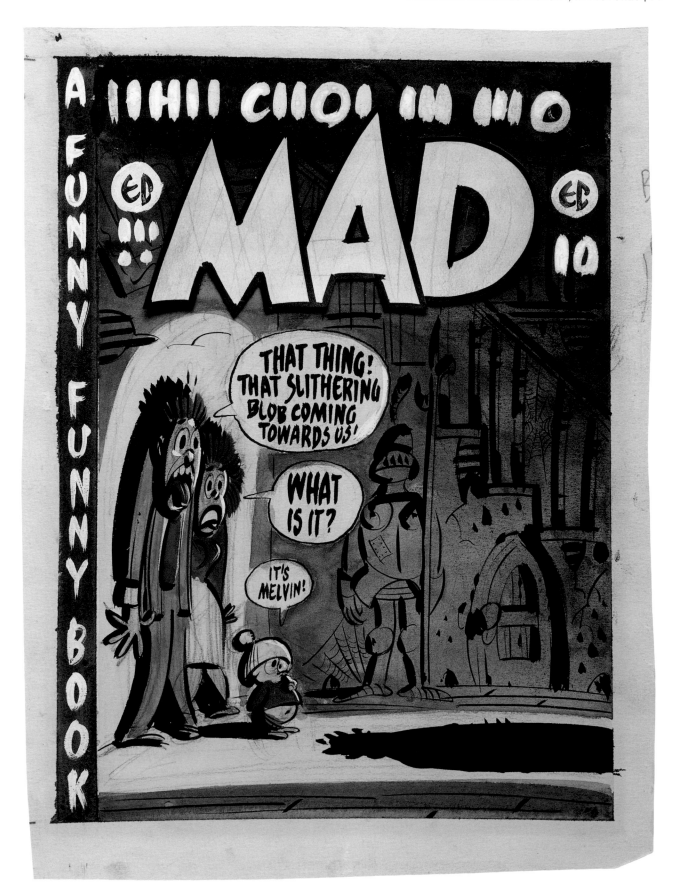

MAD no. 1 cover concept art | 1952 | Harvey Kurtzman exhausted himself assembling *Two-Fisted Tales* and *Frontline Combat* for E.C. He did extensive research, wrote most of the stories, laid them out in two stages, illustrated many of them himself, and drew most of the covers, all while doing other freelance work. Since publisher Bill Gaines paid on a piecework basis, Kurtzman was making considerably less money than Gaines's other editor Al Feldstein, whose stories required little or no research. In an effort to retain his sanity and a bank balance, Kurtzman convinced Gaines that he should create a humor title. The result was *MAD*, a series that had a profound impact on the culture.

Kurtzman's *MAD*

The contribution of Harvey Kurtzman to E.C. Comics earns him a considerable niche in American pop culture history. But his creation and the spectacular rise of *MAD* place him in a very different category, one that overshadows everything else in his life. It happened in a whirl—it would last only three years—and he walked away from the entity that could have provided the security (and even wealth) that he sought. Harvey was compelled to ponder the decisions he made during this fateful period for the rest of his life, and not only because they were a favorite subject of those who interviewed him.

His 1989 session with a representative of the Columbia University Oral History project was, if by no means comprehensive, important in symbolic terms. The Columbia archives, flagship of an oral history movement both nationally and internationally, staged the interviewing of Manhattan mayors, actors, labor leaders, and others prominent in politics and arts. Kurtzman, then in his mid-sixties, was badly weakened by illness but in good humor and entirely cogent. How, the interviewer asked, did he come to work his magic with *MAD*?

I'm a fairly rare combination of writing and drawing talent. . . . I always wrote and drew. This gave me an advantage . . . because I could always understand the visual and the verbal simultaneously. The talent was sometimes a curse because I always knew what I wanted, and the cartoonists who worked with me very often wouldn't know what I wanted, so I gave them a very hard time. And that's why I was demanding. I had it in my head, and I could visualize it to a point that I could put it on paper.

Will Elder was the one collaborator Kurtzman discussed at length in this interview, the one artist stuck most firmly to his memory, and the one who had most effectively, as well as most enduringly, embroidered in his art what Kurtzman had in mind for him to draw. In this interview, as well as others in his later life, Kurtzman wanted to remember the happy times with *MAD* and to cease talking about the fracture that exiled him from his vehicle to fame and elusive fortune. He had been asked about the controversies too often, and he no longer felt the need to go into the details.

For these reasons as well as his general nature, this interview wasn't a sorrowful conversation, and Kurtzman's laughter is noted throughout. A major source of ironic comment was another famous and later creation of his, "Little Annie Fanny." She was much on his mind, perhaps a symptom of an implied contrast between the underground comix artists who so admired Kurtzman and Hugh Hefner, his primary employer

from 1962 to 1988. Into his last days only a few years later, Kurtzman remained thoughtful about his own historical role in comics, always confident about his contributions.

THE IMPETUS BEHIND *MAD*'S CREATION

In *From Aargh! to Zap! Harvey Kurtzman's Visual History of the Comics* (which he co-wrote in 1991 with Michael Barrier), Kurtzman explained that *MAD* had been created "out of desperation" because the research of his E.C. war comics left him exhausted, without enough compensation given his page rate. Kurtzman's long hours were immaterial to Gaines, who paid by the finished work. On issues of *Frontline Combat* or *Two-Fisted Tales* Kurtzman typically received between $445 and $638 (pre-tax dollars) for his combined writing, editing, layouts, artwork, and color guides. Each issue represented, more or less, a month's income.

Al Feldstein's methods, by contrast, involved neither extensive research nor multiple stages of layouts. Feldstein was making a lot more money because, working more efficiently, he pumped out far more titles and more material. The contrast stung Kurtzman, mainly from a sense of competition but also because he worked more painstakingly, with the effects more clearly apparent. The Kurtzmans had moved to a big house in the

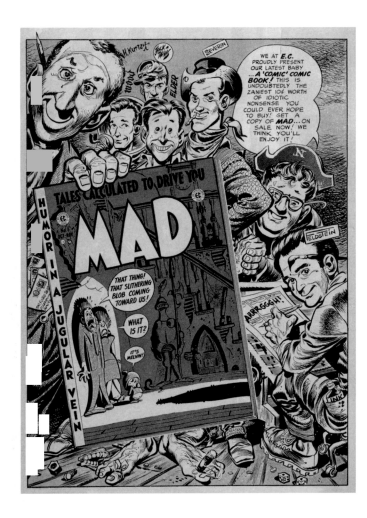

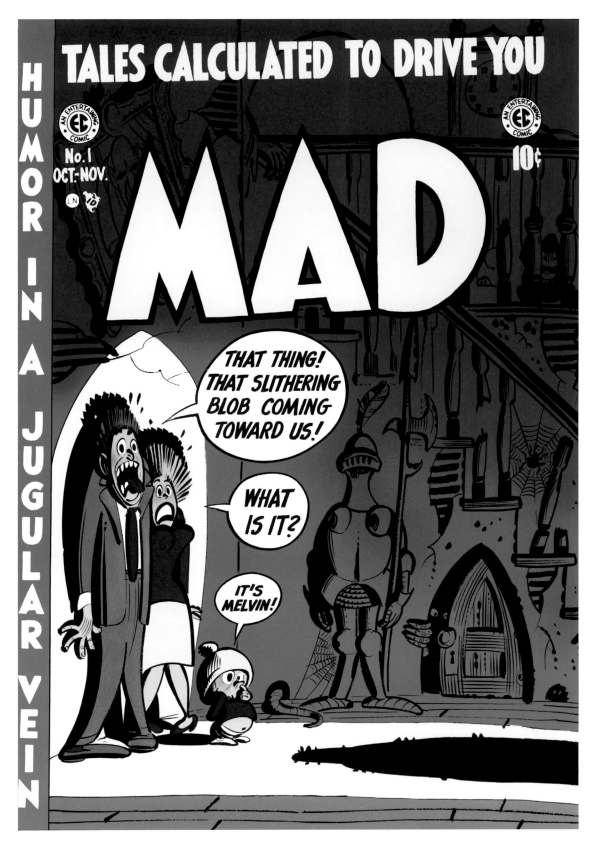

Above | MAD ad | 1952 | The primary MADmen mug in this promotional ad, which ran in various E.C. publications throughout the latter half of 1952. From left: Harvey Kurtzman, Wally Wood, Jack Davis, Will Elder, John Severin, Bill Gaines, and Al Feldstein, as caricatured by Davis. Feldstein, a cornerstone at E.C., was not part of the original MAD team, though he took over the magazine after issue no. 28 in 1956.

Right | MAD no. 1 | October–November 1952 | MAD was not an immediate success, but this cover (itself ironically parodied many times) set the tone for the peculiar Kurtzman brand of humor that would soon develop, including the use of generically funny names or sounds like "Melvin." The satire is directed at what Kurtzman liked least about E.C. Comics: its horror line. He soon tackled specific aspects of popular culture, most famously other comic strips. Next to "What—Me Worry?," the "Humor in a Jugular Vein" reading line is arguably the most identifiable MAD phrase.

suburbs and had a hefty mortgage. His family was growing (a second child, Peter, was born in 1954), and he needed more money. A humor title like *MAD*, it was reasoned, would be easier and make better, more practical use of Kurtzman's time.

Kurtzman often cited another key source of inspiration for *MAD*: the college humor magazines of his day. These zines had been around since the 1920s, some even earlier, and they embraced talented young artists and writers from Rube Goldberg to Max Shulman, who were on their way to lucrative and prestigious careers. But the years after World War II and into the 1950s might easily be described as a golden age of campus satire publications. GIs returning to an increasingly sterile and repressive culture cut loose with lampoons on the literary canons exalted by their professors, from the poetry of T. S. Eliot to the prose of William Faulkner, but especially the expressive, "tough" writing of Ernest Hemingway.

Like the writers and editors in these magazines, the artists also took personal risks. They had seen so much worse in the "Good War" or in Korea, lived through so much official military-based hypocrisy, that the prospect of suspension or even expulsion from school did not seem to intimidate them. They were existential—a popular word of the day—and not a little fascinated by Beat Generation writers. As Kurtzman put it, those college magazines had "completely irreverent sledgehammer humor" that the mainstream lacked—an "outrageous" approach—and "I wanted to be outrageous, too."

For Kurtzman, these publications took chances, even if they were regarded by contemporary pundits as mere cultural chaff. Kurtzman reminisced, as he often did, on the theme of satirical jabs through small truths:

> The style I developed for *MAD* over the next
> few years, in response to what I found in those

college magazines, was necessarily thoughtful under the rowdy surface. Satire and parody work best when what you're talking about is accurately targeted; or to put it another way, satire and parody work only when you reveal a fundamental flaw or untruth in our subject. Just as there was a treatment of reality in the war books, there was a treatment of reality running through *MAD*; the satirist/parodist tries not just to entertain his audience but to remind it of what the real world is like.

MADMEN

For the first twenty-three issues of the comic book *MAD*, Harvey Kurtzman wrote every word from front to back, and laid out every cover (drawing half of them himself), and each story and filler that appeared in between.

There was no doubt to readers that *MAD* was unique from the first page of its first issue, published in August 1952 (cover dated October–November). There was a savagery in its takedown of horror, science fiction, and westerns. Kurtzman worked out his own formula for creativity, so that his pencil-planning, layers of sketching on tracing paper, dialogue, and word balloons (lettered and inserted by Ben Oda) would be followed with almost religious loyalty by Will Elder, Jack Davis, and Wally Wood. They "always got the point" of what he wanted to say, and their work "would carry me forward," Kurtzman recalled, to the next task or vision.

These three, as well as John Severin and a handful of others who illustrated less, each provided a unique contribution. The capacity of Wally Wood to capture the essence of the target was unexcelled. Machinery, anatomy, and landscapes were captured with a precision that was (and remains) astounding. Jack Davis was a master of the more physical, cartoony strips. But it was

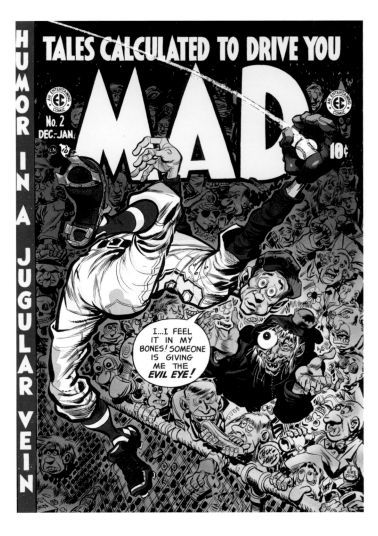

MAD no. 2 | **December 1952–January 1953** | The cover, like no. 1, in accordance with usual comic practice (soon abandoned by *MAD*), hinted at the lead story. The "evil eye" witch was only a little different from standard E.C. Comics witches, but the images of the baseball fans, certainly as weird and almost more frightening, had the *MAD* touch. Jack Davis illustrated from Kurtzman's layout.

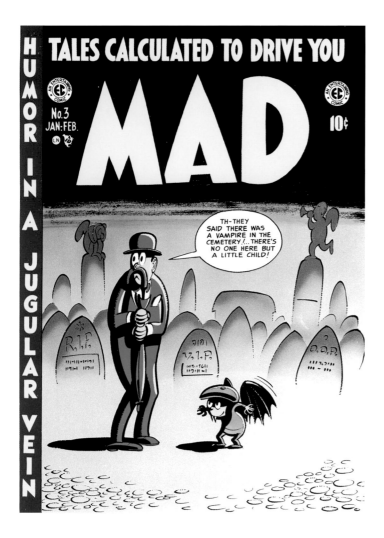

Will Elder who would become recognized as the key innovator, alongside Kurtzman, of the *MAD* archetype. Elder did not simply embellish the stories (though he did a great deal of that), rather he shifted the narrative ahead subtly, through dozens of little details, including funny signs and commentary, adding to the text and creating a subtext. Kurtzman told a Columbia interviewer that Elder "set the standard of so many details per square inch [*laughter*], per square millimeter. He was just overflowing with ideas, and that was a very useful talent."

It would have been difficult to predict the trajectory of *MAD* from its opening issues, which were predominantly satires of E.C.'s own genres. But Kurtzman later noted that in the second issue of *MAD* (December 1952–January 1953) something else happened, without much planning, in a Tarzan satire entitled "Melvin!" (an all-time favorite name within *MAD*).

Severin was not particularly the best choice of artist for the story, Kurtzman later observed, and in some ways the story didn't work narratively, making for little more than a running series of gags about Tarzan and Jane, Tarzan and African natives, or Tarzan and his beloved animals. The adopted "Boy," his shrunken head on a big body, became the climactic last-panel joke. Still, the logic of the strip, Kurtzman's semi-conscious intention of satirizing not just a popular cultural icon but the whole idea of the great white man in the African jungle, carried a larger idea forward. Even those stories in the first *MAD* issues that had notable targets, like the rough-tough cowboy, had not been aimed with any particular precision. The idea so far had been simply to make jokes. With "Melvin!," Kurtzman sharpened his aim to story specifics, thereby heightening his intensity almost unimaginably.

The definitive proof came in issue no. 3 (February–March 1953) with "Dragged Net!" and "Lone Stranger!" *Dragnet*, creatively con-trolled by television impresario Jack Webb, was the dominant law-and-order narrative of the 1950s. No criminal was ever wrongly convicted here, nor did Sgt. Friday ever use excessive force. *Dragnet*'s sponsor was a cigarette maker, and Friday was rarely seen without a smoke. With poetic logic, "Dragged Net!," drawn by Elder, began its introduction, "The story youw are about to hear is false! Only the names haven't been changed so as not to protect the writer of this story! And when John Law gets a load of this comic book, you can bet many a comic book worker will be running from the Dragged Net!"

In a later and much-improved version in *MAD* no. 11 (May 1954), the famous musical background "dom-de-dom-dom" incited delightful shtick from Elder, who filled each panel with all manner of bizarre characters playing instruments, tyrannizing Friday and his right-hand man through the same musical strophe. It was punctuated brilliantly with a heavyset middle-aged Jewish woman intermittently shouting, "VIL-LEE!" and with added gags about stakeouts, chain smoking, ridiculously brilliant crime-solving deductions by Sgt. Friday, and a last panel where the mother catches up to little "Villie Elder!" playing "Bep Bep Bep Bep!" on his kazoo. Kurtzman and Elder were well on their way to great things.

The Lone Ranger (based on the character created by a sympathetic and self-trained scholar of Indian life, Fran Striker), starring Clayton Moore and Indian rights supporter Jay Silverheels, presented itself very differently from *Dragnet* to generations of comic book readers, radio listeners, and television watchers. Yet it offered clichés just as absurd: the Ranger's moral integrity, his unbelievable shooting skill, his ability to maintain anonymity with a small conspicuous mask, and the famous climax of each episode, riding away into the distance on his horse, Silver.

MAD no. 3 | February–March 1953 (although the cover says "Jan.–Feb.") | Kurtzman's exceptionally spare drawing unites the Sherlock Holmes aura of mystery, fog, and danger with vampires (the issue included "V-Vampires!") and graveyard gags. The "V.I.P." and "O.O.P." tombstones typify the background gags or "eye pops" that Kurtzman (and Will Elder in particular) inserted into *MAD* stories.

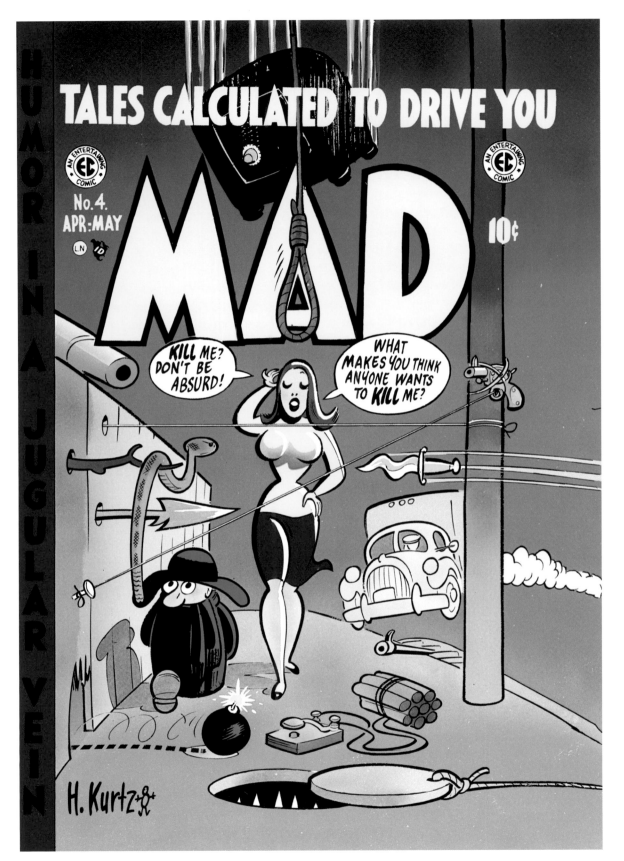

Above | "Little Orphan Melvin!" vellum fragment | 1953 |
A small number of Harvey Kurtzman's large vellum overlays
survive for his war stories (sample pages for "Lost Battalion!"
can be seen in Chapter 2). However, no pages whatsoever
are known to survive for any of his *MAD* stories. The only
exception is this fragment, from "Little Orphan Melvin!"
(*MAD* no. 9, February–March 1954). Found in Wally Wood's
estate, it is the last *MAD* link to the integral middle stage of
Kurtzman's story creation technique.

MAD no. 4 | April–May 1953 | This is the first *MAD* cover Kurtzman signed, using his distinctive H. Kurtz–plus–stickman symbol, an
evident sign of self-confidence in what had by now become a successful publication. The little guy on the cover is Lamont Cranston,
aka the Shadow, walking with girlfriend Margo Lane, satirized memorably in this issue by Kurtzman and Elder.

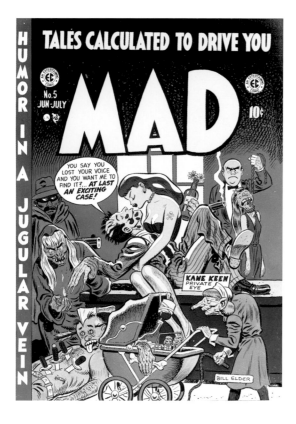 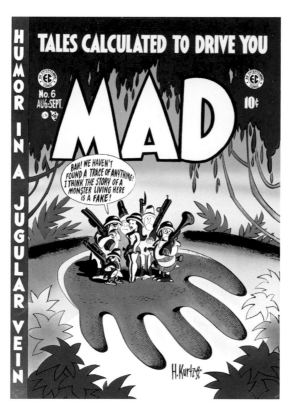 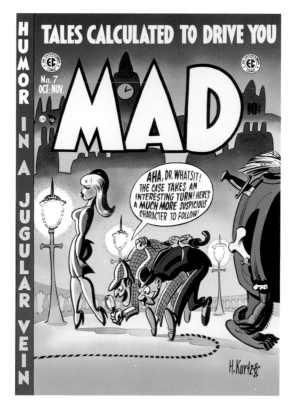

Literary comedian and television celebrity Roger Price, writing the introduction ("A Vital Message") to the *MAD Reader* paperback in 1954, hailed the "tiny but hyperactive brain of Harvey Kurtzman," a "moralist [who] smiles rarely and with great effort." Price pronounced *MAD* the "first successful humor magazine to be started in this country since the *New Yorker*." The path had been clearly laid out, and *MAD* could only get madder.

From the standpoint of Wally Wood himself, issue no. 4 (April–May 1953) and "Superduperman!" in particular, may have been the telling breakthrough, a direct comment on the lawsuit that DC Comics had launched against a rival publisher, Fawcett Comics. Captain Marvel, published by Fawcett, was one of the most popular super-hero characters, bearing a superficial resemblance to Superman. Captain Marvel and *Whiz Comics* constituted a modest improvement on the Superman original because of its humor, including its villains and the silliness of Billy Batson's "SHAZAM!" mantra. In "Superduperman!" Captain Marbles is

just as invincible as Superman, but crooked, and overcome only when he slugs himself in the head. Meanwhile, Lois Pain, the untouchable beauty (predictably a sexpot) of the Daily Dirt office, still thinks Clark Bent is a creep. Not even superpowers will get any part of him invited under her extremely tight skirt.

DC bested Fawcett Comics in the courts. Captain Marvel had an untimely end, and the corporate types at DC were not one bit amused by the appearance of "Superduperman!" Gaines promised not to repeat such tricks—at least not with DC. Then *MAD* went ahead and did it anyway, with "Bat Boy and Rubin!" (*MAD* no. 8). At the time, Batman was under attack from author/psychiatrist Dr. Fredric Wertham for suggesting (at least in his fervid brain) a homosexual relationship between the super hero crimefighter and his sidekick, Robin the Boy Wonder. Kurtzman cleverly added this disclaimer on the opening page: "Notice! This story is a LAMPOON! If you want to spend your dime on cheap, rotten lampoons like this instead of the ever-lovin' genuine real thing . . . Go right

ahead, boy!" With several other reminders and an in-joke about being sued for using Superman's characteristic phrases, perhaps DC execs were too embarrassed to make a federal case of it.

Much of Wally Wood's best work in *MAD* was devoted to parodies of comics considered canonical among comics artists, writers, and editors: *Blackhawk,* originated by Will Eisner before being carried on by successors; *Terry and the Pirates,* the Milton Caniff classic; *Smilin' Jack* by Zack Mosely; *Little Orphan Annie* by Harold Gray; *Prince Valiant* by Hal Foster; and Alex Raymond's *Flash Gordon.* (Kurtzman's satire on the latter was one of an insider. To make ends meet in 1952, he moonlighted by writing scripts and doing layouts for the *Flash Gordon* daily strip penciled by Frank Frazetta and inked by Dan Barry.)

Kurtzman, notorious for his hostility toward comic strip and comic book violence, used each of these stories to bare the clichés and falsehoods of derring-do adventure. "Little Orphan Melvin!," "Flesh Garden!," "Smilin' Melvin!," and "Prince Violent!," were relatively mild in this respect,

Above left | *MAD* no. 5 | June–July 1953 | Will Elder final art from a Kurtzman layout. Above center | *MAD* no. 6 | August–September 1953 | Harvey Kurtzman art. Above right | *MAD* no. 7 | October–November 1953 | Harvey Kurtzman art. Opposite left | *MAD* no. 8 | December 1953–January 1954 | Harvey Kurtzman art. Opposite center | *MAD* no. 9 | February–March 1954 | Perhaps a simple joke about fear inspired by the popular 1952 Gary Cooper film *High Noon*, the cover also hints at the explosive theme of interracial romance. Written by blacklist victim Carl Foreman, the movie featured Cooper as a courageous sheriff and Katy Jurado as his Chicana former lover who is definitely not leaving town when the bad guys arrive.

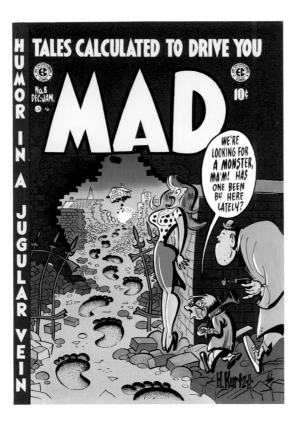

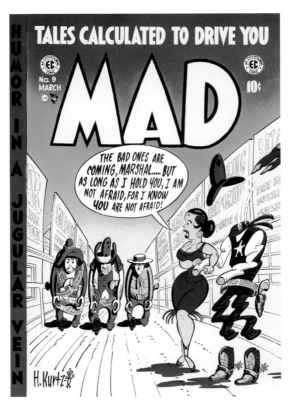

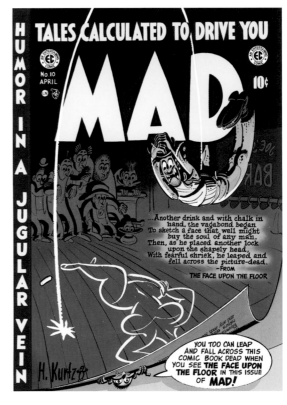

because the humor was obvious and almost benign. *MAD* exposed the set-ups of the original and the certainty of every plot outcome as being downright silly. The O. Henry surprise ending of E.C.'s comics found Valiant, for instance, shorn of his famous head of hair by the maid that he pursued; Flesh Gordon and Doctor Zark stayed on Ming rather than coming to Earth, thus enjoying the high life of beautiful dames and royal treatment. And Smilin' Melvin revealed the secret of his winning smile (a hundred dollar bill).

"Black and Blue Hawks!" and "Teddy and the Pirates!" had an especially acidic quality because the originals so exemplified the "Great Game" (the creation and sustaining of an American Empire in the model of the collapsing British empire). For many in Kurtzman's generation, the burden of empire was unsustainable for American democracy. Vietnam was, for a generation to come, to become proof positive of this folly, and more recently Iraq has become yet one more painful reminder. Kurtzman and Wood had seen this trend and shown it perfectly decades earlier: The Revolution that had

to be thwarted by those Black and Blue Hawks was, as it turned out, right on their own island.

Of course, the true genius of the Wood-Kurtzman team was embedded in the form itself. Wood was not only a political dissident at heart, but he manifested a distinct Brechtian quality in his art, as one devotee observed, with the artist as a self-conscious participant in mass culture. The artist's capacity to aid the audience in distancing itself from familiar and clichéd formats was a giant step forward, although a step notoriously difficult to transfer from the confines of the avant-garde theater to the popular mass filmgoer, or the reader. That reader—astounding in an art form ostensibly aimed at children and juveniles—was invited by *MAD* to enter into the total experience of the comic construction, while keeping a contemplative eye outside. Wood had already succeeded at this effort in his work that appeared in the E.C. titles, especially in his science fiction stories. *MAD* comics was a bridge further into what can only be described as a narrative unknown: fully realized comics art that was also about the nature of com-

ics art. It was pure genius, even if the recognition of this particular genius would be overwhelmingly lost on those who could not yet cast votes or buy an alcoholic drink.

Will Elder, however, remained the ultimate *MAD* comics artist. His later absence would mark the visual change in *MAD* Magazine as much as Kurtzman's departure.

Gaines, when asked where the peculiar *MAD* sense of humor had come from, reportedly answered "Bill Elder," without missing a beat. Elder said in later life, "*MAD* was me"—not just the Elder artist of the early 1950s but the boy and teenager, prankster and jokester. He and Kurtzman also added a peculiar Jewish New York dialect, from "Mrs. Gowanus" (a reference to the Gowanus Canal in Brooklyn) to "Potrzebie" (a real Polish word) and "fershlugginer" (an imaginary Yiddish word). They had their own satirical self-referencing system, something that no other satire magazine had or would choose to have. It was the Bronx counterpart to the sophistication of the *New Yorker* magazine.

Above right | *MAD* no. 10 | April 1954 | With this issue the increasingly popular *MAD* became a monthly. The cover—quite racy for its time—features a naked woman whose face is obscured. It references the H. Antoine D'Arcy poem adapted *MAD*-style inside, with inks by Jack Davis. Kurtzman originally wanted "The Face upon the Floor!" in the final panel (the image that struck the artist dead) to be Basil Wolverton's hideous Lena the Hyena (a version of which appears on the cover of *MAD* no. 11). Lena was the winning entry in Al Capp's famous 1946 "Li'l Abner" contest to depict the world's ugliest woman. For reasons unknown, Capp declined permission so Kurtzman went with an unknown, but still hideous, Wolverton face.

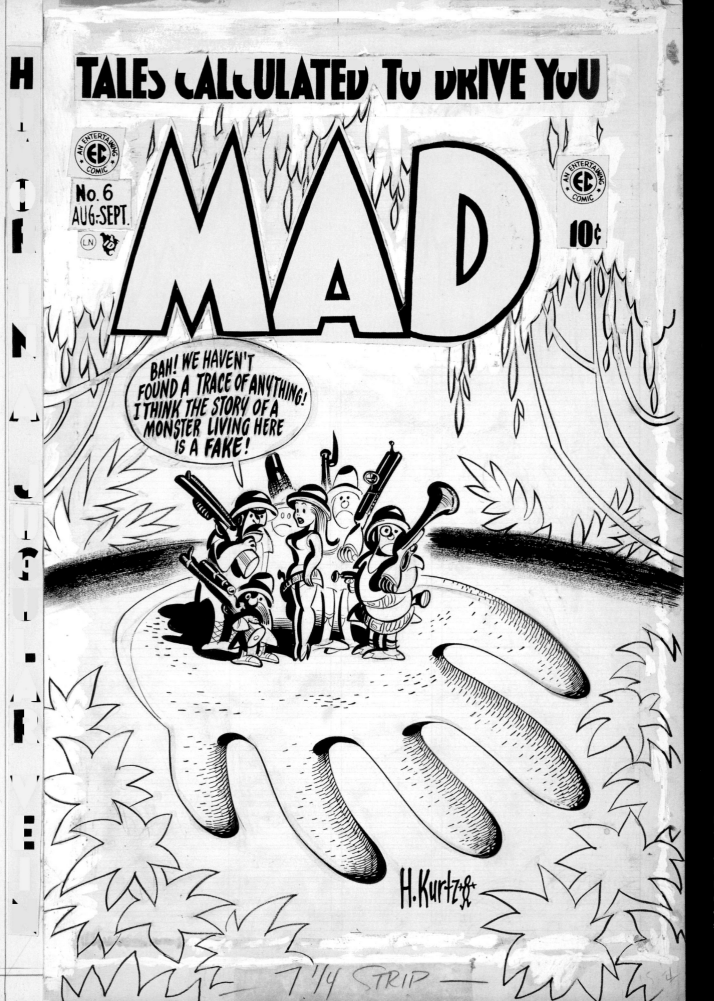

MAD no. 6 original cover art | 1953 | Typical of print production of the day, the recurring typographic elements are photostatic "paste-ups" on the illustration board. Kurtzman applied his image with pen, brush, and India ink over his pencil roughs. Afterward he applied opaque white ink over border lines and any other detail, such as tree leaves, that he chose not to be part of his final design. Any remaining flaws, visible on this original, would have been caught and corrected by Kurtzman at the printer's proof stage (see the Diamond & Gold Rings ad in Chapter 2).

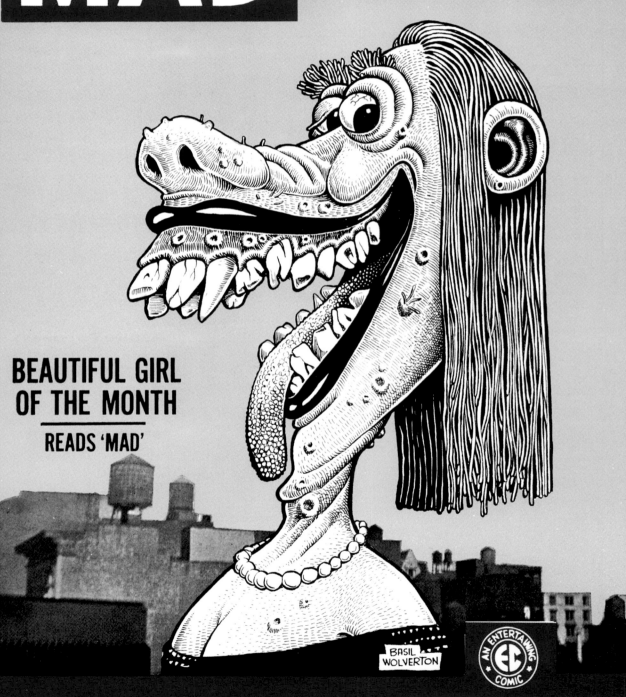

MAD no. 11 | May 1954 | The parody of a *Life* magazine cover (including its then distinctive two-color format) features another grotesque Lena the Hyena look-alike by Basil Wolverton from a Kurtzman layout. The photograph in the background was shot by Kurtzman from *MAD*'s bathroom window on Lafayette Street. Like many of Harvey's targets, *Life* magazine took offense at the unflattering parody.

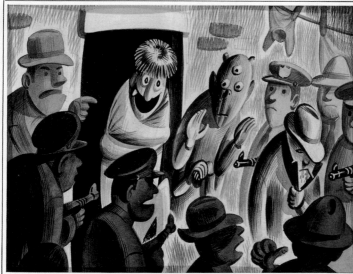

MAD no. 16 original cover art | 1954 | Harvey Kurtzman didn't draw this cover in his typical "line art" cartoon style. To simulate black-and-white photos on a tabloid newspaper of the period, he painted the illustrations in gray tones using tempera. One of the most famous of all *MAD* comic book covers, it is said to predict the rise of "underground comix" in the late 1960s, an especially alluring sign of clairvoyance since Kurtzman was himself a primary inspiration for most underground cartoonists. The cover was in fact a barely disguised attack upon the efforts of pressure groups and Congress to ban comic books in the 1950s.

Above | *MAD* no. 16 | October 1954

Right | *MAD* no. 15 | **September 1954** | Harvey Kurtzman design featuring retouched Sir John Tenniel *Alice in Wonderland* art.

Kurtzman's take on television's *Howdy Doody,* with Elder's extrapolations, was like his take on comic strips ("Gasoline Alley," "Katzenjammer Kids," and "Mandrake the Magician"), on comic books (*Wonder Woman* and *Archie*), on radio (*Inner Sanctum* and *The Shadow*), and on the movies (*King Kong* and *Frankenstein*). These takeoffs were far more than inspired nonsense. Each one offered up a dissection of form as well as content—none more so than when a story contained a social-political stinger.

Starchie was a teenager corrupted by a world of morally bankrupt high school officials and of generalized violence. "Mickey Rodent!" was as much a satire on noted strikebreaker (and red-baiter) Walt Disney as it was a commentary on the well-known characters Donald and Mickey, and it opened with rare satiric drama: comics characters being dragged off to some unknown gulag by studio stormtroopers for the crime of not wearing their mandatory white gloves.

Toward the end of the first year of publication, in *MAD* no. 5 (June–July 1953), an inside cover satire depicted Gaines ("alias Melvin") with a halo, the caption describing him as the "twisted publisher of the perverted E.C. line. . . . His father was an international Communist Banker . . . and his mother came from the Bronx," a boy who began a life in crime at a tender age, later selling cartoon books "(you know the kind!)" outside burlesque houses, preparing him for "the ultimate in depravity and debasement," that is, the comics industry. It revealed that E.C. actually stood for "Evil Comics." The "masochism, pyromania, snakes, fetishes, snakes, necrophilia, phallic symbols, snakes," and such was, of course, a reference to the national comics controversy already underway in the Senate at the time.

The November 1954 issue (no. 17) opened with a by now expectable takeoff on another old favorite, George McManus's "Bringing Up Father" ("Bringing Back Father!"), this time with the glamorous daughter at the center of the first panel reading the *Daily Worker* (with news of the Cincinnati Reds) as Jiggs is sneaking off from the dreaded Maggie. But the humorous look suddenly morphs into a stylistic dichotomy in which the Bernie Krigstein–drawn Jiggs disturbingly suffers repeated contusions from the cartoony Will Elder–drawn dishes being thrown at him.

The same issue moved on swiftly to its meatiest contents ever: a satire of the Joseph McCarthy Senate Subcommittee Hearings, rendered as the panel quiz show "What's My Shine!" (a reference to "What's My Line?"). Between commercials that reflected the real physician-looking MD—insisting that the witness "is in reality a REDSKIN!" Revealing the actual picture (implying the accused was an American Indian), the intended victim insists, "I am not and have never been a redskin!," to which McCarthy replies, "No need to raise your voice and get angry. I realize you're not REALLY a redskin but merely a dupe of the redskins!" Then the two begin wrestling, throwing the scene into total chaos that soon dissolves. At the time, no better satire of McCarthyism was being produced in an America too frightened to fight back or see any humor in its government or its politics.

Opposite left | *MAD* no. 12 | June 1954 | This daring all-typographic cover (a spoof on the *New England Journal of Medicine*) was a radical departure from any other comic book cover, and not the last such visual approach Kurtzman would take. As with issues 19 and 20, it looked superficially like something other than a comic book, and thus a publication a teenager could more easily smuggle into school or past parents who disapproved of depraved comic books.

Opposite center | *MAD* no. 13 | July 1954 | Commenting later on this "cover with the smallest title in the world," Kurtzman noted that he was "intrigued by the graphics of the thing, just doing a teeny-weeny thing with empty space, as opposed to the traditional comics that come at you again and again with everything big, big, big, big. . . . Plus the thinking that, 'Hey, if I do a tiny little drawing I can knock it out in a couple minutes as opposed to the two weeks I usually took to do everything.'"

Opposite right | *MAD* no. 14 | August 1954 | Harvey Kurtzman design.

Above | *MAD* no. 18 | December 1954 | Harvey Kurtzman art.

Left | *MAD* no. 17 | November 1954 | Behind this inventive cover, the contents were literally upside-down. The back cover opened to "Bringing Back Father" with a daughter reading the communist *Daily Worker*, and the infamous satire of the Army-McCarthy hearings

MAD Presents Another Entertaining as Well as Educational Cover Design. Humor in a Jugular Vein. Tales Calculated to Drive You . . .

Price, 10c ★ISSUE NUMBER 19

Monthly

ORIGINAL GENUINE

MAD

LN

Someday, January 1955 Price: 10c in U.S.A. **10c**
 foreigners pay more

JAMAICA RESULTS

SOMEDAY, JANUARY 1955
RAINING AND SLOPPY

FIRST—6 Furlongs. Time, 1:13⅗. Off. 1:16

Horse	Jockey	Straight	Place	Show
Man O' Peace	E Darkhairo	16.60	9.50	6.50
Sea Triscuit	T Atkindaughter		12.70	9.70
Alslab	Q Noodnik			8.50

Scr.—Recitation

SECOND—6 Furlongs. Time, 1:13⅗. Off. 1:16

Silver	L Ranger	16.60	9.50	6.50
Scout	T Tonto		12.70	9.70
Trigger	R Rogers			8.50

All ran.

POURING AND SLOPPY

THIRD—6 Furlongs. Time, 1:13⅗. Off. 1:16

Start Trotting	O Down	16.60	9.50	6.50
Now Canter	H Alt		12.70	9.70
Gallop Off	S Top			8.50

Scr.—Runaway

FOURTH—6 Furlongs. Time, 1:13⅗. Off. 1:16

Sway Back	A Reck	16.60	9.50	6.50
Dogfood	D Unfer		12.70	9.70
Glue	M Allshot			8.50

Scr.—Allran

DELUGE AND SLOPPY

FIFTH—6 Furlongs. Time, 1:13⅗. Off. 1:16

Furshlugginer	A Sturdley	16.60	9.50	6.50
Potzrebie	B Smurdley		12.70	9.70
Farshimmelt	C Smidley			8.50

Scr.—Zwolk

SIXTH—6 Furlongs. Time, 1:13⅗. Off. 1:16

Sturdley	C Farshimmelt	16.60	9.50	6.50
Smurdley	B Potzrebie		12.70	9.70
Smidley	A Furshlugginer			8.50

Scr.—Klowz

FLOOD HELP

SEVENTH—6 Furlongs. Time, 1:13⅗. Off. 1:16

On Your Mark	G Id	16.60	9.50	6.50
Get Set	D Ee		12.70	9.70
Go	Y App			8.50

Scr.—Whoa

EIGHTH—6 Furlongs. Time, 1:13⅗. Off. 1:16

Point of Order	J McCarthy	16.60	9.50	6.50
Improper Influence	R Cohn		12.70	9.70
Army Hostage	D Shine			8.50

All ran.

LAUREL RESULTS

SOMEDAY, JANUARY 1955
CLOUDY AND FAST

FIRST—6 Furlongs. Time, 1:13⅗. Off. 1:16

Horse	Jockey	Straight	Place	Show
Horsejockey	S Traight	16.60	9.50	6.50
Straightplace	P Lace		12.70	9.70
And Show	S How			8.50

Scr.—Ser

SECOND—6 Furlongs. Time, 1:13⅗. Off. 1:16

War Horse	B Oom	16.60	9.50	6.50
Spirit O' War	P Adabam		12.70	9.70
Charging War Cloud	B Adaboom			8.50

Scr.—Surrender

DAILY DOUBLE PAID $1,000,000.00

THIRD—6 Furlongs. Time, 1:13⅗. Off. 1:16

When	D Martin	16.60	9.50	6.50
The Moon	J Lewis		12.70	9.70
Hits Yor Eye	S Caeser			8.50

All ran.

FOURTH—6 Furlongs. Time, 1:13⅗. Off. 1:16

Like-a Big	I Coca	16.60	9.50	6.50
Pizzapie	J Burns		12.70	9.70
That's Amore	G Allen			8.50

All ran.

FIFTH—6 Furlongs. Time, 1:13⅗. Off. 1:16

Bet Your Life	G Marx	16.60	9.50	6.50
Father Knickerbocker	S Allen		12.70	9.70
Kapusta Kid	E Kovacs			8.50

Scr.—Henry Morgan

SIXTH—6 Furlongs. Time, 1:13⅗. Off. 1:16

Write for Work	B Elliot	16.60	9.50	6.50
Hang by Thumbs	R Goulding		12.70	9.70
Droodles	R Price			8.50

All ran.

SEVENTH—6 Furlongs. Time, 1:13⅗. Off. 1:16

†Sans Sanity	B Elder	16.60	9.50	6.50
†Girl Drawer	W Wood		12.70	9.70
†Old Beauregard	J Davis			8.50

†E.C. Entry

EIGHTH—6 Furlongs. Time, 1:13⅗. Off. 1:16

Caine Mutiny	H Wouk	16.60	9.50	6.50
Here to Eternity	J Jones		12.70	9.70
Naked Dead	N Mailer			8.50

All ran.

NINTH—6 Furlongs. Time, 1:13⅗. Off. 1:16

Strike it Rich	W Hull	16.60	9.50	6.50
Your Life	R Edwards		12.70	9.70
What's My Line	J Daly			8.50

Scr.—Red Buttons, Continental

GULFSTREAM PK. (FLA.)

29th Day—41-Day Meet. Daily Double—1st-2nd Races

FIELD HORSES GO AS ONE UNIT IN DAILY DOUBLE

GRADED SELECTIONS

Cloudy and Muddy

Official Jockeys and Post Positions

MAD SHEET FIRST EDITION

1ST—6 F. 4-year-olds up. Claiming. 1:15

1	Running Water	12	110	5-2	Drip. A
5	Galloping Dominoes	8	101	4-1	Snake. I
6	Fox Trot	11	113	2-1	Murray. A
7	Canter-bury	6	116	12-1	Bell. Z
8	Quick Henry	15	108	8-1	Flit. T
10	Quick Watson	9	110	10-1	Needle. A
12	Ach Du Lieber	14	113	8-1	Augustine. Z
14	Man of Distinction	16	113	30-1	Calvert. L
16	Hits the Spot	7	111	30-1	Pepsi. C
19	Does Everything	2	113	30-1	Duz. Z
2	Chicken	3	113		SCRATCHED
3	Wildcat	13	113		SCRATCHED
4	Rosebush	4	113		SCRATCHED
13°	Barbed Wire	1	103		SCRATCHED
15°	Mosquito	10	108		SCRATCHED
17	Poison Ivy	5	113		SCRATCHED

2ND—6 F. 4-year-olds up. Claiming. 2:15

2	Blue of Night	12	116	4-1	Crosby. B
3	Enchanted Evening	10	105	2-1	Pinza. E
6	My Pappa	16	113	4-1	Fischer. E

HUZZAH SUGGESTIONS

AT JAMAICA

1—LaVerne, Maxine, Patty
2—Vietnam, Laos, Cambodia
3—Charcoal, Sulphur, Saltpeter
4—Nitroglycerine, Pressure, Explosion
5—United Nations, Gromyko, Nyet
6—Seabeach, Sunshine, Burned
7—Pickles, Ice-Cream, Nauseous
8—Gin-Vermouth, Olive, Martini

YESTERDAY'S LATE SCRATCHES

Jamaica-Appetizer, 3rd; Mixed Salad, 5th; Ham-Hock, 7th; Strawberry Shortcake, 8th.

Laurel-Indulgence, 5th; Hangover, 6th.

Lincoln Downs-Baby, 1st; Stomach Cramps, 4th; Sleepless Night, 5th.

Gulfstream Park—Sweepstake Ticket, 7th; Lady Luck, 8th; Plenty Money, Income Tax, Nothing Left, 9th.

SEES WAR LOOMING

NEW YORK, N. Y.—It was noticed by an experienced observer here, that the firing on Fort Sumter will undoubtedly lead to Civil War.

TANFORAN (CALIF.)

24th Day—46-Day Meeting Daily Double—1st-2nd Races

GRADED SELECTIONS

(Scratches and Late Track Report Printed on Page 35.)

1ST—6 F. 4-year-olds up. Claiming. 4:30

1	*Seersucker	J Brooks	3	112	2-1
2	Gin and Tonic	X Schweppes	16	103	5-2
3	Ice-Cream	H Johnson	5	120	3-1
4	Thunderjet	M Republic	2	113	8-1
5	Electrolux	V Cleaner	6	113	5-1
6	Lucky Strike	L Myers	9	113	10-1
7	*Spearmint	P Wrigley	15	112	10-1
8	*Mona Lisa	L Davinci	1	108	12-1
9	Slide Rule	K Esser	1	115	10-1
10	Snapshot	E Kodak	8	117	15-1
11	Technicolor	N Kalmus	13	115	15-1
12	Animation	W Disney	4	108	20-1
13	Supermarket	A Pacific	7	113	20-1
14	*Cold Drink	C Cola	10	108	20-1
15	Petunia	W Burpee	7	113	20-1
16	*Peanuts	P Planters	10	108	20-1
17	Nostradamus	D Pearson	11	113	20-1
19	Malcontent	W Pegler	12	108	20-1

2ND—5 F. 2-year-olds. Mdns. Claiming. 5:10

1	Stitch in Time	S Nine	9	115	3-1
2	Haste	M Waste	8	115	4-1
3	Laugh's Last	L Best	6	115	4-1
4	Rolling Stone	N Moss	2	115	6-1
5	Penny Saved	P Earned	13	115	4-1
6	Bird in Hand	T Bush	4	108	20-1
7	Wages of Sin	I Death	11	115	12-1
8	Road to Hell	G Intentions	12	115	12-1
10	Early Bird	C Worm	1	115	10-1
12	Fool's Gold	S Parted	3	115	20-1
13	Green Grass	O Fence	1	112	20-1
14	Cleanliness	N Godliness	4	115	20-1
15	Empty Barrel	M Noise	7	115	20-1
16	Glass House	T Brick	10	112	20-1
17	Cloud	S Lining	15	113	20-1
19	Pot O'Gold	E Rainbow	16	112	20-1

4TH—1 1/16 M. 3-year-olds. Claiming. 6:15

1	Abomasum	N Zyelberkweit	8	111	3-1
2	Accipitral	F Zyller	8	111	3-1
3	*Acetabulum	A Zyman	6	111	4-1
4	Actinomycosis	C Zynger	1	104	4-1
5	Bicornuate	Zyniewski	3	115	6-1
6	Pectinate	D Zyontz	3	109	6-1
7	*Rhinencephalon	S Zysk	9	111	6-1
8	Scutellation	Al Zysman	2	103	20-1
10	Spoliation	S Zyttenfeld	1	106	20-1
12	Tenaculum	I Zywotow	7	106	20-1
13	*Ziggurat	J Zyzneski	10	109	20-1

9TH—6 F. 4-year-olds up. Clmg. Substitute

1	Hpled Elttil	G Nossilg	13	113	3-1
2	Anatnom Llib	O Retshew	1	120	4-1
3	Erif Thgilf	M Nosretep	2	120	4-1
4	*Droflas	A Arapop	15	113	4-1
5	Rab Swen	G Nossilg	6	108	6-1
6	Ryana	H Ssehttam	9	107	6-1
7	Ekaseman	F Ikeanjohc	16	107	6-1
8	Nonnac	A Yarg	10	117	8-1
10	*Imay Mik	C Ozzir	12	103	10-1
12	*Asobrag	R Kroy	3	115	10-1
13	Dlog Tirips	S Skoorb	3	112	10-1
14	*Yxof Ezdir	R Noskcaj	5	108	12-1
15	Raf-N-Ediw	M Siwel	11	115	15-1
16	Stratat Wob	F Tlefuz	1	113	20-1
17	Ytinerrep	H Onernom	7	108	20-1
19	Uol Kcihe	J Retrop	8	108	20-1

Above | *MAD no. 20* | **February 1955** | In the 1950s the most common school composition books looked exactly like this textured cover. "Designed to sneak into class," the premise was no doubt tested by thousands of young readers.

Right | *MAD no. 21* | **March 1955** | A parody of the ubiquitous and ultra-busy Johnson-Smith novelty ads, this black-and-white (except for the small *MAD* logo) unfocused hodge-podge defied every rule of cover design. But the ad embodied the elements of every red-blooded young boy's dreams: guns shooting live ammunition, daggers, air torpedoes, and live crocodiles! Not to mention comic emblems for creating knockoffs of E.C. Comics! Easy to miss in the rubber mask section is a tiny head between Joseph Stalin and Marilyn Monroe: Labeled "Idiot," it is the first appearance of Alfred E. Neuman on a cover of *MAD*.

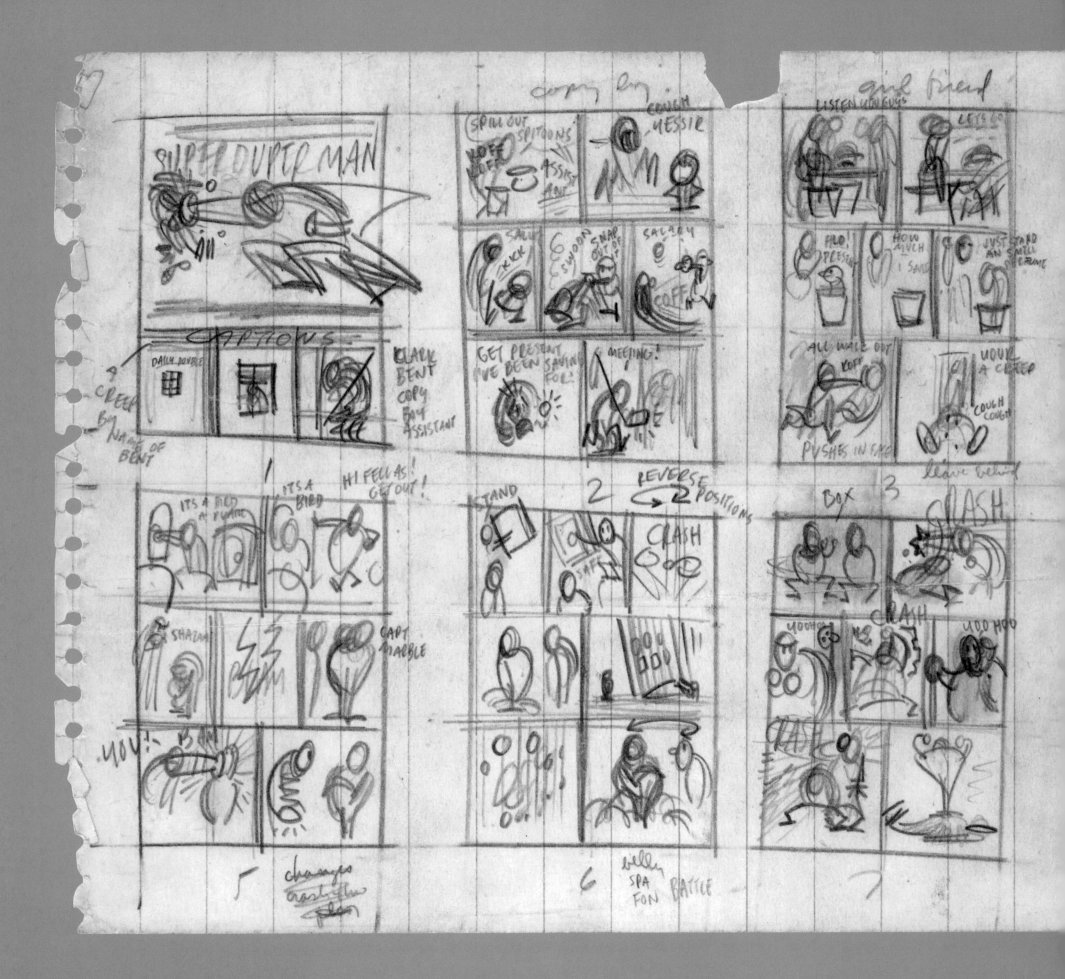

"**Superduperman**" **thumbnails** | **1952** | Not every artist in the E.C. stable enjoyed working under Kurtzman's austere command. Some resented the tissue overlays that imposed his compositions on assigned stories. Kurtzman described Wally Wood as an artist who would "suffer in silence. Wally was a time bomb; if he disagreed with something he'd just keep it bottled in." Kurtzman's large tissue overlays for *MAD* are long gone but most of Kurtzman's first-stage thumbnails survive. Like the "Black and Blue Hawks!" thumbnails shown on page 112, Wood's final inked pages are remarkably close to Kurtzman's small pencil compositions for "Superduperman!" The full story follows for convenient juxtaposition. Hoo-hah!

SUPERDUPERMAN!

"Superduperman" (*MAD* no. 4, April–May 1953), a frequent favorite of *MAD* and Kurtzman devotees, might have been a mere riff on the powers of the comic book hero in question (the *MAD*men did this hilariously, from Batman to Wonder Woman). Its secondary context, a satire on DC Comics for litigating Captain Marvel out of existence, would presumably have been enough of an added attraction. But Kurtzman and Wally Wood invented a gender narrative paralleling that of Lois Lane's ambivalent feelings toward Clark Kent and his alter ego. Weakling Clark is convinced that only a lack of muscle and charisma deprives him of the great romance (or, at least, hot sex). He's misread the female mind entirely.

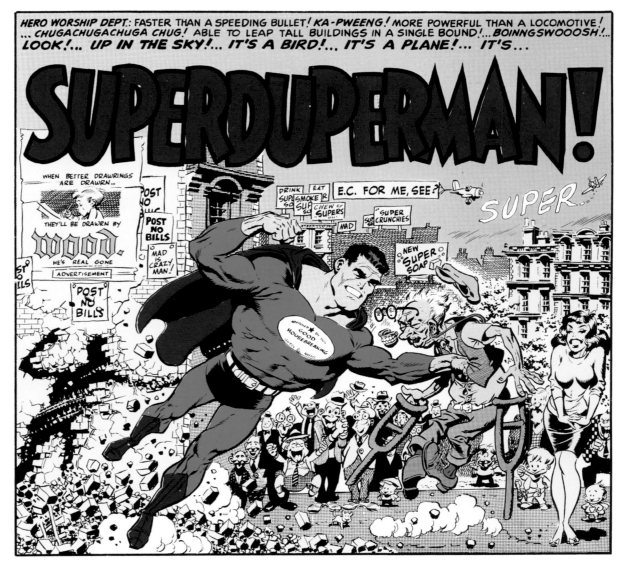

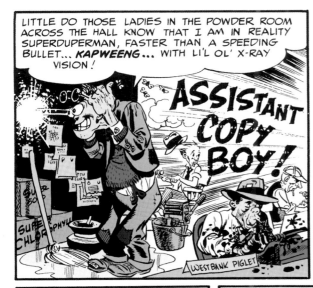

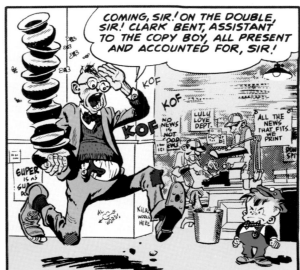

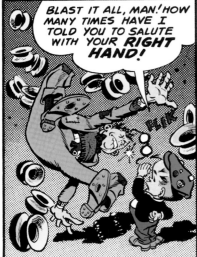

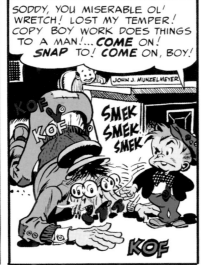

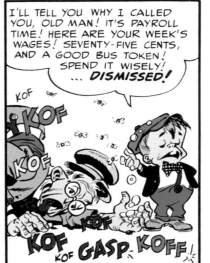

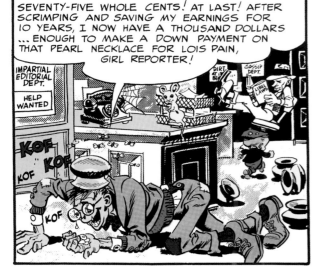

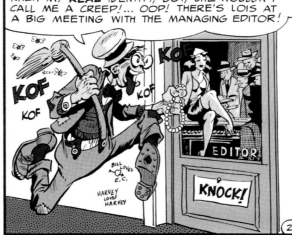

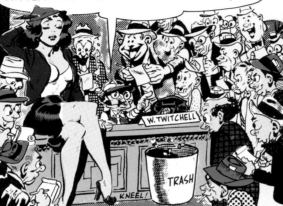

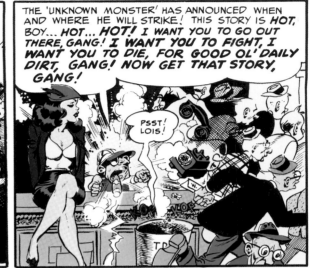

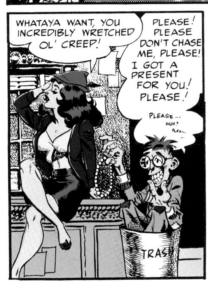

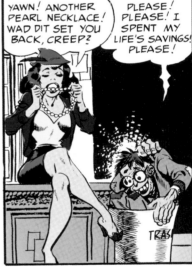

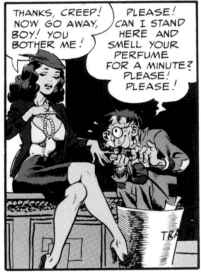

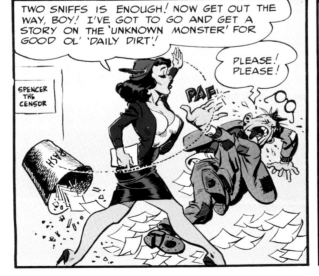

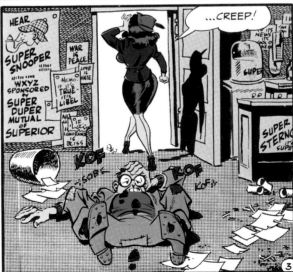

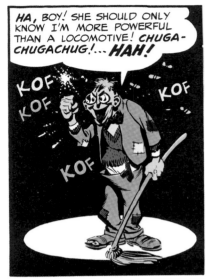

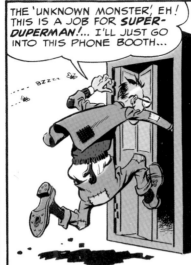

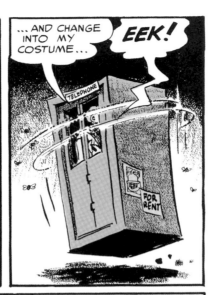

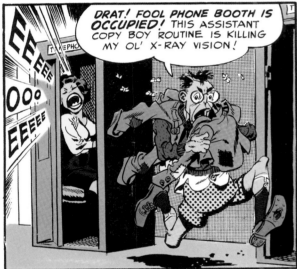

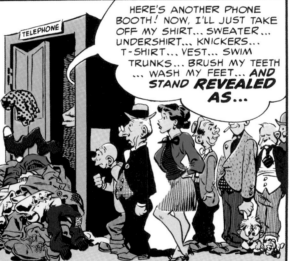

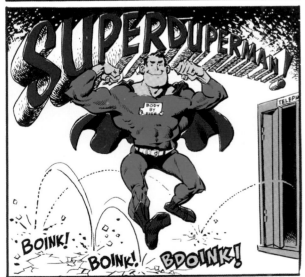

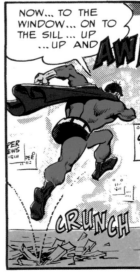

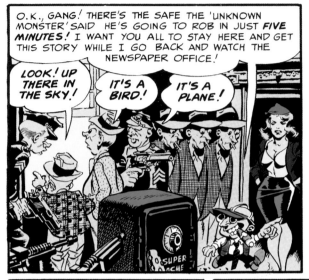

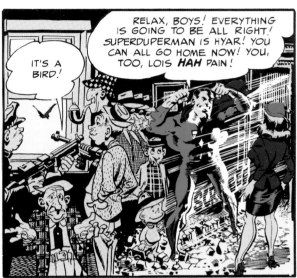

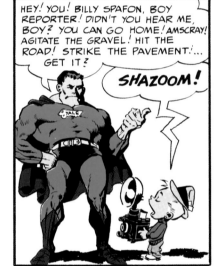

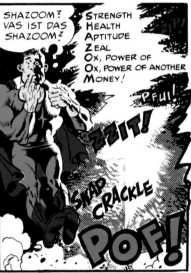

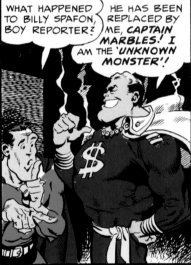

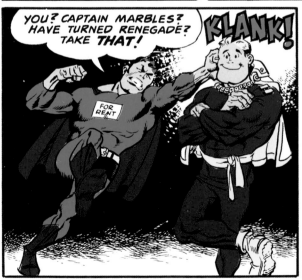

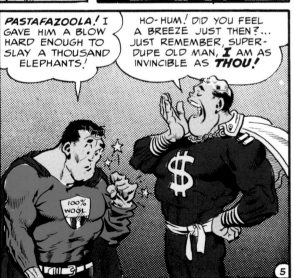

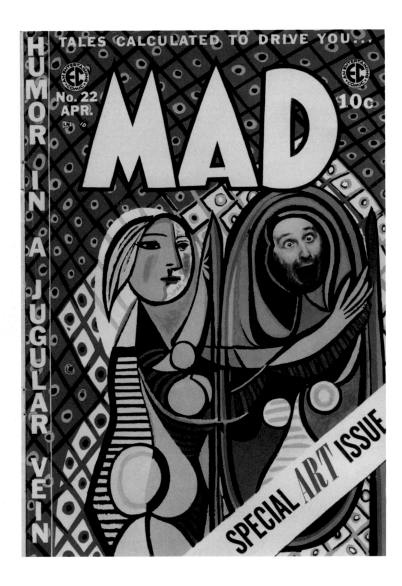

DECONSTRUCTION BEFORE IT HAD A NAME

The self-conscious playfulness with form, which became more and more intense toward the end of *MAD*'s comics run, was so sophisticated that it startles even today. A two-version story, "Murder the Husband!" and "Murder the Story!" in *MAD* no. 11 (May 1954), offers at first a typical E.C. horror plot: a paramour takes the husband of his lover on a two-man fishing trip in a boat, shoots him after a scuffle, but also shoots holes in the boat and ends up drowning—a poetic justice. Then, not changing the panels, only the script, the second version of the story is turned upside down Dada style. First, the word balloons go wild (including a Yiddish phrase, which translates as "the Danish king comes to wed in Copenhagen"), as the narrator's explanations turn to Hopalong Cassidy cap pistols and bubble gum cards.

As the intended murder victim sings one popular song favorite after another, the version entitled "Murder the Story!" not only foreshadows the deconstruction of the comics form in the artwork of the 1980s–90s, it also presents a deconstructive theory of popular art as complete as any pop art work would manage in the decades ahead (albeit sans the gallery setting that gave Andy Warhol's canvases their avant-garde flavor and collectors' prestige). One might further suggest that it achieves what Bertholt Brecht set out for cinematically in *Kuhle Wampe* (1932), shortly before Hitler ended such experimentation. But unlike Brecht's work, Kurtzman's was a success, and at the height of McCarthyism, a feat achieved by going far under the radar.

In *MAD* no. 17 (November 1954), a Kurtzman-Wood satire of movie clichés (against a background of Marlon Brando in the film *Julius Caesar*) similarly ends with a photographic Marilyn Monroe ripping off a cartoon mask and declaring, "I'm not really your *MAD* writer. In fact, this *MAD* comic book isn't really a *MAD* comic book," and then pulling up the page to reveal Disney characters. The whole issue, in fact, was printed upside down in relation to its covers.

The end of this experimentation, at once logical and glorious, was reached in April 1955. In *MAD* no. 22, the penultimate comic book, a "Special ART Issue" is devoted wholly to the story of artist "Bill (Chicken Fat) Elder" ("from the time he was a tiny, miserable two-bit hack infant to the present when he is now a big, miserable, two-bit hack grown-up"). Nothing more Jewish could be imagined than the infant "shmearing" chicken fat on towels, bald heads, visitors' dresses, and convenient walls—illustrated in color with thousands of blue and red lines. "Today those shmears . . . are hung in various museums and signed with Elder's various pen names such as 'Braque,' 'Matisse,' 'Picasso,' etc." In effect, Kurtzman had taken on the whole world of respectable art, carried it to the Abstract Expressionist extreme that was then in high fashion, and deconstructed it around his favorite artist's supposed life.

MAD BECOMES A MAGAZINE

After convincing a desperate Bill Gaines and his mother Jessie to roll the dice on *MAD* Magazine as the rest of the E.C. operation crumpled in 1955, Harvey Kurtzman realized a longtime dream to helm a slick newsstand magazine. The larger page size, the virtual doubling of the previous page count, and a divorce from the comic book format allowed new opportunities for satire, including text-heavy contributions, magazine ad parodies, and single-page shots.

The new size and better printing presses gave *MAD* a better overall look and permitted more frequent use of photographs where needed. The new format also permitted Kurtzman to reach outside the comic book world for contributors. Humorists and media personalities of the day quickly answered Kurtzman's call,

MAD no. 22 | April 1955 | Harvey Kurtzman cover art. The entire issue was designed by Kurtzman to place Will Elder as the modern Picasso, a chicken-fat genius of abstract art.

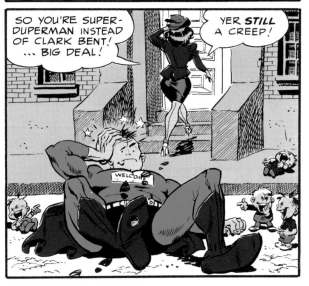

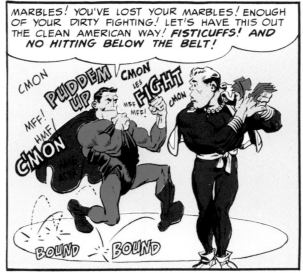
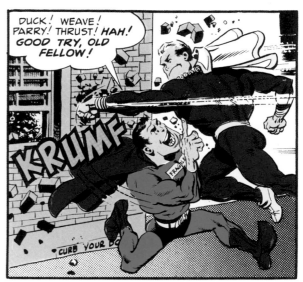
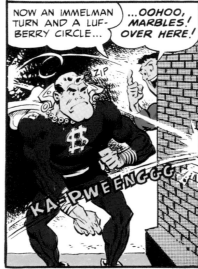
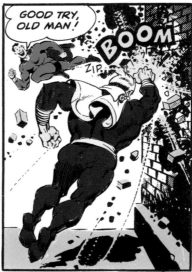
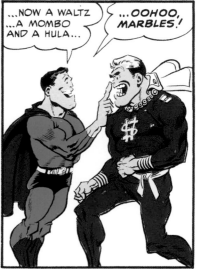
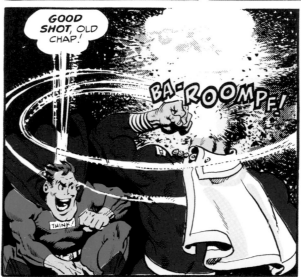
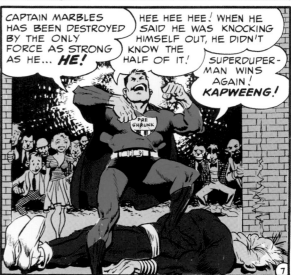

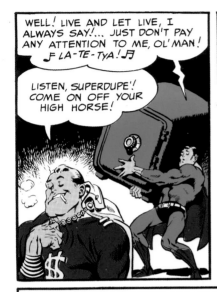

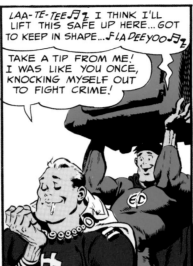

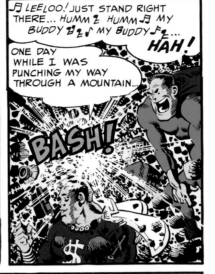

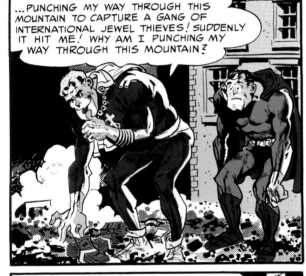

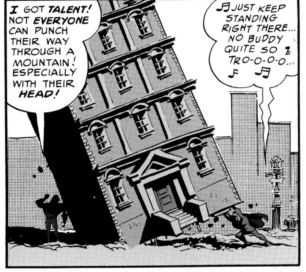

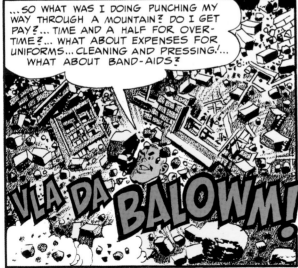

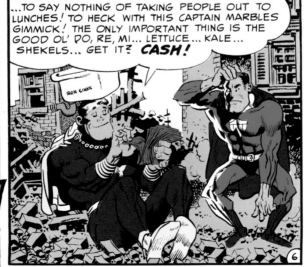

HUMOR IN A JUGULAR VEIN

TALES CALCULATED TO DRIVE YOU

No. 23
May

MAD

10c

THINK

MAD no. 23 | May 1955 | The final *MAD* comic book. The first page promised a "very very very very very very important announcement in the back of the book!" That last page announced the forthcoming *MAD* Magazine.

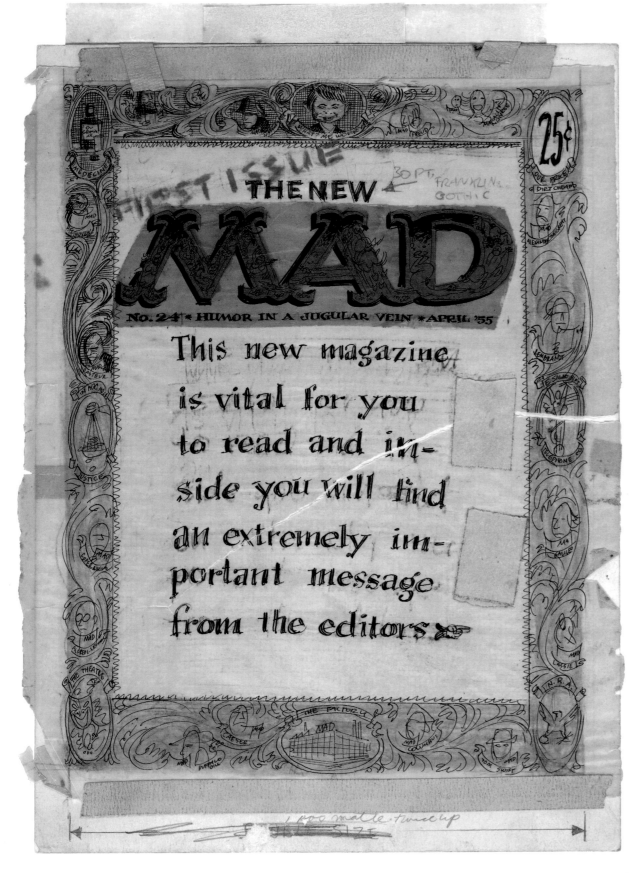

including Steve Allen, Ernie Kovacs, Stan Freberg, Doodles Weaver, and others.

Kurtzman himself became quickly overwhelmed editing a much larger and more complex magazine, so his own artistic contributions to *MAD* took a backseat. However, very significantly, he personally drew an elaborate filigreed cover border that remained a trademark of the magazine for years, and created the logo, which remains essentially the same to this day.

In the new *MAD*, the color was now gone as a necessary trade-off. A color magazine would have been prohibitively expensive for Gaines. Kurtzman would look back, decades later, at how much Marie Severin had added to the look of his publication. Marie, sister of artist John Severin, had become known as one of the best colorists in the business. Newer readers of *MAD* Magazine and the *MAD* paperback collections probably never knew how rich in color the original comic books were. An era had passed in more than one way as Gaines substituted black and white for color in his last effort, "Picto-Fiction Library," before giving up on comic books altogether.

Above left | *MAD* no. 24 cover concept | **1955** | Kurtzman's intricately filigreed border and illustrated *MAD* logo were conceived in this design for the first magazine cover. The initial concept is remarkably spot-on compared to the final version. This never-before-published concept drawing remained a sentimental favorite of Kurtzman's, hanging prominently in his living room for the rest of his life. The *MAD* logo retains its same shape over a half century later on both the current magazine and on *MADtv*. **Above right** | *MAD* no. 24 | **July 1955** | With "The New *MAD*" Kurtzman finally had the format he coveted. With this, and a higher cover price, he was able to escape the comic book ghetto and theoretically reach a more sophisticated audience.

On its own terms, *MAD* Magazine was quite revolutionary. Though Kurtzman had a difficult time convincing publisher Bill Gaines to make the format leap, it is often cited, in hindsight, along with *Playboy* and *Reader's Digest*, as one of the magazine publishing phenomena of the twentieth century.

The new *MAD* involved a type of concept that had not yet existed. "I knew what I wanted," Kurtzman later recalled, "and if you know what you want, you can create [it. I] saw the image—I knew where I wanted to go." He also knew that the format and newsstand placement permitted him to go after an older and more sophisticated audience. As the "Very Important Announcement" in the final issue of the comic intoned, "For the past two years now *MAD* has been dulling the senses of the country's youth. Now we get to work on the adults."

The staffers headed out to Brooklyn to see the first issue of the magazine come off the press, watching the workmen laughing as they did their jobs. Like the screenwriter who goes to the out-of-town preview and sees the audience on the edge of its chairs, the *MAD* men knew they had something

special, and they weren't wrong. The almost instantaneous newsstand sell-out and quick reprint was a gratifying confirmation to all involved.

And yet, only five issues into seeing his magazine dream fulfilled, and with all signs pointing to both critical and commercial success, Kurtzman abruptly left *MAD* and Gaines, leaving a trail of bitter acrimony. It was a decision he would have a lifetime to second guess.

A shattered Gaines re-hired Al Feldstein to continue the magazine. In a very practical, bottom-line sense, the post-Kurtzman *MAD* Magazine would soon look for younger readers, and Gaines and Feldstein would largely replace Kurtzman's loyal inner circle with somewhat tamer artists and writers. Feldstein was not looking to challenge or exceed anything in particular: He was simply producing what he thought readers wanted, while businessman Gaines kept his focus on the bottom line. Kurtzmaniacs and most critics deride the subsequent Feldstein-era *MAD*, but the bottom line under the new regime was very good indeed: By 1974 *MAD*'s circulation exceeded two million, nearly three times the sales during the Kurtzman

era, though by the end of the decade its sales were down considerably and today's *MAD* circulation is far less than it was even during Kurtzman's tenure.

Could Kurtzman have done something different than the *MAD* Magazine of the Feldstein era? Perhaps a better question is, Could he have *prevented* himself from doing something different, something that would diminish the commercial boom that *MAD* was about to enjoy?

Looking at his subsequent ventures, such as *Humbug*, Kurtzman might have wanted *MAD* to become sharper politically, tackling civil rights and other burning issues of the day, as part of a more "adult" thematic approach. On the other hand, the great civil liberties issues of the early 1950s that had so driven him were now slipping away, and with them the newness of the consumerist self-promotion that followed World War II. With the public memory of the Depression and the Good War slipping away, especially for the younger generation, and the rebellious impulses in rock and roll demanding a more sophisticated approach, how would Kurtzman have adapted? The questions remain open, and fascinating.

Above left | *MAD* no. 25 | September 1955 | Thomas Nast cover art with Harvey Kurtzman border, logo, and design. **Above center | *MAD* no. 26 | November 1955 |** Wally Wood cover art from Harvey Kurtzman layout, with Kurtzman border and logo. **Above right | *MAD* no. 27 | April 1956 |** This issue is dated five months after the previous one. Elaborate Jack Davis cover art from Harvey Kurtzman layout with a new Kurtzman logo and new Will Elder border from a Kurtzman layout.

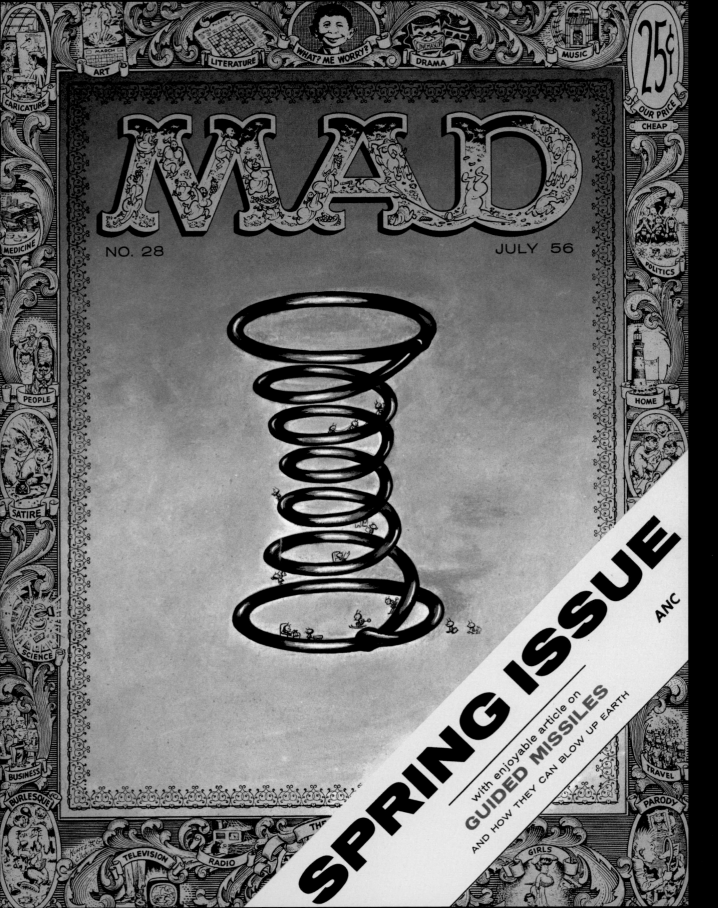

MAD no. 28 | July 1956 | This "Spring Issue" was the final complete issue under Kurtzman's editorship. Central art and logo by Kurtzman. Border art by Will Elder from Kurtzman layout.

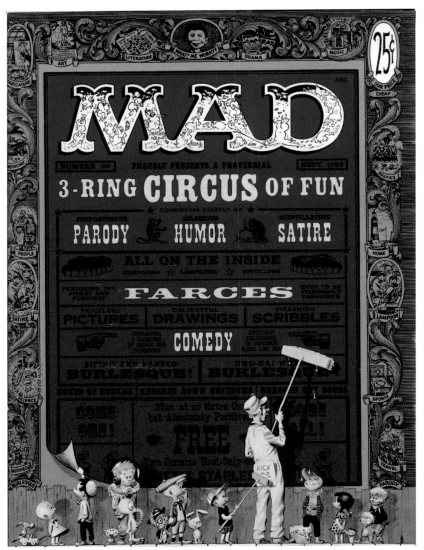

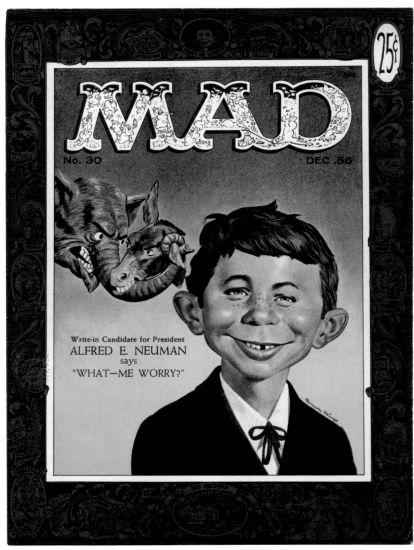

Top | *MAD* logo | 1955 | After Harvey Kurtzman realized his longtime dream to produce a "slick" magazine, he characteristically immersed himself in every detail of *MAD*'s new look. He personally designed and drew the fanciful logo. Readers who looked closely saw grape-eating nymphs in search of a bacchanal chasing down shy centaurs through the corridors of hollow letters. In combination with his equally elaborate cover frame, this logo gave readers twenty-five cents worth of eye-pops before they even opened the magazine. **Above left and right | Kurtzman lingers on |** *MAD* **no. 29 | September 1956 (art by Wally Wood) |** *MAD* **no. 30 | December 1956 (art by Norman Mingo) |** Inherited and edited by Al Feldstein, who was rehired by Bill Gaines after Harvey Kurtzman abruptly quit after finishing issue no. 28. Since a good deal of the following two magazines were created under Kurtzman's stewardship, they are included here to reflect his extended influence into the thirtieth issue.

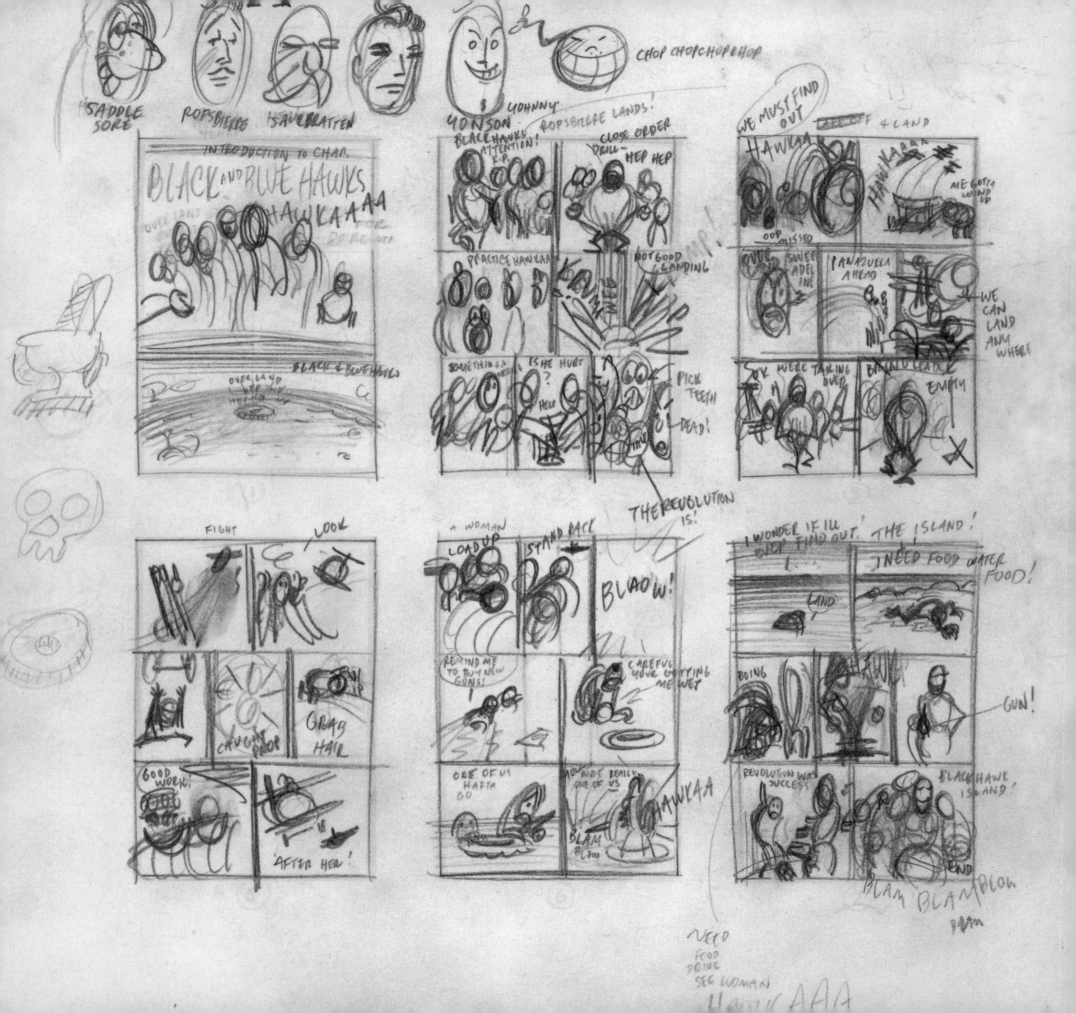

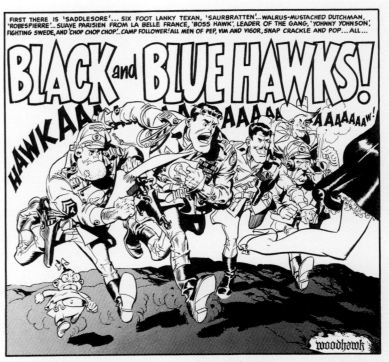

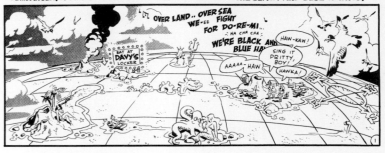

Left | "Black and Blue Hawks!" thumbnails | 1953 | Kurtzman's thumbnails (actual size less than 6 x 9 inches) reveal his first thoughts about the layout and the look of the individual characters.

Above | "Black and Blue Hawks!" splash page from *MAD* no. 5 | June–July 1953 | Other than spelling variations on character names (including one less "Chop") Kurtzman's first impressions and layouts remain typically very close to Wally Wood's final interpretation. Kurtzman's larger intermediate vellums for *MAD* (with a single two-panel exception) did not survive.

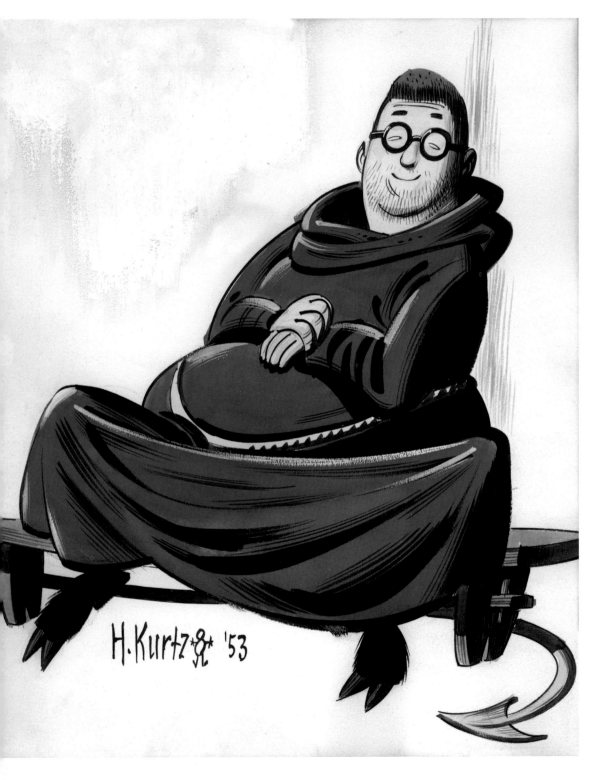

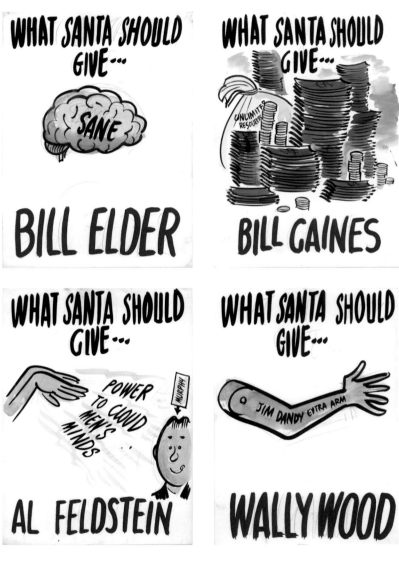

Above | E.C. office Christmas drawings | 1950 | Publisher Bill Gaines enjoyed office parties and giving presents (such as movie cameras) to his staff and contributors. Kurtzman and other artists sometimes contributed gag drawings. These Kurtzman examples poke good-natured fun at colleagues.

Left | Bill Gaines as devil | 1953 | This caricature of Gaines as a devil in monk's clothing was done during the best of times, as *MAD*'s circulation and impact were rapidly rising. But like much of Kurtzman's humor, there was an uneasy truth lying underneath. There were tensions between the two men that within two years would lead to an acrimonious parting. They would not reconcile for many years.

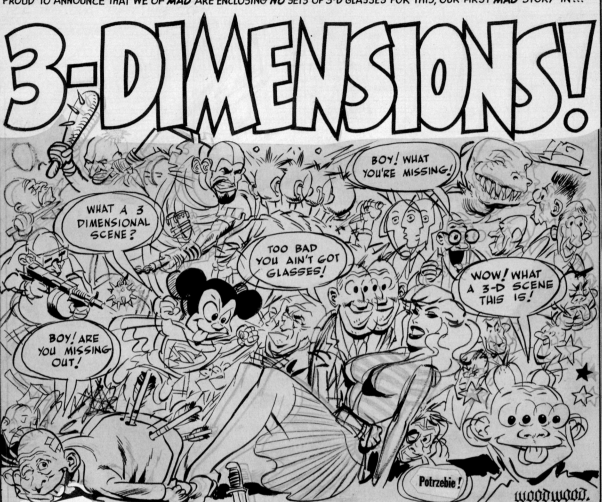

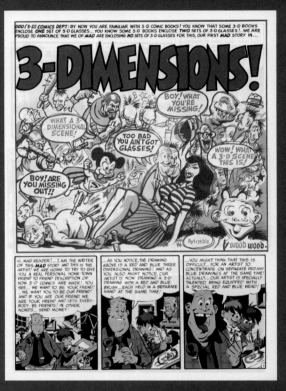

Rarely seen original art to "3-Dimensions!" (*MAD* no. 12, June 1954), by Wally Wood, based on Harvey Kurtzman's story and layouts. 3-D comics, read with 3-D glasses, were all the rage in the early 1950s, and thus grist for satire. Kurtzman and Wood's dissection of the mind-bending visual gimmickry culminates with the very fabric of comic book reality being shredded.

3-D films were a short-lived response to a combination of changing technology and accelerated media competition. For satirists of the time, the 3-D glasses (plastic lenses on a cardboard frame, one lens blue or green, the other red) were an instant metaphor about the blind consumerism of the age. For film studios, they mostly added a "dimension" to the supposed scariness of horror films without any improvement of plot. (Russ Meyer's soft-core pornography 3-D films came later.)

3-D print experiments were even more limited in number and ambition to a scattering of largely gimmicky comics, so much so that this Kurtzman/ Wood story is probably the outstanding example, even though two-dimensional: As was the case so often in *MAD*, the satire was better than the original. The gags are steady here, perhaps a climax to the old comics ploy of escaping the panels.

ABS: I photographic print
this size

ALSO — 3 prints of these
I pos. stat - Matte finish
this size — ALSO

12

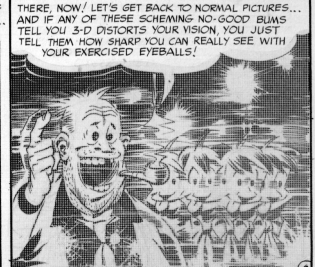

Wooo! this panel comes out!

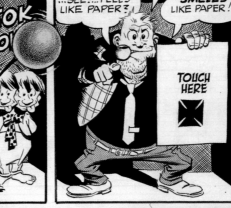
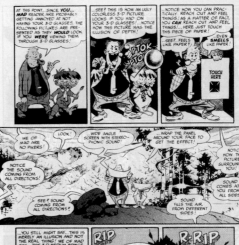
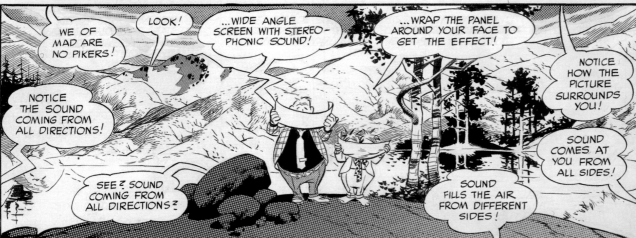
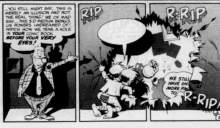
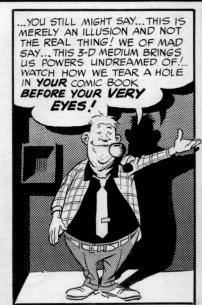
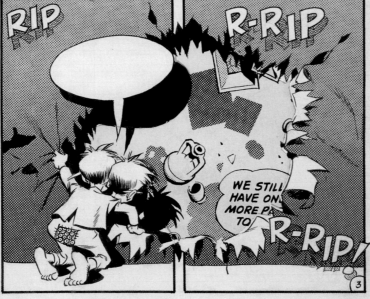

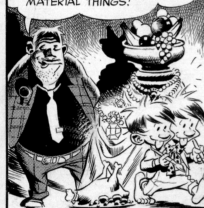

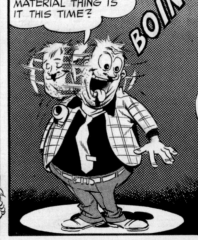

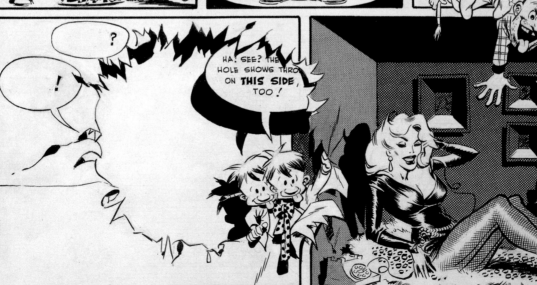

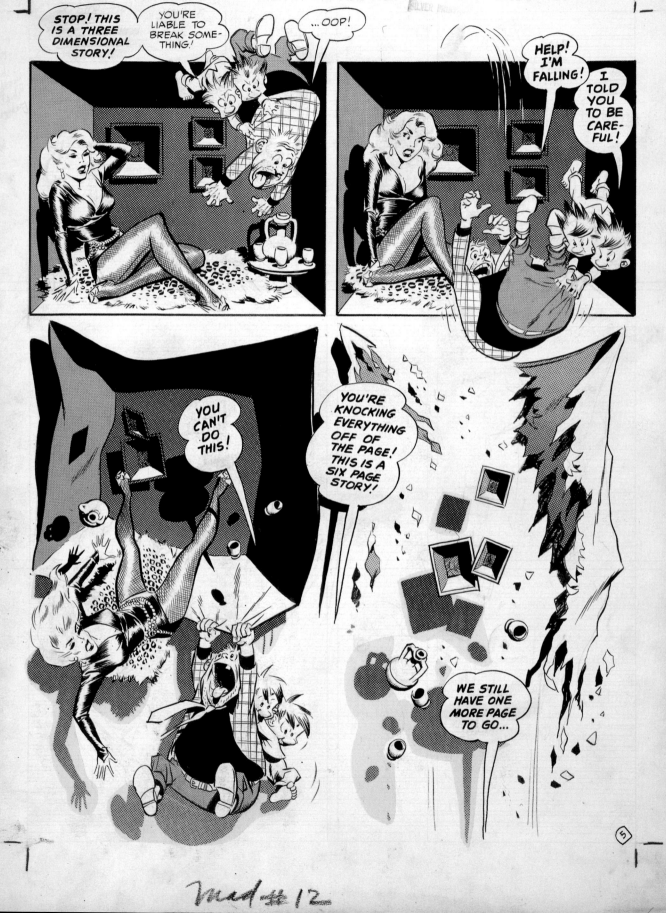

The original art for the five drawn 3-D pages is reproduced in full here, but readers will have to use their imagination for the audacious "punch line." The sixth and final page in the published *MAD* story was a totally blank white page.

CHAPTER 4

Three Magazines and Freelance Hell

Harvey Kurtzman's career moves from 1956 onward can be described as perennially disappointing or catastrophic, marked with flashes of creative brilliance and opportunity that faded from sight soon enough.

His departure from *MAD* was profound. He felt that staying without any real control might have meant a reasonable degree of personal success and, probably, a certain degree of artistic autonomy—so long as he produced on schedule. With a combination of hubris and reality, Kurtzman felt personally responsible for both the success of *MAD* and the very survival of Bill Gaines's company. But he felt unrewarded and frustrated with Gaines's control at all levels. He also found himself wooed by and attracted to a charismatic new player.

Hugh Hefner had become, almost overnight, the enfant terrible of the magazine industry. *Playboy* reinvented the girlie magazine, and simultaneously transformed the gentlemen's magazine. It even looked a little like *Esquire* (where Hefner originated) in that magazine's early period of publishing glory. But *Esquire* was for the imagined gent in the chauffeured sedan, or for those who fantasized themselves as gents, while *Playboy* was for the young fellow in the sports convertible, the imagined connoisseur of clothes, cars, and heterosexual adventure, but also of literature.

Hefner discovered *MAD* on a Chicago newsstand when he was sending an early issue of *Playboy* to press. A one-time cartoonist, Hefner had a lifelong appreciation of comics and knew he was seeing something extraordinary. He reached out to Kurtzman, and soon the two met in New York. Hefner made his admiration for Kurtzman's talent clear and indicated there would be a place in his growing empire if Kurtzman ever left *MAD*. *Playboy* aspired to reach the sophisticated audience Kurtzman craved, and Hefner paid the very top magazine rates for leading authors, illustrators, and cartoonists. Kurtzman found the allure irresistible.

Kurtzman had, in his own words, created *MAD* comics in 1952 "out of desperation," but his next move was calculated. Impressed by Hefner's operation and flattered and emboldened by his overtures, Kurtzman decided to make the big break in 1956. But he decided to hedge his bets, as he later described in a 1962 letter:

I was resolved to leave E.C., Gaines, and *MAD*. I'd made up my mind. My decision was firm with the one possible long-shot reservation, and a highly improbable reservation. I would stay if I could have legal control of the magazine, which was the only way to have real editorial control that

I knew of. But [Gaines] obviously wasn't aware of my determination to quit. . . . I wanted CONTROL . . . not the profits.

Kurtzman knew with relative certainty that Gaines would never give up control of the family business, but he felt he had nothing to lose by his bold play. Therefore he informed Gaines that he wanted stock in the corporation. Gaines was not happy, but terrified at the prospect of losing the key man at his sole remaining publication, so he made a "last and best" offer of a 10 percent equity share.

Gaines's offer, while not unreasonable in retrospect, fell far short of Kurtzman's lofty and unrealistic target. Via Harry Chester, Kurtzman followed up with a demand for 51 percent. The paternalistic Gaines was truly outraged by both the figure and the impudence, and he immediately bade Kurtzman farewell. The quick rupture left Gaines's operation suddenly reeling, and the men's relationship in tatters for quite some time.

Five years after their split, in 1961, Gaines sold *MAD* to Premiere Industries for a reported five million dollars. Had Kurtzman accepted Gaines's offer of 10 percent equity in 1956, his share would have been in the neighborhood of $500,000. But it was a moot point.

Humbug no. 11 cover detail | October 1958 | The forlorn final cover for *Humbug* reflects the staff's sense of hopelessness and failure. Underground cartoonist Robert Crumb parodied this Kurtzman image on the third cover of his own *Weirdo* magazine in 1981.

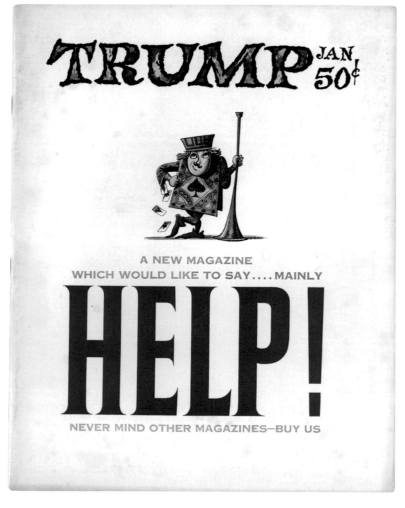

Right | *Trump* no. 1 | January 1957 | The *Trump* covers radiate sophistication but also the mark of *Playboy*: a hipster knave who, as a playing card, will "trump" any situation. A punster could also add that the knaves were "horny." The dominant headline, "HELP!" presages the name of Kurtzman's fourth and final satire magazine, just as a rejected title for *Trump* (*Humbug*) became the name of his third magazine. Below | *Trump* no. 2 cover detail | 1956 | Original Kurtzman art for the *Trump* mascot that appeared on the second cover.

THE BIRTH AND QUICK DEATH OF *TRUMP*

Hugh Hefner made good on his promise, quickly agreeing to underwrite a first-class humor magazine, in color, with Kurtzman at the helm. Initially it had no name and was called simply *X*. Though Kurtzman and Harry Chester began drawing salaries in April 1956, followed by Will Elder, Al Jaffee, Irving Geis, and Ed Fisher in May, it took a seven-month gestation to determine the magazine's actual title—so much time that embossed stationery with *X* was actually printed and used. The name *Trump* didn't come easily. Kurtzman held out for *Pickle Stick* and *Humbug*, but the *Playboy* publisher and his right-hand man, Victor Lownes, imposed *Trump*, a title Kurtzman never warmed to.

One thing Kurtzman *did* warm to was Hefner's attitude toward money. With Gaines, Kurtzman had "been used to working with budgets, with specific quantities." When he asked Hefner what his budget was on the start-up magazine, Hefner told Harvey, "We don't start with a budget; we start to make a good magazine and then we'll see what it costs." After all the penny pinching and page-rate wrangling at E.C., Kurtzman no doubt felt he had died and gone to publishing heaven.

It must have seemed like the perfect moment to launch a magazine like *Trump*. The Cold War cultural climate was starting to lighten up, and comics like Stan Freberg and Ernie Kovacs were winning millions of viewers and listeners. Lenny Bruce had surfaced and would even be offered his own television show (though it didn't work out).

If *Trump* was a flash in the pan, then what a flash it was! Kurtzman took with him from *MAD* Magazine artists Will Elder, Jack Davis, Russ Heath, Al Jaffee, business manager Harry Chester, and, briefly, Wally Wood. He added cartoonists Bob Blechman and Arnold Roth. Irving Geis, who had shared a studio with Kurtzman in the pre–Charles William Harvey

Above right | *Trump* no. 2 | March 1957 | This understated black cover is in stark contrast to the elaborate border, logo, and often the interior images Kurtzman employed on his *MAD* Magazine covers. Some think this sophisticated cover approach hurt *Trump*'s sales. Regardless, a financially stressed Hugh Hefner pulled the plug quickly on *Trump*. A *Playboy* executive told *MAD*'s business manager at the time, Lyle Stuart, that even if sell-through on the first two issues had been 100 percent, Hefner still would have lost a quarter million dollars on *Trump*.

days, was the art director. Other contributors included Mel Brooks, Doodles Weaver, Roger Price, and Max Shulman.

The expense alone of "Our Own Epic of Man," a color gatefold, must have been considerable. Kurtzman and Elder ambitiously took on the popular *Life* magazine features of human social evolution from ancient times. These reconstructions from geological tracings were cross-referenced with Coney Island, subway stops, Marilyn Monroe, Jane Russell, Alfred E. Neuman (he didn't yet seem to belong exclusively to *MAD*), Howdy Doody, and so on. It couldn't have been done in black and white, and it couldn't have been effective unless done as a foldout. Kurtzman was going for broke.

Not unexpectedly, there was more sex, or rather, everything short of actual sex, in terms of satire-as-titillation, rather like some pages of *Playboy* (only without the photos of naked ladies), with a lot of drawings of "bosomy dames." The real Daisy Mae of "Li'l Abner" never looked like the *Trump* satire of her, despite the suggestive curves from the pens of Al Capp and his hired artists such as Frank Frazetta. On the other hand, perhaps *Trump* did not go far enough to titillate and agitate the potential buyer willing to lay down fifty cents (twice the price of *MAD* Magazine). The satires of advertising, television shows, and films looked a lot like the model already evolving in *MAD*, if only sharper and more lushly rendered than they were in the magazine after Kurtzman's brief tenure there.

Trump, like *MAD*, did not carry advertising but relied solely on healthy newsstand sales. The first issue, cover dated January 1957, did very well, selling two-thirds of its print run—an excellent sell-through, particularly for a new magazine. Things looked bright on the surface. But unfortunately, all was not well.

As *Trump*'s debut issue hit newsstands, *Playboy*'s distributor went under. No revenue for that entire print run was forthcoming from the busted distributor, and by the time the second issue was going to press, *Trump* had already run up costs of nearly $100,000. At the same time, *Playboy* was making an expensive move into new Chicago offices, and its advertising revenue was down. Compounding problems, Hefner's bank, believing he was overextended, refused to renew *Playboy*'s line of credit. It was a quadruple whammy, and Hefner had no choice but to kill *Trump* after just two issues. *Playboy* eventually recovered and flourished, but in the interim Hefner had to take himself off salary, cut other executives' pay, and put up 25 percent of *Playboy*'s stock as collateral for a short-term loan to cover his losses.

If Hefner hadn't been hit hard by cash-flow stresses, he might have held on, despite the humor magazine's considerable overhead. And *Trump was* unquestionably an expensive proposition. As Hefner dryly summed it up later, "I gave Harvey Kurtzman an unlimited budget, and he exceeded it."

Trump **knaves | 1956 |** The Knaves on the left and middle were drawn by Arnold Roth and intended for the first two *Trump* covers but ultimately not used. Harvey Kurtzman instead went with his own versions of the horn-blowing (opposite page) and horn-leaning (far right) mascot. Kurtzman even rejected the face of his own knave for the first cover. The disembodied head at the top left was superimposed on the body for the final cover.

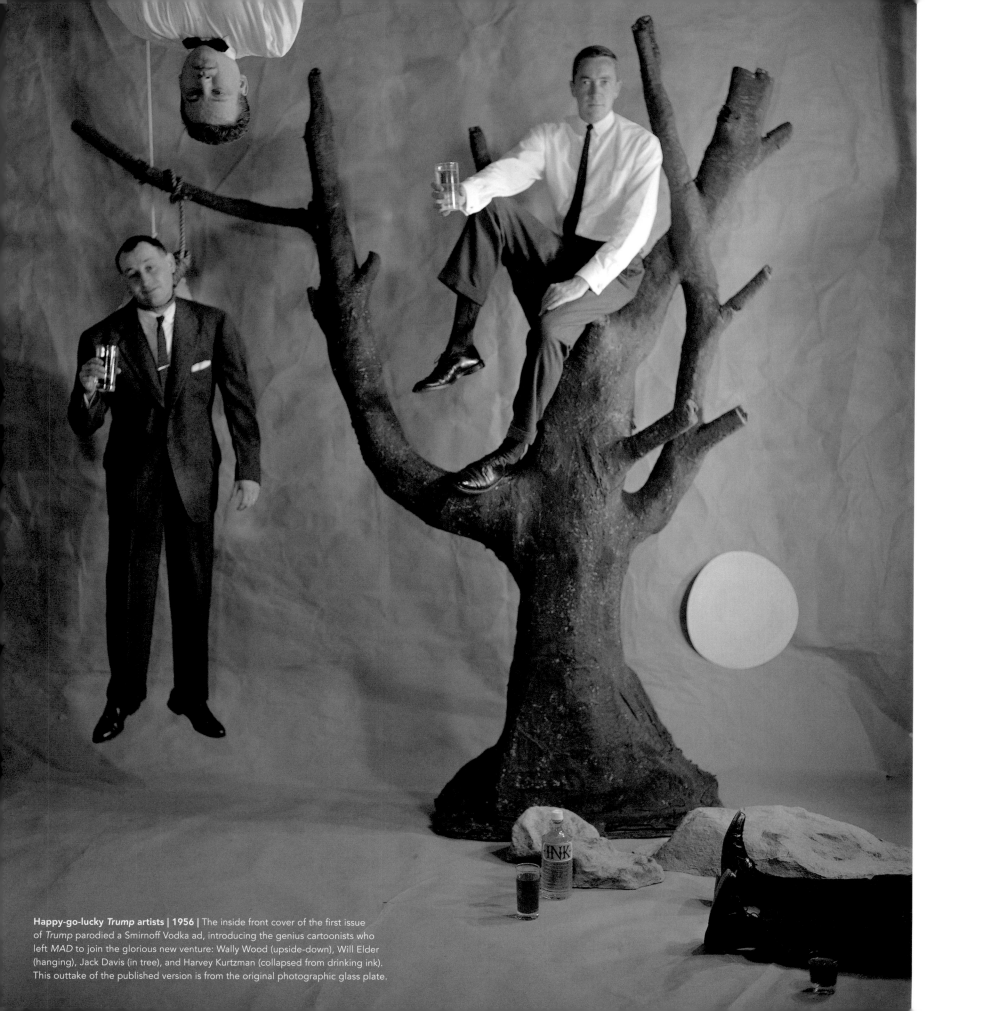

Happy-go-lucky *Trump* artists | 1956 | The inside front cover of the first issue
of *Trump* parodied a Smirnoff Vodka ad, introducing the genius cartoonists who
left *MAD* to join the glorious new venture: Wally Wood (upside-down), Will Elder
(hanging), Jack Davis (in tree), and Harvey Kurtzman (collapsed from drinking ink).
This outtake of the published version is from the original photographic glass plate.

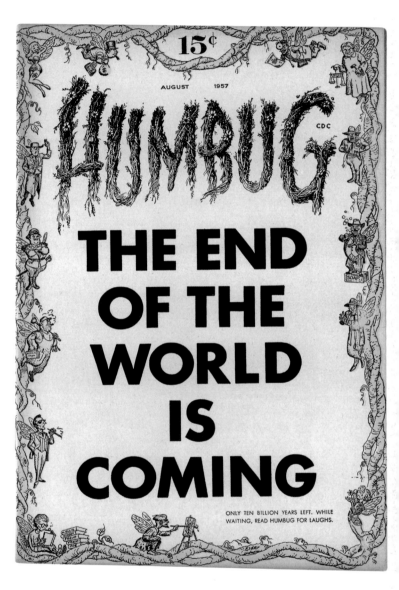

The news came when Kurtzman was in the hospital maternity ward where Adele had given birth to their third child, Elizabeth. The day appeared to be one of the happiest in Harvey's life. He saw Hefner waiting for him in the hallway and was surprised that the busy man had come so far out of his way to offer congratulations and get a cigar. Instead, Hefner had come to personally inform Harvey that he was pulling the plug on his dream.

Kurtzman was devastated and sobbed loudly after receiving the news. Adele said it was the only time in their long relationship that she had seen him cry.

Kurtzman reflected later in his life that he "never did get to do the perfect humor magazine," but "*Trump* came the closest." And it lasted the shortest. The creative genius of Kurtzman had soared beyond comics, but whether it had anywhere left to go in slick magazines, where visual humor remained a sort of page lightener, remained to be seen. The formula that succeeded just once—enough to create the most lucrative humor magazine of an era—never succeeded again, with all the tweaking that he did, time after time.

But the heartbreak of *Trump* didn't hold Kurtzman down long. Life had to go on. Not long afterward, the gang was sitting in the New York *Playboy* offices feeling mightily depressed when Arnold Roth came in with a bottle of Scotch. After a few drinks, the artists resolved to move ahead somehow. "It was one of those classic disastrous decisions," Kurtzman would later say.

ENTER *HUMBUG*, THE CARTOONIST COLLECTIVE

The collective result was *Humbug*, a name Kurtzman retrieved from his rejected candidates for *X*. Financed by the founders themselves, *Humbug* was the adventure of a lifetime, allowing artists—however briefly—the rare experience of both creative and equity control over their medium.

Pooling their money from meager life savings as best they could, the partners formed Humbug, Inc., with $6,500 in capital. Of that, $2,500 came from Arnold Roth, $1,500 from Al Jaffee, $1,000 each from Kurtzman and Will Elder, and $500 from Harry Chester. Despite unequal investments, they were nonetheless equal partners, "but there was never a doubt that the guy who led that thing was Harvey," Roth stressed.

Jack Davis, though a regular contributor throughout *Humbug*'s run, opted not to become an equity partner, and thus was the only regular not to lose his shirt. As Roth joked with Kurtzman in 1974, "All these sharp Jewish New York guys lost money, and this one gentile from Georgia got paid every week!"

Humbug was the self-conscious invention of artists and satirists without any sense of how their efforts and investment could make any money. As Kurtzman was to recall with an almost gleeful gloom:

> We didn't have any money, and we tried to go by our own guts. I designed a format that would be incredibly cheap to reproduce, so we turned out this incredible magazine which had the most beautiful artwork we'd ever done, the most carefully crafted stories and layouts, and we printed the whole thing on toilet paper! A terrible mistake! The format was a disaster!

The format posed additional competitive problems. They couldn't afford a full four-color process, so *Humbug*'s interiors were strictly black and white with a second washed-out and often off-register color. Despite this, the retail price was fifteen cents, fifty percent more than any comparable comic book that had full color throughout. A desperate switch to a thin twenty-five-cent magazine for the last two issues failed to work magic.

Above | *Humbug* no. 1 | August 1957 | Comic book–sized, but 50 percent more expensive at fifteen cents retail and without full color, *Humbug* was neither a magazine nor a comic book. The publication also suffered from poor printing quality and weak distribution. Though the self-published artists produced some of their finest work for *Humbug*, the doomed experiment didn't last a dozen issues. Jack Davis inked the logo and Will Elder the border art, both from Kurtzman layouts.

Above | *Humbug* no. 2 title page logo | September 1957 | The title logos by Arnold Roth generally had a seasonal theme, such as this beach scene for the issue dated September but on sale in midsummer.

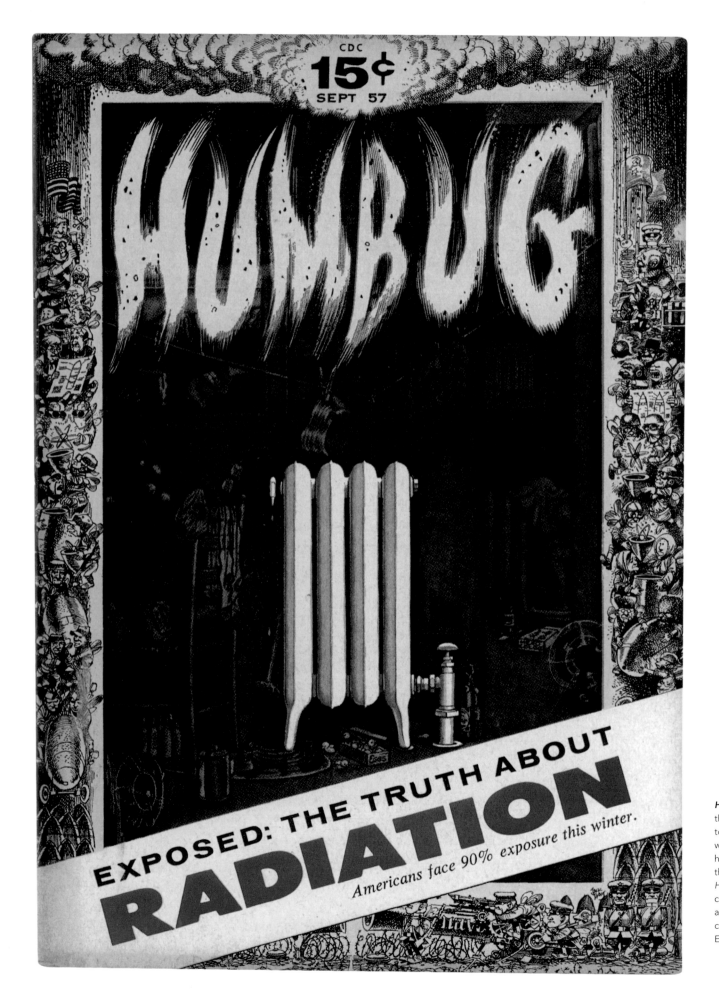

***Humbug* no. 2 | September 1957 |** During the Cold War, the threat of a Soviet-American atomic war was an omnipresent topic that only a humor magazine could temporarily alleviate with a bad pun (some modern readers may not recognize a hot water radiator). Robert Crumb has solemnly stated that this cover "changed his life" as a youthful aspiring cartoonist. *Humbug* had a big impact on Crumb's future underground comix colleagues and other young readers, even as the naïve artist partners proceeded to lose their shirts. The elaborate cover frame is by Jack Davis and the interior painting is Will Elder's, both from Harvey Kurtzman layouts.

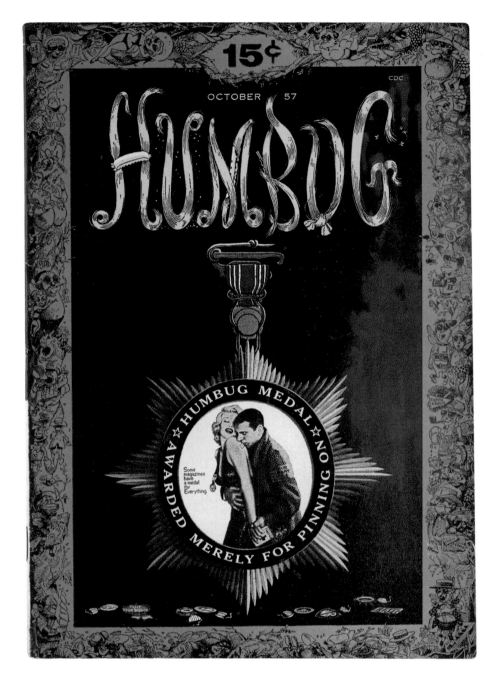

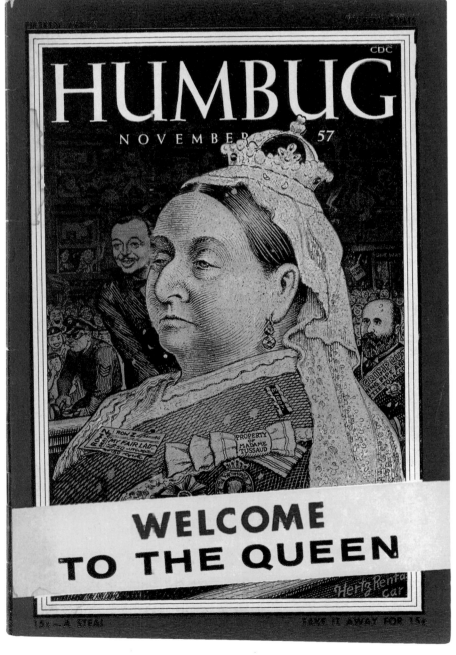

Above | *Humbug* no. 3 | October 1957 | An all-new fanatically detailed cover border by Jack Davis frames a Will Elder interior cover, both based on Kurtzman layouts.

Right | *Humbug* no. 4 | November 1957 | Young Queen Elizabeth II made her first visit to America in 1957, so naturally *Humbug* welcomed Queen Victoria. The fellow over Victoria's right shoulder is Jack Bailey, emcee of TV's popular *Queen for a Day*, while Prince Albert (from the tobacco tin) peers over her left. In an attempt to mimic a red-bordered *Time* magazine, *Humbug* eschews a fancy cover border. The brief trademark will not return, probably due to ever-tightening budgets. In keeping with the Victorian theme, Will Elder manages to convey a steel-engraving look to his drawing.

Humbug no. 5 | December 1957 | Al Jaffee's first *Humbug* cover generally parodies S&H Green Stamps, redeemable for cash and a staple of retailers in the 1950s. The individual stamps (and their respective numeric values) give high values to the likes of Marilyn Monroe and Mount Everest while taking pokes at tainted teamsters, Argentine dictators, Green Stamps and, presciently, a ninety-year supply of *Humbug*. And note the Freudian juxtaposition of the Fort Knox key and oil derricks with actress Sophia Loren's keyhole.

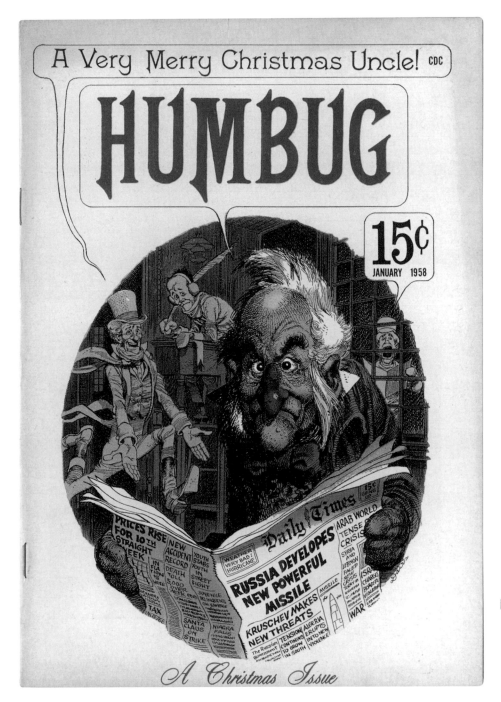

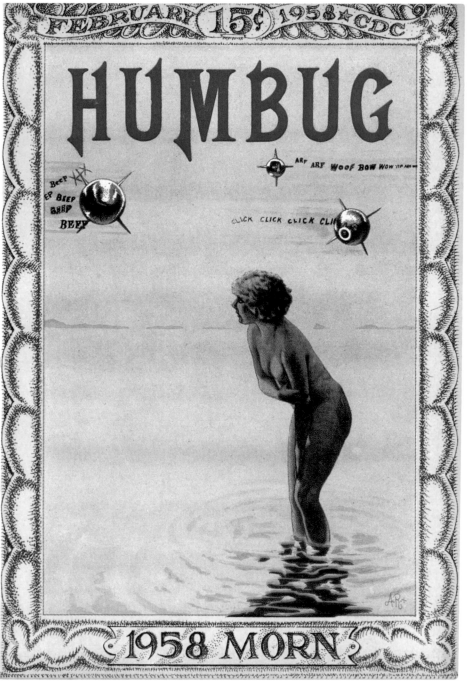

Above | *Humbug no. 6* | **January 1958** | Charles Dickens's Scrooge, the man most associated with uttering "Humbug!" suitably graces the Christmas issue, masterfully drawn by Jack Davis. Grim newspaper headlines give the literary curmudgeon extra reason to be grumpy, but editor Harvey Kurtzman was no doubt grumpy himself after this issue was printed: "Develops" is misspelled in the Russian-missile headline. After six different logos in a row, the *Humbug* no. 6 logo became the keeper (for the last six issues).

Right | *Humbug no. 7* | **February 1958** | The launch of the USSR's Sputnik satellite in 1957 sparked a space technology battle with America. Arnold Roth's spy-in-the-sky technology beeps, woofs, and clicks over *September Morn*, a once scandalous painting by Paul Émile Chabas. Assailed for indecency in America in 1913, *September Morn* became famous, and countless lithographic copies kept it in the public eye for decades. But any nude made a risqué cover subject in 1958, especially on a comic book presumably aimed at young readers.

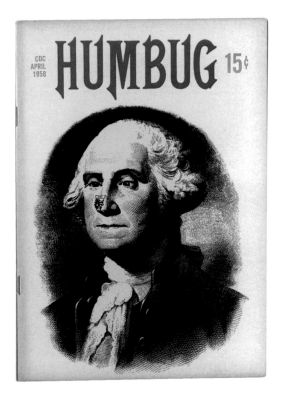

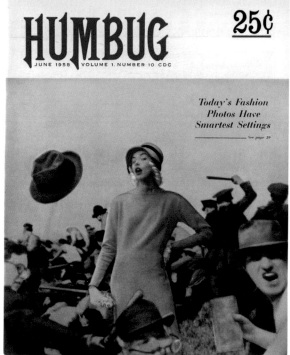

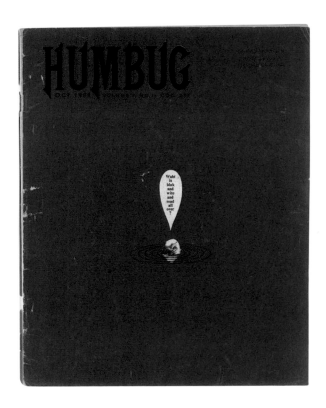

Al Jaffee, who had been Will Elder's closest pal at Art and Music, could appreciate the possibilities best, in some ways, because he had only begun work for *MAD* toward the end of Kurtzman's tenure and faced the prospect of more hack work (for Stan Lee) or striking out in a new direction. "*Humbug*," he later exclaimed, was a "turning point in my life." Jaffee felt the breeze of freedom. He told an inquiring friend at the time, "Actually I'm sort of unemployed. But I'm having the most marvelous time of my life."

Arnold Roth, whose illustrations would later grace various magazines, including *Playboy*, put it differently in regard to Kurtzman and working with him at *Humbug*: "I don't want to say that he had revolutionary values, but he was always questioning, and that really attracted me. . . . Nothing was really sacred." Everything could be challenged—but never for the sake of mockery alone. "Otherwise you're like a hired gag writer to fill out scripts . . . a mechanic."

Humbug was more political, in the narrow and broad sense of the term, than either *MAD* or *Trump* hoped to be. It also felt more like the adult version of a college humor magazine, with prose features not to be found in *MAD* or *Trump*, along with well-crafted standard riffs (a satire on Robert Ruark, titled "Something of Mau Mau," was among the sharpest and best, with the neo-colonialism and feigned exoticism of the contemporary bestseller shredded). Almost inadvertently, it expressed a keen view of social history.

Nothing quite so marked the *Humbug* view of a world gone by than the outside and inside front cover of no. 10 (June 1958). On the front cover was a retouched photo of the Memorial Day Massacre in Chicago, 1938, a famous (if, outside labor itself, unacknowledged) day in American class struggle. Police bend over bystanders seeking to escape, planting clubs upon skulls. While one fellow has a brick in hand, the overlay in the middle of the cover is a fashionable lady of the present, hat and purse neatly matching her dress, with the caption, "Today's Fashion Photos Have Smartest Settings."

Inside the same issue was Roth's "Mayday Parade." For generations, from the 1890s to the 1940s, New York's Mayday had been an occasion of radical bravura, red flags, men and women holding up union signs, and bands playing. In *Humbug*'s depiction, the once-glorious parade had been reduced to three marching geezers, a trumpeter, and a drummer. Doormen and the rich stare at them from what must be an Upper East Side avenue.

The 1957–58 recession, the most serious since 1945, spawned omnipresent layoffs and sinking profit margins. On the back cover of an early *Humbug* issue, Will Elder brilliantly mocked a famous Western Union ad, with a businessman looking at the bad news, a colleague with a pistol to his forehead (and with perfect Elder detail, a bottle of poison on the desk, half-full). Inside the issue, a "Humbug Award" in the Dutch Masters cigar tradition showed those Masters—in real history, many of them cunning calculators of their paintings' value on the medieval equivalent of the

Opposite middle | *Humbug* **no. 10** | **June 1958** | The bedraggled partners decided that the only salvation for the failing *Humbug* was to transform its format to a magazine. The publication increased its trim size—not the interior page count, which remained at thirty-two—but the retail price nearly doubled to twenty-five cents, theoretically providing a greater profit margin. The penultimate issue tried to look more like a magazine, with its first photographic cover juxtaposing high fashion and a labor riot, along with a photo feature inside. But Kurtzman's successful switch of *MAD* from comic size to magazine was not to be repeated with *Humbug*.

Opposite right | *Humbug* **no. 11** | **October 1958** | The magazine bulked up to forty-eight pages (thanks in part to recycling sixteen pages of *Trump* material) and exhibited a more promising, sophisticated, and quarter-worthy look. But no. 11 hit newsstands four months after the tenth issue and was the end of the line. One could be forgiven for assuming that the balding and bruised man drowning in red ink on Kurtzman's cover was Kurtzman himself.

stock exchange—bleeding a dead-looking "Bank of America," while calculating their own benefits. This was 1930s radical stuff, updated but far from the New Left styles of anti-establishment satire a decade (and a large generation) later.

Hugh Hefner remained a friend and supporter of Kurtzman and "those strange ones" gathered around him. Besides letting the *Humbug* crew use *Playboy* office space in New York City without paying the agreed-upon rent, he also promoted the fledgling publication with a prominent nine-page feature, "The Little World of Harvey Kurtzman," in the December 1957 issue of *Playboy*.

But even a boost from Hefner didn't help. After eleven grueling issues, a largely indifferent market, and constant wrangling with a crooked distributor, the great venture into freewheeling humor was over after barely a year. By May 1958, Kurtzman was on his own and nervous about the future. *Humbug* had exhausted both him and his finances. Collecting unemployment compensation, he desperately looked around for ways to pay his mortgage and feed his family.

Above | *Humbug* **no. 9** | **May 1958** | The most whimsical *Humbug* cover—and the final comic book cover— was drawn by illustrator/cartoonist R. O. Blechman, who contributed occasional droll strips for the publication. He accepted Kurtzman's cover invitation and chose to draw it at *Humbug's* small office. Kurtzman watched as the perfectionist Blechman drew every hat on a piece of vellum, then watched him cut out each tiny hat with an X-acto blade, apply a dab of rubber cement and slowly and carefully place each into his layout. Then he watched as Blechman studied the array and judiciously repositioned several hats. Finally the artist pronounced his composition done and left the office. Later, near press time, Kurtzman found a solitary Blechman hat on the floor. He agonized before assigning it a place. Blechman never noticed.

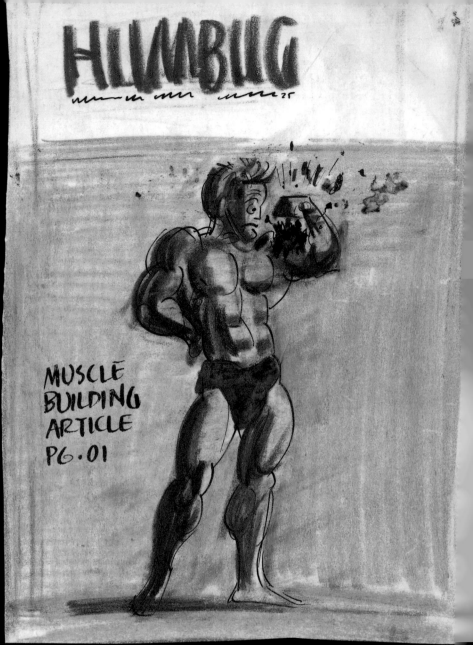

Left | *Humbug* Frankenstein's monster cover concept | 1958 | Three of Harvey Kurtzman's unused *Humbug* cover concepts survive. His May 1958 cover idea was ultimately superseded by Blechman's blowing hats design (no. 9), a cover arguably better suited for the *New Yorker*. Frankenstein's monster might have sold considerably more copies to a young male audience, but Kurtzman instead went with Blechman's offbeat approach.

Right | *Humbug* muscle building cover concept | 1958 | Intended as the basis for the cover of issue no. 11, Kurtzman instead used the bursting–bicep gag for the interior splash page of the Will Elder–illustrated "Muscle Magazines" feature. Again, one could argue that Kurtzman should have gone with his first instinct, a muscle gag, as opposed to the high-concept but not exciting

OPTICAL ILLUSION COVER: IF YOU STARE AT BOXES—AS YOU WATCH THEY SEEM TO BE ONE WAY—THEN ANOTHER—

Above | *Humbug* **optical illusion cover concept | 1958 |** Had *Humbug* continued, this might have been the design of the twelfth cover. Kurtzman was fascinated with optical illusions and puzzles throughout his career. In this version the beautiful illusion unravels, a fitting metaphor for the magazine.

Right | *Humbug* **form letter | 1958 |** When the end came but letters kept pouring in, Harvey Kurtzman created a form letter to console hopeful fans and to thank them for their support and well wishes.

HUMBUG

Dear Humbug letter-writer:

 This printed letter is the best way we could think of to answer our mail.

 As you probably know, Humbug has, for the time being, ceased publication, and we of the staff have been busy mending our various careers.

 In the meantime, a pleasant, yet distressing circumstance has come about in that the mail continues to arrive and accumulate in a large pile; mail full of friendliness and warmth from all over the hemisphere and Europe. Our writing subscribers have, almost to a man, told us not to worry about their money. Many readers have mailed us cash <u>contributions</u>. We can't remember any experience like this before.

 Apart from the letters, condolences have come to us from all sorts of remarkable people--many of them professional humorists who, like we did, felt our magazine was a little something extra-special.

 All of this has given us a certain degree of comfort... hope and faith, and we shall continue to seek ways to revive Humbug.

 Unhappily, it has become literally impossible for us to answer the letters individually, so we've decided to use the contributions towards printing and mailing out this note.

 We apologize to those whose letters we are late in answering. To those who requested back-issues, collections, etc., we are sorry but we've disposed of everything and have nothing to send out. To those who sent money to help us out, you are sicksicksick. But we love you. And to those of you who had assorted off-beat questions--please understand they will have to go unanswered because of our circumstances.

 Finally, thank you all for writing. We only hope our message conveys personal feeling that we <u>did</u> have when we read your particular letter.

Sincerely,

Harvey Kurtzman

Harvey Kurtzman

PURGATORY – FROM A TRYPTICH BY HYRANIMUS BOSCH – 15ᵗʰ CENTURY.

PHOTO OF CAVE DRAWINGS, APPROX. 5000 BC, LESCAUX, FRANCE... DEPICTING TRIBESMEN OUT HUNTING WHILE THE WOMEN STAY BEHIND.

Opposite | Hieronymous Bosch Beat concept | November 1958 | Following the demise of *Humbug*, Harvey Kurtzman's savings were exhausted. Collecting unemployment compensation and desperately looking for freelance work, he turned to old friend Hugh Hefner with various pitches, one based on the premise that the Beat Generation existed throughout history. Kurtzman described his "favorite" to Hef: "Have you ever seen any of those 15th century paintings by . . . and I don't know the spelling . . . Hyronymous Busch [*sic*], of people being shoved down into hell and everybody is screaming in horror except our beat character who thinks it is all great kicks."

Above | Cave painting Beat concept | November 1958 | Kurtzman continued his Beat history pitch to Hefner: "Have you ever seen those cave drawings and Neolithic statuary of women and they're all bulbous and sagging and real as hell. . . . I'm thinking the cave drawings could be silhouettes, as they usually are and . . . the hunters are out hunting the bison and the three-toed horse and our beat character is digging the girls."

Right | Boston Tea Party Beat concept | November 1958 | A third element of Kurtzman's Beat pitch incorporated "an old political cartoon with those script balloons that come out of the mouth like smoke and read sideways. We did something like this in the last *Humbug* only we didn't spend too much time in making it authentic-looking. The balloon would give us a chance to use some bop language here . . . or rather 'beat' language." But seven months after the initial pitch Hefner rejected the proposal and Kurtzman despaired of ever working for *Playboy* again. "I'm sorry at what I sense to be the final flicker of our association," he wrote Hefner. "Trying to create for *Playboy*, I've a blind spot that I don't think I can ever overcome."

THE BOSTON TEA PARTY

ENGRAVING...STRUCK OFF IN BOSTON, 1773

MARLEY'S GHOST

In 1954 Harvey Kurtzman ambitiously tackled a graphic novel adaptation of Charles Dickens's *A Christmas Carol*. He penciled over seventy thumbnails, anticipating at least one hundred graphic pages, and finished eight sample "Marley's Ghost" presentation pages. He also had Jack Davis interpret one of his pages (see page 142), thinking that publishers might prefer Davis's more polished and commercial style to his own. Kurtzman envisioned "a large coffee table book . . . with as much of Dickens's dialogue and text as possible." He pitched the idea in a letter to Simon & Schuster, but editor Dorothy Bennett declined to meet with him. He was finally able to see "Mr. Monjo," Bennett's editorial assistant, but struck out with the underling. There is no record that a demoralized Kurtzman tried elsewhere at that time, though it may have been futile. Such a lavish comics-based book was unprecedented in the early 1950s, and would be for decades. Editors at Simon & Schuster and other publishing houses at that time were unlikely to appreciate either Kurtzman's artistic vision or his bold, expressionistic style, though one can't help but think that had young Mr. Monjo been a comics or *MAD* fan, graphic novels may have enjoyed an accelerated development.

Kurtzman tried to revive the Dickens project in 1962 with a quixotic pitch to the *Saturday Evening Post* but, not surprisingly, it went nowhere. Kurtzman blamed himself. "I never pursued anything, and that's probably been my biggest failing. I never like to sell anything. I was never a salesman. I never hustled projects the way I should have." What Kurtzman sorely needed, in retrospect, was a literary agent to be his pitchman. But literary agents, following the dollars and the marketplace, didn't seek out cartooning auteurs in Kurtzman's day. What we are left with is a tantalizing glimpse of what might have been.

H. Kurtz | THE MAD GENIUS OF COMICS

Oh but he was a tight fisted hand at the grindstone, Scrooge! a squeezing, wrenching, grasping, covetous old sinner

The cold within him froze his old features, nipped his pointed nose, shrivelled his cheek, stiffened his gait...

He carried his own low temperature with him, he iced his office in the dog-days; and didn't thaw it one degree at Christmas.

Nobody ever stopped him in the street to say, with gladsome looks "My dear Scrooge, how are you? when will you come to see me?

No beggers implored him to bestow a trifle, no children asked him what it was o'clock,...

no man or woman ever once in all his life inquired the way to such and such a place, of Scrooge.

Even the blindmen's dogs appeared to know him; and when they saw him coming on, would tug their owners into doorways...

...and up courts, and they would wag their tails as though they said, "no eye at all is better then an evil eye, dark master!"

But what did Scrooge care? It was the very thing he liked.

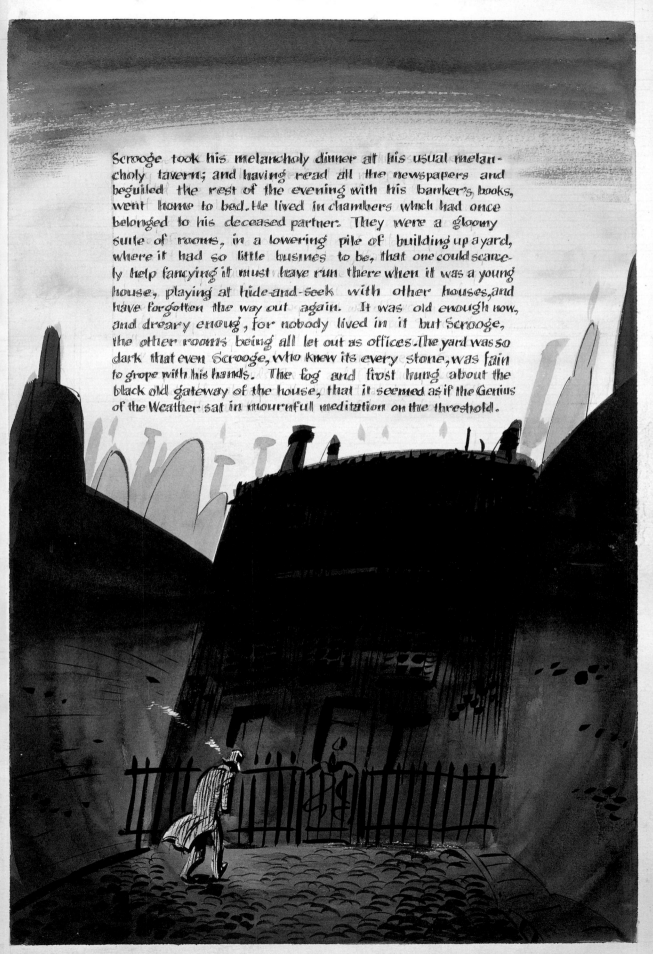

Scrooge took his melancholy dinner at his usual melancholy tavern; and having read all the newspapers and beguiled the rest of the evening with his banker's books, went home to bed. He lived in chambers which had once belonged to his deceased partner. They were a gloomy suite of rooms, in a lowering pile of building up a yard, where it had so little business to be, that one could scarcely help fancying it must have run there when it was a young house, playing at hide-and-seek with other houses, and have forgotten the way out again. It was old enough now, and dreary enough, for nobody lived in it but Scrooge, the other rooms being all let out as offices. The yard was so dark that even Scrooge, who knew its every stone, was fain to grope with his hands. The fog and frost hung about the black old gateway of the house, that it seemed as if the Genius of the Weather sat in mournful meditation on the threshold.

Now it is a fact that there was nothing at all particular about the knocker on the door; except that it was very large.

It is also a fact that Scrooge had seen it night and morning during his whole residence in that place;

...also that Scrooge had as little of what is called fancy about him as any man in the City of London...

...even including—which is a bold word—the corporation, alderman, and livery. Let it also be borne in mind that Scrooge had not bestowed one thought on Marley once his last mention of his seven years dead partner that afternoon.

And then let any man explain to me if he can, how it happened that Scrooge, having his key in the lock of the door; saw in the knocker, without its undergoing any intermediate process of change: not a knocker, but Marley's face.

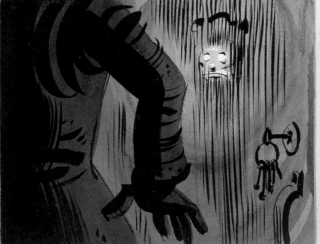
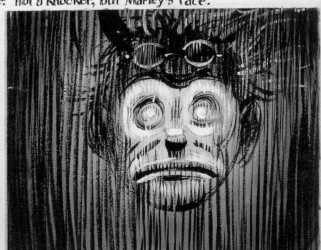

Marley's face. It was not impenatrable shadow as the other objects in the yard were, but had a dismal light about it, like a bad lobster in a dark cellar. It was not angry or ferocious, but looked at Scrooge as Marley used to look...The hair was curiously stirred as if by breath or hot air, and, the eyes were wide open, they were perfectly motionless...As Scrooge looked fixedly at this phenomenon, it was a knocker again.

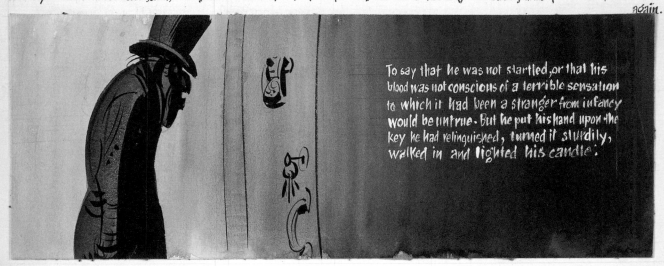

To say that he was not startled, or that his blood was not conscious of a terrible sensation to which it had been a stranger from infancy would be untrue. But he put his hand upon the key he had relinquished, turned it sturdily, walked in and lighted his candle.

He *did* pause with a moment's irresolution before he shut the door and he *did* look cautiously behind it first,

...as if he half expected to be terrified with the sight of Marley's Pigtail sticking out into the hall. But there was nothing...

...so he said "Pooh, Pooh!" and closed it with a bang. The sound resounded through the house like thunder.

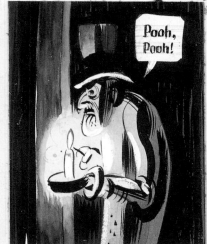

Pooh, Pooh!

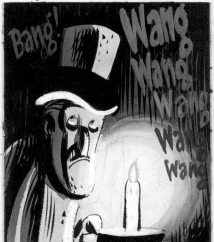

Bang!

Wang Wang Wang Wang Wang

Every room above, and every cask in the wine-merchant's cellars below, appeared to have a seperate peal of echoes of its own. Scrooge was not a man to be frightened by echoes. He fastened the door, and walked across the hall and up the stairs, slowly too, trimming his candle as he went.

You may talk vaguely about driving a coach-and-six up a good flight of stairs or through a bad young Act of Parliament; but I mean to say you might have got a hearse up that staircase and taken it broadwise. Which is perhaps the reason why Scrooge thought he saw a locomotive hearse going on before him in the gloom.

H. Kurtz & | THE MAD GENIUS OF COMICS

...you may suppose it was pretty dark with Scrooge's dip. Up Scrooge went, not caring a button for that...

...Darkness is cheap, and Scrooge liked it. But before he shut his heavy door, he walked through his rooms to see that all was right.

He had just enough of the recollection of the face to desire to do that. Sitting-room, bed-room, lumber-room. All as they should be.

Nobody under the table... nobody under the sofa... a small fire in the grate... Spoon and basin ready...

...and a little saucepan of gruel upon the hob. Nobody under the bed; nobody in the closet, nobody in his dressing gown, which was hung in a suspicious attitude against the wall.

Lumber-room as usul. Old fire-guard, old shoes, two fish-baskets, washing-stand on three legs, and a poker. Quite satisfied, he closed his door, and locked, double-locked himself in.

In an effort to sell his Dickens adaptation, Kurtzman enlisted Jack Davis to draw a "slick" and presumably more commercially appealing version of page 26 to show editors. But in 1954—nearly a quarter century before the term "graphic novel" was coined and the medium proved viable—publishers weren't interested in either artist's version of *A Christmas Carol* in this format. Nor were they any more receptive to Kurtzman's second, half-hearted pitch in 1962.

Thus secured against surprise, he took off his cravat; put on his dressing-gown and slippers, and his night-cap; and sat down before the fire to take his gruel. It was a very low fire indeed; nothing on such a bitter night...The fire-place was an old one, built by some Dutch merchant long ago and paved all around with quaint Dutch tiles designed to illustrate the Scriptures.

There were Cains and Abels; Pharaoh's daughters, Queens of Sheba, Angelic Messengers descending through the air... ...Abrahams, Belshazzers, Apostles putting off to sea in butter-boats, hundreds of figures to attract his thoughts; and yet that face of Marley, seven years dead, came like the ancient prophet's rod, and swallowed up the whole.

If each smooth tile had been a blank at first, with power to shape some pictures on its surface from his thoughts, there would have been a copy of Marley's head on every one. After several turns, he sat down again. As he threw his head back in the chair, his glance happened to rest upon a bell, a disused bell, that hung in the room...

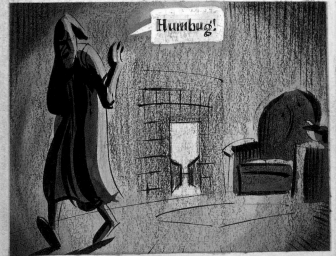

Humbug!

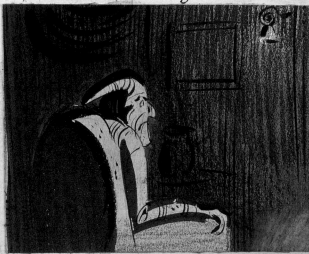

H. Kurtz + | THE MAD GENIUS OF COMICS

...and communicated for some purpose now forgotten with a chamber in the highest story...

It was with great astonishment and inexplicable dread...

that as he looked...

...he saw this bell begin to swing.

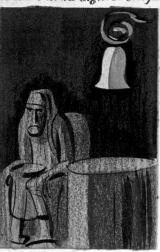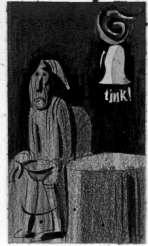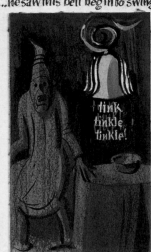

It swung softly in the outset that it scarcely made a sound, but soon it rang out loudly; and so did every bell in the house.

This might have lasted half a minute or a minute, but it seemed an hour. The bells ceased as they had begun together.

They were succeeded by a clanking noise deep down below; as if some person were dragging a heavy chain over the casks in the wine-merchants' cellar.

Scrooge then remembered that to have heard that ghosts in haunted houses were described as dragging chains. The cellar-door flew open with a booming sound, and then...

he heard the noise much louder on the floor below... ... then coming up the stairs.... ...then coming straight towards his door.

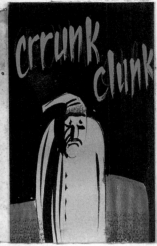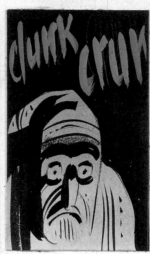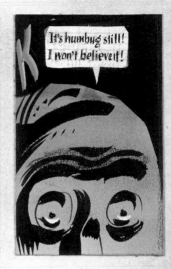

It's humbug still! I won't believe it!

His colour changed though, when, without a pause, it came on through the heavy door and passed into the room before his eyes. Upon its coming, the dying flame leaped up as though it cried "I know him! Marley's Ghost!" and fell again.

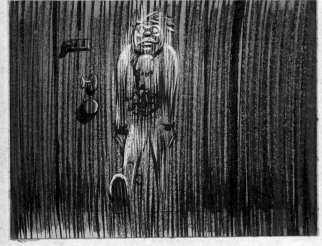

The same face, the very same. Marley in his pig-tail, usual waist-coat, tights and boots, the tassels on the latter bristling, like his pig-tail, and his coat-skirts, and the hair upon his head. The chain he drew was clasped about his middle. It was long, and wound about him like a tail, and it was made (for Scrooge observed it closely) of cash-boxes, keys, padlocks, ledgers, deeds, and heavy purses wrought in steel

THE AMORÉ CONVERTIBLE

THE HATELY-VICIOUS

SWAPPER, DELUXE

I think these people should be shorter to make the scale grooovier

SUPERIORITY COMPLEX
CONTINENTAL
THE SNOBLEY - PRETENTIOUS, SUPER

EXTROVERT

love

THE AMORÉ CONVERTIBLE ✗✗✗ 100X's

Opposite and above | Freudian cars concept drawings | 1958 | Kurtzman was fascinated with psychology and returned to the theme again and again. Trying to get freelance work in 1958, he pitched the idea of Freudian underpinnings to American cars, then at their zenith of excess. The Superiority Complex, for example, satirizes not a car but the American driver. These sketches were among many he created to establish the premise. Hugh Hefner and then low-rent *Playboy* rivals *True* and *Cavalier* all rejected the

Contact print | 1958 | This promotional photo shoot was in connection with "Conquest of the Moon," a "wacky and somewhat wobbly" ten-page feature Harvey Kurtzman (left) and Will Elder (right) created for *Pageant* magazine in the difficult aftermath of *Humbug*. The hand holding the cup and saucer was airbrushed out of the version that ran in the magazine to simulate a flying saucer buzzing the shocked artists.

Self-portraits as mug shots | 1959 | Drawn as mug shots on a "Wanted" poster for the back cover of *Harvey Kurtzman's Jungle Book*, these self-portraits, particularly the front view, have become iconic. The front view of Harvey Kurtzman has been widely used in connection with the annual Harvey Awards, presented for excellence in over twenty professional cartooning categories. The side view proves conclusively that cartoon characters are in fact two-dimensional.

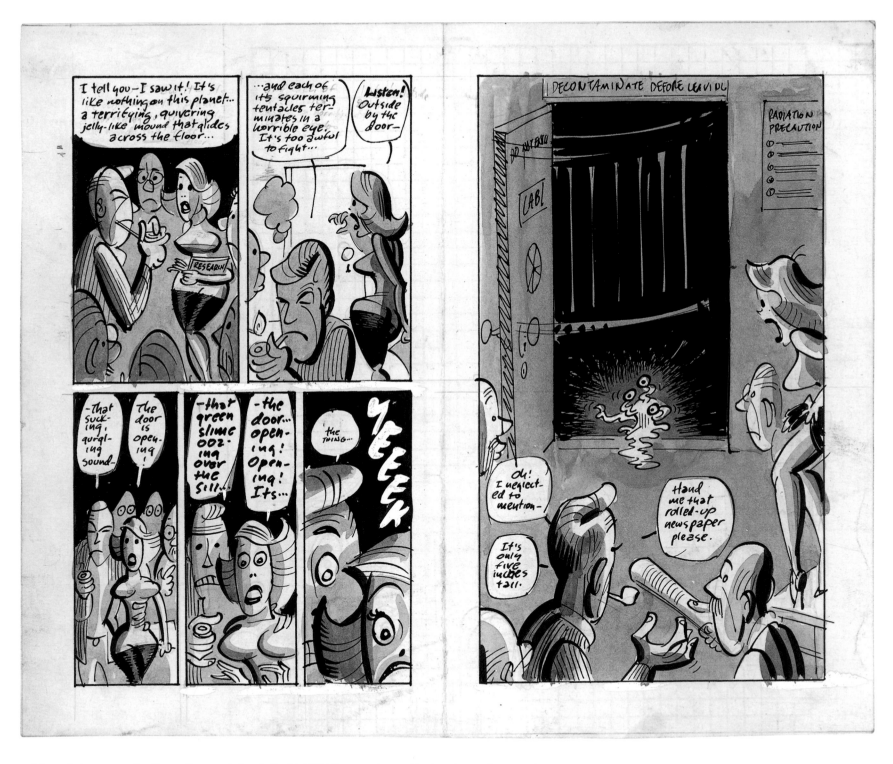

Science fiction concept for *Harvey Kurtzman's Jungle Book* | 1958 | Kurtzman, in post-*Humbug* desperation, turned to mass market paperback publisher Ian Ballantine, who had sold tons of *MAD* paperback collections. Ballantine bought Kurtzman's pitch for an original cartoon paperback based largely on Kurtzman's early *MAD* success, faith, and a few samples, including this never-before-published idea about science fiction movie clichés. The science fiction story was cut, for some reason, from what became *Harvey Kurtzman's Jungle Book*. **Opposite** | *Harvey Kurtzman's Pleasure Package* **cover** | 1959 | Had *Jungle Book* been successful, its sequel would have been called *Pleasure Package*. Nothing survives except this cover, but the teaser panel suggests that the science fiction story scuttled for *Jungle Book* would have appeared here.

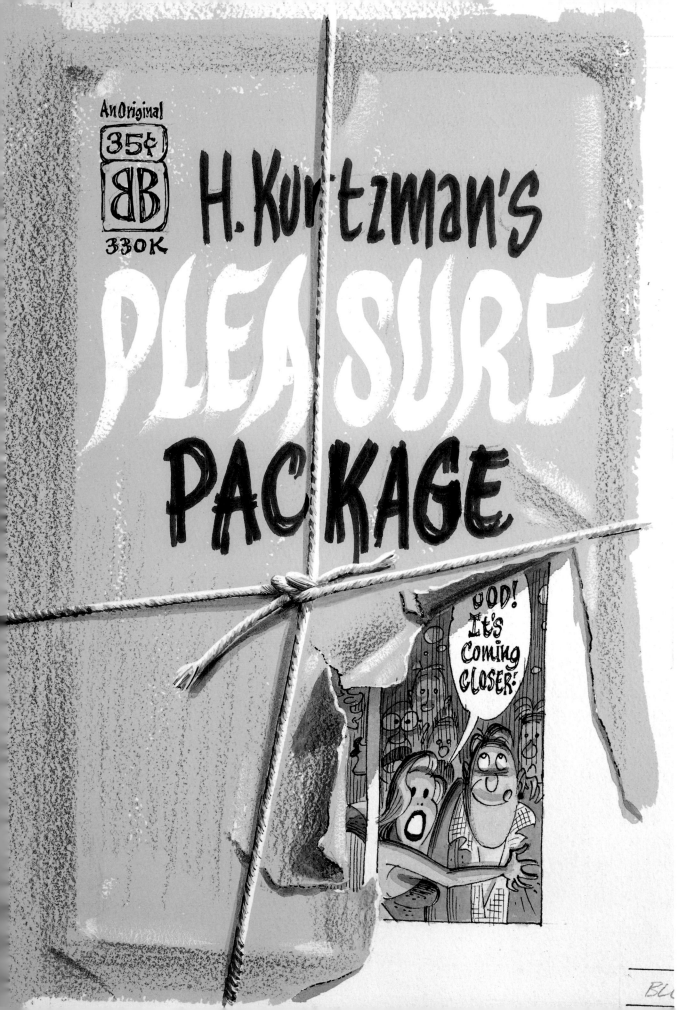

JUNGLE BOOK

By 1958, Ian Ballantine had published five extremely successful *MAD* reprint paperbacks, edited by future *Ragtime* author E. L. Doctorow, before Gaines took the future volumes over to rival Signet. Ballantine Books had also published *The Humbug Digest* paperback, with far less success. His latest magazine expired, and without prospects, Kurtzman pitched the publisher with a vague idea for an original cartoon paperback about "let's say, a western, a science-fiction story, and a big-business story [that] might purely furnish vehicles for perhaps television . . . the science race, and hidden persuaders."

Kurtzman was candid about not being able to provide much on spec because he felt that would quickly make him a "hardship case," that any failure to get an adequate advance "would mean disaster," and that he felt his idea should be accepted on "faith."

Ballantine knew Kurtzman was the creative force behind his company's perennial bestsellers, *The MAD Reader, MAD Strikes Back!, Inside MAD, Utterly MAD,* and *The Brothers MAD.* He respected Kurtzman's talent but feared (correctly as it turned out) that it was the *MAD* name that sold books, not Kurtzman's. Whether through faith or pity or both, Ballantine rolled the dice on the desperate cartoonist.

Harvey Kurtzman's Jungle Book came out in 1959 and was arguably in the finest tradition of artistic publishing experiments, but being in the form of comics, and a lowly paperback at that, it was outside all artistic expectations.

Jungle Book was the very first paperback comprised entirely of all-new art—a fascinating if ambiguous achievement at a time when paperbacks had just begun to emerge from their own pulpy background into a kind of secondary dignity (it may have been doomed for that very reason). Today it would be called a graphic novel. Virtually every author,

as well as every publisher, wanted to do well in paperback, but every author and every publisher wanted to make a mark in hardcover first, because that's how the prestige reviews were solicited, and that's where the great bulk of the company profits as well as author/artist royalties came from. *Jungle Book* suffered accordingly. As Kurtzman recalled:

> The package itself was rinky-dink. It was small and printed on bad paper, and the printing itself was two cuts under the pulps. On top of that, I did the art on sheets of blue-lined paper. It was an experiment. The printer assured me that the lines wouldn't show up, but of course they did. Still do. The gray wash reinforced the blue, and so the thing is noticeable. It was a case of experimenting with a form before all the bugs were out.

The four stories making up *Jungle Book* were surprisingly subtle, very likely too subtle for the audience of average paperback buyers, quite apart from the problems of the format. Kurtzman didn't have his eyes fixed on the dumb-ass Republicanism that liberal commentators (and Adlai Stevenson boosters) loved to criticize snobbishly during the Eisenhower years, but instead directed his gaze at the supposedly sophisticated social criticisms attempted in current novels, film, and dramatic television. At their best, these mid-century creations showed Americans incapable, indeed unwilling, to take a measure of themselves, and correspondingly eager for the feel-good version delivered in popular art. But they also usually contained large doses of liberal self-satisfaction, a key source of their popularity among the prestigious commentators of the day.

"Thelonius Violence" is ostensibly a satire of *Peter Gunn,* the popular private eye television half-hour that featured a jazz background, a hip detective—his liaison with a sexy nightclub singer was hinted at if not explored—and a friendly cop. Kurtzman abandoned everything but the protagonist and the music, engaging in a narrative/visual experiment of "rhythm and movement," recalling with pride, "I had control of this story. . . . It took me time and practice and effort to get it, but it's there." In that sense, it may escape the satirical

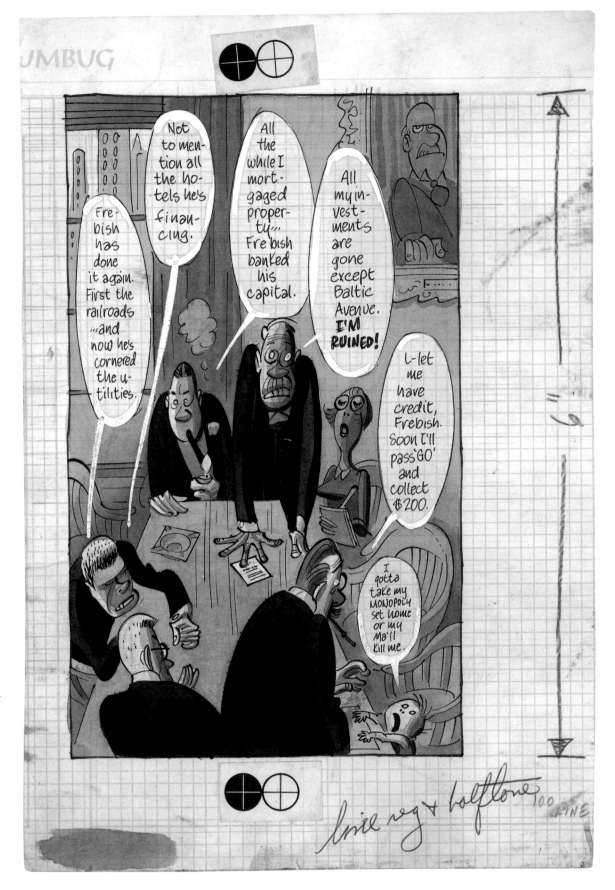

"Organization Man in the Grey Flannel Executive Suite" concept splash page | 1958 | Above is Kurtzman's first concept for "Organization Man . . ." Other than a name change (Krelm for Frebish), the published *Jungle Book* version on the opposite page is virtually identical in text and composition. But the original concept drawing is cartoonier, like the other first drafts he created for publisher Ian Ballantine. Kurtzman decided to make the characters in his final pages more angular and heavily shaded. He also, curiously, made his word balloons narrower, creating more hyphenated words that are harder to read.

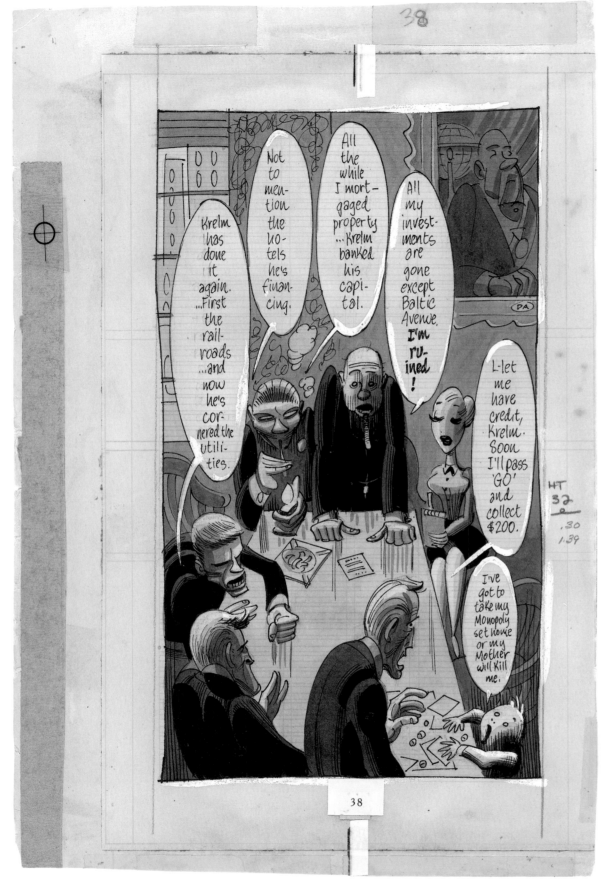

"Organization Man in the Grey Flannel Executive Suite" published splash page from *Jungle Book* | 1959 | A good deal of this story is autobiographical in nature, based on Kurtzman's experiences at Martin Goodman's Timely/Marvel publishing operation in he 1940s. Much of Kurtzman is in the character Goodman Beaver, an idealistic young man who enters the business doing crossword puzzles. The character is corrupted in this *Jungle Book* story but reemerges a short time later in the pages of *Help!* and, oddly enough, eventually transmogrifies into "Little Annie Fanny."

premise altogether, into a realm that, consciously or subconsciously, Kurtzman was intending. At its most effective he seamlessly fuses two disparate mediums—jazz and comics.

"Decadence Degenerated" perhaps offered the easiest target, because Tennessee Williams's stage reputation was at an apex, and adaptations of Williams and Faulkner had begun to infiltrate Hollywood. Kurtzman insisted that the real model was the Paris, Texas, that he experienced near his army base. "I just wanted a parody of that town. I worked from memory," especially memories of accents that he'd picked up at USO dances there. Kurtzman's fine ear for dialogue and Southern drawl is at its best here.

The sins of the South—racism and the dubious attachment to both religious claims and the purifying effects of violence—were easy for others to see at the time, of course. Kurtzman's little town had unemployed men sitting in the sun spitting tobacco juice and fantasizing about the choicest local dame; the only intellectual in town (he even had a beret) is strung up after her murder; and the sheriff is perfectly indifferent to injustice despite the presence of a truth-seeking northern reporter. In Kurtzman's twist, the lynched man is guilty not only of the single crime but of much more.

"The Organization Man in the Grey Flannel Executive Suite," featuring Shlock Publications, was the world that Kurtzman knew best (a reference to Timely in particular), and he himself is "this idiot," the young idealist who enters a career naïvely hoping to make a change in American intellectual and popular culture for the better. Here, the men are all ferocious cynics and hacks, and the women are nubile secretaries destined to be continually pursued, pinched, and propositioned. With pungent satire, Kurtzman reveals the Philistinism of "whatever sells," the mutual throat-cutting of executives, and the steady corruption of our protagonist—all of this at the heart of a business culture treating "art" and "ideas" in printed pages.

A planned sequel, *Harvey Kurtzman's Pleasure Package*, was scuttled when *Jungle Book*, though enthusiastically embraced by a new generation of cartoonists, proved a commercial dud.

Western concept for *Jungle Book* | 1958 | Unlike the discarded science fiction roughs, the Western concept not only made it into *Jungle Book*, but Kurtzman faithfully followed his initial rough layouts in the final version on the opposite page. In fact, the initial concepts, first published here, are arguably bolder and stronger in this instance than in the published version.

"Compulsion on the Range" pages from _Jungle Book_ | 1959 | The totemic TV Western _Gunsmoke_, recognizable here thanks to a rendition of Marshall Matt Dillon/James Arness, was among the more sophisticated of contemporary shows, with psychological angles alongside the predictable violence. Kurtzman pokes fun at the inevitable victory of the iconic fictional lawman, with a special ability to draw expression for motion, as if creating animation on the printed page.

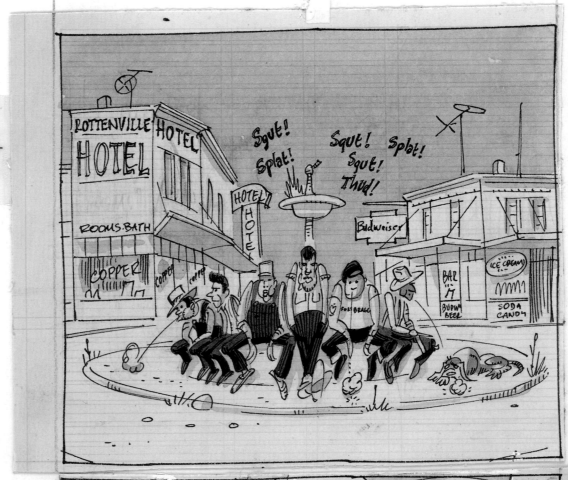

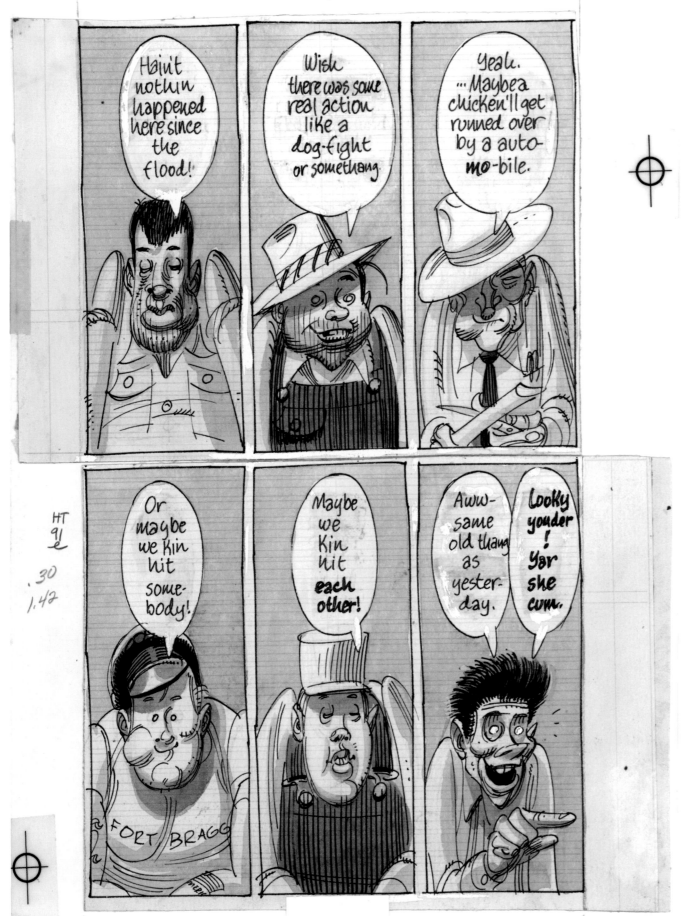

Opposite and left | "Decadence Degenerated" pages from *Harvey Kurtzman's Jungle Book* | 1959 | The setting of this story is based on Kurtzman's memories of the small-town South near his Paris, Texas, army base during the Second World War. Kurtzman's gift for dialogue and drawl is superlative here. The loafers and tobacco-chewing-and-spitting bigots represented the species of Americans that a big-city liberal disliked most. But mentally undressing approaching damsels is not unique to Southern culture, of course. However, what Kurtzman wanted to do was reveal motion, a cartoon counterpart to *Nude Descending a Staircase* or early experiments with film, counterposing the images against his satirical observations of grotesque imperfection.

Art Spiegelman noted in his introduction to the 1986 reissue of *Harvey Kurtzman's Jungle Book* that the sequence on the following spread with Honey Lou being observed, "burned itself into my impressionable eleven-year-old brain when I first saw it. . . . No, not just for the—HOO HAH!—obvious reasons, though this was Hot Stuff in 1959, but because something was happening here with the pictures, with the words, and with the pictures as words that could happen in no other medium."

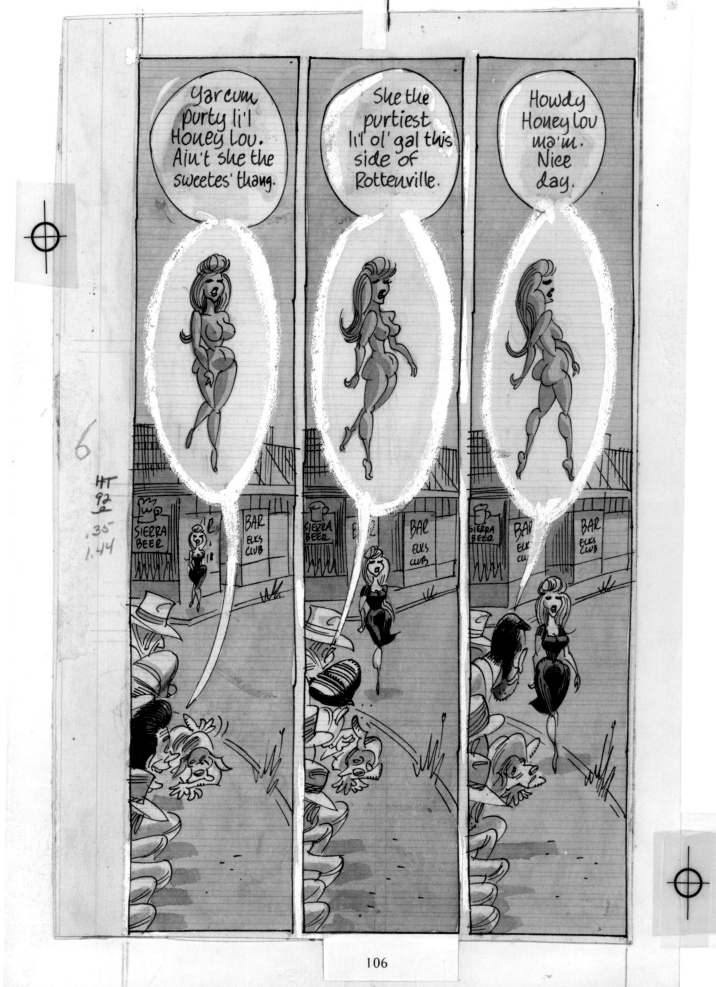

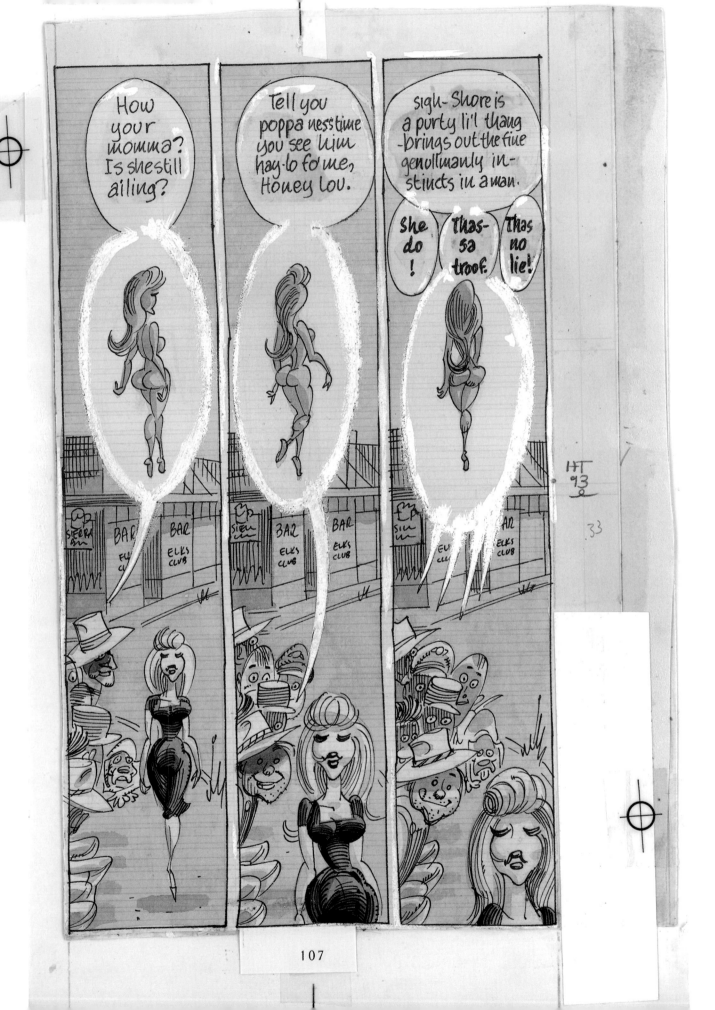

107

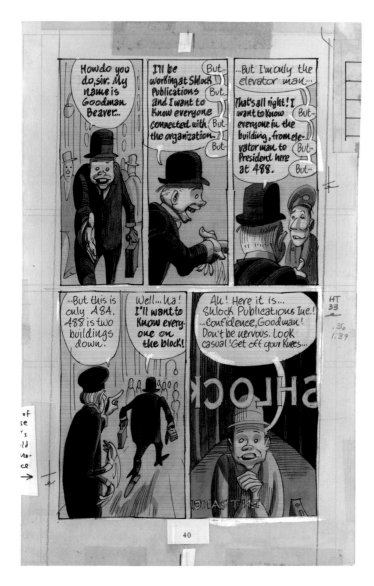

FINDING WORK WHEREVER IT WAS: 1959–61

Kurtzman did a considerable amount of free-lancing during 1959–61, including satirical writing and drawing for magazines such as *Madison Avenue, Esquire*, the *Saturday Evening Post, TV Guide, Pageant, Playboy* (for which he wrote the satirical essay "The Real Lady Chatterly"), and editing two throwaway paperbacks for Fawcett, *Favorite Westerns of Filmland*, and *Who Said That?*, a novelty photo book. Kurtzman planned and produced a newspaper strip, "Kermit the Hermit," with Elliott Caplin, but it didn't sell. His personal

files reveal one disappointment after another, especially in television, where his contacts with top humorists should have allowed him a point of entry but somehow didn't. His desperation, perhaps, was too obvious—the business culture was just as heartless as he depicted it.

While these were largely lean financial years for Kurtzman, much of the material was, of necessity, solo work, which many critics think shows Kurtzman at his finest, if most underappreciated. Much of his original art from this period, alas, does not survive, discarded or destroyed by cavalier publishers, such as the double-page illustration spreads he created for *Pageant*. An exquisite example that does survive, reprinted on pages 182–83, is an alternate version of "Times Square" from *Pageant*, which he proudly hung in his living room.

Kurtzman also did some exceptional work during this period for *Esquire*, whose editor, Harold Hayes, was a big fan. He sent Kurtzman to Ireland to do a comics impression of a James Cagney film shoot (*Shake Hands with the Devil*, 1959) and, again, to a Marlon Brando/Tennessee Williams set (*The Fugitive Kind*, 1960) and a Franz Liszt biopic (*Song Without End*, 1960).

The dark satire and assured ink-and-watercolor technique in "The Grasshopper and the Ant," published in *Esquire* in 1960, suggest what might have come in droves if Kurtzman, the fully mature artist, had not spent the last quarter-century of his career producing "Little Annie Fanny." "Grasshopper" can also be seen as an allegory. The hipster grasshopper and hard-working ant, expressing opposite views of life, are both expressions of Kurtzman himself—the offshoot of his internal conflict and monologue. Of course, it is also about the corporate world and its intersection with 1950s Manhattan bohemia.

During the summer, Grasshopper is playing the bongos and reciting his own "cool-chirping" poetry, hanging out with a butterfly babe, denouncing conformity, and renouncing the work ethic articulated by the crumb-accumulating Ant. Autumn comes, all the other insects are dead or leaving the scene ("What's happened to the art of conversation!"), and then he discovers that Ant has become a hipster eager to share

hard-earned grain during winter with his old friend. The grain turns out to be gravel, and in a single panel, they are both dead. Unhappy ending. But for all those working hard and those hardly working, it was real life. This is Kurtzmanian existentialism, quite a distance from Sartre and Camus, but inspired by the same sources and older ones as well. Why, he felt, did any real artist expect to escape from a garret and achieve recognition before the Grim Reaper added commercial value to his work?

A GRAPHIC NOVEL THAT DIDN'T KNOW WHAT IT WAS

In 1962 Kurtzman revived an ambitious project he had begun—remarkably—back in 1954. He attempted nothing less than a graphic novel adaptation of "Marley's Ghost" based on Charles Dickens's *A Christmas Carol*. He created around seventy thumbnails for a planned 100-page book, and finished seven of them on spec, in color. He also had Jack Davis reinterpret one of his pages, presuming that publishers would prefer Davis's style to his own.

Regardless of artist, the proposal was evidently viewed as outlandish, if not pretentious, to publishers like Simon & Schuster, where Kurtzman originally pitched the idea in 1954. *Classics Illustrated* had typecast comics adaptations of literary works as lowbrow bastardizations. Though Kurtzman was riding high, in some circles, with *MAD* at the time, comic books were under harsh public attack, and no respectable publisher wanted anything to do with the genre, even disguised as a 100-page book. Eight years later, Kurtzman approached the *Saturday Evening Post* and other publications—and was likewise shot down. *A Contract with God* (comprising four short pieces, like *Jungle Book*), written and illustrated by his colleague Will Eisner, would not kick-start the graphic novel revolution until 1978, and even then it took another two decades or more for the genre to gain wide acceptance.

As with most things Kurtzman attempted, he had great vision, but was too often out of step with his time.

Above | "Organization Man in the Grey Flannel Executive Suite" excerpt from *Jungle Book* | 1959 | This literal introduction of the character Goodman Beaver would not be nearly as memorable if Harvey Kurtzman had not revived the semi-autobiographic figure in several notable *Help!* magazine features and later, in the unlikely transformation into "Little Annie Fanny" for *Playboy*. Both latter incarnations featured finished art by longtime collaborator Will Elder.

the Grasshopper! and the Ant -

The vast majority of Harvey's Kurtzman's most widely known work— *MAD* and "Little Annie Fanny" and even his E.C. war comics—was collaborative. His multiple talents (editing, writing, and drawing), his heavy workload and commercial considerations, made such collaborations both practical and necessary. Many of those collaborations are among the finest examples the comics medium can offer. But many fans prefer Kurtzman's solo work, and wish he had done much more on his own. In a creative freelance spurt from 1959 to 1961, after *Humbug* and before *Help!* and "Little Annie Fanny" consumed him, Kurtzman created *Jungle Book* and other outstanding solo work, particularly for *Esquire* and *Pageant* magazines.

"The Grasshopper and the Ant," originally appearing in *Esquire* (May 1960), is a rare example of a solo Kurtzman story also created in full color (not black-and-white line art with flat comic book color added mechanically). His confident, fluid brushwork is complemented by watercolor both subtle and, defining seasonal change, bold. The cynical beatnik reinterpretation of the venerable Aesop fable stands alone, and is masterful. But autobiographic elements can be read into the story. Kurtzman had Beat friends and was attracted to the movement. Had he been younger and single, he'd almost certainly have been caught up in the artsy/jazzy philosophical Grasshopper lifestyle. But, as Art Spiegelman puts it, Kurtzman was "90 % Workaholic Ant and 10 % pure Anarchist Grasshopper," diligently working late nights to make mortgage payments and lovingly raising several children. For Harvey there was no time for bongos.

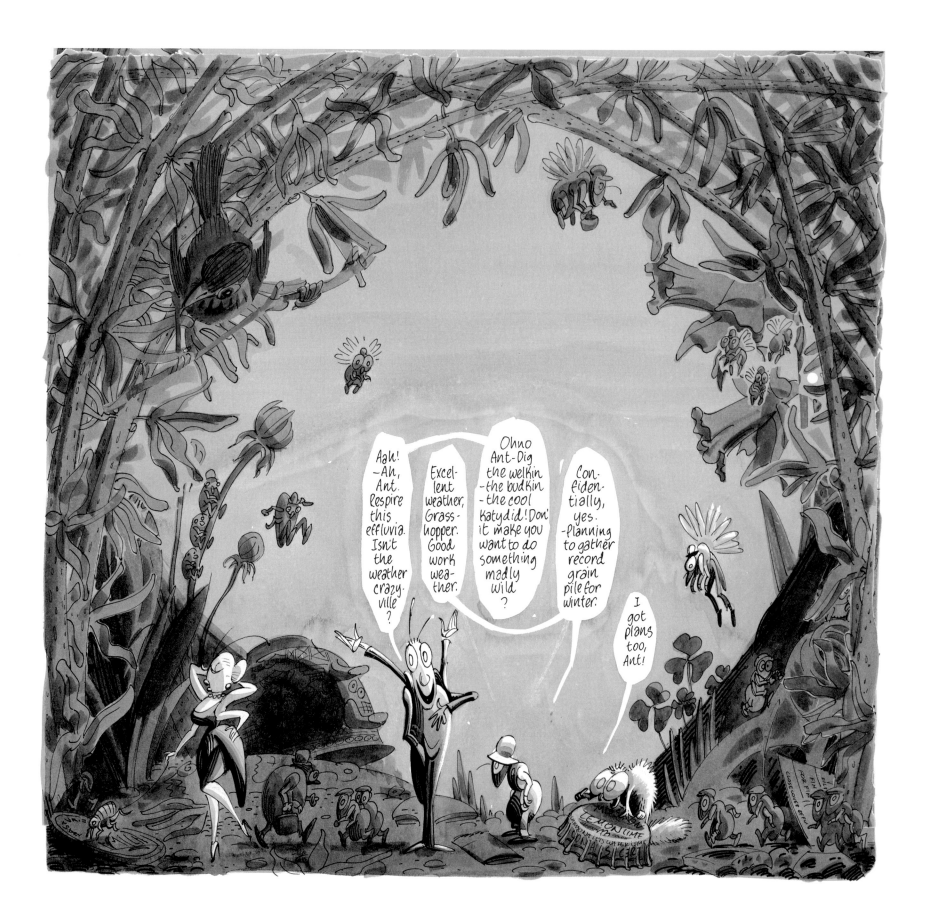

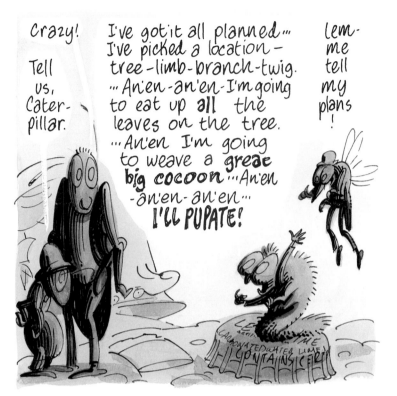

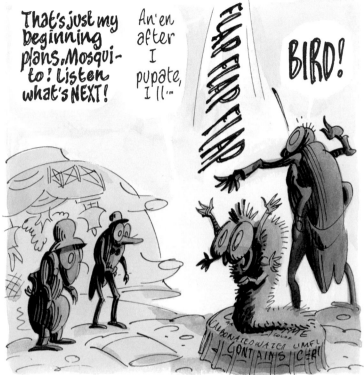

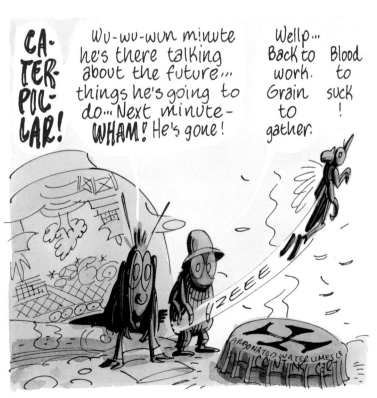

But Ant! what does it all MEAN? Should we not contemplate? —question? After all—we have BRAINS! That's what separates insects from bacteria!

SLAP!

Clomp Clomp

Yak! They got me, men!

SEE? SEE? Is gathering GRAIN—BLOOD—all there is? Must we plod the frightening stretches of the vast back-lot without meditating on the meaning of life? without THINKING?

Clomp Clomp Clomp Clomp Clomp

Gathered seven grains while you were thinking.

Clomp Clomp Clomp Clomp Clomp

Summer

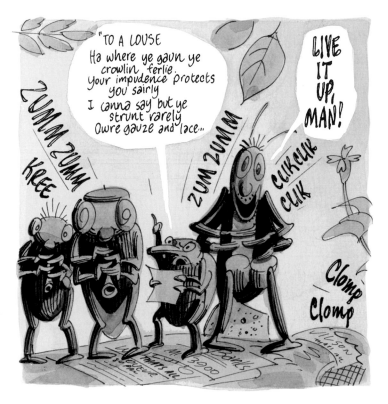

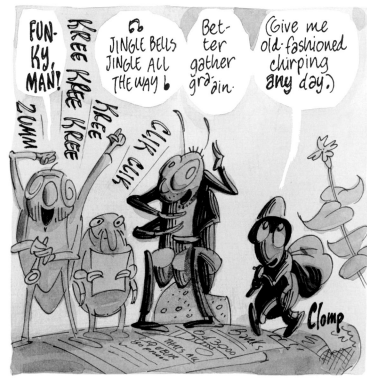

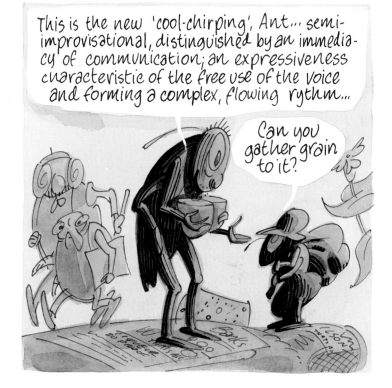

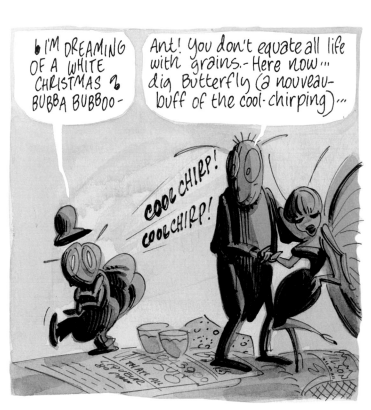

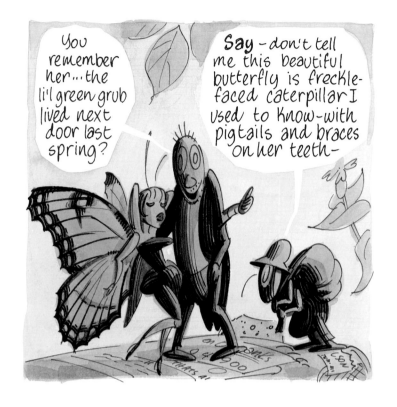

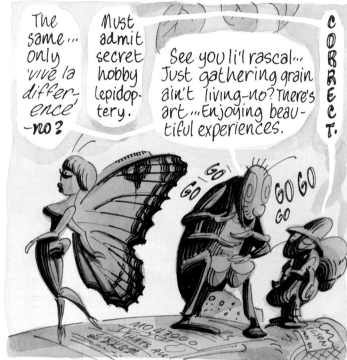

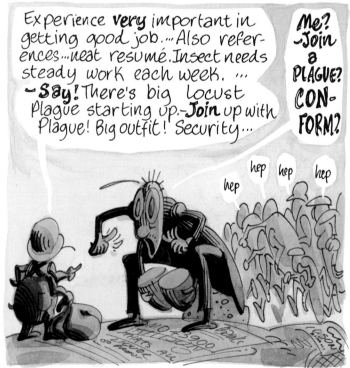

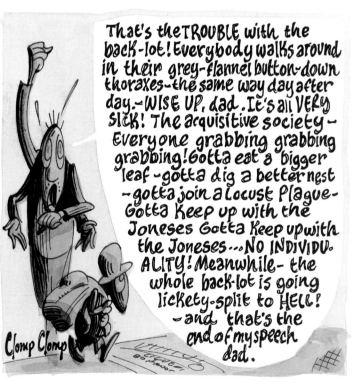

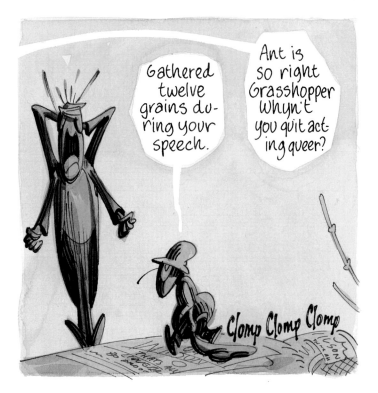

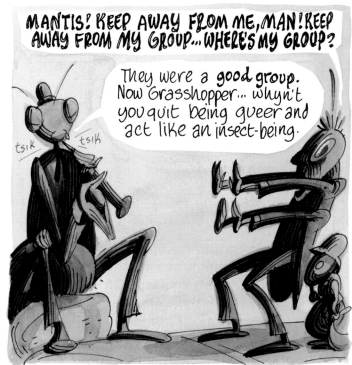

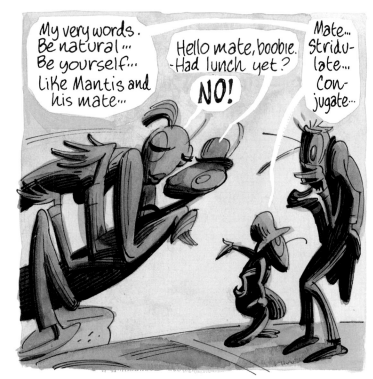

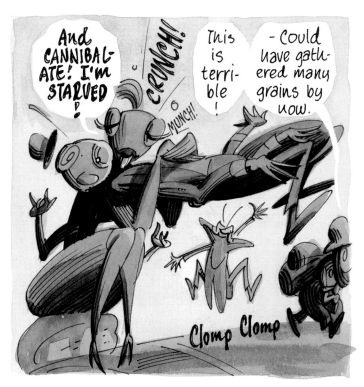

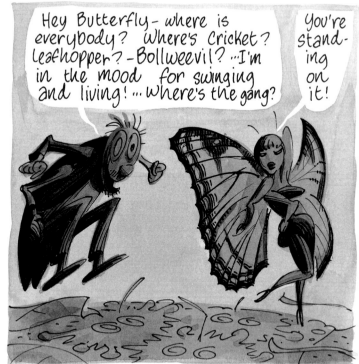

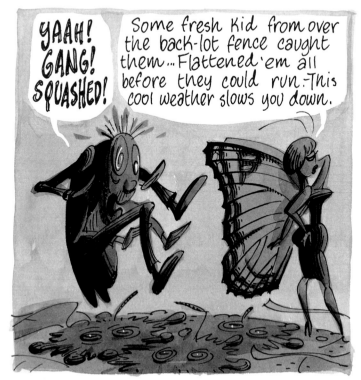

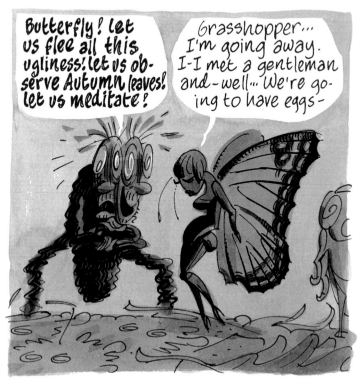

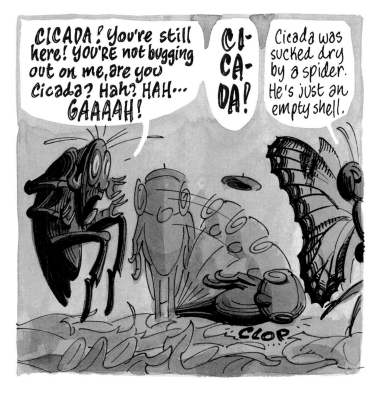

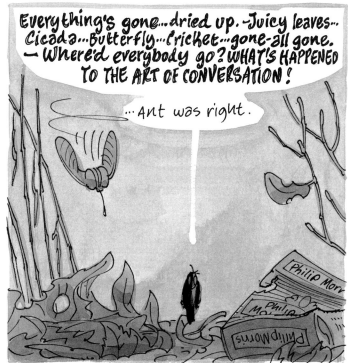

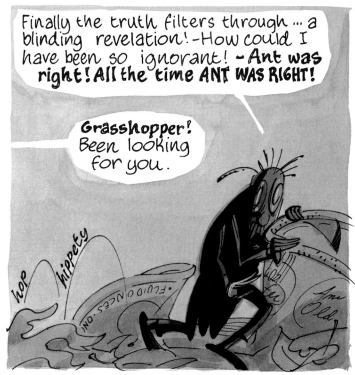

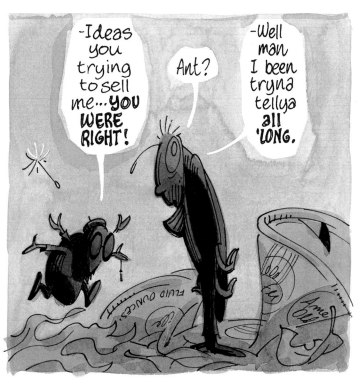

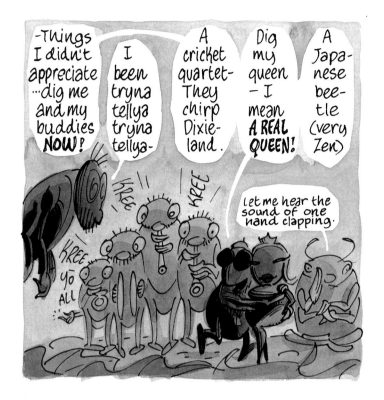

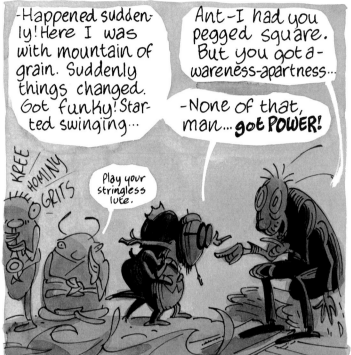

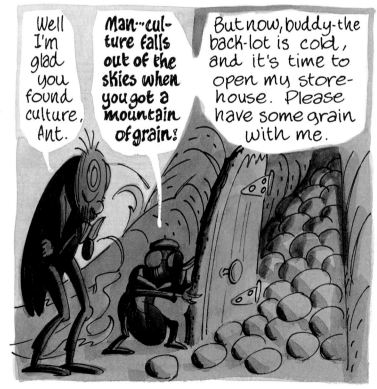

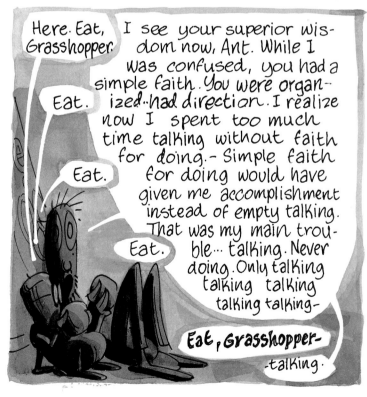

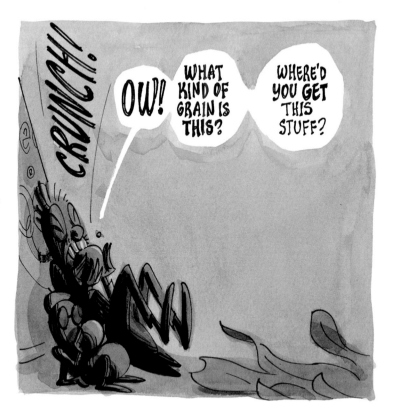

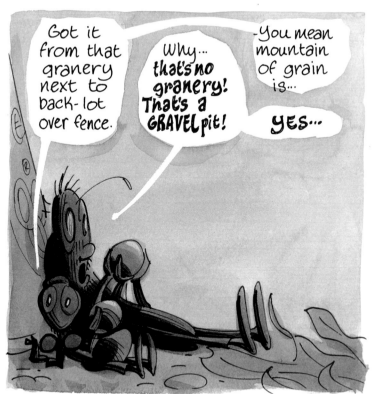

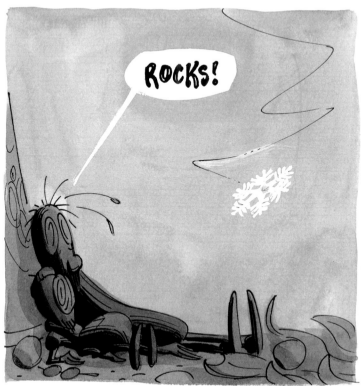

Above | *Paperback Review: Information for Advertisers* cover | Spring 1960 | Around the time Harvey Kurtzman partnered with James Warren to create *Help!* in 1960, he became briefly involved in another venture with Warren, a proposed 900,000-circulation supplement to college newspapers called *Paperback Review*. The principals, pictured on this 10 ³⁄₄ x 12 ³⁄₄ inch advertising brochure, are (standing left to right): Harry Chester, Kurtzman, an unknown woman, and Warren. Sitting is probably publisher Alan Gillespie.

Left | "The Night Club" | 1959 | *Pageant* magazine, which had sought Harvey Kurtzman since his heady days at *MAD*, was one of the patrons that helped him through his lean post-*Humbug* period with this $150 assignment. Kurtzman researched this double-page spread at The Latin Quarter at 48th and Broadway, and the resulting masterpiece appeared in the April 1960 *Pageant*. "Happiness U.S.A.!: The Night Club" displays Kurtzman's mastery of the ink-and-wash technique, and of light and shadow, composition, and lively crowd scenes. The denizens of this club aren't simply faces in a background texture. Each person, pairing, and cluster displays distinct personalities. Sight gags permeate the seeming chaos: A lecher buys a cigarette girl's entire inventory; a waitress's top falls down; a flicked cigar sets a woman's hat on fire; the roving photographer snaps the *American Gothic* couple; and a patron distracted by the showgirls stabs himself in the eye. Sadly, the original is not known to have survived and the details from this screened proof are not sharp, but even with such a handicap the panorama still shines.

I recieve in the mail-an assignment.

I am calm. ...Twenty hours later..

..Ireland! A waterproofed Englishman meets me.

He fills me in on the way to Dublin.

At a pub-I wonder what Cagney will be like.

How will he recieve me?

I finally meet Jimmy Cagney.

Cagney dances for excersize.

I dance—

the secretary dances—

The make-up man dances—

Everyone dances.

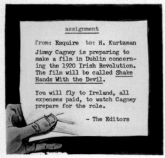
I receive an assignment in the mail.

I am calm.

I collect research—stills of Cagney.

I find some marvelous stills . . .

—not of Cagney, but I collect them anyhow.

Ireland! A waterproofed Englishman meets me.

He fills me in on the way to Dublin.

I wonder what Cagney will be like.

How will he receive me?

I finally meet Jimmy Cagney.

Cagney dances for exercise.

I dance —

Opposite | Layout for "Assignment: James Cagney in Ireland" | 1958 | In his initial layouts, Kurtzman arrives in rainy Ireland in the third panel, but for the final version he inserts a three-panel joke about movie stills that pushes the original layout forward.

Left | "Assignment: James Cagney in Ireland" | *Esquire* | April 1959 | Page two of four.

I go with Cagney to a hurling match.

Men strike each other with hockey sticks.

Excitement mounts.

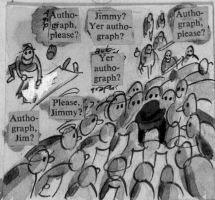

The crowd reaches a fever pitch.

We leave as the action subsides.

Next day - I tell Cagney a joke.

I display my command of Yiddish.

Cagney has some knowledge of the language.

Later, I watch them inspecting locations.

Director Mike (around the World in 80 Days) Anderson.

— has problems

The secretary dances —

The make-up man dances —

Everyone dances!

We rest.

I go with Cagney to a hurling match.

Men strike each other with hockey sticks.

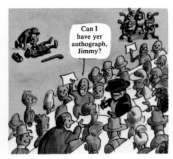

Excitement mounts.

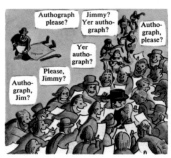

The crowd reaches a fever pitch.

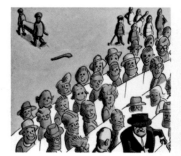

We leave. The action subsides.

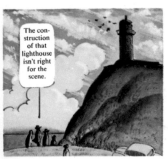

Later, I watch them examine locations.

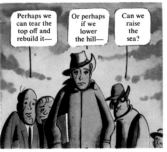

Director Mike (Around the World in 80 Days) Anderson

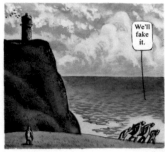

has problems.

Opposite | Layout for "Assignment: James Cagney in Ireland" | 1958 | After inserting three panels of stills on the finished second page and a additional panel to the dance routine on the third page, Kurtzman must cut four panels. He jettisons a sequence where he tells James Cagney a joke in Yiddish and the actor responds in fluent Hebrew. Cagney, a social rebel of 1930s Hollywood who turned cautious with his skyrocketing fame, retained a bit of an edge or perhaps came back to it near the end of his career. Kurtzman must have felt some warmth toward the Irish-American who spoke Yiddish and was caught in the clichés of Hollywood film production.

Left | "Assignment: James Cagney in Ireland" | *Esquire* | April 1959 | Page three of four.

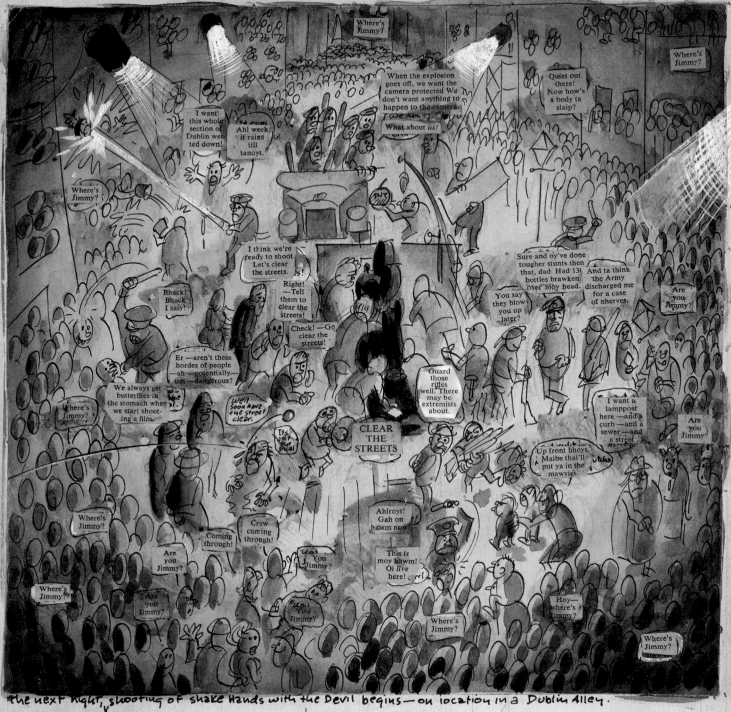

the next night, shooting of Shake Hands with the Devil begins—on location in a Dublin Alley.
all night,

Meanwhile, where is Cagney?

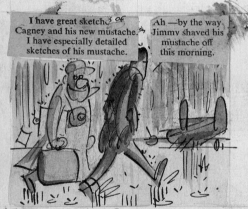

In the morning, I leave Ireland.

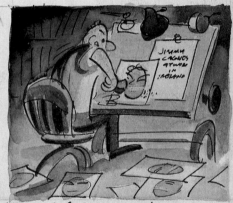

Home—End of trip—beginning of story.

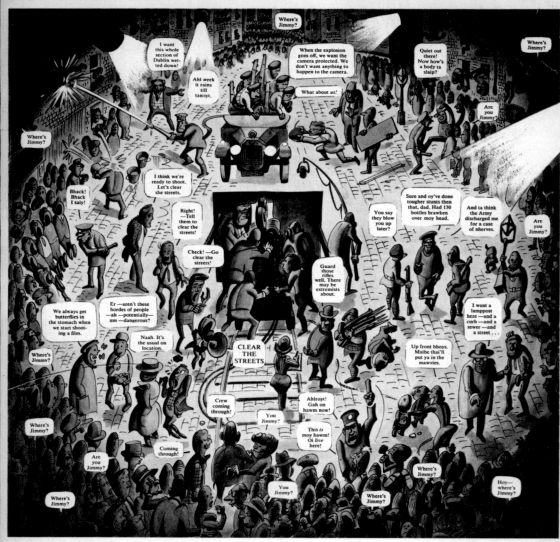

The next night, all night, shooting of Shake Hands With the Devil begins on location in a Dublin alley.

Meanwhile, where is Cagney?

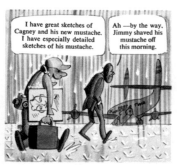

In the morning I leave Ireland.

Home — end of trip — beginning of story.

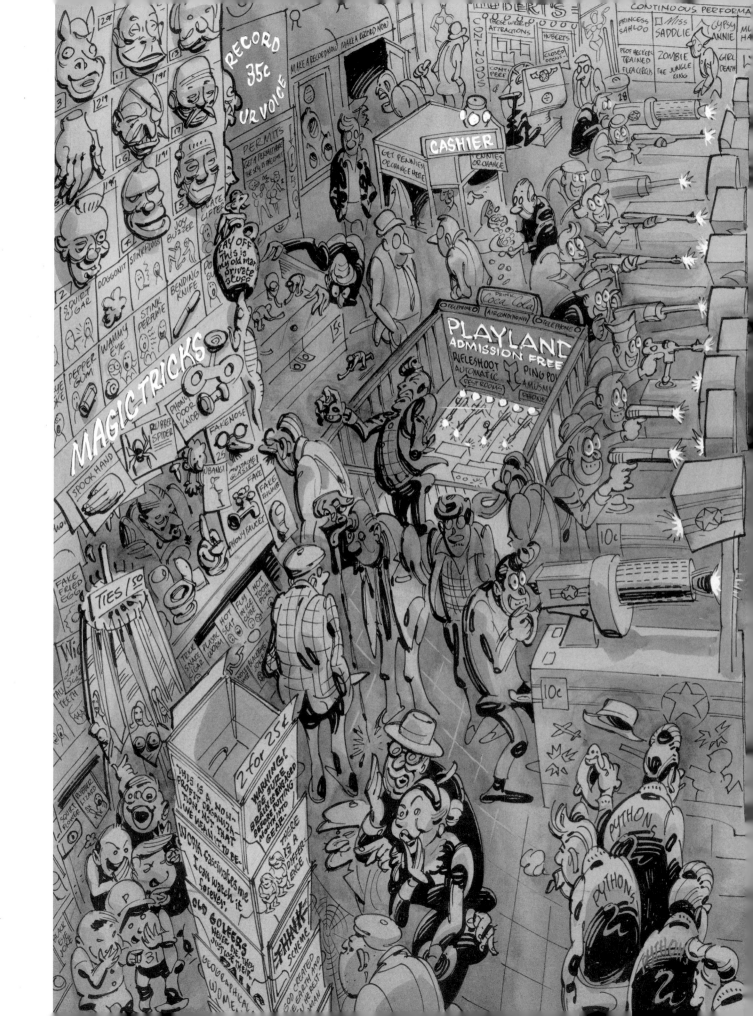

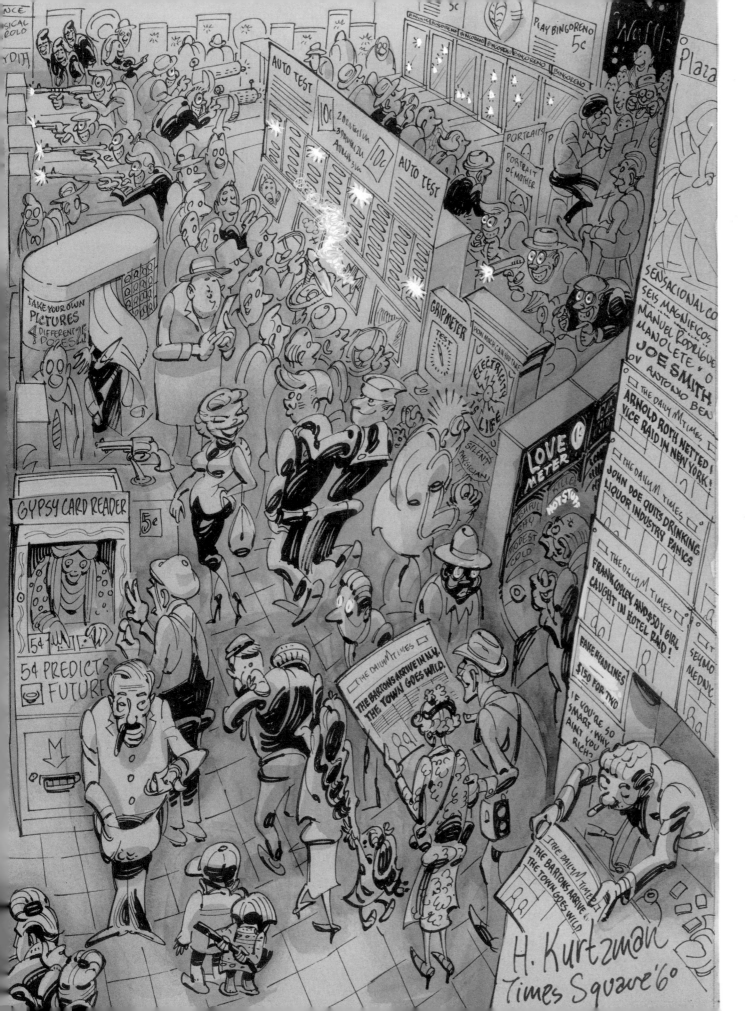

"Times Square" | 1960 | Another *Pageant* assignment took Harvey Kurtzman to Times Square to research a spread called "Happiness U.S.A.!: The Penny Arcade" for the magazine's October 1960 issue. Kurtzman took Polaroid photos of tacky Americana—Ubangi masks, naughty slogan signs, fake newspaper headlines, joy buzzers, and of course arcade games—incorporating them into this complex bird's-eye view. *Pageant*, which didn't return Kurtzman's art, ran a cropped variant of the image that appears here. This version, either a first draft or a *Pageant* reject, was retained by Kurtzman and hung in his living room for the rest of his life. It remained unpublished until he authorized a signed and numbered lithograph in 1973, one of the few such prints he consented to.

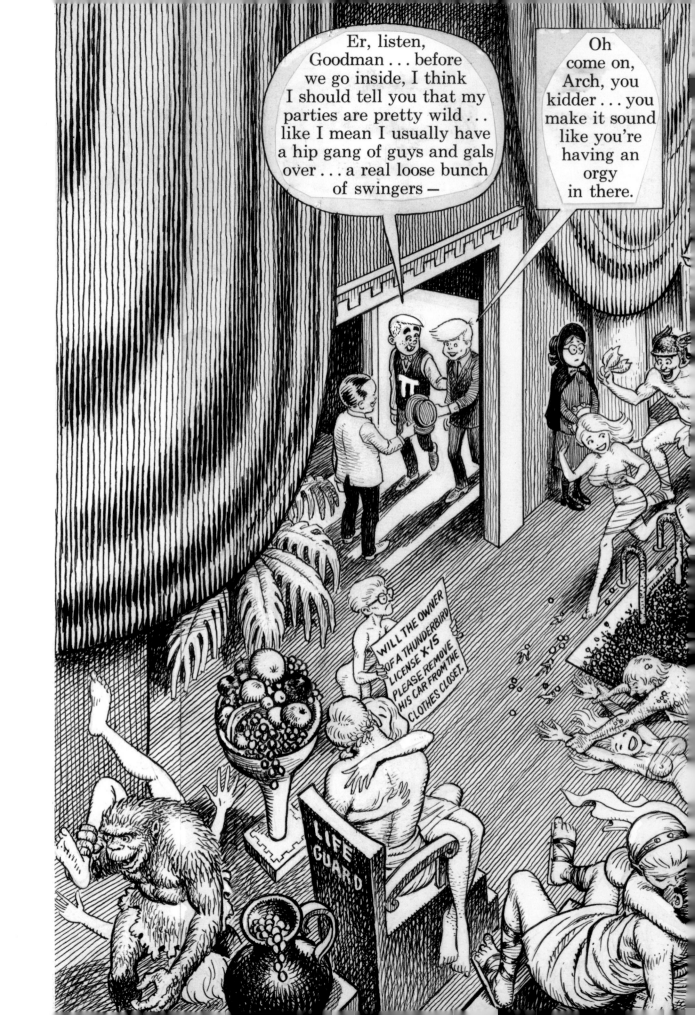

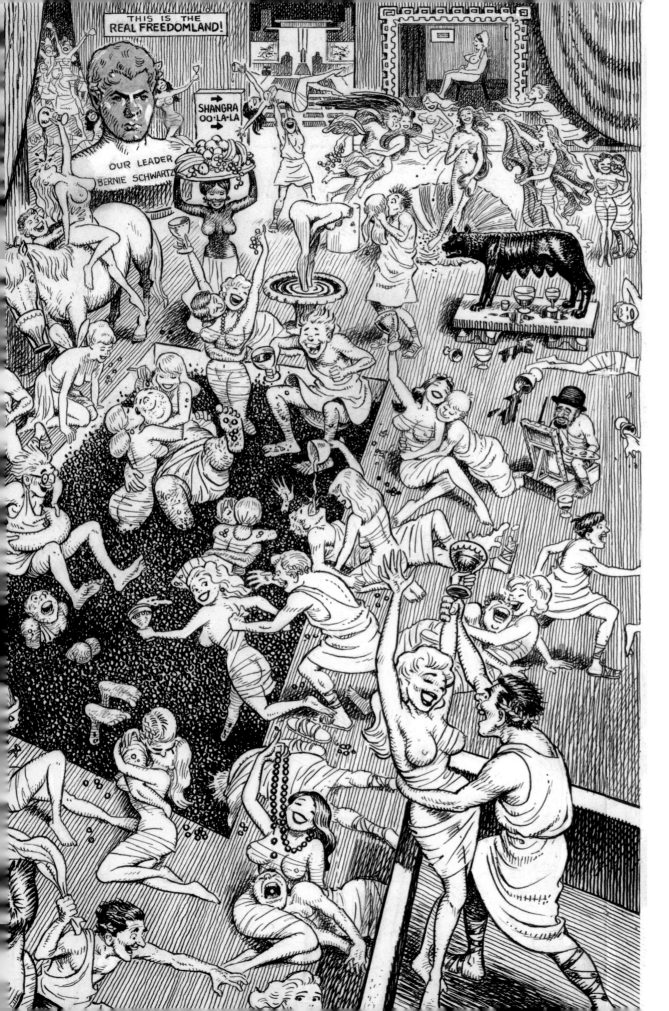

"Goodman Goes *Playboy*" orgy scene | 1961 | The cover of *Help!* vol. 2 no. 1 (February 1962) boldly proclaims, "Hey! Boys and Girls! ADULTS ONLY!," but the tongue-in-cheek disclaimer was not without merit. Kurtzman satirized the *Playboy* lifestyle using the Archie cast as victims of the hedonistic allure. Ironically, Hugh Hefner (though depicted as Satan elsewhere in the satire) was highly amused and soon hired Kurtzman to produce "Little Annie Fanny" (Goodman with a gender change) while the humorless owners of Archie comics sued *Help!* and the artists. This famous orgy scene, expanded in dimension like the "S*perm*n" example on the following page to fit the paperback proportions of *Executive's Comic Book*, was quite risqué for its day—so risqué that the nipples were deleted in both earlier incarnations.

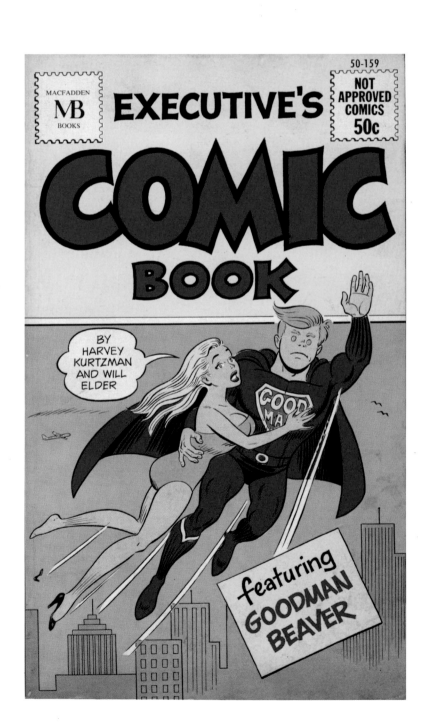

Right | *Executive's Comic Book* | **1962 |** MacFadden Books published this collection of four Goodman Beaver stories (including the infamous "Goodman Goes *Playboy*") after they appeared in *Help!* But because the proportions of the paperback format did not make for an easy transition from the square-ish original panels, Will Elder painstakingly extended the bottoms of the individual panels to closer fit the paperback pages.

Far right | "Goodman Meets S*perm*n" splash | **1962 |** This marvelously detailed splash panel leads off Kurtzman and Elder's spoof of Superman: not the Superduperman of *MAD*, but a cynical hero who drops out of saving the world (until he meets naïve optimist Goodman Beaver). The story appeared in *Help!* vol. 2 no. 3 (August 1962). Will Elder described this story and splash as "Marx Brothers on paper. You never knew what to expect. There were things coming in from all over. But that was constantly entertaining. The people loved it—they were never bored." The panel shown here, containing more detail than the *Help!* version, was expanded to fit the *Executive's Comic Book* paperback.

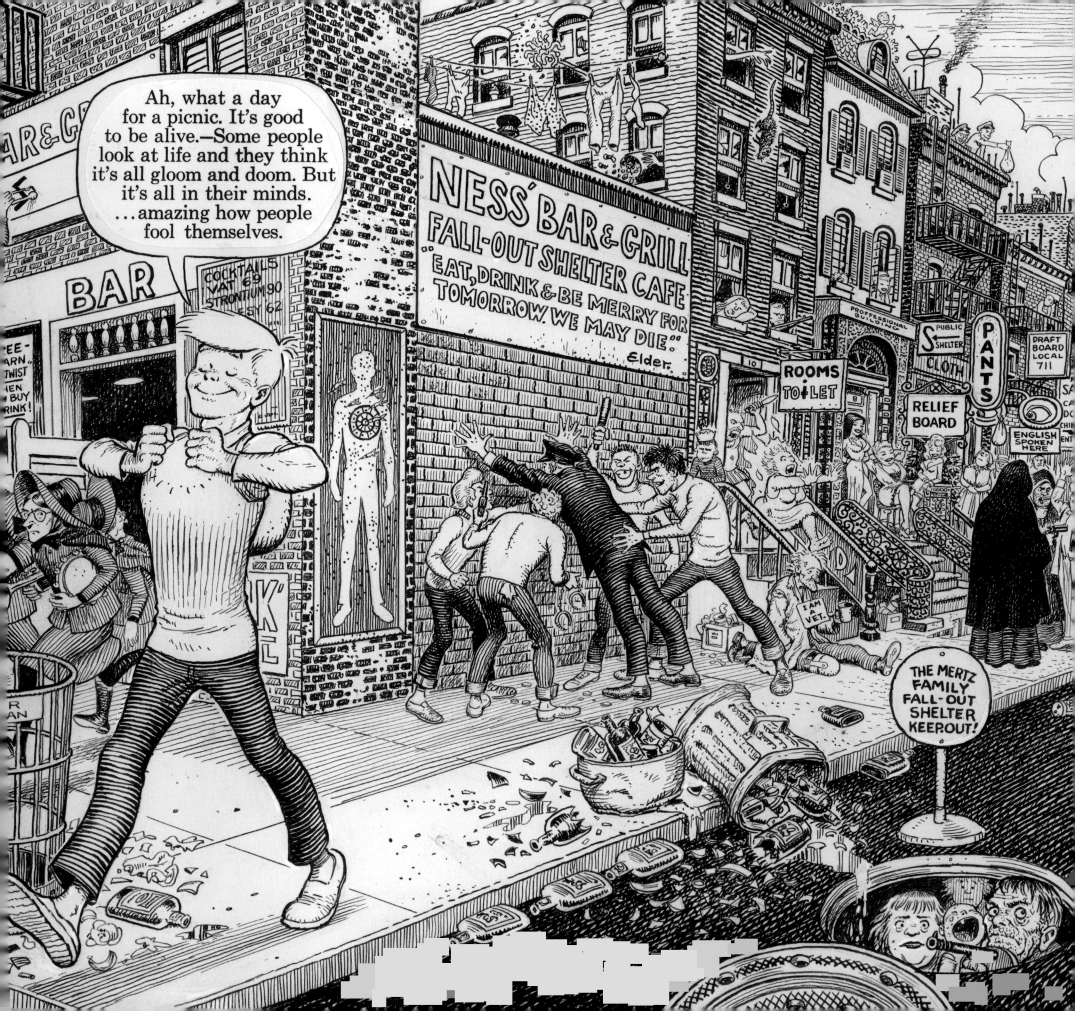

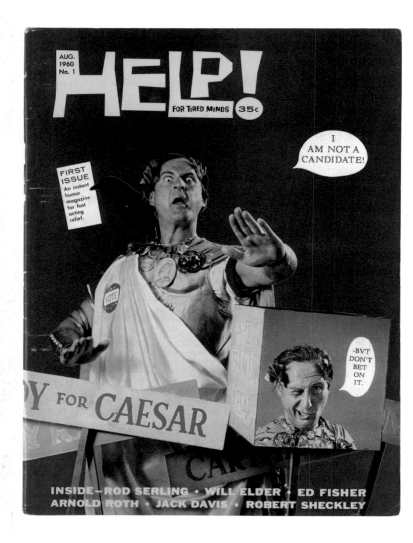

Above | *Help!* no. 1 cover | August 1960 | Early covers of *Help!* featured celebrities, generally comedians, often recruited by Kurtzman's persuasive assistant editor Gloria Steinem. This cover, hitting stands in the midst of the John Kennedy/Richard Nixon presidential race, featured Sid Caesar playing his Roman namesake.

A FINAL HELPING OF MAGAZINE

The failure of *Humbug* and the disappointment of *Jungle Book* threw Kurtzman, full of energy and not yet forty, back into the pulps with a vengeance. He dreamed up another humor magazine, and in 1960 partnered with James Warren, whose repertoire included horror fan magazines and other low-level denizens of the distinctly non-slick newsstand pulps. Co-owning *Help!* with Warren gave Kurtzman the ultimate control he had sought at *MAD* while also assuring that someone else ran the business side. *Help!* lasted five years, a good run for Kurtzman.

Help! drew to Kurtzman a staff that included future feminist superstar Gloria Steinem, film director Terry Gilliam, cartoonist R. Crumb, and on a more casual basis, public comic celebrities of the day including Orson Bean, Tom Poston, Dick Van Dyke, and a young Woody Allen. It brought Gilliam and John Cleese together, establishing the relationship for the future *Monty Python's Flying Circus,* the biggest development in Anglo-American comedy after *MAD* and a decade before *Saturday Night Live.* If this weren't enough, *Help!* reinvented a comic form for the sake of American readers, and reintroduced as a key protagonist who evolved into Little Annie Fanny.

Genius was, as always in Kurtzman's career, born of necessity. With a tight creative budget, Kurtzman adapted a format hugely popular in Italy since the 1940s, and increasingly so in France, Spain, and much of Latin America. The *fumetti,* photo sequences in picture-stories that mimicked comics panels, offered a satirical framework, sometimes even enticing stand-up comedy and television personalities to take part. Kurtzman paired these celebrity features with old silent and obscure film stills or news photos, captioned in unpredictable ways with word balloons.

Kurtzman notably solicited for *Help!* the work of college humorists, including Gilbert Shelton, soon to become one of the key underground cartoonists (*The Fabulous Furry Freak Brothers*), and he featured the work of a distinctly non-collegiate protégé, Robert Crumb. Kurtzman developed a special affinity for Crumb, sending him on cartoon assignments to Harlem and, strangely, to Bulgaria on his honeymoon.

The cartoons and comics drawn by these young men were deeply sarcastic, sometimes openly anti-clerical, and presaged the under-ground comix that would spring forth in the late 1960s. At least in the crucial cases of Crumb and Shelton, Jay Lynch, Skip Williamson, and Joel Beck, *Help!* was the catalyst for their own personal comix, which were actually set off by a wave of counterculture, mega-spectacle rock concerts (with a need for posters), and the briefly ubiquitous underground press. A *MAD* comics cover had once joked, as the congressional investigations neared, that comics were going underground. And they were about to.

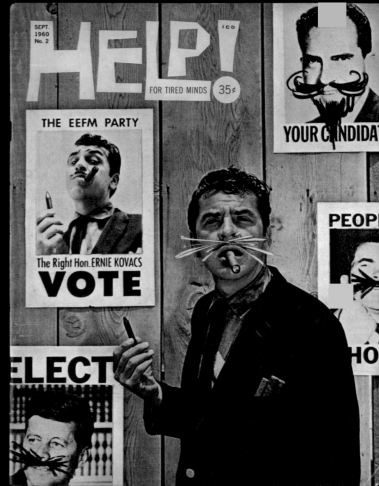

Left | Help! no. 1 cover rough | 1960 | Harvey Kurtzman gave satire magazines a fourth and final try, forming a corporation with James Warren in 1960 to launch *Help!* Though they jointly owned the publication, a somewhat savvier Kurtzman personally owned everything he himself created for *Help!*, such as Goodman Beaver. The magazine combined new and vintage cartoons, *fumetti*, text pieces, and archival and news photos with word balloon captions. Unlike all earlier Kurtzman magazine efforts (except *Humbug* no. 10), every issue of *Help!* had a photographic cover. That didn't stop Kurtzman from creating compositions like this to direct the photographer and models.

Above | Help! no. 2 cover | September 1960 | Continuing the election campaign theme, comedian Ernie Kovacs gets tit for tat.

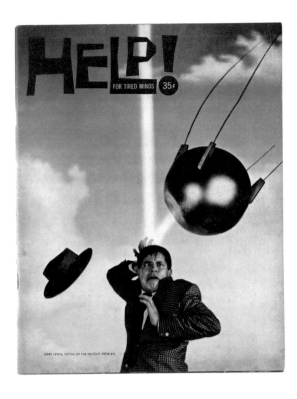

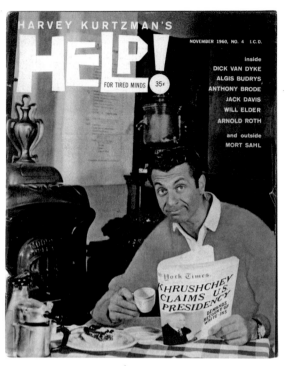

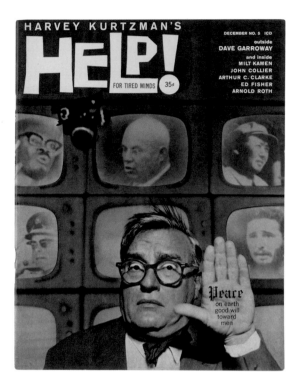

These combined ploys accomplished their immediate purpose: They filled many of the pages of *Help!* cheaply or for free. By 1970, when underground culture was full-blown, *Help!* would seem to many former subscribers and fans at once passé and, in retrospect, hugely promising. Crumb alone had created for himself hundreds of thousands of readers, and not only in the United States.

In France, thanks in part to the May 1968 uprising of students and workers, *fumetti* that looked like they might have come out of *Help!*'s ridicule of authority became a major form of political art—the artistic expression of students ridiculing their elders in ways that echoed Kurtzman but by now made him nervous. Once again, he had shown that something altogether remarkable was possible, but he gained precious little for himself in the process. It was as if Fate had spoken. Again.

But this all could be seen most clearly, of course, in woeful retrospect. Kurtzman had hoped for better. The first issue of *Help!* (August 1960) opened with Sid Caesar on the cover, dressed as the original Roman emperor, but in this case running for office as a typically oily American politician. The teaser at the bottom boasted of TV super-auteur Rod Serling, popular sci-fi writer Robert Sheckley, and a big four of artists (Will Elder, Jack Davis, Arnold Roth, and Ed Fisher). The mini-masthead inside revealed a mere four people at work: Kurtzman as editor, Warren as publisher, Gloria Steinem as editorial assistant, and Harry Chester as production manager.

The *fumetti* style that became the *Help!* signature did not actually appear until the third issue (October 1960). "On the Coney," by Ed Fisher, satirized *On the Beach*, with a decisive twist. The last woman on Earth, presumably mated to the last man (after he murders his rival), turns out to be a transsexual, back from surgery in Sweden, à la Christine Jorgenson.

Help! also boasted comics reprints, including excerpts from *Jungle Book* and a pantomime comic strip Kurtzman was never able to place. European cartoon work, such as Albert Dubout's crowd scenes of the French in their cities and on vacation, were matched in later issues with American classics like Thomas Nast, or more recent but unavailable material like Milton Caniff's risqué "Male Call" and Will Eisner's "The Spirit." Kurtzman had begun a process of recuperation of comics art from earlier generations, destined to become a major phenomenon of postmodernism and of particular importance for comics art because so little revival was done until the 1970s (and continuing through the present with books such as this Kurtzman biography).

Covers of *Help!* featured Sid Caesar, Ernie Kovacs, Jerry Lewis, Mort Sahl, Dick Van Dyke, Dave Garroway, Jonathan Winters, Jackie Gleason, and even Hugh Downs, demonstrating how much cachet Kurtzman had (Gloria Steinem was also reputedly hyper-persuasive with these actors' agents). *Help!* was not only daring, within limits, it was also "connected." How daring was properly tested not so much by sex or even religion but by Kurtzman's second and third round with the gatekeepers and censors of the publishing industry itself.

Above left | *Help!* no. 3 cover | October 1960 | Satellites were still a novelty when they buzzed the "September Morn" girl on the cover of *Humbug* no. 7 in 1958. But by 1960 satellites were so commonplace that they were falling on Jerry Lewis's head. **Above middle** | *Help!* no. 4 cover | November 1960 | For the third time in the first four issues, the presidential campaign inspires the cover topic. Political satirist Mort Sahl fittingly holds an issue of the *New York Times* with a famous Cold War headline. **Above right** | *Help!* no. 5 cover | December 1960 | Dave Garroway, long-running host of TV's *Today* show, provides the Christmas message against a backdrop of threatening world figures. Kurtzman had ongoing conversations with Garroway about work opportunities after *Humbug* collapsed, but ultimately nothing happened.

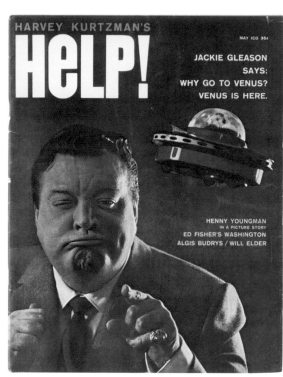

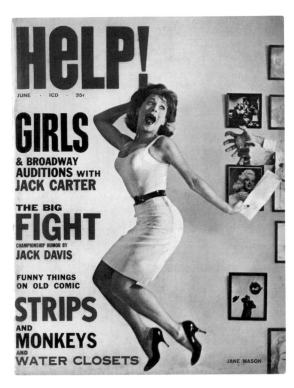

Top left | *Help!* no. 6 cover | January 1961 | Jonathan Winters finds it hard to celebrate the New Year with atomic warfare omnipresent. **Top middle** | *Help!* no. 7 cover | February 1961 | Comedian Tom Poston evokes the Valentine's Day Massacre to usher in February. **Top right** | *Help!* no. 8 cover | March 1961 | Low-key television personality Hugh Downs graces a *Help!* cover. **Bottom left** | *Help!* no. 9 cover | April 1961 | Husband and wife entertainers Phil Ford and Mimi Hines team up for a "kissie" cover, a curious *Help!* tradition in which young male readers theoretically kissed a photograph of a sexy woman. The ninth issue switched from newsprint interiors to the kind of slick paper Kurtzman cherished, making the photographs and art much sharper than before. This experiment was to last only a single issue (no doubt after Jim Warren paid the printing bill). **Bottom middle** | *Help!* no. 10 cover | May 1961 | TV star Jackie Gleason was a fitting subject for a flying saucer cover since he was an ardent believer in UFOs. With the tenth issue the page count dropped from sixty-four to forty-eight. **Bottom right** | *Help!* no. 11 cover | June 1961 | Jane Mason, a Broadway and Hollywood actress, not only accepted the cover girl assignment, but co-starred in this issue's *fumetti* with comedian Jack Carter.

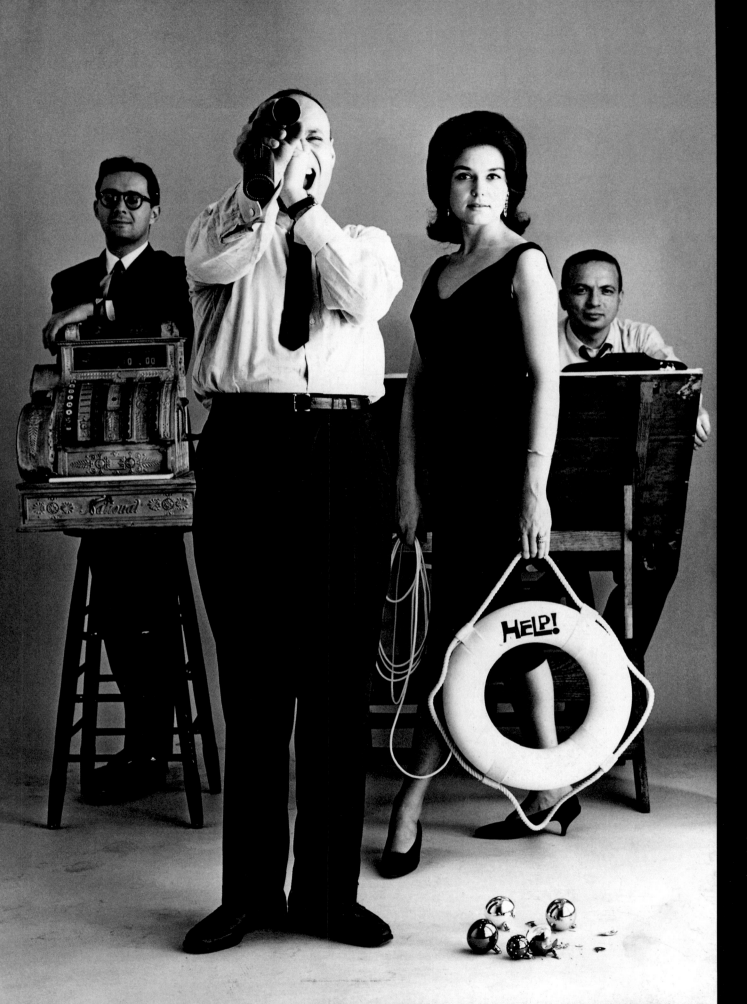

Help! **staff photo | 1961 |** Charting the course of *Help!* In this photo, which originally ran in the April 1961 issue, are publisher James Warren, with the cash register; editor Harvey Kurtzman, as the visionary; assistant editor Gloria Steinem, with the life saver; and production manager Harry Chester at the drafting board. Who could have guessed that within a short time Gloria Steinem would become an undercover Playboy bunny, a leader of the women's liberation movement, and founder of *Ms.* magazine?

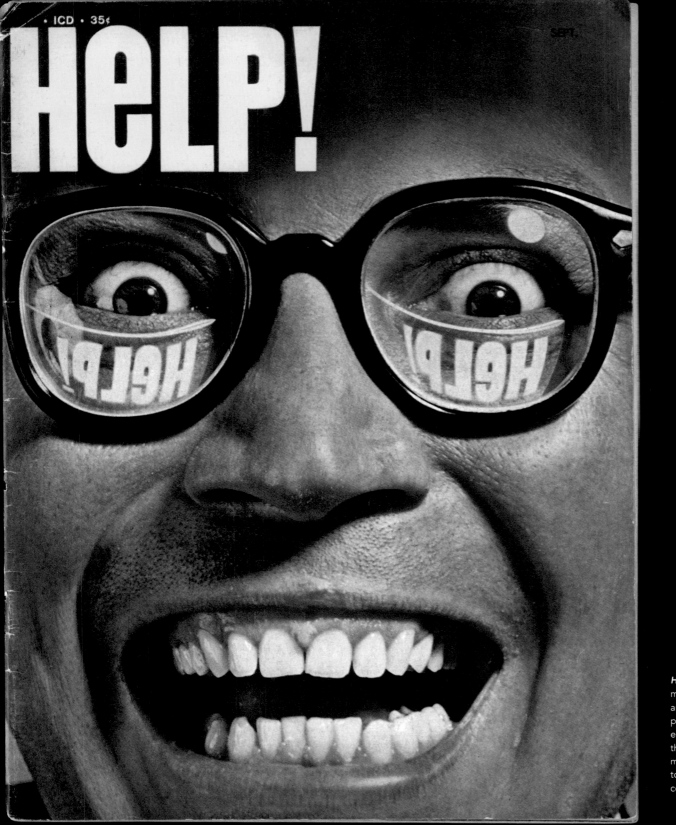

Help! no. 12 cover | September 1961 | With this issue the monthly magazine abruptly switches to a quarterly schedule and the celebrity covers cease and design-heavy covers predominate. Chuck Alverson became the new assistant editor and Gloria Steinem moved on, though remaining on the masthead for a while as a "contributing editor." The magazine's slowdown coincided with Kurtzman's own efforts to find greener pastures. By late 1961 he was having serious conversations again with *Playboy* about a new venture.

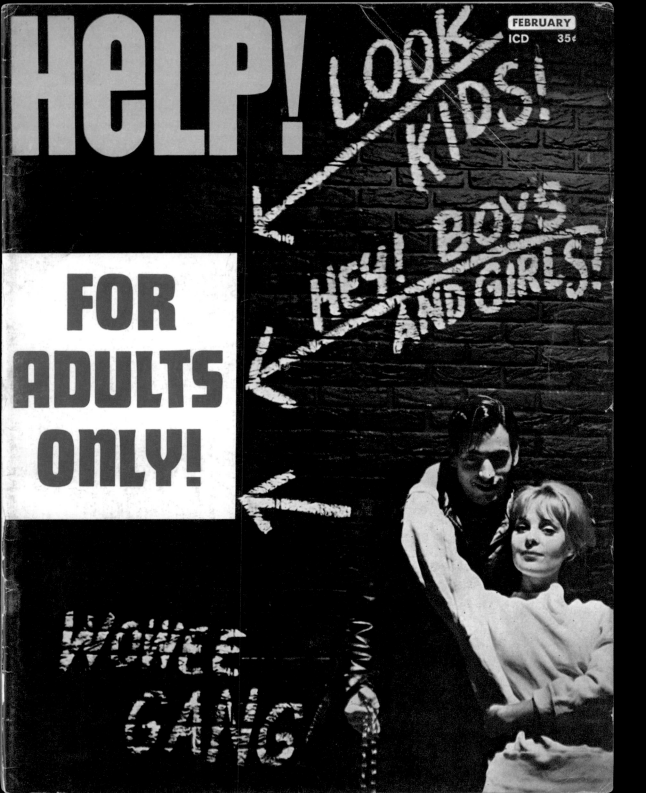

***Help!* no. 13 cover | February 1962 |** The enticing juvenile delinquent cover lures readers to the racy "Goodman Goes *Playboy*," which Kurtzman called one of "the best stories I've ever written." The satire helped catalyze the character's transformation into "Little Annie Fanny," but also triggered a troublesome lawsuit by the owners of Archie comics. Kurtzman's partner James Warren quickly caved and placed an abject apology in the following issue, greatly annoying Kurtzman. The February issue also introduced Will Eisner's *The Spirit* to tens of thousands of young fans who never saw the comic's original run in the 1940s and '50s.

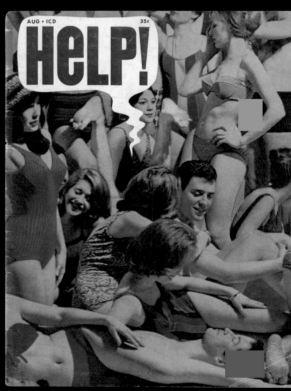

Left | *Help!* no. 14 | May 1962 | The issue featured "Goodman, Underwater," a simultaneous spoof of TV's *Sea Hunt* and American/Soviet tensions.

Above | *Help!* no. 15 | August 1962 | Kurtzman and Elder's "Goodman Meets S*perm*n" highlights this issue. The biting satire was less about the character Superman and more about cynicism and altruism.

Above | John Cleese *fumetti* **| 1964 |** Harvey Kurtzman's brief description of John Cleese in *Help!* no. 24 (May 1965) said the "law graduate and BBC writer came to New York with a small satirical revue called the Cambridge Circus." In December 1964, the fledgling actor was hired as the lead in "Christopher's Punctured Romance," a *fumetti* in which Cleese's character becomes infatuated with his daughter's Barbie. Of much more cultural significance, Cleese hit it off with Kurtzman's assistant, Terry Gilliam. The two stayed in touch and reconnected in England, where, before long, they became founding members of Monty Python.

Top right | Woody Allen *fumetti* **| 1963 |** At the cusp of his early stand-up career, Woody Allen was amusingly cast by Harvey Kurtzman as Mr. Big in "The Unmentionables," a loose *fumetti* parody of *The Untouchables* (*Help!* no. 19, October 1963). In his editor's preface for that issue, Kurtzman described Allen as "a young comedian of blinding insight, unerring wit and expensive vocabulary. Wearying of being pelted with money for writing for some of the biggest names in comicdom, Woody of late has taken to the smoky dens and piercing spotlight himself."

Bottom right | R. Crumb *fumetti* **cameo | 1964 |** A still from R. Crumb's cameo appearance as a partygoer in the *fumetti* "Thigh of the Beholder," which appeared in the final issue of *Help!* (no. 26, September 1965). Not counting his earlier greeting card work, Crumb made his professional debut in *Help!*, contributing strips and features toward the end of the magazine's run. Crumb came to New York hoping to land a job with his hero Harvey Kurtzman. Crumb was the heir apparent to Terry Gilliam, but *Help!* had run its course as Kurtzman was increasingly immersed in "Little Annie Fanny," so Crumb moved on. Two years after this *fumetti* appearance, Crumb launched *Zap* and triggered a new comix revolution.

Opposite | Outtake | 1962 | Kurtzman doesn't look especially happy, despite standing near a nude woman in this outtake from the cover photo shoot for *Help!* no. 17.

HAPPY 1961-HELP! READERS

C.P.D.A.
CONVENTION
N.Y. 1960

Right | Council for Periodical Distributors Association (C.P.D.A.) convention photo | September 1960 | For a periodicals distribution convention, Kurtzman painted a backdrop of New York City and a hole where staff and attendees could insert their head for a souvenir photo. The stork represented *Help!*'s infancy as a magazine. Eight-by-ten glossies were later sent to individual distributors as a New Year's present. Twenty-two of the shots appeared small in *Help!* no. 6 (January 1961) as a means of flattering the men crucial to newsstand sales.

Opposite | Kurtzman blowing bubbles | circa 1960 | This wry variation on the traditional author photo appeared in *Help!* no. 7 (February 1961). Kurtzman, for many years, smoked a real pipe.

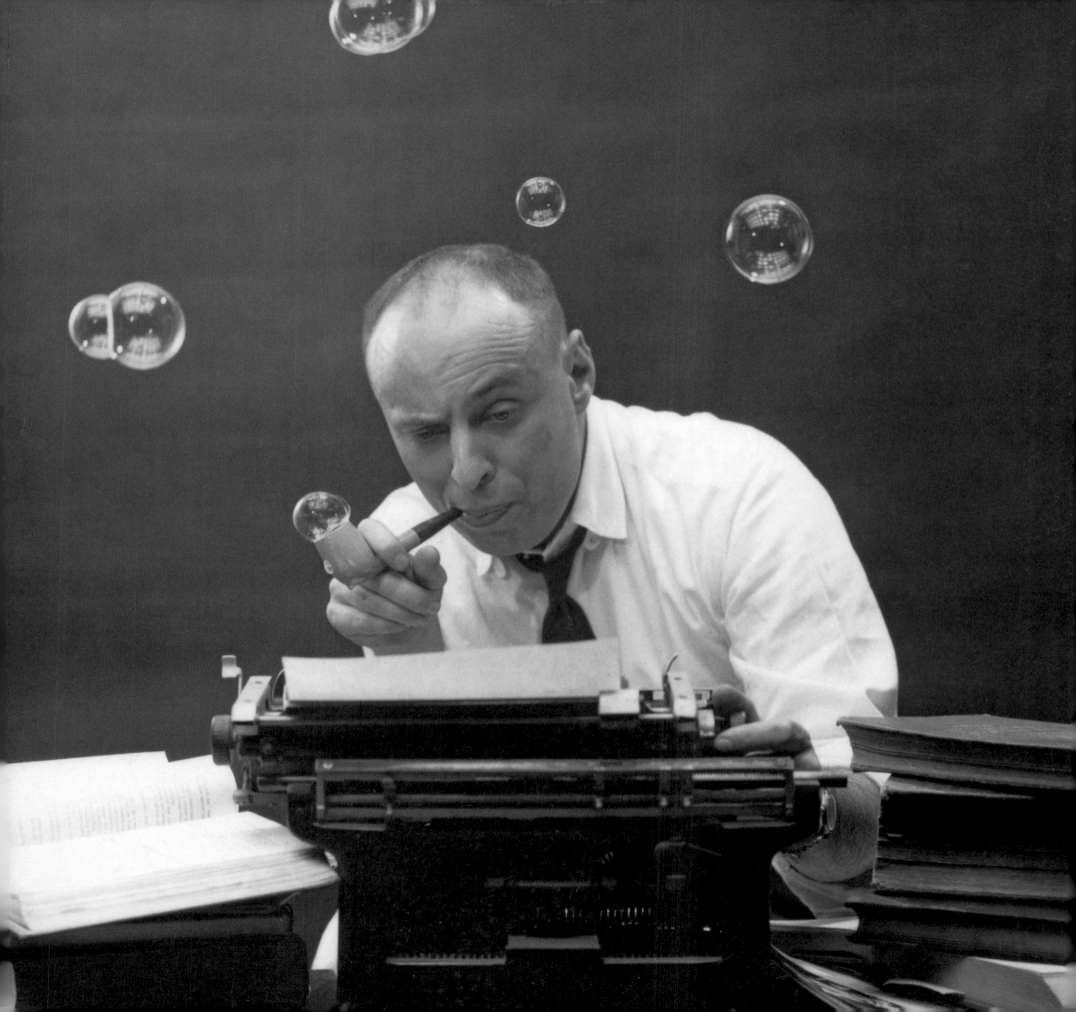

Above | *Help!* no. 16 cover rough | 1962 | Well before Toyota and Honda dominated the automobile market, Japanese-made transistor radios, cameras, and other commodities were already ubiquitous.

Right | *Help!* no. 16 | November 1962 | Kurtzman's cover rough is translated faithfully in the final photographic version.

FEB · ICD

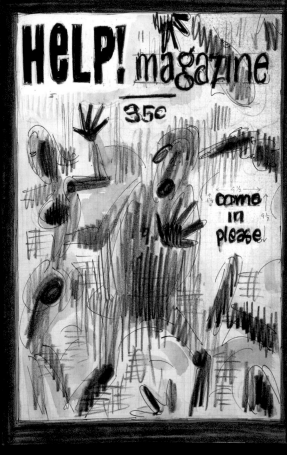

Above | *Help!* **no. 17 cover rough** | **1962** | If Kurtzman's rough composition seems rougher than usual, it's because he was trying to convey the effect of semi-transparent office glass blurring the interior. How else to put a naked lady on the cover?

Left | *Help!* **no. 17 cover** | **February 1963** | Harvey Kurtzman himself models, appropriately, for a glimpse into the purported *Help!* office. The magazine's modest surroundings were hardly a raucous den of iniquity, but it didn't hurt to make readers think they were. Terry Gilliam, later of Monty Python fame, made his debut in this issue as the associate editor and occasional contributing cartoonist.

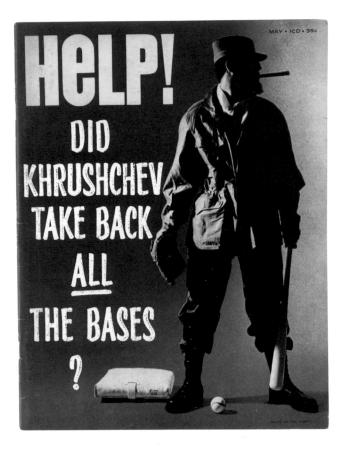

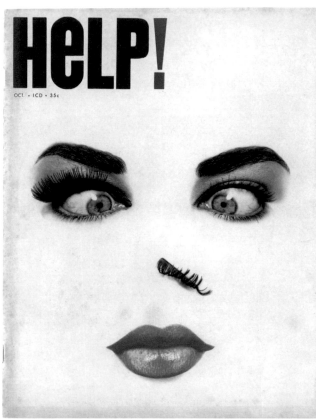

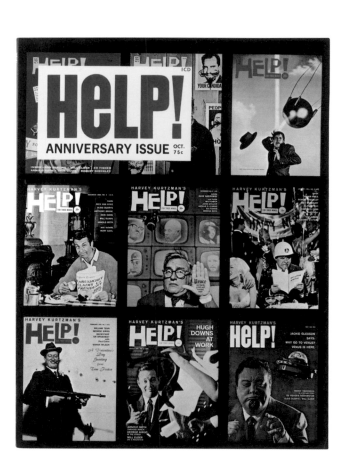

Left | *Help!* no. 18 cover | May 1963 | Kurtzman's cover spoof on the Cuban missile crisis worked on a secondary level because Fidel Castro really was a serious baseball player. This issue contained a cartoon feature on "The Last Days of Burlesque" by Arnold Roth, and Gilbert Shelton's "Wonder Wart-Hog Meets the Mob!" **Middle** | *Help!* no. 19 cover | October 1963 | "Jack Davis Meets the [N.Y.] Mets" and a *fumetti*, "The Unmentionables," featuring Woody Allen, were highlights, along with "A Thousand Pictures Worth One Word," which published for the first time several pantomime comic strips that Harvey Kurtzman failed to sell to a newspaper syndicate in earlier years. **Right** | *Help!* no. 21 cover | October 1964 | Signs of Kurtzman's increasing preoccupation with "Little Annie Fanny" are abundant. There is an eight-month gap between the twentieth and twenty-first issues, and on top of that virtually everything in this ninety-six-page issue is recycled *fumetti* stories. Even the cover recycles previous covers. The only new editorial material? Three pages of letters loudly complaining about "My First Golden Book of God" in the February 1964 issue.

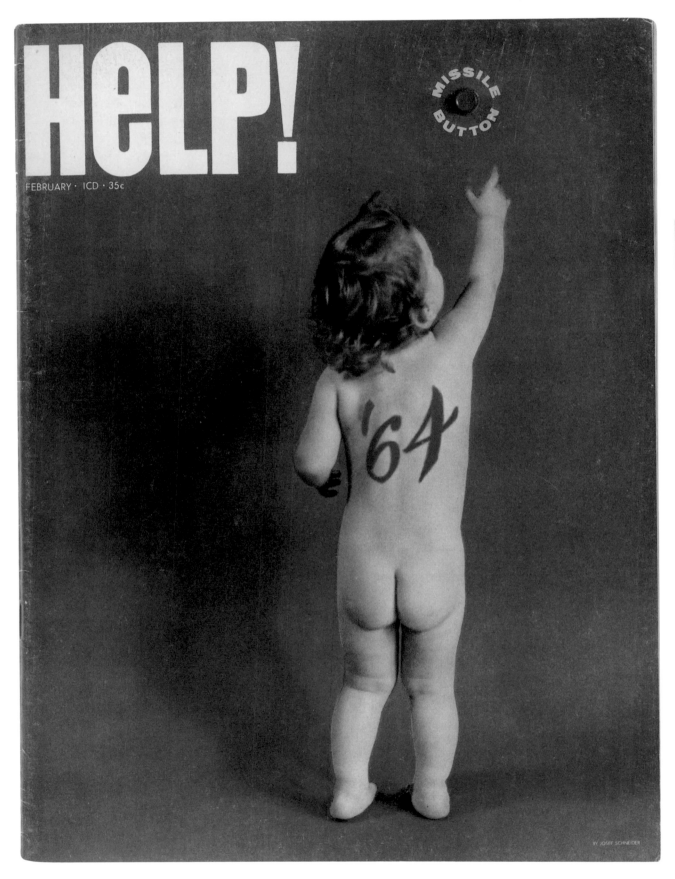

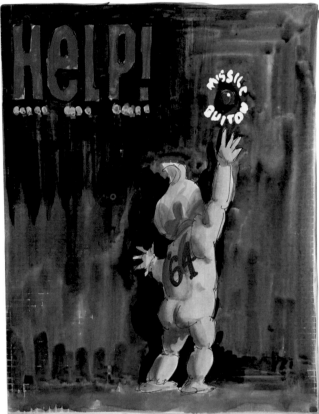

Above | *Help!* no. 20 cover rough | 1963 | There was no escape in the early 1960s from the threat of nuclear annihilation. Not even the New Year's baby was immune. This preliminary cover, unlike earlier roughs, was done in color markers, a new medium Kurtzman was using with regularity on his layouts for "Little Annie Fanny," a feature he was now producing simultaneously with *Help!*

Left | *Help!* no. 20 cover | February 1964 | The issue's blasphemous "My First Golden Book of God," written by soon-to-be TV critic Joel Siegel, evoked an outcry from many readers.

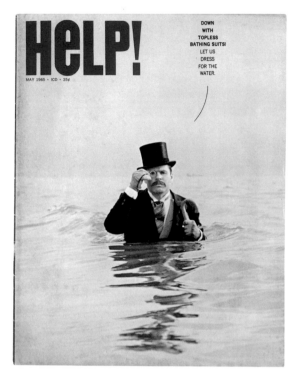

"Goodman Beaver," introduced as a character in *Jungle Book*, was reincarnated in *Help!* as a modern Candide. By taking on Superman and Archie through the eyes of Goodman Beaver, Kurtzman (and Elder, who did the art) revived the Superman/Captain Marvel controversy and his own, more specifically intractable, role of antagonizing Archie's corporate operators—who spearheaded the Comics Code that helped murder E.C.

The S*perm*n that Goodman meets has abandoned the life of a Goody Two-Shoes for a Thoreau-like existence in the woods (saving the world was impossible anyway). Reality, however, turns out to be too grim for super hero solutions. "Goodman Goes *Playboy*" in late 1961 took a poke at Kurtzman's friend Hugh Hefner and the cult of sophistication that was, at its basic root, not much more than skirt-chasing. The peachy-keen, innocent Goodman, returning to his hometown from college, finds a bacchanal, with "Archer" gone sybaritic (with Hefner as the devil, running the show).

The humor-impaired owners of Archie (still annoyed by "Starchie" in *MAD*) promptly went after *Help!* with the threat of a lawsuit. Warren's lawyer recommended settling, not because they would lose but because even winning "would be a pyrrhic victory," thanks to legal fees—no doubt just the intimidation Archie's publishers intended. Kurtzman couldn't afford to fight on his own, but the decision to settle out of court struck him as entirely mistaken, "very, very wrong . . . very bad. I thought I had really prostituted myself by going along," and contributed a "terrible precedent" to the larger struggle against censorship. To add to his embarrassment, James Warren included a note in *Help!* slavishly apologizing to Archie Comics. Ironically, Hefner, the actual target of the satire, loved the piece, and his subsequent correspondence with Kurtzman led to Goodman's "sex change" and the 1962 debut of "Little Annie Fanny" in *Playboy*.

Kurtzman was very pleased to be reunited with Hefner. *Playboy* had established itself as a solid American institution by the 1960s. But, cognizant of the short-lived *Trump* experience, Kurtzman hedged his bets by keeping his day job with *Help!*

Kurtzman seemed intent on making up for the Archie slight with even more intense social commentary. Many readers would remember the vividness of a four-page feature illustrated by Terry Gilliam, "Buster, Have You Ever Stomped a Nigra?," purporting to be a recruitment brochure for the Ku Klux Klan, who were once again active in real life with the rise of the civil rights movement (unprotected by the U.S. Justice Department) in the South.

Experimenting with form as the end of *Help!* loomed, Kurtzman combined *fumetti* with his own art in a feature literally starring Jackie Gleason, Mickey Rooney, Anthony Quinn, and mega-producer David Susskind, all centered around Rod Serling's *Requiem for a Heavyweight*. It was a remarkable multimedia story.

Kurtzman increasingly found Warren an untenable partner and, on a number of counts, preferred to work with Hugh Hefner. Sales of *Help!* were in general decline anyway, and Warren did not fight the move. With issue no. 26 (September 1965) *Help!* came to an end, by which time Kurtzman and Elder were fully immersed in "Little Annie Fanny." Some would see it as his last hurrah; for others, that distinction belonged to *Help!*

Above left | *Help!* no. 22 cover | January 1965 | An incongruous bald Beatles cover introduced the debut of R. Crumb with a two-page "Fritz the Cat" story and "Harlem: A Sketchbook Report." From Kurtzman's preface: "Our cartoon report has an interesting author. Out of the west has come a fast pen who goes by the unlikely name of Robert Crumb. This child of twenty-one, come east to seek his fortune, is a terror with an ink-loading rapidograph, and you may judge his marksmanship by his sketches on pages . . ." **Above middle | *Help!* no. 23 cover | March 1965 |** Gilbert Shelton contributes another "Wonder Wart-Hog" story, and Jay Lynch and Skip Williamson have gag cartoons in the "Public Gallery" section (at five dollars a pop). With R. Crumb and Joel Beck also appearing in *Help!*, Kurtzman has nurtured and given first wide exposure to five key members of what would soon become the underground comix movement.

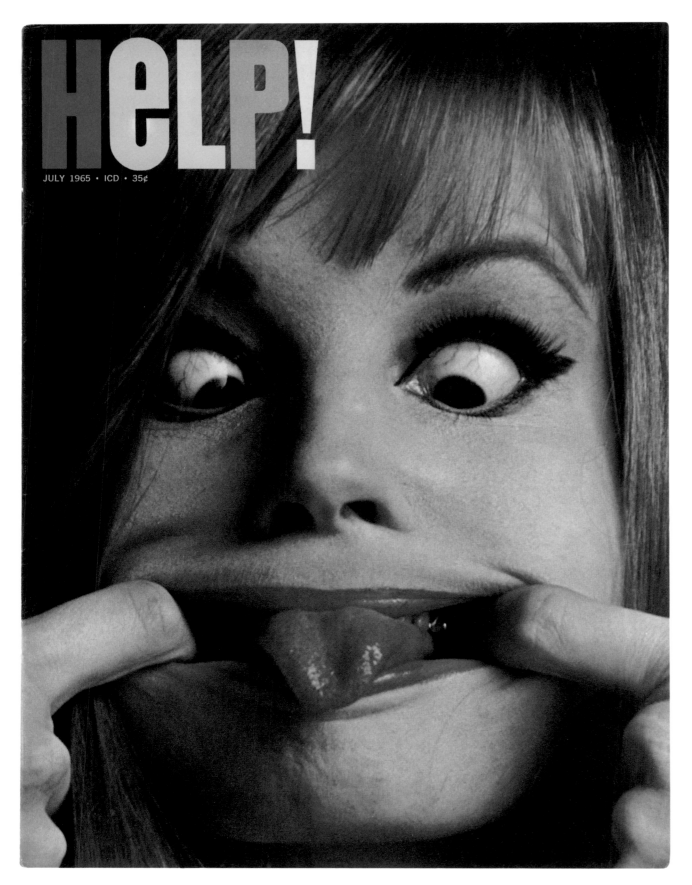

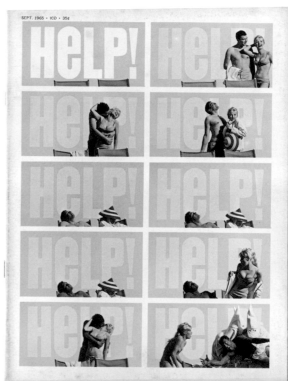

Above | *Help!* no. 26 cover | September 1965 | The final issue of *Help!* Terry Gilliam exited with an anti–Ku Klux Klan feature, "Buster, Have You Ever Stomped a Nigra?" Kurtzman's cover reflected the theme: a well-tanned white man hauled off by Klansmen. Five future underground artists all appeared in this issue: Joel Beck, with a page; Jay Lynch and Skip Williamson, with gags; Gilbert Shelton, with a five-page "Wonder Wart-Hog" story; and Crumb, in a *fumetti* cameo. There was no farewell announcement, and a subscription ad gave every indication the magazine would continue. Kurtzman had already designed the twenty-seventh cover and approved the next *fumetti*. But sales of *Help!* were in decline, and Kurtzman had a testy relationship with partner James Warren. Hugh Hefner, who paid top rates, was pressuring Kurtzman to produce more "Little Annie Fanny" pages for *Playboy*'s much larger audience. In the end, it was no contest.

Opposite right | *Help!* no. 24 cover | May 1965 | A virtually unknown off-Broadway actor named John Cleese was hired as the lead in the "Christopher's Punctured Romance" *fumetti*.

Left | *Help!* no. 25 cover | July 1965 | Several years earlier, a struggling Harvey Kurtzman was sent on assignment to Ireland by *Esquire*. Kurtzman, in turn, sent a struggling Robert Crumb to dreary iron-curtain Bulgaria. From Switzerland, Crumb sent a postcard: "Dear Harvey, I got my Visa for Bulgaria finally. Evidently very few Americans go to Bulgaria just to see Bulgaria. . . . The Bulgarian consul was amazed that an American wants actually to see their little insignificant country." After turning in his assignment, Crumb lobbied for a Red China trip, but it was not to be.

***Help!* no. 16 alternate cover rough | 1962 |** Kurtzman's original idea for the November 1962 cover was a commentary on the stock market: ticker tape going right into the garbage. A small photo of a ticker tape machine appears on the masthead, suggesting that Kurtzman was well along with the idea before scuttling it, probably because the fickle stock market was incompatible with a quarterly humor magazine. The same masthead has a blank spot for assistant editor. Chuck Alverson moved on, though he would continue to freelance for the magazine.

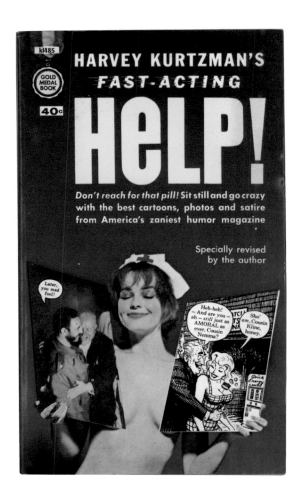

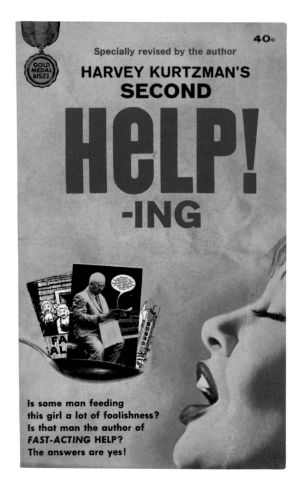

Left | *Harvey Kurtzman's Fast-Acting Help!* | **1961** | Cover to the first *Help!* paperback collection, published by Fawcett's Gold Medal imprint. **Middle** | *Harvey Kurtzman's Second Help!-ing* | **1962** | Cover to Fawcett's second paperback collection. Jerry Lewis wrote the foreword. Both published covers feature the same trio: a photo of a pretty woman, Nikita Khrushchev, and Will Elder cartoon babes with ample cleavage. A JFK satire was deleted from the second edition. **Right** | *Instant Help!* **cover rough** | **circa 1963–64** | Kurtzman's concept drawing for *Instant Help!*, the planned, but never published, third paperback collection. The fatalistic head in a sea of red ink (with a shark fin for good measure) is reminiscent of the last cover of *Humbug*.

CHAPTER 5

Satire in Technicolor

THE TWENTY-SIX YEARS "Little Annie Fanny" appeared in *Playboy* were, in any number of ways, the climax to Harvey Kurtzman's career. Never, with *Playboy* peaking at a seven-million circulation, did he reach so many readers. Never, in a life spent in pulp quarters with shaky budgets, could he have otherwise lavished his work with color, on slick paper, regardless of the expense of the process. In an industry built on churning out volume product, Kurtzman made a living during that quarter-century averaging fifteen "Little Annie Fanny" pages not per month but per *year*, at page rates unheard of. *Playboy* provided him with a stable income and, eventually, good medical benefits (often out of reach for free-lancers), and he enjoyed far-flung expense-paid trips to research his stories. Plus the majority of his work was with his nearest and dearest collaborator in life and in work, Will Elder.

That most Kurtzman devotees would not consider "Little Annie Fanny" genius work (and some would argue the opposite: that it was genius diluted or degraded) probably troubled Kurtzman not as much as his own dogged perfectionism of form and content. He had less latitude in *Playboy*'s pages than he had had since his early days in the comic book mainstream, before focusing on his own "Hey Look!" fillers. That for many of the years he had the close attention of Mr. Playboy himself, Hugh Hefner, was no great consolation.

It may have been the reverse: His boss was often a punctilious taskmaster with a heavy red pen who often had very different ideas about what was funny or satiric. And the formula invariably had to include Annie disrobing.

So it all involved a compromise, a series of compromises possibly long enough to have reached from his New York suburbs to the Chicago (and then Los Angeles) Playboy Mansion by Scotch-taped memos, phone notes, and the lengthy correspondence involved in the process. That *Ms.* magazine founder Gloria Steinem, who had worked for Kurtzman in the *Help!* office a few years earlier, was busily denouncing *Playboy* and everything it stood for must have marked an odd irony for Kurtzman, but it was only one of many. (He once considered setting up his pre-*Ms.* assistant on a date with Hef.) Meanwhile, the underground comix artists who Kurtzman helped to launch, and for whom he served as a Dutch Uncle, generally scorned *Playboy*.

"I bow to no one in my appreciation for H. Kurtzman," Hugh Hefner wrote to the artist/editor in late 1958. He was explaining why he had turned down detailed proposals from a man who was clearly looking hard for career opportunities and for cash. According to *Playboy*'s savant, then still in a rather raw patch of a lucrative empire-building experience, the failure of *Humbug*, he felt, had left Harvey too pained to do his best humorous work.

According to Harvey himself, "Trying to create for *Playboy,* I've a blind spot that I don't think I can ever overcome." Decades later, he put it almost the same way: "The sexuality of 'Fanny' tends to conflict with the satire of 'Fanny' because we're always obligated to give the feature that dollop of sex, and very often it gets in the way."

And yet, these conclusions were not mutually exclusive, as it turned out, mainly because Kurtzman accepted compromise, not so much in principle as in practice, script by script, and finalized strip by strip. There was also another reason why, but it was more subtle, deeply rooted in a pulp history that survived and thrived in *Playboy*'s pages: girlie humor.

If the earliest of illuminated texts produced in numbers for an elite audience of the Middle Ages had offered semi-pornographic drawings in the guise of spiritualism, and if the breakthroughs in portrayal of peasants (by Pieter Brueghel among others) included naked breasts and buttocks, it should have been no surprise that the first real mass-published "pulps" in the nineteenth century were loaded with sexual suggestiveness. The comic book industry itself had its roots and placed a few of its pioneers in the pornographic section of Manhattan's pulp trade. As Gerard Jones has shown best in *Men of Tomorrow: Geeks, Gangsters, and the Birth of the Comic Book* (2004), industry giants Jack Liebowitz and Harry Donenfeld sought

Opposite | *Playboy's Little Annie Fanny* detail | 1965 | During Harvey Kurtzman's earlier career as a satirist, he generally had full rein over his creations. But offsetting the good pay, high production values, and large audience at *Playboy*, his "Little Annie Fanny" stories required Hugh Hefner's approval, and the heroine's disrobing was de rigueur. This symbolic detail is taken from the unexpurgated cover of *Playboy*'s first collection of "Annie" stories, published in 1966. Painted by Will Elder from Kurtzman's layout.

fortunes in lurid pulp materials until they hit the mother load with *Superman* and *Batman*. With the comic book boom, "good girl comics" offered readers scantily clad, bosomy female bodies in all manner of danger, bordering upon the masochistic and often crossing that border, occasionally on the dominatrix side (*Wonder Woman* and *Sheena, Queen of the Jungle*).

These were not the most raw comics by a long shot. An estimated 700–1,000 "Tijuana Bible" titles were published from the late 1930s through the 1950s. As Art Spiegelman has written, they were always sub rosa, sold "out of the backs of station wagons, or from outsized overcoat pockets, and . . . in schoolyards, garages, and barber shops," at prices that varied from a quarter to five dollars, whatever the market would bear. No publisher was ever listed, and no return address could be found, not even a year of publication. Misspelling was more common than misogyny or racism (true to the comics mainstream, nonwhites made fairly infrequent appearances, always in stereotype), free-spirited dames were very common (although only young ones were sexually desirable, and heavy-set or older women were deployed for sexual ridicule), and the argot seemed straight out of contemporary blue-collar life. The main feature, alongside the graphic sex, was the satire of existing newspaper comics and comic book, film, and radio characters—fictive or, in some cases, real actors. Tijuana Bibles were porn thinly disguised as humor, although also sometimes real humor (of the flaccid penis or expansive vagina variety) through porn.

The milder cartoon-and-gag booklets of sailors-and-gals style collections of humor, suggestive but not quite pornographic, were still very much around when *Playboy* hit the stands in 1953, with naked breasts in photo-abundance and cartoons that carried somewhat further the suggestions seen in *Esquire*. *MAD* hardly dared to venture into this territory, for obvious reasons, but *Trump* leaped in the direction of suggestiveness and would no doubt have continued in that direction if the magazine had been successful and had continued being published. After all, *Trump* was *Playboy*'s baby. Yet there was something holding back the more direct, corn-fed full breasts that were be-

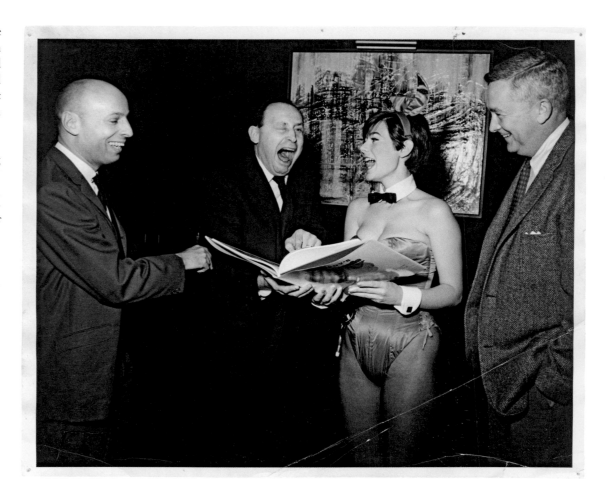

ing seen in the parent magazine's pages, and that degree of restraint was in no doubt due partly to Kurtzman. Perhaps restrained by the usual fears, including the perception of a still largely young audience, but also by a sense of sexual delicacy, *Humbug* pulled back even from the handful of revealing pages seen in *Trump*. Likewise, Kurtzman's later solo artistic phase saw little of it.

In retrospect, *Help!* marked a compromise. Its captioned photos were full of sexual fun, its *fumettis* often one long joke about men's seductive impulses (sometimes women's as well), and the phase of pill-enhanced sexual freedom of youth could be seen coming over the horizon. For that matter, and though somewhat carefully calibrated, skin did make an appearance, most notably on one *Help!* cover that featured a blurred female nude (no. 17, February 1963).

The orgy scene in "Goodman Goes *Playboy*" was notably risqué, though each nipple was carefully retouched with white ink prior to publication. It was humor of the day, no more daring than film, a little more daring than television, without the claim of "wholesomeness." Though, like *MAD* Magazine, the audience would have been overwhelmingly male—like the college-humor magazine that *Help!* seemed to have spiritually absorbed.

"Little Annie Fanny," in any case, grew directly out of the Goodman Beaver stories. Kurtzman wrote hopefully to Hefner in 1960 that Goodman "is a lovable, good-natured, philosophical idiot. He's restless. He wanders and can show up anywhere. He's young and can get involved in sexy situations (that last sentence was for you)."

Above | Publication party | 1966 | Left to right: Harvey Kurtzman in his shaved-head period, Will Elder hamming it up, an unknown Playboy bunny, and Jack Davis looking on at a publication party for the first "Little Annie Fanny" collection.

One of Hefner's assistants, *Playboy* executive editor Ray Russell, wrote Kurtzman in February 1960 that "good draftsmanship, action, sexy girls in brief costumes, and (last but not least) satire" would be desirable, satire in particular "as an excuse or rationale for a slick magazine to be publishing a comic strip."

But if cartoons were a natural, indeed an expected, part of the *Playboy* package, comic strips needed justification. They were, even in this context, not quite respectable or grown-up. Kurtzman himself suggested to Russell in late 1961 a solution—a way to cross the gap: "What would you think of a girl character, roughly modeled along the lines of Belle Poitrine-Lace, etc.?" (*Belle Poitrine* was a risqué 1961 novel by Patrick Dennis, and "Lace" may refer to Milton Caniff's sexy "Miss Lace" strip drawn for GIs in WWII and once featured in *Help!*)

Kurtzman got his answer quickly: "a Goodman Beaver strip of two, three, or four pages, but using a sexy girl . . . is a bull's eye. We can run it in every issue." Although *Playboy* was unable to go that far—the feature proved far too labor intensive—the premise was set.

Kurtzman had another reason to relish the arrangement. The "Goodman Goes *Playboy*" thatriled the litigious Archie publisher demonstrated how easily publisher James Warren would fold under pressure. Kurtzman looked for a protector, and Hefner, it seemed, was the one with the means and the integrity to give him a creative firewall.

The other half of the "Annie Fanny" team for its twenty-six-year run, with periodic assistance from others, was Will Elder; it could hardly be anyone else. The two of them were not the same hotheaded youngsters they were in their *MAD* days, and Elder's freelancing was not so secure that he could pass up an opportunity of this kind, even if he'd wanted to. Will felt he never had a better collaborator than Harvey, and he jumped at the chance.

The way the process worked, Kurtzman would develop an idea, get it approved, send a preliminary script to Hefner, and then get *that* approved. There remained no assurance that Hefner or his assistants would not opt for changes in some of

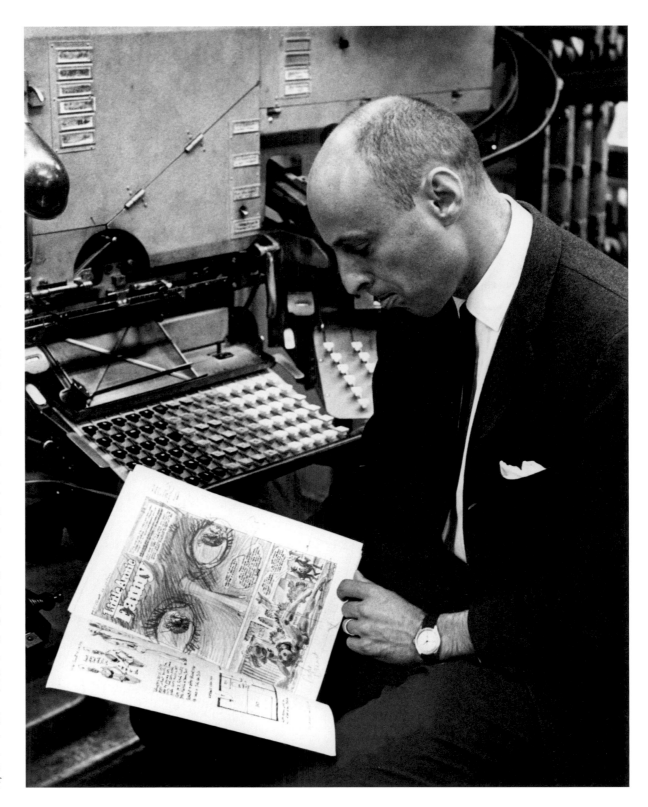

Above | Harvey Kurtzman and "Annie" prelims | July 1966 | Annie's creator examines the pencil layouts for the "Las Vegas Kidnapping" episode, which was published in the May 1967 *Playboy*. The big eyes in this layout evolved into sunglasses reflecting the images in the published version.

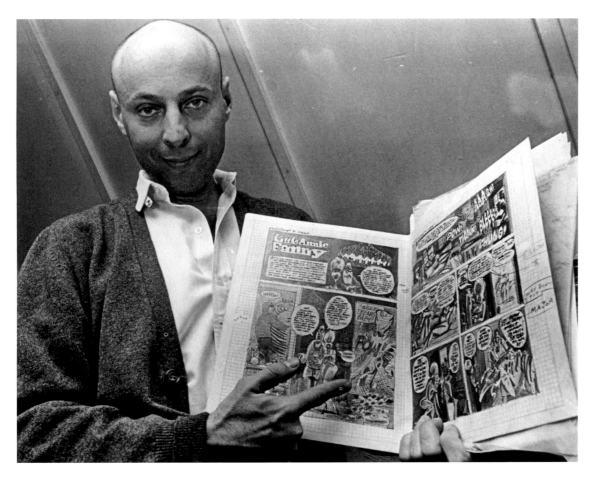

strips. A nominally short, three-page story might involve as many as six to nine tight layouts. Each time, the finished layout would go to Elder, who would look for "holes" in the layouts where he could insert "eye pops," or visual gags. He knew that many of his suggestions would be edited out by *Playboy*. Its audience, they believed, was "the young executive. So I think they felt my shtick was unnecessary."

In reality, of course, *Playboy* was a heavy seller in most every military PX, the life of the "young executive" more likely a matter of fantasy than reality for the average *Playboy* reader. Perhaps the college student or college graduate from the old *MAD* days was the desired readership, and the focus on the sexy parts would presumably have been diffused by the "shmear" style that Elder had made so famous in the pages of *MAD* and its various reprints.

From another, operational, standpoint, Elder would work his genius on minor characters and on details, some of which would survive the magazine's numerous visual edits. Thus Elder's caricatures of various celebrities, real life and fictionally iconic, like Henry Kissinger and John Wayne (two conservatives especially repellant to Harvey and Will), or Dick Tracy, Popeye, etc., would make it to the final printed page.

The final genius of Elder was the work process itself, made possible by the lavishness of the *Playboy* budget to reproduce faithfully what he would achieve in his studio. Discerning readers appreciated that *Playboy* was printed using the rotogravure process, which provided a remarkable and subtle density range for centerfolds and color cartoons alike. Color washes, layer after layer, brought tones never before seen in any comic strip. Elder aimed for a kind of iridescence, with his white illustration board as a base for dark oils, with light oils applied over them, followed by tempera and watercolors, and then finally all shadowing and detail adjusted with the use of an electric eraser.

The mixture of scathing satire that revealed truths the mainstream culture was not ready to accept, along with well-proportioned young female bodies, went to the core of "Annie"'s popularity and to its problems for Kurtzman as well as his

the basics, put the strip on hold, or even cancel it, for which Kurtzman and Elder did not automatically earn a kill fee. Early on they were strictly freelancers with all the expected downside that implies. For example, any insurance benefits would be added at the discretion of their employer. It was, in this crucial respect, the worst of *MAD* and Gaines all over again. Still, Harvey and Will proceeded with a large degree of expectation.

By the early 1970s, the team was receiving more than $3,000 per page for "Little Annie Fanny" stories—an astonishing and unprecedented page rate, yet one mitigated by the slow and tedious pace of their creative methods. Kurtzman also rushed excitedly into this business relationship with Hefner without due process. He assumed that he—the creator of the concept and the stories—was the copyright owner; however, he never got anything in writing. By the time he realized

his mistake, he was papered to death by *Playboy*'s attorneys. It was a horrible blow, but Kurtzman soldiered on nevertheless, focusing on the work that he had to get done and hoping for the best.

Each month Will would drive up from New Jersey in his latest car—practically the only luxury the man without any known vices allowed himself—and the two would discuss the latest "Little Annie Fanny" story.

"Harvey would act out every part," Elder said. "He would change his voice and take on the characteristics of each role. We would sit there for hours and work out all the details of the story by acting them out. We'd crack each other up and fall down laughing as we developed the stories. It was a lot of fun."

Then Kurtzman would proceed to do his preliminary artistic work. Kurtzman's archives document the process for a number of the published

Above | Harvey Kurtzman and "Annie" prelims | circa 1966 | Kurtzman holds his pencil layouts to "High Camp," published in the January 1967 *Playboy*. The story spoofed the Pop Art fad along with the revival of super heroes as camp imagery.

devotees. Decades after, as the series ground toward an end, he admitted that he often wanted *less* garish sexuality, visually as well as in the writing, whereas the *Playboy* team inevitably wanted more, and prodded him in that direction.

One of the best stories about "Little Annie Fanny"'s deadline hurdles is told by Al Jaffee, in which he recalls the circle of former *Humbug* artists all being called in to the *Playboy* mansion, at considerable expense, to produce the next installment—or else. (This was probably "The Set Jets to South America," January 1964.) However, the faster they worked, the faster perfectionist Will Elder used his electronic eraser to wipe out their work. And while they spent their leisurely moments contemplating the "citadel of pussy" that surrounded them in the Mansion (with none of these aging men actually doing anything about it), Will, who seemed to miss the whole double-entendre of the conversation, was heard contemplating a family photo from his wife. It was all too ludicrous, too un-*Playboy*, and they couldn't stop laughing.

Celebrities were always favorite targets for Kurtzman and Elder, including a range of comics like Mort Sahl, Lenny Bruce, Peter Sellers, and Terry-Thomas; actors like Kirk Douglas, Lionel Barrymore, and John Wayne; in later years Charles Bronson, Lee Majors, Sylvester Stallone, John Travolta, Elvis Presley, Leonard Nimoy, Robert Redford, and Woody Allen; musicians like the Beatles, Pavarotti, Alice Cooper, and many, many more were all treated as cameos from the entertainment world—cavorting around in the strip, usually revealing some character flaw, more often lusting wildly for Annie.

Annie's sex life, meanwhile, was practically zero; she couldn't have one anyway, given the innocent premise of her character—the beauties of *Playboy*'s centerfold would spread their legs for the fantasy of the lustful male reader. When the competition from *Hustler, Penthouse,* and the home video market got more intense, and as the market shares at *Playboy* dropped, its spreads, so to speak, got stronger and more explicit, with the alluring promise of super-hot sex. Annie would occasionally, very occasionally, seem to be overwhelmed by desire or circumstance, but it was always out of sight and

This *Scripto* 19¢er commercial will be seen by over 142,000,000 people.

Silent

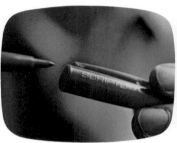

Introducing the Scripto 19¢er.

A 19¢ fiber tip that writes just like the 49¢ fiber tip.

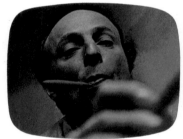

Writes bold.

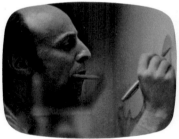

Writes light.

And it's good to know that the Scripto 19¢er writes just as long as the leading 49¢ fiber tip. And that's a long . . .

Long . . . long time.

Try the new Scripto 19¢er.

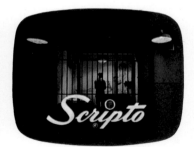

You 49¢ fiber tips, the handwriting is on the wall.

Above | Scripto television ad storyboard | 1972 | Kurtzman starred in a television commercial for Scripto fiber-tip markers in 1972. This internal corporate storyboard provides an essential breakdown: An artist (Kurtzman) draws a voluptuous Annie-like figure on a wall as the camera recedes, revealing that the artist is in a jail cell. If the trade ad can be believed, nearly a hundred and fifty million viewers saw the commercial. Kurtzman, however, was never identified and was recognized only by the cognoscenti.

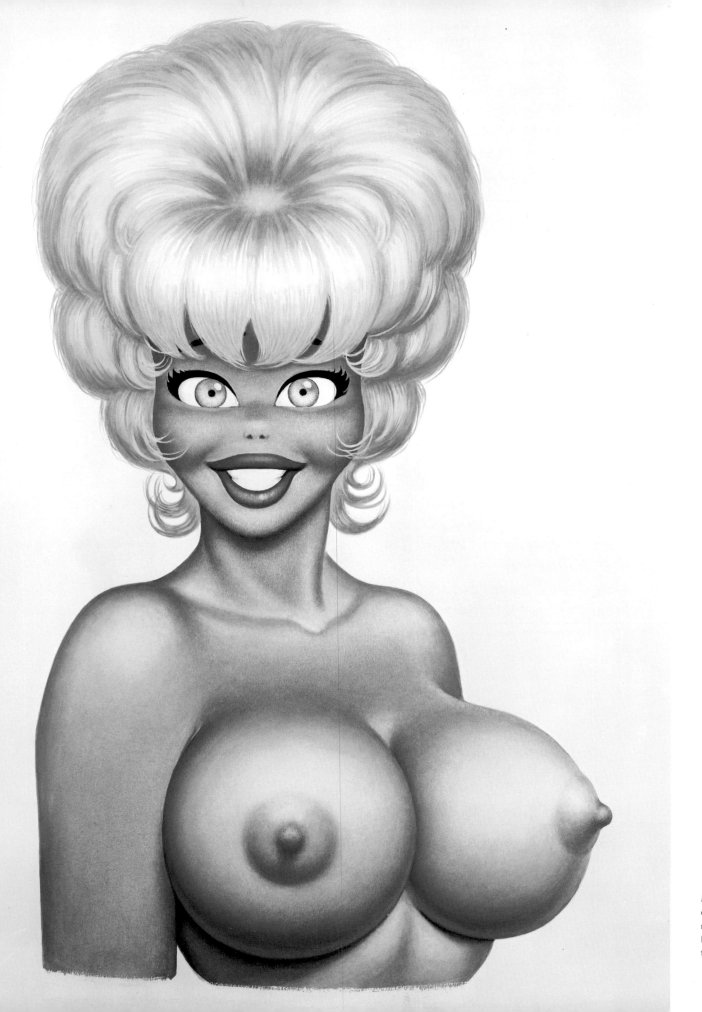

Playboy's Little Annie Fanny **original cover art | 1965 |** The cover art for *Playboy's* 1966 "Little Annie Fanny" collection naturally had to draw the line at Annie's ample cleavage, but Kurtzman and Elder nonetheless drew the full torso. This is the first time the full image has been published.

curred in the last panel. This panel, however, had always, in Kurtzman's comics, been reserved for something else.

Annie's realization of some heretofore unanticipated truth was, of course, the surprise ending that Kurtzman had been delivering since his first days working at E.C. Comics. Those endings had been thrilling even when they came as no surprise to the veteran reader; they still contained deeper meanings of human emotion and often social context. It would be unfair to say that the very notion of deeper meaning was being satirized in "Little Annie Fanny," but a steady satire on the lack of values in society often seemed on the side of moral nihilism—cultured pearls cast before swinish readers. And yet there was more to Annie Fanny than even that—not always, perhaps not even most of the time, but often enough to remind Kurtzman fans of his old magic.

Kurtzman was freed by the power of *Playboy*, one might say, to take on politics, the State, and most especially the concept of war as the profitable sport and pleasure of the rich and powerful. Although Annie's Sugardaddy Bigbucks (i.e., Daddy Warbucks of "Little Orphan Annie") fades out after early appearances, his political connections in high places, his amorality, and his indifference to the loss of life are delivered powerfully, never more so than in "The Set Jets to South America" (January 1964), where Daddy whisks Annie to his lavish estate, walled off from the moiling peasantry. "Facing in this direction you get a magnificent view of the house . . . and sunset!" he explains. "The only trouble is you mustn't face in the other direction." There, hungry children can be seen in the foreground, along with Banana Republic–style executions amid scattered Coca-Cola care packages, etc.

Kurtzman's attack on J. Edgar Hoover ("Las Vegas Kidnaping," May 1967), at a time when the chief still wielded enormous influence inside the Beltway (and, reputedly, the power to blackmail people even more powerful than he was), was another jab at political propriety, and arguably Kurtzman at his bravest. In this installment, Hoover, the prissy moralist, is right at home in the corruption of Las Vegas. Kurtzman also wanted a crackpot scientist who looked exactly like Edward Teller, father of the A-bomb and hawkish exponent of "first strike" against then-dreaded enemies. Hefner, however, insisted that "Dr. Neutrino" be made an effeminate Truman Capote. To play fair, Kurtzman introduced Cuban kidnappers to the scene—Raul Castro and Che Guevara.

Over the years, there were problems with Annie's continuing narrative. Her quasi-boyfriends were so unreal that they could not provide adequate foils for her. Annie's early escort, young ad exec Ralph Battbarton (sporting a pipe, driving a nifty convertible, looking rather like a younger, more unruffled Hugh Hefner), was soon to be displaced by the more intellectual and Goodman Beaver–naïve Ralphie Towzer, who endured until 1979 and then was cast aside (apart from a cameo in the twentieth-anniversary episode in 1982). Perhaps Annie had to be emotionless in order to be so adrift, but she also lacked the depth for character evolution, a flaw that became more and more obvious over time.

Though Hefner was often a heavy-handed and demanding editor, Kurtzman generally respected his editorial judgments and appreciated the detailed attention he received from the workaholic editor/publisher who would sometimes send Kurtzman "Little Annie Fanny" critiques twenty pages or more in length. As Hefner's life became more complicated, he increasingly delegated tasks, and Kurtzman was shuttled off to various editors, eventually to Michelle Urry, whose pettiness, abuse of situational power, and weaker editorial sense drove Kurtzman and Elder bewilderingly crazy. They yearned for the punctilious but direct Hefner.

Kurtzman, in later years, would have recurring nightmares in which he would be caught sardine-like in an indifferent, dense crowd, plaintively calling out, "Hef ! Hef !" to no avail. It doesn't take Freud to interpret. *Playboy*'s increasingly political layers, the inability to wrestle back the ownership of the strip and, most galling of all, the inability to even get back a meaningful share of their original art, made work on "Little Annie Fanny" more of a drudge job and less the exciting, creative venture it had been. With Kurtzman's health failing and Elder's eyesight faltering, "Annie"'s run came to an end in 1988.

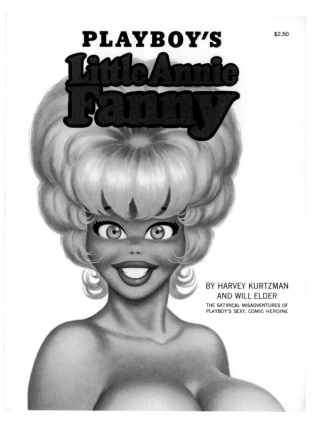

Above | *Playboy's Little Annie Fanny* **cover** | **1966** | The large (11 x 14 inches) and classy collection reproduced twenty-six of the earliest "Annie" stories larger than their magazine appearance—a visual treat for aficionados.

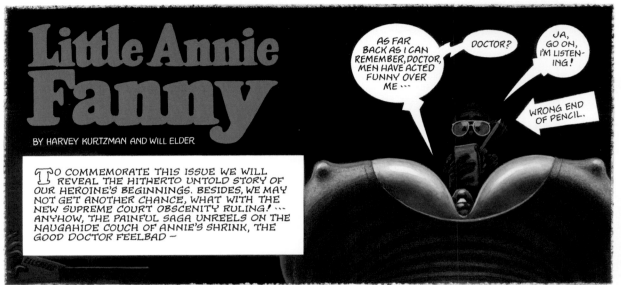

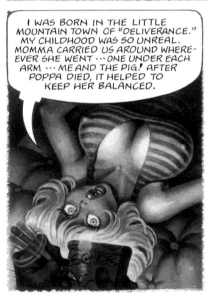

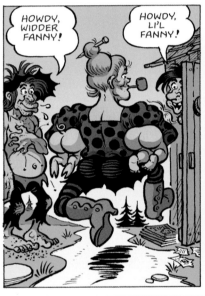

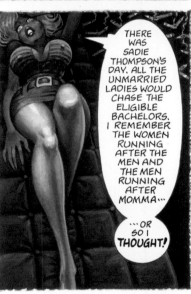

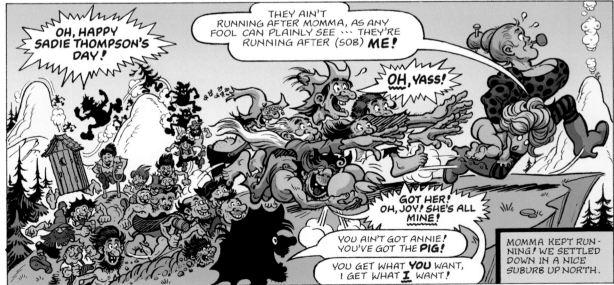

"Little Annie Fanny" origin story, splash | 1973 | This magnificent three-page story has never appeared in print, either in *Playboy* or any previous collection, until now. Intended for *Playboy's* twentieth anniversary issue in 1974, Kurtzman decided to create a back story for Annie in the form of flashbacks of her childhood. The "real" Annie, in her psychiatrist's office, is rendered in the usual three-dimensional painterly style, but her childhood recollections are drawn as black-and-white line art with flat color like newspaper strips. The technical gimmick allows Kurtzman to very effectively parody several famous comic strips along the way, starting with a feature he has always admired, Al Capp's "Li'l Abner." A minor but recurring Dogpatch resident was Fruitful Cornpone, a mother almost always seen with several naked children under her arms. Here Fruitful becomes Widder Fanny (wearing Daisy Mae's polka-dot blouse and Mammy Yokum's boots). Her passengers' bare posteriors belong to a piglet and Annie. In the second newspaper-style panel, Sadie Thompson's Day refers to Capp's annual Sadie Hawkins Day race, where desperate women have one day to literally chase and catch a husband. Here it is the usually non-libidinous hillbillies who find Annie irresistible.

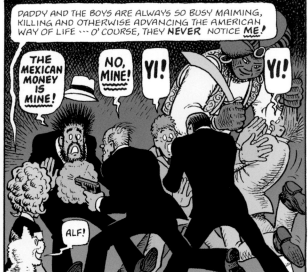

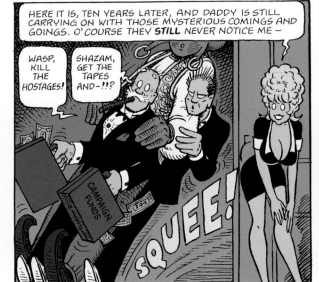

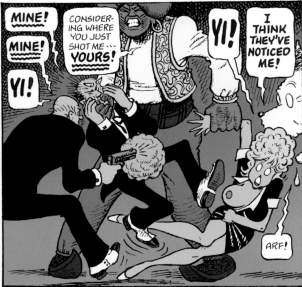

"Little Annie Fanny" origin story, page 2 | 1973 | At Annie's next stage of development she is a chesty tyke in Charles Schulz's "Peanuts," where Linus, Schroeder, and Charlie Brown all eagerly want to play doctor. Annie passes through puberty in her namesake strip, Harold Gray's "Little Orphan Annie" (note the equally hollow eyes and nipple in the last panel). Kurtzman's eye and ear are spot-on, and Elder mimics each cartoonist's style masterfully in the flashbacks.

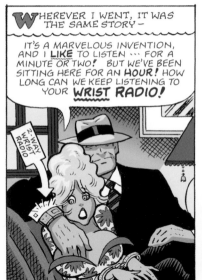

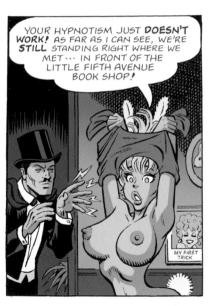
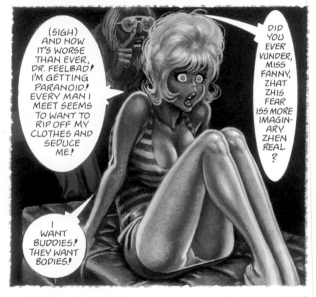
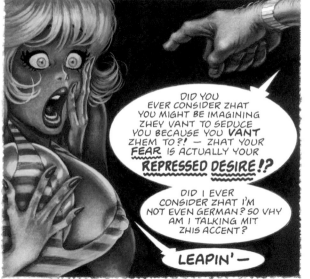
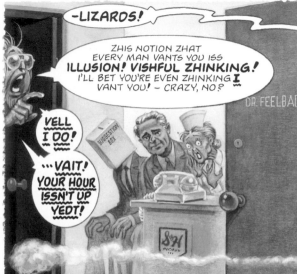
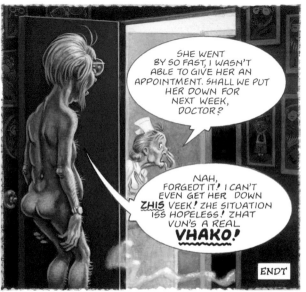

"Little Annie Fanny" origin story, page 3 | 1973 | As the all-too-short flashbacks end, Annie romps through Chester Gould's "Dick Tracy," Mort Walker's "Beetle Bailey," and Lee Falk's "Mandrake the Magician" before returning to reality. Kurtzman's initial pencils for this story included a parody of *Archie*, but after earlier litigious run-ins with Archie's owners, discretion proved to be the better part of valor. Little Annie Fanny's raison d'être is to become disrobed by the end of each strip, but in a final twist, there is virtually no Annie nudity in this episode, and it is her horny psychiatrist who ends up naked.

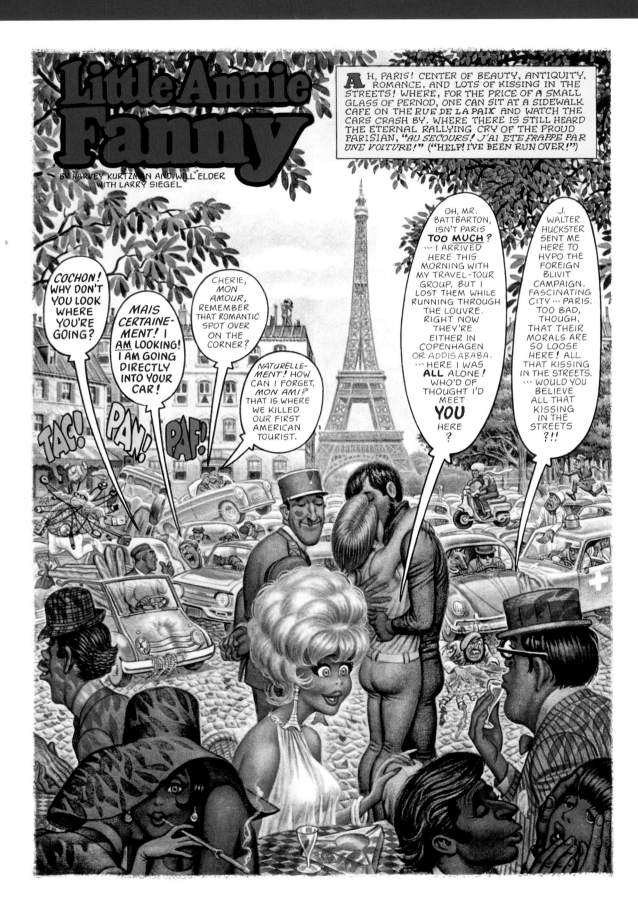

This page and overleaf | "Americans in Paris" | *Playboy* | August 1967 | Little Annie Fanny and her sometime boyfriend Benton Battbarton are the relatively prudish Americans in amorous Paree. Though Will Elder was Harvey Kurtzman's principal collaborator on "Little Annie Fanny" on all 107 installments from 1962 through 1988, various artists assisted along the way (notably Jack Davis, Russ Heath, Arnold Roth, Al Jaffee, Bill Stout, and Sarah Downs). In "Americans in Paris," the thirty-third "Annie" story, Elder created the final painted pages from Kurtzman's layouts, and it is a tour de force.

PERFECT COLLABORATORS

Will Elder (September 22, 1921–May 15, 2008), an epitome of the *MAD* comics artist and the closest collaborator that Harvey Kurtzman ever had, was a genius in his time and place, and a historic figure in his own right in comics art history. Elder, born Wolf William Eisenberg in the Bronx, met Harvey Kurtzman at the High School of Music and Art, but they were in different grades, and did not become close friends. Will was more of a clownish cut-up, pulling pranks, while Kurtzman was more the young artist working on his craft. But there is no doubt that the mood of the school's jokers, satirizing the clichés of contemporary film and television, was shared by both, though perhaps shaped more actively by Will.

An aspiring young artist placed in the army's corps of topographical engineers, Elder had hoped to work in animation, but drifted into comics after the war. Before long he joined fellow veteran Kurtzman and a third classmate, Charles Stern, to form the Charles William Harvey Studio. Though not the most notable artist working in the E.C. New Trend comics, Will Elder emerged in the *MAD* comic books as Kurtzman's genius collaborator. He became immediately renowned in the trade and among fans for his "shmear," or chicken-fat, style of embroidering the visual text with abundant details. Elder found hilarity in the smallest of possibilities, inserting visual puns, signage, and ironic placements in backgrounds and the nooks of panels. Kurtzman, appreciating the unique touch Elder added,

fully indulged him, until eventually Hugh Hefner discouraged excessive eye pops (not sophisticated) in *Playboy*'s "Little Annie Fanny."

Elder also affirmed, perhaps subconsciously, that the Yiddish language was funny, or full of potential humor, and that Jewish-American life—then undergoing major changes from tenement to suburb—was full of humorous contradictions. Amid all this, Elder proved himself the best imitator of existing comic styles anywhere, and was thus the perfect artist for satirizing anyone from Al Capp to Norman Rockwell.

More than any other artist of the crowd, Elder was reliant on Kurtzman's layouts, and he sought to improve and elaborate rather than challenge the master's overall concepts in both language and imagery. The two Bronx boys worked, then, as a brilliant team, each an extension of the other, as demonstrated by their famous, co-created illustrations and comics.

Will Elder went loyally with Kurtzman from *MAD* through assorted (and sometimes poorly paying) professional adventures. Increasingly liberated in his treatment of sexuality and the human foibles around this sensitive subject as a key source of humor, he segued successfully with Kurtzman into "Little Annie Fanny," the pair's extended and most visually elaborate, if not most brilliant, work. As Kurtzman faded physically, Elder largely retired to his studio. It might be said that they passed together as artists, although Elder outlived his perfect collaborator by fifteen years—he died at eighty-six on May 15, 2008.

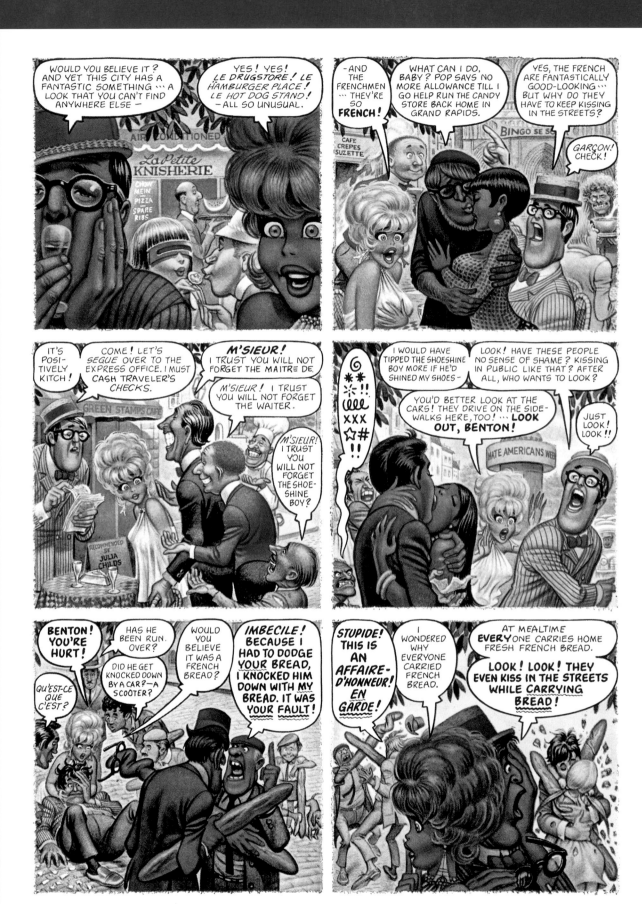

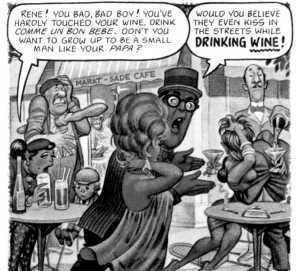

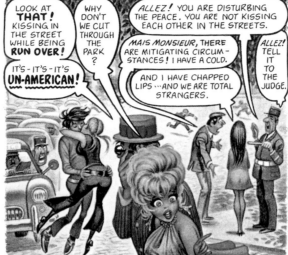

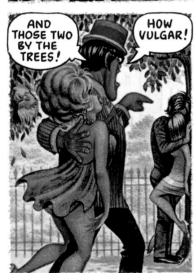

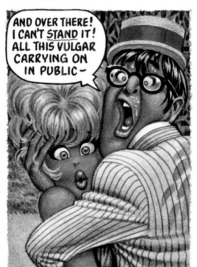

Harvey Kurtzman and Will Elder portrait | 1984 | Elder created this drawing as the signature tip-in plate for the hardcover edition of their *Goodman Beaver* collection. The six hands and upside-down pencil are trademark Elder eye-pops.

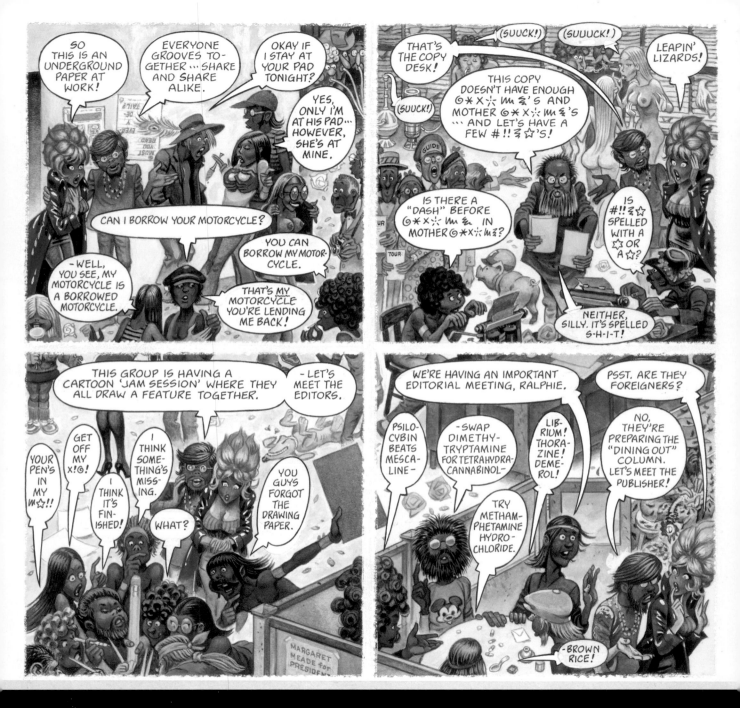

"Underground Press" unpublished outtake | 1969 | Kurtzman parodied the counterculture's "underground" newspapers in a four-page "Little Annie Fanny" that ran in the July 1970 *Playboy*. The story featured a novel splash page: Annie's sometime boyfriend and hippie editor Ralphie Towzer displays an *East Village Mother* spread with new "Angelfood McSpade" and "Fabulous Furry Freak Brothers" strips by Robert Crumb and Gilbert Shelton, drawn especially for Kurtzman. But two-thirds of a page was cut in the final story, and those excised panels appear in print here for the first time. Kurtzman was on close terms with numerous hippies, including many of the underground cartoonists, and was sympathetic to many of the new generation's ideals. But nothing was immune from his satire, and in these four lost panels he pokes fun at the notion of communal property, rampant profanity, the underground cartoonists, rampant drug use, and vegetarian diets.

OTHER PROJECTS DURING THE "ANNIE" YEARS

Kurtzman nurtured a variety of other projects during the "Little Annie Fanny" era, some creatively satisfying, but few especially auspicious. In 1972, he actually appeared in a funny television commercial for Scripto pens. As Harvey drew an Annie-like figure on a wall with his Scripto, the camera slowly pulled back to reveal that he was inside a prison cell.

That same year, inspired in part by the birth of he and Adele's last child, Nellie, in 1969, Kurtzman wrote, designed, and co-directed several animated shorts for PBS's famed *Sesame Street*. He was especially proud of a one-minute animation he created for them, "Boat," about a fisherman who loads numbers onto his small craft from a pier. The smaller digits are literally depicted smaller in size, but as they approach "10" the in-creasingly large numbers sink his boat. The short won an international animation award for him (in the "Humor" category) and for its animator (Phil Kimmelman), who turned Kurtzman's drawings into moving images.

In the 1970s, Kurtzman created guest covers for the underground comix *Bijou Funnies* no. 8 (which was itself a tribute issue to Kurtzman's *MAD*) and *Snarf* no. 5 (which parodied "Flash Gordon"). In 1980, he contributed to the "Spirit Jam" (*Spirit Magazine* no. 30), where he coined the term "Eisnshpritz" for the torrential rains commonplace in Will Eisner's stories, an expression now part of the comics lexicon.

Nuts!—an obvious riff on *MAD*—was assembled in 1985 for packager Byron Preiss and Bantam books, who hoped some of the Kurtzman magic was left. The humor was aimed at teens, coinciding with Kurtzman's daughter Nellie's ado-lescent years. Harvey's wife, Adele, appeared as herself in the strips drawn by "Little Annie Fanny" assistant Sarah Downs, and several young writers and artists (Bob Fingerman, Chris Browne, Rick Geary, Kevin Sacco, Ralph Reese, Mel Gilden, and George Chastain) contributed as well. It was pure silliness, with no intended bite, and scarce social content (a teenager comes home to her parents, pregnant, and announces, "I got it at the mall!").

In the mid 1980s, Kurtzman produced several stories with the assistance of Downs and in collaboration with Will Elder for *MAD* Magazine (where he had reconciled with Gaines)—none of them in any way comparable to his prior *MAD* work and which only served, by comparison, to show just how far he had strayed from his initial genius. In 1988, Kurtzman collaborated with Peter Poplaski to create a guest cover for the serialized graphic novel *Kings in Disguise*.

Kurtzman's relationship with publisher Byron Preiss took another step with *Harvey Kurtzman's Strange Adventures* (1990), which was unique in that Kurtzman scripted and provided layouts for a collection of admiring artists: Sarah Downs, Jean Giraud (the French artist known globally as Moebius), *MAD* Magazine regulars Sergio Aragonés and Thomas Bunk, Dave Gibbons (*Watchmen*), graphic designer William Stout, and alternative comics artist Rick Geary. Kurtzman himself inked one story, and Robert Crumb and Art Spiegelman provided loving tributes. Unfortunately, the finished book was a bit of a disappointment, from both a visual and sales point of view.

Kurtzman was suffering from Parkinson's disease, greatly affecting his hand-eye coordination, and as a result his work was showing a diminished facility. His pencil roughs and the inking on his solo story lacked his characteristic vigor and inspirational form. The book was well intentioned in spirit, and all the collaborators were no doubt thrilled to work with the master, but there was a pervasive sense that no one involved wanted to tell the emperor he was sans clothing. An ill-advised brief revival of *Two-Fisted Tales*, packaged by Preiss, had the same feeling. Kurtzman was rapidly losing his once marvelous chops, and it was sad to behold.

Kurtzman at home | 1970 | Captured at a moment of reflection or weariness, Kurtzman in his Mt. Vernon, New York, living room.

"New! Different!" | circa 1970s | This model switcheroo gag is undated, and its publication and purpose unknown.

OFFSETTING LATE-CAREER CONSOLATIONS

If Kurtzman suffered at the disappointment of his three Byron Preiss projects so late in his life, they followed many other disappointments. Kurtzman's artistic and editorial consolations began, one might say, with the affection and admiration heaped upon him by the suddenly prominent Terry Gilliam, Robert Crumb, and Art Spiegelman, among others, who pronounced Harvey the inspiration of a generation. The rise of an expanded comics fandom, with its own scholarly apparatus, made Kurtzman's constituency into an organized force.

Publisher Russ Cochran reprinted deluxe volumes of Kurtzman's E.C. Comics action work, *Two-Fisted Tales, Frontline Combat,* and most crucially four volumes of Kurtzman's *MAD* comics. Kitchen Sink Press released hard- and softcover collections of his other seminal work: "Hey Look!," *Jungle Book,* "Goodman Beaver," and even the 1952 "Flash Gordon" dailies that he laid out and scripted, as well as lesser work like "Betsy's Buddies." Extensive interviews with Kurtzman started to appear in the *Comics Journal, Squa Tront,* and other publications. He was now repeatedly interviewed for the press and on radio as the Great Old Man of comics satire.

Harvey Kurtzman had become a majordomo, at least to the thousands interested in that corner of American popular culture. Jules Feiffer was to observe later, after Kurtzman's passing, that now "there were no Orson Welleses around," which is to say magnum creators who shaped a visual/narrative world around themselves. Kurtzman, in advancing years, no doubt understood.

Kurtzman taught at the School of Visual Arts in New York from 1973 until the middle of the 1980s, bringing him special enjoyment and, in a way, real fulfillment. A former student, Tom Sito, who would go on to a career in animation, recalled his mentoring by Kurtzman:

> Harvey conducted himself in a low-key, dignified manner, while never being cold or distant. He seemed genuinely interested in our ideas rather than if we executed his orders. He was a good listener. This is rare among art teachers. Harvey enjoyed new minds with new ideas. When he was stumped on an idea or we momentarily got the better of him, instead of feeling his dignity as an educator was compromised, he would lower his head, blush, and look back up at us with his small wry smile, to milk the moment of its maximum of merriment. He was playing Hardy to our Laurel. He was liberal in his praise. He encouraged, guided, and nurtured like a gardener raising bulbs, rather than being merely concerned with hammering down his personal dogma on young minds.

Toward the end of his life, and far more after it ended, the historical applause grew louder. In 1988 the Harvey Awards, named for him, were launched to recognize excellence in comics art in more than twenty categories; they are currently presented annually in Baltimore each fall. Ironically, in that same year his friend Will Eisner was likewise honored with the creation of the Eisner Awards, and each soon ended up as a recipient of the other's namesake award.

Kurtzman passed away on February 21, 1993. *The Comics Journal* ran a special issue largely devoted to Kurtzman and his work only a few months before his death, and in 2000 the *Journal,* in its wrap-up of the 100 best comics of the century, included no less than five of his genius children among the first sixty-four: *MAD,* New Trend action comics, *Jungle Book,* "Hey Look!," and "Goodman Beaver."

Appreciation for Kurtzman's original art has only grown posthumously. He was one of seven pivotal comic book artists featured in the acclaimed "Masters of American Comics" exhibition that toured five major art museums in 2005 and 2006, and in the new century his artwork has been on almost continuous display at other institutions worldwide.

"Kurtzman's Suburbia" | circa mid-1970s | A self-deprecating gag believed to have been created for *Kar-tunz*, the annual magazine put out by his students at the School of Visual Arts in New York.

Little Annie Fanny

BY HARVEY KURTZMAN AND WILL ELDER

Each and every "Little Annie Fanny" story underwent several labor-intensive steps before reaching the final published stage. To demonstrate a typical evolution, on the following vellum pages we reproduce four of Harvey Kurtzman's preliminary stages of the splash page from "Van-In" (*Playboy*, May 1978), followed by the published page.

This particular story began in mid-1977, when Harvey Kurtzman ran the basic concept by *Playboy* publisher Hugh Hefner: "I collected van cult magazines, discovering that vans are essentially elaborate traveling *bedrooms*!" Kurtzman said in his pitch to the publisher. Customized vans were all the rage that year, furnishing an essential topical angle, while the bed aspect served the risqué cornerstone crucial to every Annie story. Next Kurtzman did on-site research, attending a van show in New Jersey that August. He filled a small spiral notebook with sketches, dialogue snippets, and ideas while gathering other visual references. Then he wrote the script.

1. Kurtzman's first visual step in the final-page process was his pencil layout on Bristol board roughly the size of the magazine, using shades of gray in anticipation of collaborator Will Elder's finished paintings. Sometimes dialogue would change, and balloons or "eye-pops" were added after this stage, but once Kurtzman had reached this point, the finished composition remained remarkably close.

2. Working at 8 ½ x 11 inches, Kurtzman created a color guide for Elder. These guides are frequently delightful abstractions in their own right. Sometimes Kurtzman would add marginal notes detailing special color instructions or describe the particular color effect he desired from Elder, whose painterly skills he trusted implicitly.

3. Kurtzman next prepared a "tracing" on a much larger sheet of translucent vellum, with an image area of 10 ½ x 15 inches, creating compositions by building layers with fine- to medium-tip color markers. He would start with the lighter colors, working in a very loose freestyle. Then, with a slightly darker color, he would work directly over the earlier lines but tighten up the composition. He would continue to do so with successively darker tones until he was satisfied with the exact placement of elements and balance.

4. Over this still relatively loose rainbow composition Kurtzman would lay another sheet of vellum and trace with a fine-line marker, tightly delineating the final exacting layout. Generally two such vellum sheets would suffice, but Kurtzman would add a third, fourth, or even fifth comprehensive layer when he remained unsatisfied with a second sheet. For "Van-In," a third vellum page focused on the perspective of all the vehicles (space doesn't permit its inclusion here).

5. The final vellum provided a precise blueprint for Will Elder, but only after he painstakingly traced Kurtzman's line art onto a separate sheet backed with pencil rubbings, which was laid face down on the heavy illustration board Elder would paint on. Using watercolor and tempera, Elder transformed the image into its final stage—the only one the public would see when printed in *Playboy*.

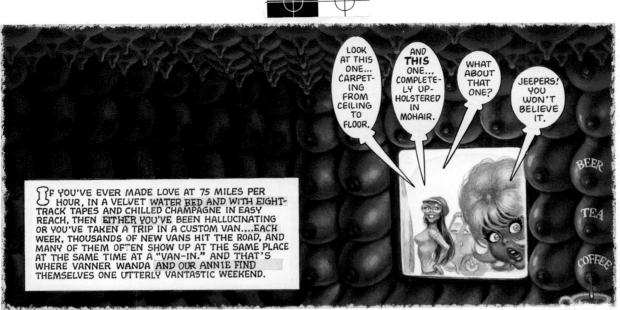

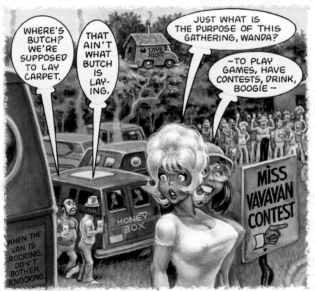

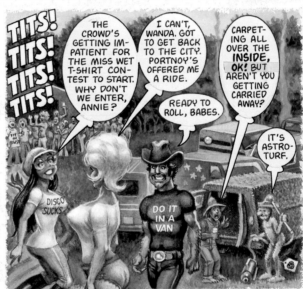

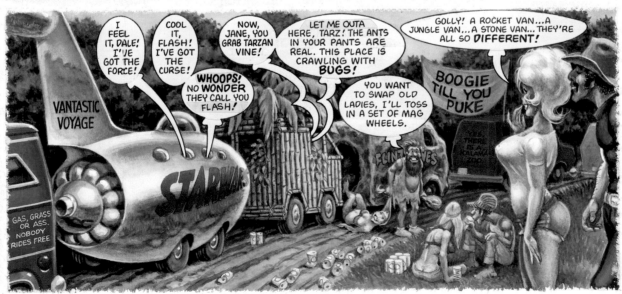

"Dracula: His Cousins" | 1974 | "Little Annie Fanny" demanded the great bulk of Harvey Kurtzman's time and energy from the late 1960s until the end of his career, but he managed to produce some exquisite solo comics in the mid-1970s for the French alternative comics market. He created three short Dracula parodies during this interlude, including the two-pager shown here, as well as "Women!" on the following spread.

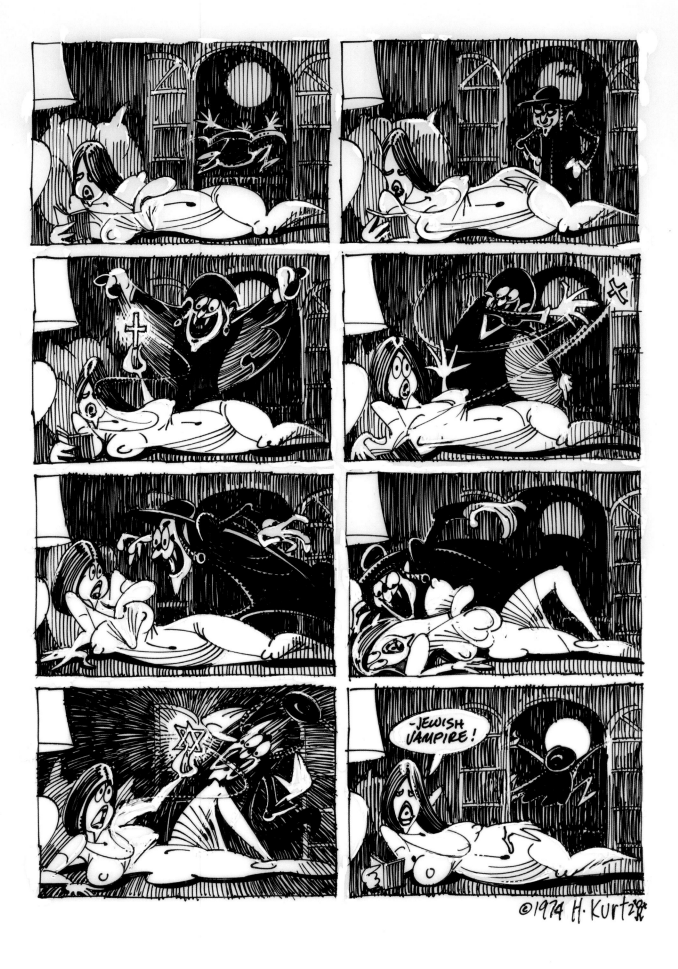

Top left | Nellie Kurtzman and her father | 1977 | Taken at the San Diego Comic-Con.

Above | Harvey Kurtzman and Gilbert Shelton | 1975 | Kurtzman gave Shelton's "Wonder Wart-Hog" its first national exposure in *Help!* magazine in the early 1960s. Here the pair meet at a convention dedicated to underground comix in Berkeley in 1975, where Kurtzman was revered as the "father-in-law" of the movement and Shelton's "Fabulous Furry Freak Brothers" was the most popular

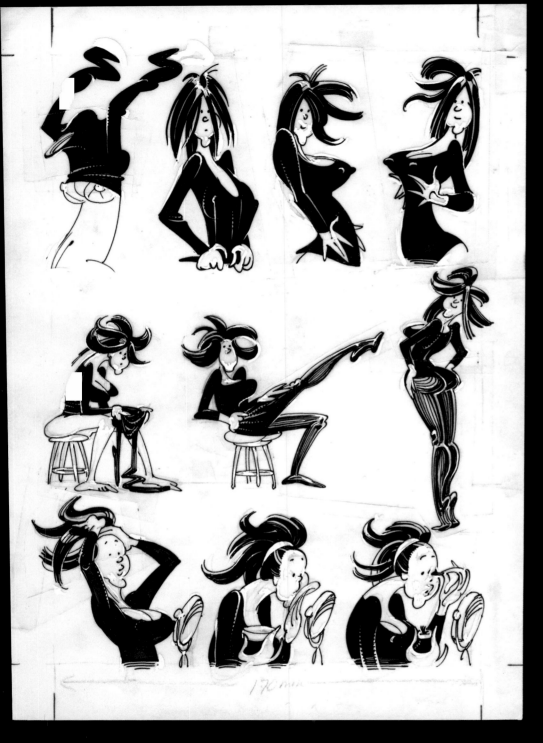
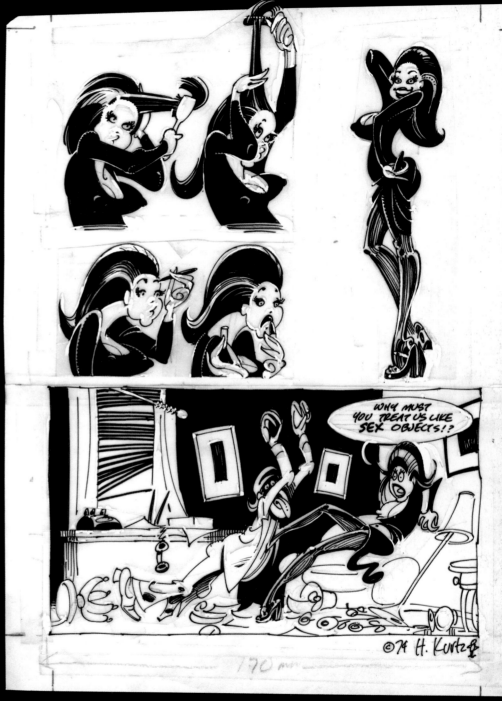

Opposite right and above | "Women!" | 1974 | A big admirer of the French alternative comics scene in the 1970s, Harvey Kurtzman created several pages and short pieces specifically for the magazine *L'Echo des Savanes*, generally translated (where necessary) by the cartoonist Mandryka. "Women!" is one such example, showing the solo Kurtzman still in top form. "Women!" was not published in America until appearing in the anthology *Mona* no. 1 in 1999.

The stamp of Kurtzman was on so much of the comics art landscape at the turn of the millennium, it would be impossible to make any ready assessment. Did the collected work of R. Crumb, now available in such quantity and in practically every part of the world, reflect the Kurtzman influence? Crumb would say so, and has, repeatedly. Did Kurtzman's vision help Art Spiegelman fashion *Maus* or *In the Shadow of No Towers*? Spiegelman insists that it did. Do we still find Kurtzman's influence among the newest generation of today's artists? That may be the largest question that remains to be answered, but the cartoonist's large shadow still remains, without a doubt.

Time magazine columnist Richard Corliss, writing in 2004, recalled that Kurtzman had remained a strangely unrecognized giant of American social satire. Though *Time* had brushed him off at his death in a mere forty-three words, and the *New York Times* gave him hardly more—until prompted by the suddenly prominent Spiegelman—Kurtzman's memory was rescued, beyond comics circles, mainly in a 1993 memorial piece by Adam Gopnik in the *New Yorker* (illustrated by Spiegelman and Elder). Gopnik provocatively concluded that if *MAD* had been the first major source of critique-as-satire upon popular entertainment at large, Kurtzman's sensibility was such that "almost all satire today follows a formula that Harvey Kurtzman thought up." It was a pardonable exaggeration, also marked by Gopnik's own underestimation of the political underpinnings of Kurtzman's effort.

It goes almost without saying that Kurtzman's influence on comics art is large and enduring. He was altogether too modest to say that his work, at its best, gave us, his faithful readers, the critical insights that shaped our view of vernacular art and its uses, but it also helped shape the world as it came out of the war in the 1940s by giving us a very different future. And it still does.

Above left | *Bijou Funnies* no. 8 cover | 1973 | When Jay Lynch, editor of the underground comix series *Bijou Funnies*, wanted to do an homage to *MAD*, with underground cartoonists parodying one another, who else but Kurtzman could do the cover? **Above** | **Harvey Kurtzman and Patrick Rosenkranz** | **1975** | Patrick Rosenkranz, chronicler of the underground comix movement, interviewed Kurtzman at his Mt. Vernon home.

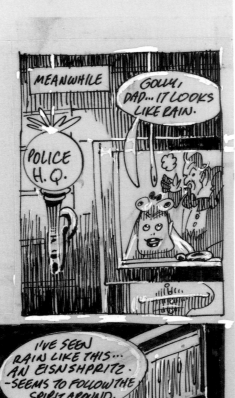

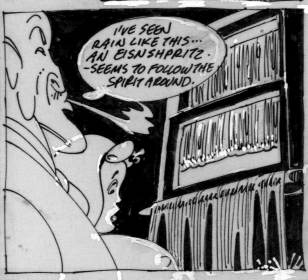

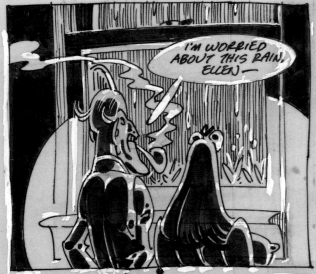

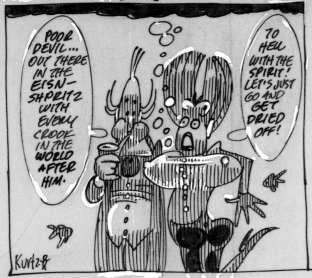

Above | *The Illustrated Harvey Kurtzman Index* | 1976 | Collector extraordinaire and comics scholar Glenn Bray compiled and published a complete guide to every single item Kurtzman created, edited, or contributed to up till 1976. When Kurtzman looked at the published index he held it, studied it carefully, and finally said, "My entire life is in this slim book." Then, pausing, added, "How *depressing*."

Left | **Contribution to "The Spirit Jam"** | 1980 | A special issue of *The Spirit Magazine* was devoted to a Spirit "jam" involving fifty professionals all having fun with Will Eisner's venerable character. Harvey Kurtzman's contribution was notable for coining the ersatz Yiddish term "Eisnshpritz" for the torrential rains, puddles, dock scenes, and watery elements common in his good friend's work. The term has caught on among comics fans, though it is more typically spelled "Eisenshpritz" or "Eisnershpritz." The blank areas at the beginning and end of this page are where other artists overlapped with Kurtzman in the long jam story.

Left | Pencil and marker rough for *Kings in Disguise* no. 2 | 1988 | By the late 1980s, Harvey Kurtzman's health was deteriorating and he no longer had the same hand-to-eye coordination, but he continued to work and was still able to produce work in collaboration with others. This rough pencil composition on the left is for the second cover of the serialized graphic novel *Kings in Disguise* by James Vance and Dan Burr.

Above | Tight marker rough for *Kings in Disguise* no. 2 | 1988 | Kurtzman's tighter cover composition, using color markers, was given to collaborator Peter Poplaski to finish.

Opposite | Final art for *Kings in Disguise* no. 2 | 1988 | Peter Poplaski's inked version of Kurtzman's cover design. Poplaski had worked with Harvey on the design of some of his book compilations, such as *Jungle Book* and *Goodman Beaver*, and he was one of the younger generation of artists Kurtzman trusted to finish his work.

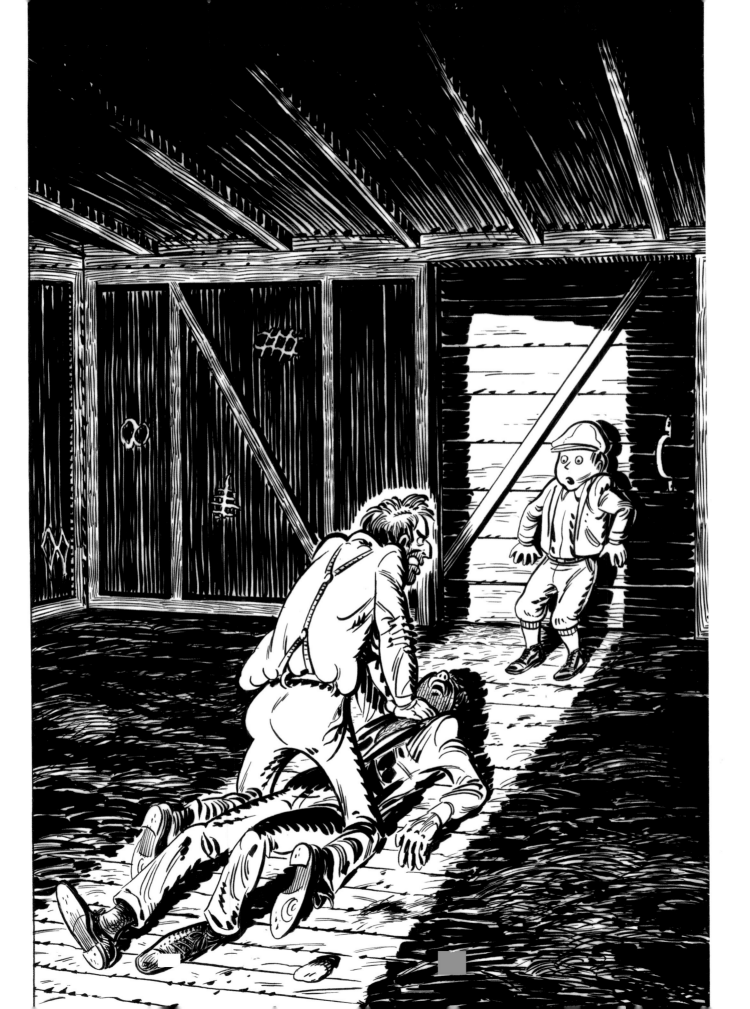

Above | *From Aargh! to Zap! Harvey Kurtzman's Visual History of the Comics* | 1991 | Kurtzman had long planned to write and design a personal history of comics, but back-burnered the project for many years as other priorities prevailed. With his health declining, he agreed to collaborate, making his notes and outline available to comics historian Michael Barrier. The resulting book was thinner and more picture heavy than he had planned, but the handsome volume still had an impact, hitting the market just two years before his death.

From Aargh! to Zap! Harvey Kurtzman's Visual History of the Comics (1991) might have been a sort of validation—a long look backward at his own place in history. If, that is, Kurtzman's health had lasted. As it was, comics scholar Michael Barrier did a workman-like job of filling in. To say it was seamless would be too much, and Barrier would not himself make such a claim. The text was considerably thinner than the full treatment that Kurtzman had intended, with the ratio of pictures to text far greater in the visual direction. And yet the volume reveals much about Kurtzman's frame of mind as he, after being hit by Parkinson's, also faced cancer and the end of his life.

The book was about his chosen profession, of course, and said little about his personal life, something that he rarely discussed in public. From the birth of his first child in 1950, Kurtzman had been the one father in the neighborhood who was usually home with the kids during the day. He entertained them and their neighborhood pals with trips to the beach or for ice cream, puppet shows of his own creation, and endless attention. One of his great tragedies was that his youngest daughter had to grow into her teen years and beyond with a deeply ill parent. The other chief tragedy was, of course, his son's autism and the shadow that it threw across their family life, a shadow lifted only somewhat by Harvey and Adele's local volunteer work for autistic and special needs children.

Their Westchester County home had always been open to a steady stream of visitors, and for periods of time in the 1960s the likes of Robert Crumb, Terry Gilliam, and others had been non-paying houseguests—and the casual drop-bys and scheduled appointments were a part of the lifestyle that only diminished in later years. This sociability, and in particular the encouragement to young artists, confirmed something about the Kurtzmans' collective character and something about Harvey's whole life going back to Music and Art. His early home life could not have been overly warm, despite his mother's devotion; his family life, despite difficulties overshadowed by financial fears, was rich and rewarding. His boyhood friendships, extended through a lifetime, offered proof of the educational opportunities offered in a post-war America that was starkly different from the conservative and neoconservative social attitudes of the generations that followed.

Fittingly, the last chapter of *From Aargh! to Zap!* was titled "Comics as Art." In the closing decade of the twentieth century, comics had finally earned the status of art, which they had deserved all along, and had begun to be published more respectfully, selling in greater and greater numbers. Kurtzman's own best work pointed the way decades earlier, and it stands as a benchmark for all that follows.

Above | Harvey Awards | Named after Kurtzman, the Harvey Awards were established in 1988 (the same year as the Eisner Awards, named after his close friend Will Eisner). The Harvey Awards are presented annually for excellence in over twenty professional categories in the comics industry. Professionals both nominate candidates and vote in the final selections. The awards are currently presented each fall at a banquet held in conjunction with the Baltimore Comic-Con. **Opposite | Harvey Kurtzman | September 1965 |** Barefoot and with his head shaven, Harvey Kurtzman in the mid-1960s struck a Zen pose.

Sources

CHAPTER ONE

Andriola, Alfred. "Charlie Chan" section of the "Adventure Strips" chapter in *Classic Comics and Their Creators*, by Martin Sheridan. Arcadia, CA: Post-Era Books, 1973. p. 120. Originally published in 1942.

Benson, John. "A Conversation with Harvey Kurtzman and Bill Elder," *Squa Tront* no. 9. New York: John Benson, 1983. p. 69.

———. "A Conversation with Harvey Kurtzman and Bill Gaines," *Squa Tront* no. 9. New York: John Benson, 1983. pp. 83–92.

———. "Hey Look! An Introduction," *Hey Look! Cartoons by* MAD *Creator Harvey Kurtzman*. Princeton, WI: Kitchen Sink Press, 1992. p. 8.

Harrison, Hank. *The Art of Jack Davis*. Detroit: Stabur Press, 1987. p. 8.

Jones, Gerard. *Men of Tomorrow: Geeks, Gangsters and the Birth of the Comic Book*. New York: Basic Books, 2004.

Kurtzman, Harvey. "Interview with Harvey Kurtzman" by John Benson, *A Talk with Harvey Kurtzman*. Privately published in mimeograph, August 20, 1965.

———. "Interview with Harvey Kurtzman" by Paul Buhle, *Shmate* no. 8, Summer 1983. pp. 24–25.

———. "Harvey Kurtzman: The Man Who Brought Truth to Comics." 1981 interview conducted by Kim Thompson, Gary Groth, and Mike Catron, reprinted in *The Comics Journal Library Volume Seven: Harvey Kurtzman*. Seattle: Fantagraphics Books, 2006. p. 96.

———. "Interview with Harvey Kurtzman" by James Vance and Denis Kitchen, September 23, 1989. Unpublished.

Kurtzman, Harvey, with Michael Barrier. *From Aargh! to Zap! Harvey Kurtzman's Visual History of the Comics*. New York: Byron Preiss/Prentice Hall, 1991.

Kurtzman, Harvey, with Howard Zimmerman. *My Life as a Cartoonist*. New York: Minstrel/Pocket Books, 1988.

Rubin, Shirley. "It's All in the Teacups," *The High School of Music and Art Yearbook*. New York: Published by the students of the High School of Music and Art, Spring 1941. p. 103.

VandenBergh, Gary. "The Private Life of Will Elder," *Will Elder: The Mad Playboy of Art*. Seattle: Fantagraphic Books, 2003. p. 13.

CHAPTER TWO

Benson, John. "A Conversation with Harvey Kurtzman and Bill Elder," *Squa Tront* no. 9. New York: John Benson, 1983. p. 74.

Benson, John, David Kasakove, and Art Spiegelman. "An Examination of 'Master Race,'" *Squa Tront* no. 6. New York: John Benson, 1975. pp. 41–47.

Jacobs, Frank. *The Mad World of William M. Gaines*. Secaucus, NJ: Lyle Stuart, 1972.

Kurtzman, Harvey. "The Reminiscences of Harvey Kurtzman," interview by Paul Romaine. New York: Columbia University Oral History Office, 1989. Unpublished.

———. "Interview with Harvey Kurtzman" by James Vance and Denis Kitchen, September 23, 1989. Unpublished.

Reidelbach, Maria. *Completely Mad: A History of the Comic Book and Magazine*. Boston: Little, Brown, 1991. p. 22.

Stewart, Bhob. *Against the Grain: Mad Artist Wallace Wood*. Raleigh, NC: TwoMorrows Press, 2003. pp. 7–50.

Sadowski, Greg. *B. Krigstein, Volume One: 1919–1955*. Seattle: Fantagraphics Books, 2002. pp. 120–23, 133, 170–72.

Schreiner, Dave. "Flash Gordon vs. the Reluctant Collaborators of Manhattan Isle," *Flash Gordon: The Complete Daily Strips, November 1951–April 1953*. Princeton, WI: Kitchen Sink Press, 1988. pp. 119–125.

Schutz, Diana with Denis Kitchen, eds. *Will Eisner's Shop Talk*. Milwaukie, OR: Dark Horse Books, 2001. p. 135.

Von Bernewitz, Fred, and Grant Geissman. *Tales of Terror!* Seattle: Gemstone Publishing/Fantagraphic Books, 2000. pp. 20–27, 36, 38, 49–50, 66–67, 78, 93, 144–53, 183.

CHAPTER THREE

Jacobs, Frank. *The Mad World of William M. Gaines*. Secaucus, NJ: Lyle Stuart, 1972.

Kurtzman, Harvey. "Notes and Comments," *MAD Volume 3*. West Plains, MO: Russ Cochran, 1987.

———. "The Reminiscences of Harvey Kurtzman," interview by Paul Romaine. New York: Columbia University Oral History Office, 1989. Unpublished.

———. "Interview with Harvey Kurtzman" by James Vance and Denis Kitchen, September 23, 1989. Unpublished.

Kurtzman, Harvey, with Michael Barrier. *From Aargh! to Zap! Harvey Kurtzman's Visual History of the Comics*. New York: Byron Preiss/Prentice Hall, 1991. p. 41.

Kurtzman, Harvey, with Howard Zimmerman. *My Life as a Cartoonist*. New York/Minstrel: Pocket Books, 1988.

Price, Roger. "A Vital Message from Roger Price," *The Mad Reader*. New York: Ballantine Books, 1955.

Reidelbach, Maria. *Completely Mad: A History of the Comic Book and Magazine*. Boston: Little, Brown, 1991. p. 32.

Stewart, Bhob. *Against the Grain: Mad Artist Wallace Wood*. Raleigh, NC: TwoMorrows Press, 2003. p. 43.

VandenBergh, Gary. "The Private Life of Will Elder," *Will Elder: The Mad Playboy of Art*. Seattle: Fantagraphic Books, 2003. pp. 13, 41, 45.

Wolverton, Basil. "Interview with Basil Wolverton," *Graphic Story Magazine* no. 14, Winter 1971–72. p. 47.

CHAPTER FOUR

Benson, John. "A Conversation with Harvey Kurtzman, Arnold Roth, and Al Jaffee," *Squa Tront* no. 10. New York: John Benson, 2005. p. 36.

Corliss, Richard. "That Old Feeling: Hail, Harvey!" *www.time.com*, May 5, 2004.

Elder, Will. "What's in It for Me?" interview by David Schreiner, *Goodman Beaver*. Princeton, WI: Kitchen Sink Press, 1984. p. 92.

Fleischer, Richard. *Out of the Inkwell: Max Fleischer and the Animation Revolution*. Lexington, KY: University Press of Kentucky, 2005.

Kitchen, Denis. "Man, I'm Beat! Harvey Kurtzman's Frustrating Post-*Humbug* Freelance Career," *Comic Art* no. 7, Winter 2005.

———. Introduction to *The Grasshopper and the Ant*. Northampton, MA: Denis Kitchen Publishing Co., 2001.

———. "The Origins of Little Annie Fanny," Playboy's *Little Annie Fanny: Volume 1*, by Harvey Kurtzman and Will Elder. Milwaukie, OR: Dark Horse Comics, 2000 (released in paperback in 2001). pp. 203–11.

Kurtzman, Harvey. "Catching Up with Harvey Kurtzman," interview by Lee Wochner, *The Comics Journal* no. 100, July 1985.

———. "Interview with Harvey Kurtzman" by James Vance and Denis Kitchen, September 23, 1989. Unpublished.

Kurtzman, Harvey, ed. *Harvey Kurtzman's Strange Adventures*. New York: Epic Comics/Byron Preiss, 1990.

———. *Nuts! The Hot New Humor Book*. New York: Bantam Books/Byron Preiss, 1985.

Harvey Kurtzman Satire Club Bulletin no. 4, August 15, 1959. Final issue.

Kurtzman, Harvey, with Howard Zimmerman. *My Life as a Cartoonist*. New York: Minstrel/Pocket Books, 1988. p. 185.

Levin, Bob. *The Pirates and the Mouse: Disney's War Against the Counterculture*. Seattle: Fantagraphics Books, 2003. pp. 220–21.

Marcus, Greil. "The Devil Is in the Details," *Artforum*, November 2005. p. 54.

Miller, Russell. *Bunny: The Real Story of Playboy*. New York: Holt, Rinehart and Winston, 1984. pp. 65–66.

Reidelbach, Maria. *Completely Mad: A History of the Comic Book and Magazine*. Boston: Little, Brown, 1991. p. 167.

Schreiner, Dave. "The Gnawing Truth Behind Satire," *Goodman Beaver*. Princeton, WI: Kitchen Sink Press, 1984. pp. 6–13.

———. "Outro," *Harvey Kurtzman's Jungle Book*, second edition. Princeton, WI: Kitchen Sink Press, 1986, pp. xi–xii.

———. *Kitchen Sink Press: The First 25 Years*. Princeton, WI: Kitchen Sink Press, 1994. pp. 21, 35, 41, 67, 78, 117.

Steinem, Gloria. *Outrageous Acts and Everyday Rebellions*, second edition. New York: Henry Holt, 1995.

Warren, James. "Apologies," *Help!* vol. 2 no. 3, August 1962. p. 3.

CHAPTER FIVE

Benson, John. "A Conversation with Harvey Kurtzman, Arnold Roth, and Al Jaffee," *Squa Tront* no. 10. New York: John Benson, 2005.

Corliss, Richard. "That Old Feeling: Hail, Harvey!" *www.time.com*, May 5, 2004.

Gopnik, Adam. "Postscript: Kurtzman's Mad World," *The New Yorker*, March 29, 1993. p. 75.

Kitchen, Denis. "The Origins of Little Annie Fanny," Playboy's *Little Annie Fanny: Volume 1*, by Harvey Kurtzman and Will Elder. Milwaukie, OR: Dark Horse Comics, 2000 (released in paperback in 2001). pp. 203–11.

———. "The Ski Lodge: Metamorphosis of an Annie Story," Playboy's *Little Annie Fanny: Volume 2*, by Harvey Kurtzman and Will Elder. Milwaukie, OR: Dark Horse Comics, 2000 (released in paperback in 2001). pp. 222–32.

Kurtzman, Harvey. "Interview with Harvey Kurtzman" by James Vance and Denis Kitchen, September 23, 1989. Unpublished.

Kurtzman, Harvey, ed. *Harvey Kurtzman's Strange Adventures*. New York: Epic Comics/Byron Preiss, 1990.

Levin, Bob. *The Pirates and the Mouse: Disney's War Against the Counterculture*. Seattle: Fantagraphics Books, 2003. pp. 220–21.

Spiegelman, Art. Introductory essay to *Tijuana Bibles: Art and Wit in America's Forbidden Funnies, 1930s–1950s*, by Bob Adelman. New York: Simon and Schuster, 1997. p. 6.

VandenBergh, Gary. "Little Annie Fanny Through the Eyes of Will Elder," Playboy's *Little Annie Fanny: Volume 2*, by Harvey Kurtzman and Will Elder. Milwaukie, OR: Dark Horse Comics, 2000 (released in paperback in 2001). pp. 203–10.

The authors wish to acknowledge the following sources not cited above: An in-person interview and telephone follow-ups with Adele Kurtzman (April 2006); Harvey and Adele Kurtzman's personal correspondence (1946–47); Harvey Kurtzman's professional correspondence files; Harvey Kurtzman's ledger for the Charles William Harvey Studio (1947–48); and Harvey Kurtzman's personal ledger (1949–53).

Index

Page numbers in *italics* refer to illlustrations.

A

Ace/Periodical House, 47
"Ad-Man's Dream World," *67*
"Air Burst," *68*
All American Comics (publisher), 49
Allen, Woody, 188, *197*, 202
Alverson, Chuck, *192*, *193*, 206
"Americans in Paris," *219, 220, 221*
Andriola, Alfred, 10, 12
Archie comics, 36, 37, 40, 194, 204, 211, 218
Art Students League, New York, 6
"Assignment: James Cagney in Ireland," *174–81*
Association of Comic Magazine Publishers (ACMP), 77
Astérix (comic), 47
"Atom Bomb!" 62
Aviation Press, 47

B

Ballantine, Ian, 150, 151
Ballantine Books, 151
Bantam Books, 223
Barkley, Violet, 30
Barks, Carl, 60
Barrier, Michael, 236
Barry, Dan, 63, 86
"Bat Boy and Rubin!" 86
Batson, Billy, 86
Bean, Orson, 188
Beat concepts, *134–35*
Beatles, the, *204*
Beck, Joel, xiii, 205
Benson, John, 18
"Big 'If'!" 62
Bijou Funnies (comic), xiii, 223, *232*
Billy the Kid (comic), 41
Biro, Charles, 42
"Black and Blue Hawks!", 87, *112–13*
"Black Venus", *11*, 14
Blechman, R.O., *131*
Bray, Glenn, 233
Brecht, Bertholt, 106
"Bringing Back Father!" 92, 93
Bruce, Lenny, xi
Buffalo Bob contest, *5*
Byron Preiss (publisher), 223

C

Caesar, Sid, *188*, 190
Caniff, Milton, 10, 12, 86
Cape Cod watercolors, *32–33, 41*
Caplin, Elliott, 40–41, 60, 67, 160
Capp, Al, 40, 41–42, 87, 216
Cartoon History of the Universe (comix), 60
censorship, 77–78, 90
Charles William Harvey Studio, 18–19, *19*, 21, 219
Chester, Harry, *5*, 121, 122, *173*, *192*
Children's Digest, 46
"Christopher's Punctured Romance" (*fumetti*), *197*, 205
Classic Comics and Their Creators (Sheridan), 10
Cleese, John, xiii, 197, *204*, 205
Cochran, Russ, 224
Collier's magazine, 77
Columbia University, 81
Comic Book Price Guide (Overstreet, Robert), 10
Comics noir (comic genre), 42
Comix, underground, xiii, 60, 90, *232*
Communism, 2–3, 49, 92, 93
Compact magazine, 65
Contact Comics, 11
Contract with God, A (Eisner), 160
Cooper, Gary, 86
Corliss, Richard, v, 232
Corporate Crime (comix), 60
"Corpse on the Imjin!" *70–76*
Craig, Johnny, 56
Crandall, Reed, 56, 57
Crime Does Not Pay (comic), 42, 59
Crime Patrol (comic), 50
Crumb, Robert, iii, xiii, 126, 188, *197*, 204, 205, 224, 232
Crypt of Terror, The (comic), 50

D

Daily Worker, 3
D'Arcy, H. Antoine, 87
Davis, Jack, xiii, *42*, 56, 58, *59*, 60, *82*, 83, *124*, 125, *125*, *126–27*, 137, 142, 160, 202, *210*, 219
DC Comics, 49, 86, 97
DeFuccio, Jerry, 58

Disney, Walt, 92
Donenfeld, Harry, 209–10
Dorsey, Frank, 18, *19*
Downs, Hugh, 190, *191*
Downs, Sarah, 219, 223
"Dracula: His Cousins," *228–29*
"Dragged Net!" 84
Dragnet (television show), 84

E

E.C. Comics, xiii, 21, 23, 47, 49–50, 56, 58–62, 66, 70, 77–78, 92, *114*, 121
Eisenberg, Wolf. *See* Elder, Will
Eisner, Will, xiii, 8, 41–42, 60, 86, 160, 194, 233
Elder, Will, xiii, 5, 8, 18, *19*, 30, *42*, 56, *58*, 77–78, 81, *82*, 83–84, 87, *114, 124, 125, 126–27*, 130, *132, 148*, 204, 207, 209, *210*, 211–12, 213, 219–20, *221*, 226
Eliot, T.S., 83
Esquire magazine, 160, 205, 210
Evans, George, 61
Executive's Comic Book (Kurtzman and Elder), *186*

F

Faulkner, William, 83
Fawcett Comics, 86, 160, 207
"Feds 'n' Heads," xiii, *62–63*
Feiffer, Jules, 224
Feldstein, Al, 49–50, 56, 60, 66, 78, 81, *82*, *114*
Ferstadt, Louis, 10, 12–13
figure drawings, *6–7*
"Flash Gordon," *62–63*
"Flesh Garden!" 86
"Follow That Girl!" *43*
Ford, Phil, *191*
Foreman, Carl, 86
Fort Bragg Christmas card, 12
Foster, Hal, 86
Frazetta, Frank, 63, 86
freelancing, 121–23, 130–31, 160
Freudian cars concepts, *146–47*
From Aargh! to Zap! (Kurtzman), 8, 81, 236, *236*
Frontline Combat, 51, 59, 60, 61, 66, 67, *68, 69*
fumetti, xiii, 190, *197*, 210

G

Gaines, Bill, 23, 47, 49–50, 60, 66, 67, 77, 78, *82*, 87, 92, *114*, 121
Gaines, Jessie, 78
Gaines, M.C. "Max," 49, 60
Garroway, Dave, 190, *190*
Gay Comics, 27
Geis, Irving, 18
Gilliam, Terry, xiii, 188, 197, 201, 205, 224
Gleason, Jackie, 190, *191*
Goldberg, Rube, 10, 12, 83
Gonick, Larry, 60
Goodman, Martin, 22
"Goodman Goes *Playboy*," *184–85*, 194, 204, 210, 211
"Goodman Meets S*perm*n," *186–87*, 195, 204
Gopnik, Adam, 232
Gordon, Ramon, 18
Goscinny, René, 46, 47
"Grasshopper and the Ant, The," 160, 161, *162–71*
Gray, Harold, 86
Great Depression, the, 3, 56

H

Harmon, Harvey, 45, 47
See also Kurtzman, Harvey
Harvey, Robert, 58, 62
Harvey Awards, 236, *236*
Harvey Kurtzman's Jungle Book, 22, *150*, 151–52, 153, *153*, *154–59*
Harvey Kurtzman's Strange Adventures, 223
Hasan, Adele. *See* Kurtzman, Adele
Haunt of Fear (comic), 56, 58, 61
Hayes, Harold, 160
Heath, Russ, xiii, 219
Hefner, Hugh, xiii, 81, 121–22, 123, 125, 131, 135, 147, 204, 205, 209, 211–12, 215
Help! magazine, xi, xiii, 188, *188, 189*, 190, *190, 191–203*, 204, *204*, 205–07, 210
Hemingway, Ernest, 83
"Hey Look!" 22, *23–28*, 29, *35*, 38, 40, 41
"High Camp," 212
High Noon (film), 86
High School of Music and Art, New York, 4, 5, 8, 219

Hillman, Alex, 77
Hines, Mimi, *191*
Hirshfeld, Harry, 41
Hiss, Alger, 49
Hoover, J. Edgar, 215
Horror comics, 50, 58
"House of Horror," 50, *56*
Howdy Doody (television show), 91
"How We Laugh," *67*
Humbug magazine, xiii, *120*, 125, *125*, *126–29*, *130*, 130–31, *131*, *132–33*, 210

I

Illustrated Harvey Kurtzman Index, The (Bray), *233*
income rates, 67, 77, 79, 81, 121, 122, 212
Ingels, Graham, 56
Inner Sanctum (radio show), 50

J

Jackson, Jack, 60
Jaffee, Al, xiii, *128*, 130, 219
Jewish people, 1, 2–3, 5, 10
John Wayne Adventure Comics, 41, 42
Jones, Gerard, 209–10

K

Kefauver, Estes, 77, 78
Khrushchev, Nikita, 207
Kinderland, 3
Kings in Disguise, *234–35*
Korean War, 70
Kovacs, Ernie, *189*, 190
Krazy Komics, 38
Krigstein, Bernie, 56, 60
Ku Klux Klan, 2, *205*
Kunen Books, 46, 47
Kurtzman, Adele, xiii, 6, 21, 30, *31*, 32–35, 38, 42, 47, *59*, 223, 236
Kurtzman, David, 1, 2
Kurtzman, Edith, 1
Kurtzman, Elizabeth, 125
Kurtzman, Harvey, artistic styles, 58, 83–84, 87, 88, 90, 226
Kurtzman, Harvey, early life, 1–3, *2*, *3*, 5, *5*, 8, 10, 12, 25
Kurtzman, Harvey, income rates, 67, 77, 79, 81, 121, 122, 212
Kurtzman, Harvey, later life and death, 223, 224
Kurtzman, Harvey, photographs, *14*, *15*, *42*,

58, *59*, *124*, *192*, *196*, *198–99*, *210*, *211*, *212*, *213*, *223*, *232*, *237*
Kurtzman, Harvey, self-portraits, *9*, *24*, *30*, *149*
Kurtzman, Meredith, *42*, 47
Kurtzman, Nellie, 223, *230*
Kurtzman, Peter, 83
Kurtzman, Zachary, 1, *3*, 3
"Kurtzman's Suburbia," *225*

L

Ladies' Home Journal, 77
LaGuardia, Fiorello, 5
"Last War on Earth," 59
lawsuits, 77, 78, 86, 204
Lee, Stan, 22, 30, 33, 36, 38, 39, 40
Lev Gleason Publications, 42
Lewis, Jerry, 190, *190*, 207
Liebowitz, Jack, 209–10
"Little Annie Fanny," xi, xiii, 81, 194, 202, 203, 204, 205, *208*, 209, *210*, 210–11, *211*, *212*, 212–13, *214*, 215, *215*, *216–22*, *226–27* (insert)
Little Lulu (comic), 60
"Little Orphan Melvin!" *85*, 86
Lone Ranger, The (television show), 84
"Lone Stranger!" 84
"Lost Battalion!" *52–55*
Lownes, Victor, 122
Lucky Fights It Through (comic), 47
Lucky Luke (comic), 47
Lynch, Jay, xiii, 205

M

MacFadden Books, 186
Madison Avenue magazine, 160
MAD books, 151
MAD Magazine, xi, xiii, 21, 77–78, *79*, *80*, 81, *82*, 83, *83*, 84, *84*, 85, 86, *86*, 87, *87*, *88–91*, 92, *92*, *93–95*, 106, *106*, *107*, *108*, 108–09, *109*, *110–11*, 121
Magazine of Popular Psychology, The, 67
Margie (comic), 26
"Marley's Ghost," *136–45*, 137, 160
Mason, Jane, 191
"Masters of American Comics" (exhibition), 224
McCarthy, Joseph, xiii, 92
"Memphis!" 57
"Mickey Rodent!" 92
Monroe, Marilyn, 106, *128*
Monty Python, xiii, 197

Monty Python's Flying Circus, xiii, 188
Moon Girl (comic), 50
Moore, Clay, 84
Mosely, Zack, 86
Murrow, Edward R., xiii
"My First Golden Book of God," 202, 203

N

Naked Gun, xiii
Nellie the Nurse (comic), 25
New Deal, the, 5, 49
"New! Different!" *224*
New Trend titles, E.C. Comics, xiii, 50, 58–59
New York Herald-Tribune, 29, 40
New York Times, The, 3
"Night Club, The," *172–73*
Nixon, Richard, 49
Nuts! magazine, 223

O

Oda, Ben, 83
"Organization Man in the Grey Flannel Executive Suite," *152*, 153, *153*, *160*
Overstreet, Robert, 10
Overtone (student newspaper), *4*

P

Pageant magazine, 77, 148, 160, 173
Panic magazine, 77–78
Paperback Review (newspaper insert), *173*
Parents Magazine, 47
Paris, Texas, 153, 157
Pearl Harbor, 50
Perkes, Abraham, 1–2, 18
Perkes, Daniel, *3*
Persky, Lester, 18, *19*
Picture Stories from the Bible (comic), 47, 60
"Pigtales," *35*, 38, *39*
Playboy magazine, xiii, 121, 123, 125, 131, 135, 147, 160, 193, 204, 210, 212–13, 226
See also "Little Annie Fanny"
Pleasure Package (Kurtzman), *150*, *151*, *153*
Poplaski, Peter, 234
Poston, Tom, 188, *191*
"Pot-Shot Pete," 41, 42
"Prairie Schooner Ahoy!" 47
Pratt Institute, 3
Price, Roger, 86
"Prince Violent!" 86
pulp-fiction, 42, 50, 188, 209–10

Q

Quality Comics, 47

R

racial issues, 2, 18, 78, *205*
Raymond, Alex, 86
Rifa, Leonard, 60
Rosenkranz, Patrick, *232*
Roth, Arnold, xiii, 125, *129*, 130, 202, 219
Russell, Ray, 211
"Rusty," *37*, 40

S

Sahl, Mort, 190, *190*
Sale, Robert Q., 18, *19*
Saturday Evening Post, 160
Saturday Night Live, xi, xiii, 188
"Scenes from College Life," *64–65*
science-fiction comics, 50, 58–59
Scripto television ad, *213*, 223
"Secret Thoughts of an Undergraduate," *45*
Seduction of the Innocent (Wertham), 77
self-portraits, *9*, *24*, *30*, *82*, *149*, *221*
Sesame Street, 223
Severin, John, 18, *19*, 47, *58*, 62, *82*, 83, 84
Severin, Marie, 58
Sharp Comics, 10
Shearer, Harry, xi
Shelton, Gilbert, xiii, 188, 202, 204, 205, *230*
Shulman, Max, 83
Sickles, Noel, 10
Silverheels, Jay, 84
"Silver Linings," *29*, 40
Simon & Schuster, 137, 160
Sito, Tom, 224
"Smilin' Melvin!" 86
Snarf magazine, 223
Spiegelman, Art, xiii, 157, 210, 224, 232
"Spirit Jam, The," 223, *233*
Spirit Magazine, The, 41, 194, *233*
spoofs, 86–87, 92, *92*
Squa Tront: The Complete Guide to E.C. Comics (Kurtzman and Benson), 18
Stanley, John, 60
Steinem, Gloria, xiii, 188, 190, *192*, 193, 209
Stern, Charles, *5*, 18, 19, *19*, 219
storytelling styles, 58, 83–84, 87
Stout, Bill, 219
Striker, Fran, 84
"Superduperman!" 86, *96–97*, 97, *98–105*

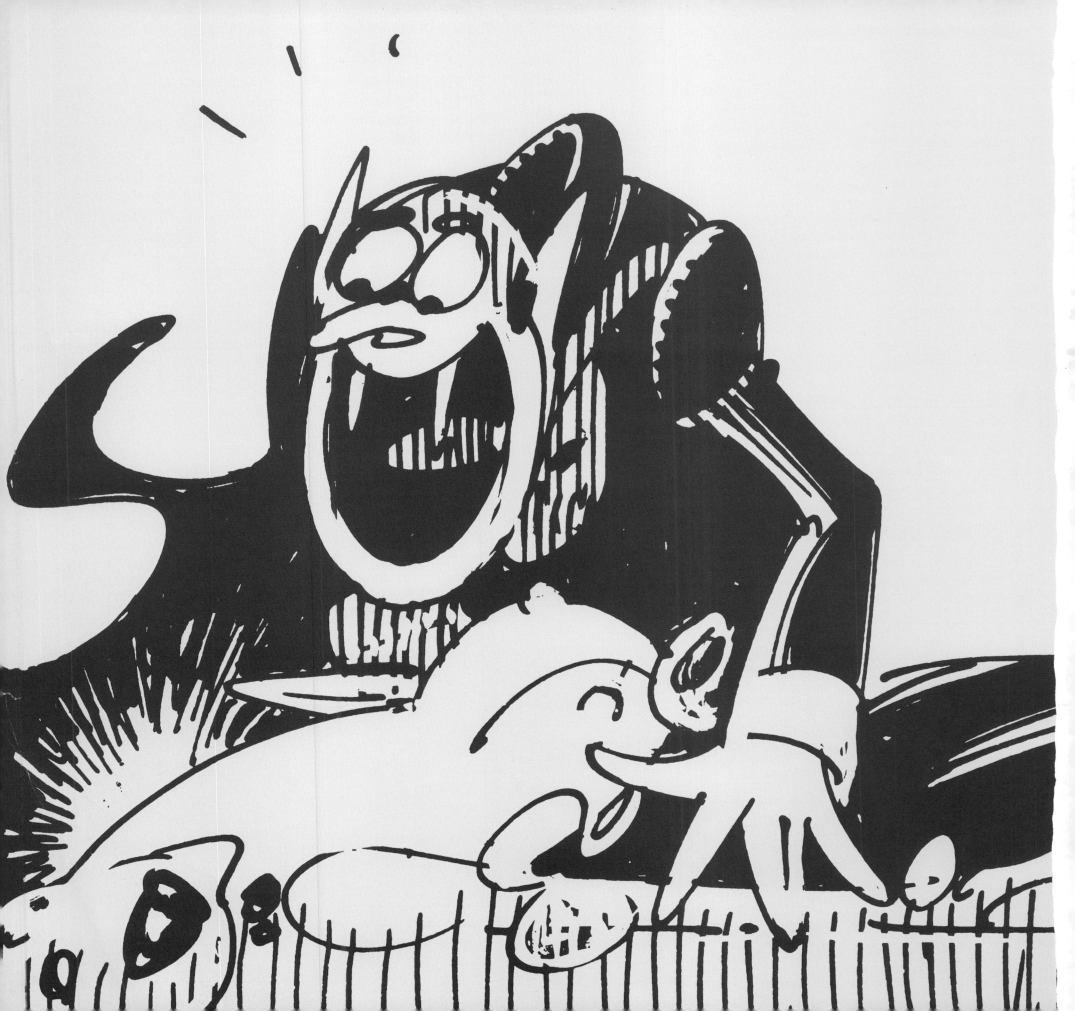

Superman (comic), 49
Survey: A Comic Magazine Devoted to the Juvenile Market, 38, 40

T

Tales from the Crypt (comic), xi, 50
"Teddy and the Pirates!" 87
Tenniel, John, 91
"Thigh of the Beholder" (*fumetti*), *197*
"Thirty Second Movies" (Hirshfeld), 41
"3-Dimensions," *115–19*
thumbnail sketches, *52–55*, 66, *96–97*, *112–13*
Tijuana Bibles, 210
Timely/Marvel Comics, 22, 28, 30, 33, 35, 36, 37, 38, 39, 40, 47
"Times Square," *182–83*
Toby Press, 40–41
Toth, Alex, 60
True Comics, 60

Trump magazine, xiii, *122*, 122–23, *123*, *124*, 125
TV Guide, 160
Two-Fisted Tales, *52–55*, 59–60, *61*, 62, *66*, *67*, *68*, *70*

U

ulcer illustrations, *xiv*, *21*
Uncle $crooge (comic), 60
underground comix, xiii, 60, 90, *232*
"Unmentionables, The" (*fumetti*), *197*, 202
Upholsterer's International Union Social Security Program, *44–45*

V

Van Dyke, Dick, 188, 190
Van Reil, Harold, *5*
Varsity magazine, *43*, 45, 47
Vault of Horror, The (comic), 50, 58
vellum layouts, *57*, *62–63*, 85

W

"War Dance!" 62
Warren, James, *173*, 188, *192*, 194, 204, 205, 211
wars, *11*, *12*, 13–14, *14*, *15–17*, *18*, 13–19, *48*, 49–50, 61–62, 66, 70, 83, 87, 126
Webb, Jack, 84
Weird Fantasy (comic), 50, 58
Weird Science (comic), 50, 58
Wertham, Fredric, 77, 78, 86
"What Can You Do?" (Army camp flyer), *18*
"What's My Shine!" 92
Whiz Comics, 86
Why magazine, *67*
Williamson, Al, 56
Williamson, Skip, xiii, 205
Willie (comic), 28
Winters, Jonathan, 190, *191*
Wolverton, Basil, 87, 89

"Women!" *230–31*
Wood, Wallace "Wally," xiii, 56, *58*, *82*, *83*, 85, 86, 87, 97, 113, *114*, *124*
World War II, *11*, *12*, 13–14, *14*, *15–17*, *18*, 18–19, *48*, 83

Y

Yank (Army weekly), *17*

Z

Zap (comic), xiii

Essential Harvey Kurtzman Bibliography

Bray, Glenn. *The Illustrated Harvey Kurtzman Index*. Sylmar, CA, 1976.

Groth, Gary, and Kim Thompson, eds. *The Comics Journal Library Volume Seven: Harvey Kurtzman*. Seattle: Fantagraphics Books, 2006.

Kurtzman, Harvey. *Harvey Kurtzman's Jungle Book*. New York: Ballantine, 1959. Second edition, Princeton, WI: Kitchen Sink Press, 1986.

———. *Harvey Kurtzman's Strange Adventures*. New York: Epic Comics/Byron Preiss, 1990.

———. *Hey Look!* Princeton, WI: Kitchen Sink Press, 1992.

———. *The Grasshopper and the Ant*. Northampton, MA: Denis Kitchen Publishing Co., 2001.

Kurtzman, Harvey, William Ashman, Clare Barnes, Jr., Bob Blechman, Mel Brooks, Parke Cummings, Jack Davis, Will Elder, Ed Fisher, Jack Fuller, Leon Golumb, A. Green, Russ Heath, Carl Hubbel, Phil Intralandi, Al Jaffee, Seymour Mednick, Roger Price, Arnold Roth, H. A. Schneider, Bernard Shir-Cliff, Max Shulman, Ira Wallach, Doodles Weaver, and Wally Wood. *Trump*. Milwaukie, OR: Dark Horse Comics, 2009.

Kurtzman, Harvey, with Michael Barrier. *From Aargh! to Zap! Harvey Kurtzman's Visual History of the Comics*. New York: Byron Preiss/Prentice Hall, 1991.

Kurtzman, Harvey, Dave Berg, Gene Colan, Johnny Craig, Reed Crandall, Jack Davis, Colin Dawkins, Jerry DeFuccio, Will Elder, Ric Estrada, George Evans, Al Feldstein, Bernard Krigstein, Joe Kubert, John Putnam, John Severin, Alex Toth, and Wally Wood. *Two-Fisted Tales (The EC Archives)*. York, PA: Gemstone Publishing, 2007.

———. *Two-Fisted Tales: Volume 2 (The E.C. Archives)*. York, PA: Gemstone Publishing, 2007.

Kurtzman, Harvey, Harry Chester, Jack Davis, Will Elder, Al Jaffee, Arnold Roth, and Wally Wood. *Humbug*. Seattle: Fantagraphics Books, 2008.

Kurtzman, Harvey, Jack Davis, Jerry DeFuccio, Will Elder, Ric Estrada, George Evans, Russ Heath, Joe Kubert, John Severin, Alex Toth, and Wally Wood. *Frontline Combat (The E.C. Archives)*. York, PA: Gemstone Publishing, 2008.

Kurtzman, Harvey, and Will Elder. *Goodman Beaver*. Princeton, WI: Kitchen Sink Press, 1984.

———. Playboy's *Little Annie Fanny: Volume 1, 1962–1970*. Milwaukie, OR: Dark Horse Comics, 2001.

———. Playboy's *Little Annie Fanny: Volume 2, 1970–1988*. Milwaukie, OR: Dark Horse Comics, 2001.

Kurtzman, Harvey, with Howard Zimmerman. *My Life as a Cartoonist*. New York: Minstrel/Pocket Books, 1988.

Harvey Kurtzman: Retrospective of a MAD Genius. San Francisco: Cartoon Art Museum, 1995.

Usual Gang of Idiots, The. *MAD Archives*. New York: DC Comics, 2002.

———. *MAD Archives: Volume 2*. New York: DC Comics, 2007.